Season of Promise

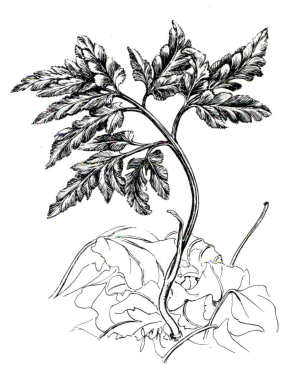

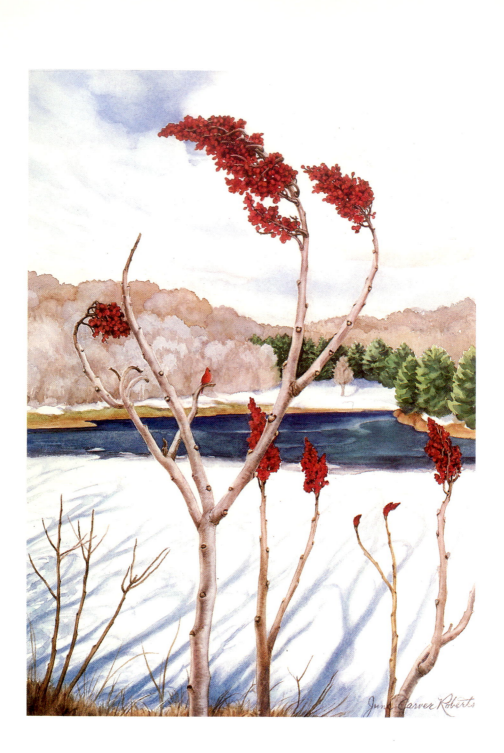

June Carver Roberts

Season of Promise

Wild Plants in Winter
Northeastern United States

June Carver Roberts

Ohio University Press, *Athens*

Library of Congress Cataloging-in-Publication Data

Roberts, June Carver.
 Season of promise : wild plants in winter, northeastern United
States / June Carver Roberts.
 p. cm.
 Includes bibliographical references and index.
 ISBN 0-8214-1022-9 (cloth). — ISBN 0-8214-1023-7 (paper)
 1. Plants in winter—Northeastern States. 2. Botany—Northeastern
States. 3. Phytogeography—Northeastern States. 4. Botanical
illustration—Northeastern States. I. Title.
QK117.R63 1992
581.5'43—dc20 92-20596
 CIP

Graphic Design by Don F. Stout
Director of Ohio University Publications

Ohio University Press books are printed on acid-free paper ∞

To Donald

CONTENTS

❄ Indicates plants that can be seen in their flowering state in
Born in the Spring, by June Carver Roberts; Ohio University Press, 1976.

FOREWORD

Wildflowers have held a special fascination for me since I was a junior in high school. During the intervening years, I have shaped my career around the study of these special creations of nature.

I have found, with much satisfaction, that many people share my enthusiasm for wildflowers, yet finding books that reflect this enthusiasm is not always easy.

One person who knows how to transfer her feelings for wildflowers to the artist's canvas and the printed page is June Carver Roberts. Having published the handsome and popular *Born in the Spring: A Collection of Spring Wildflowers,* June Roberts has now brought us *Season of Promise: Wild Plants in Winter.* As in her previous book, she has captured the mystique of each plant in her true-to-life paintings in *Season of Promise.* Her lucid descriptions that accompany each painting are accurate and written in a style that is sure to appeal to anyone interested in flowers. Her first-hand information on what the plant looks like during the winter cannot be found in any other book, and her discussion of the utility of each plant is timely.

Although I have seen and studied scores of books about wildflowers, June Roberts's two books find a cherished spot on my library shelf. Wildflower enthusiasts cannot afford to be without them.

Robert H. Mohlenbrock
Distinguished Professor
Department of Botany
Southern Illinois University

PREFACE

While doing field research for *Born in the Spring,* I watched plants emerge from the ground, bud, flower, and bear fruit spring after spring. Questions began to arise in my mind about what transpired in the intervening months; what preparations are necessary for these rebirths to take place after the seemingly dead months of winter? When spring merged into summer I also watched the later wildflowers whose year-round lives are more apparent. As an artist I have always been delighted with the special beauty in the rhythms, gestures, and patterns of leafless trees, dry grasses, and fruited wildflowers in winter.

Soon after finishing the spring book, I visited George LeBoutillier, then retired from the Department of Architecture at Ohio University. As we walked across a snow-covered field near his Vermont home, George said he wished I would do a book on dry winter stalks and their interesting fruits. At George's words, the idea that had begun with my own interest germinated, and I began work on "the winter book," which I eventually entitled *Season of Promise.*

Once started I found, as so often is the case, that questions answered pose ever more questions, and that nature has an inexhaustible fund of varieties and variations on every theme. I learned that in autumn roots of perennial and biennial flowering plants develop runners, stolons, basal shoots or leaf rosettes to keep the plants alive for the next season of flowering and fruiting; that soil is revitalized to continue nourishing plants by receiving recycled parts of the plants themselves. Some of the large wildflowers store food in rhizomes over two or more winters before having adequate reserves to produce a flowering stalk. Mature seeds disperse, come to rest, and sprout if the location is suitable. Some species sprout in autumn so that the plant may come into flower more quickly in spring, and those of other species overwinter to sprout in spring or summer.

Flowering occurs in every season, including winter, even here in the Northeast (see Witch-hazel, Skunk Cabbage and Common Spicebush). I learned of evergreen plants that manage to keep their leaves green all year, and of plants that have leaves in winter only, one indication of how positive and necessary to the life cycles of many plants the cold season is—its touch also can ripen fruits, mature seeds, and provide rest.

Along with flowering plants, the clubmosses, ferns, fungi, and lichens can be seen on winter walks. I wanted to know about all of these mysteries, and the answers involved every season of the year. A dry fruiting stalk, capsule, berry, nut, fern frond, mushroom, or a lichen thallus is the result of that plant's style of procreation and cannot be separated from a description of what came before and what is to follow.

In the case of wildflowers, the design of the flower in which the ovary grows is linked to how it is pollinated and matures into viable seeds; the type of seedcase is the one that best keeps the seeds safe and dry until they are dispersed; the seeds' design is suited to their method of dispersal, and the manner in which they disperse gives them the best chance of arriving in the habitat they need to germinate and regenerate their species. The time of year in which a plant flowers and fruits is also part of the ongoing story, the flowers fulfilling the promises of overwintering roots, leaves, or fruit.

Identifying a dry stalk is like playing detective. Gathering what clues may be present and searching botany manuals and illustrated flower guides, one may be able to deduce the solution. Be aware, however, that the plant will almost always be taller, fuller, and more branched than those pictured in the guides, which usually show an early stage, not the full extent of the plant's growth potential. I have drawn and painted what we see in winter and explained it by describing the year-round life of each plant. I had ample time in the more than ten years of working on the book to check the flowering stage of most of the dry stalks included, but any errors are my own.

I have only briefly touched upon these plants' interdependence and importance to other species, in winter as well as in summer. Plants offer food, homes, and refuge for insects, birds, and mammals. Plants are so important to humans in summer, as the source of oxygen, flood prevention, shade, beauty, and so on, that we should be aware of their winter survival efforts, to be sure that we do not hinder them or interfere.

Man's relationship to plants spans eons, from their inclusion in myths and religions, through their employment as medicines, crops, and manufacturing materials, to their use as landscaping ornamentals, and a subject for books. Today, we appreciate them not only for how we can use them but for themselves, as an integral part of life on planet Earth. We now know that wild plants are free gifts, not requiring our cultivation, but that at present they will not survive without our informed concern, followed by action. We in the United States are lucky to have enough room, so far, to afford wild plants; in Britain some lovely wildflowers were eradicated because they were considered harmful to farm crops.

As for the use of wild plants for food or medicine today, I am not recommending either; I mention these uses as a matter of historical interest. Such usage requires positive identification as well as expert knowledge of the stage at which a plant is edible or effective, and its exact preparation or dosage. Plants that are not toxic to one person may be to another; also, few plants now grow out of the reach of pollutants. Our food is amply supplied by supermarkets, and medicinal properties are chemically synthesized so that we no longer are dependent upon wild plants. This helps preserve our botanical heritage, *and* the hard-pressed wildlife for whom wild plants may be the only source of nourishment. As I understand it, the present high cost of research and patenting restrictions are keeping new discoveries of natural medicinal properties at a minimum in the United States. When plants are dug for this purpose, it is only until a synthesis of their medicinal properties is perfected.

Many of the common plants found in winter are included here, as well as some very rare ones that once were common. I have included recent state listings of the condition of native plant populations, but these necessarily lag behind present circumstances, and species not yet listed may be in jeopardy. My hope is that by keeping their status ever before us they may be saved from extinction. It was not until *after* the last Passenger Pigeon died that songbird species were protected and saved. A few states have laws against picking or digging endangered native wild plants, but more legislation is needed; several plant species already have been extirpated from some areas. Of course, laws alone won't be sufficient; in order to save what diversity we have left, each of us must respect the natural world and take from it

with moderation and gratitude, following the example of the native peoples who lived on this land before us. It is encouraging to know that in a few places school-children are being taught environmental etiquette and conservation—hope for the future resides there.

* * *

My knowledge of botany is mostly visual; this book is primarily for amateur botanists like myself, who are curious about everything natural outdoors. I have covered as many plant groups as I could research and fit into one book, including a few ferns, mosses, fungi, and lichens, but I was forced to omit algae, liverworts, grasses, sedges, and trees! The book is arranged by habitats, but some species occur in more than one, so check other sections of the book besides the one in which your plant was found. The plants are arranged in the order of their botanical classification within each section, with only a few exceptions to accommodate page design.

The area covered is from Maine to Minnesota south to the southern boundaries of Virginia, Kentucky and Missouri, referred to in flower guides as the Northeast quarter of the United States. Many of the species included here also range northward into Canada, to the Northwest and California, or southward in mountains, often extending to Florida and Texas, and many also occur in other parts of the world. You will discover that a number of ranges have shrunk over the years and a few others have spread beyond their original locations, especially of some exotic plants.

Plant names, both Latin and English, reflect and record superstitions, history, folklore, people, and places. They are sometimes humorous and often poetic. Many are discriptive and helpful; others are misleading. I have used botanical terms in the text when they are more accurate or concise; however, they are defined in the Glossary. Please refer to the Bibliography for the names of books whose authors I mention in the text.

For plant nomenclature I have followed Fernald's *Gray's Manual of Botany,* 8th Edition, diverging from it only to avoid confusion when contemporary field guides consistently show a different usage. In spite of current convention I have followed Fernald's advice to retain capitals for species derived from names of persons in order to avoid misinterpretation. In the headings I have cited the authors of the scientific names, followed by the translations of those names in parentheses. It has been rewarding to learn of these scientists, some of whom lived before Christ, who studied and named plants that we know today. I am grateful to all of the authors—even common plants should have an appellation so that we may address them properly as we pass, and so that we may discuss them. Being able to recognize plants when they are dry and in fruit as well as when in colorful flower adds to my pleasure in and appreciation of them. I hope this book will do the same for its readers.

J.C.R.

ACKNOWLEDGMENTS

I am deeply indebted to Marilyn Ortt, a field botanist for the Division of Natural Areas and Preserves in the Ohio Department of Natural Resources, who not only checked my plant identifications and the manuscript but patiently answered endless questions and gave freely of her advice on the preparation of this book. My special thanks also go to Anne Culbert and Faye Klahn who read the manuscript for clarity and errors with care and cheerfulness. All those who helped me locate or keep watch on plants also have my gratitude.

Above all, I thank my husband Donald, whose help, support, and enthusiasm for every aspect of this project was, as always, complete. I also wish to thank the Ohio University Press for their willingness to print this book as well as *Born in the Spring*.

GENERA BY FAMILIES

Generic names of species included in this volume in the logical order of their relationships.

VASCULAR CRYPTOGAMS, NON-FLOWERING PLANTS

Lichens

Parmeliaceae: a Lichen Family
Parmelia
Umbilicariaceae: a Lichen Family
Umbilicaria
Usneaceae: a Lichen Family
Usnea
Cladoniaceae: a Lichen Family
Cladonia

Fungi

Sarcoscyphaceae: Cup Fungus Family
Sarcoscypha
Xylariaceae: a Flask Fungus Family
Xylaria
Cantharellaceae: Chanterelle Fungus Family
Craterellus
Polyporaceae: Polypore Fungus Family
Ganoderma
Trametes
Polyporus
Stereaceae: Parchment Fungus Family
Stereum
Boletaceae: Bolete Fungus Family
Strobilomyces
Geastraceae: a Puffball Fungus Family
Geastrum
Lycoperdaceae: a Puffball Fungus Family
Calvatia
Lycoperdon
Nidulariaceae: Bird's-nest Fungus Family
Cyathus
Astraeaceae: a False Puffball Fungus Family
Astraeus
Sclerodermataceae: a False Puffball Fungus Family
Scleroderma

Mosses

Sphagnaceae: Peat Moss Family
Sphagnum
Climaciaceae: Tree Moss Family
Climacium

Ferns & Fern Allies

Equisetaceae: Horsetail Family
Equisetum
Lycopodiaceae: Clubmoss Family
Lycopodium
Ophioglossaceae: Adder's-tongue Family
Botrychium
Polypodiaceae: Fern Family
Matteuccia
Onoclea
Dryopteris
Polystichum
Camptosorus
Asplenium
Adiantum
Polypodium

FLOWERING PLANTS, SEED-PLANTS

Gymnospermae

Pinaceae; Pine Family
Juniperus

Angiospermae

Monocotyledoneae
Typhaceae: Cattail Family
Typha
Juncaginaceae: Arrow-grass Family
Triglochin
Alismataceae: Water-plantain Family
Alisma
Araceae: Arum Family
Symplocarpus
Liliaceae: Lily Family
Allium
Smilax
Dioscoreaceae: Yam Family
Dioscorea

Iridaceae: Iris Family
 Sisyrinchium
 Iris
Orchidaceae: Orchid Family
 Cypripedium
 Habenaria
 Pogonia
 Spiranthes
 Goodyera
 Corallorhiza
 Aplectrum
 Hexalectris

Dicotyledoneae
 Salicaceae: Willow Family
 Salix
 Myricaceae: Wax-myrtle Family
 Myrica
 Comptonia
 Corylaceae: Hazel Family
 Corylus
 Alnus
 Urticaceae: Nettle Family
 Boehmeria
 Polygonaceae: Buckwheat Family
 Rumex
 Chenopodiaceae: Goosefoot Family
 Salicornia
 Phytolaccaceae: Pokeweed Family
 Phytolacca
 Caryophyllaceae: Pink Family
 Arenaria
 Stellaria
 Lychnis
 Saponaria
 Dianthus
 Ranunculaceae: Buttercup Family
 Thalictrum
 Hepatica
 Anemone
 Clematis
 Coptis
 Aquilegia
 Cimicifuga
 Lauraceae: Laurel Family
 Lindera
 Cruciferae: Mustard Family
 Thlaspi
 Lepidium
 Capsella
 Brassica
 Alliaria
 Hesperis
 Nasturtium
 Barbarea
 Cardamine
 Sarraceniaceae: Pitcher-plant
 Family
 Sarracenia

Droseraceae: Sundew Family
 Drosera
Crassulaceae: Orpine Family
 Sedum
Saxifragaceae: Saxifrage Family
 Penthorum
 Tiarella
 Heuchera
 Hydrangea
Hamamelidaceae: Witch-hazel
 Family
 Hamamelis
Rosaceae: Rose Family
 Spiraea
 Aruncus
 Gillenia
 Potentilla
 Geum
 Rubus
 Agrimonia
 Rosa
Leguminosae: Legume Family
 Baptisia
 Trifolium
 Desmodium
 Lespedeza
Linaceae: Flax Family
 Linum
Anacardiaceae: Cashew Family
 Rhus
Celastraceae: Staff-tree Family
 Euonymus
 Celastrus
Staphyleaceae: Bladdernut Family
 Staphylea
Vitaceae: Vine Family
 Parthenocissus
 Vitis
Malvaceae: Mallow Family
 Abutilon
 Hibiscus
Hypericaceae: St. Johnswort
 Family
 Hypericum
Cistaceae: Rockrose Family
 Lechea
Lythraceae: Loosestrife Family
 Lythrum
Onagraceae: Evening-primrose
 Family
 Ludwigia
 Epilobium
 Oenothera
 Circaea
Umbelliferae: Parsley Family
 Osmorhiza
 Cicuta
 Heracleum
 Daucus

Pyrolaceae: Wintergreen Family
 Chimaphila
 Moneses
 Pyrola
 Monotropa
Ericaceae: Heath Family
 Ledum
 Rhododendron
 Kalmia
 Epigaea
 Gaultheria
 Arctostaphylos
 Vaccinium
Primulaceae: Primrose Family
 Dodecatheon
 Lysimachia
Plumbaginaceae: Leadwort Family
 Limonium
Oleaceae: Olive Family
 Ligustrum
Gentianaceae: Gentian Family
 Gentiana
 Swertia
Apocynaceae: Dogbane Family
 Apocynum
Asclepiadaceae: Milkweed Family
 Asclepias
 Ampelamus
Convolvulaceae: Morning-glory
 Family
 Ipomoea
 Convolvulus
 Cuscuta
Polemoniaceae: Phlox Family
 Polemonium
Hydrophllaceae: Waterleaf Family
 Hydrophyllum
Labiatae: Mint Family
 Trichostema
 Scutellaria
 Agastache
 Glechoma
 Prunella
 Leonurus
 Galeopsis
 Lamium
 Monarda
 Blephilia
 Hedeoma
 Cunila
 Lycopus
Solanaceae: Nightshade Family
 Solanum
 Datura

Scrophulariaceae: Snapdragon
 Family
 Verbascum
 Linaria
 Scrophularia
 Chelone
 Penstemon
 Mimulus
 Gerardia
 Veronica
Bignoniaceae: Bignonia Family
 Campsis
Orobanchaceae: Broomrape Family
 Epifagus
 Conopholis
Plantaginaceae: Plantain Family
 Plantago
Rubiaceae: Madder Family
 Mitchella
Caprifoliaceae: Honeysuckle
 Family
 Lonicera
 Symphoricarpos
 Linnaea
Dipsacaceae: Teasel Family
 Dipsacus
Cucurbitaceae: Gourd Family
 Echinocystis
Campanulaceae: Bluebell Family
 Campanula
 Lobelia
Compositae: Composite Family
 Vernonia
 Eupatorium
 Liatris
 Solidago
 Aster
 Anaphalis
 Gnaphalium
 Ambrosia
 Xanthium
 Rudbeckia
 Echinacea
 Helianthus
 Actinomeris
 Bidens
 Achillea
 Chrysanthemum
 Tanacetum
 Arctium
 Cirsium
 Centaurea
 Cichorium
 Taraxacum

Season of Promise

Typhaceae: Cattail Family

COMMON CATTAIL
Typha latifolia Linnaeus (of fens or bogs) (broad-leaved)

Common Cattail is an extraordinary, albeit a common, native wildflower of marshlands, found throughout most of the United States. It flowers in late spring, ripens in August or September, disperses seeds by parachute through fall and winter, and continues to stand until it breaks down to become mulch for the next year's growth. In the illustration I have shown the mature pistillate head and the ensuing stages of seed dispersal. Late winter colonies are uniformly pale with weathered clumps of fluff still attached or empty stalks atop bleached stems.

Persisting through the year in both fresh and brackish water, the rigidly erect stems stand straight to about 9 feet (2.7 m) in height. In spring, new flower stalks bear both male and female spikes, the staminate above the pistillate on the same axis at the summit of the stem. Staminate flowers loosen their yellow pollen early and the wind carries it to pollinate the pistillate flowers of neighboring plants, leaving their section of the axis bare. The pistillate part of the spike, the velvety green-brown "cat's tail," may be 12 inches (30 cm) long and 1 inch (2.5 cm) in diameter and may contain as many as 125,000 densely packed flowers. Each flower is comprised of a minute ovary and a tuft of tawny bristles; there are no other flower parts, since flags and landing platforms for insects are not needed.

At maturity thousands of nutlike seeds are released from the spike and their bristles open to form the fluff of an exploded head. Again the wind is employed to disperse the airborne seeds. Over winter, some fall on wet ground favorable for germination. The plant also has a creeping rootstock that sends up new shoots each spring.

The leaves, often exceeding the stem and over 1/2 inch (1.3 cm) wide, are flat, stiff, and parallel-veined; their bases sheathe the stem and overlap each other. Cattails grow ever farther out into the water, leaving behind the dry land they have made where land plants take hold. During winter most of the leaves break off, adding to the mass of old plants that eventually helps build soil.

In ancient times, the heads of *Typha* plants were dipped in tallow to make torches; native peoples and early colonists in America used the pollen and the starchy rootstocks for food, and the leaf sap as an antiseptic on cuts and abrasions. The leaves were and still are used in chair caning. Stands of Cattails provide shelter, food, and homes for wildlife: Redwing Blackbirds and other marsh birds nest among them, using the fluff to line their nests; muskrats build homes there, using the plants for building materials, and eating the whole plant including the starchy rootstocks, thus helping to keep the plants in check.

Common Cattail occurs in the United States, Mexico, Eurasia and northern Africa. *Typha* is the only genus in this family, with 4 species in the Northeast.

MARSHES NATIVE

PLANTS OF SHORES AND WETLANDS

Lake and Sea Shores • Streams
Swamps • Marshes • Bogs and Fens

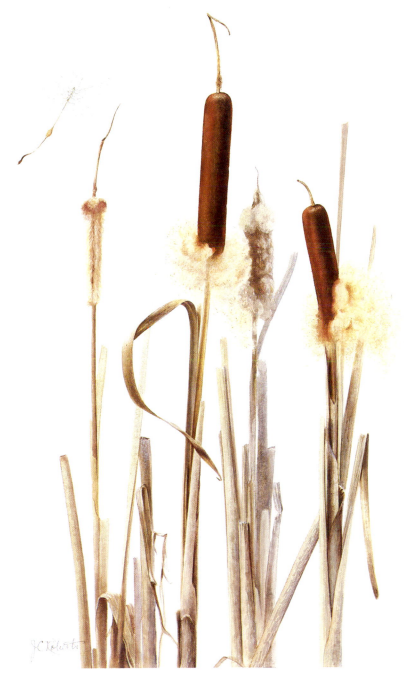

Common Cattail

Sphagnaceae: Peat Moss Family

SPHAGNUM MOSS, PEAT MOSS, BOG MOSS
Sphagnum sp. Linnaeus (a moss)

Sphagnum Moss is a large genus of the Northern Hemisphere, colonizing wet acid places. Many species are recognized; five or six may be found in any given peatland. Species differ in color, size, shape, texture, and habitat. Sphagnum is in the Bryophyta, a division of non-vascular plants. *Sphagnum,* however, is atypical of mosses, differing in reproducing vegetatively as well as by spores, and in having leaves whose chlorophyll-bearing cells are interspersed with colorless empty cells. These cells allow the soft leaves to absorb and hold great amounts of water, giving the plants rigidity and buoyancy to keep the live heads above the surface of the bog. In dry times the stored water evaporates, and the bog area is kept humid.

The number of rows of small, translucent leaves around the slender branches varies among the species; branches grow in twos or threes along the stem. Spores develop in globular capsules atop short stalks out of the heads in summer, opening with an audible pop at maturity; but more frequently, new plants sprout from broken off leaves and branches.

As the plants add growth at the top, their rootless bottoms die. A "quaking bog" results when the moss has covered the surface of the water but not yet touched the bottom. Over centuries the moss fills the bog, the bottom layers decay, become compacted with other plant debris, and form peat. Microorganisms that decompose dead vegetable matter cannot live in the oxygen-deficient stagnant water, therefore the peat layers continually build. Logs, animals, and human corpses have been found in these beds, perfectly preserved after thousands of years. Eventually a meadow may grow over the peat.

Bog trees such as tamarack and black spruce grow in sphagnum bogs; also such wildflowers as sundews (page 16), bog orchids (page 12), Labrador-tea, (page 24), and Skunk Cabbage (page 10). Amphibians and insects live in bogs and many birds feed there. The health of peatlands reflects environmental conditions, since dying moss results from lack of adequate water due to draining and other ecological changes. Wetlands filter pollutants, therefore their continued loss is of vital concern to us today.

Peat has been used in Europe for centuries as fuel and peatland as pasture. Blueberries and cranberries (page 24) are cultivated in sphagnum bogs. Due to its antiseptic and sterile qualities, sphagnum is used by nurseries for shipping live plants, as a component in potting soil, and as a mulch and natural soil conditioner for gardens. In World War I surgical dressings were made of sphagnum, and I have read that the American Indians had sterile, disposable, biodegradable diapers—of sphagnum.

BOGS NATIVE

Sphagnum Moss

Alismataceae: Water-plantain Family

AMERICAN WATER-PLANTAIN
Alisma subcordatum Rafinesque-Schmaltz () (somewhat heat-shaped)

Water-plantain is well adapted to its habitat, growing in freshwater marshes, shallow ponds, the margins of lakes, or other watery places from a perennial fleshy rhizome. In deeper water the plant has narrow leaves that can glide through the currents—some authors list this form as a separate species. More often the plant has large, broad leaves, similar to those of plantain, that are held above the water by long stalks. Leaves vary in shape from elliptical or ovate to heart-shaped. Their blades are prominently veined and their bases sheathe the rhizome.

The scape may be 3 feet (91 cm) tall, is triangular and bears a widely branched, loose head of flower clusters in summer. The clusters are composed of many whorled branches that terminate in smaller whorls of pedicels, each tipped with a tiny, waxy, white or rose-pink flower whose three-petaled corolla resembles an Arrowhead flower, *Sagittaria,* in the same family. Although each flower is small, the hundreds of flowers on a plant offer an inviting quantity of nectar and pollen to honeybees and small flies that are the plant's primary pollinators.

Each of the tiny goblet-shaped fruits that follow is composed of ten to twenty-five achenes with flat sides and rounded backs neatly fitted together. Some of the multitudinous seeds of a whole plant may float away on the water and some may be carried on the feet of wildfowl to new sites, but others may fall on dry, unpromising ground during the hot, arid times of summer. Since chance determines how many seeds are dispersed and their landing sites, overproduction is necessary for regeneration of the species; this benefits the species and local wildlife.

Approximately seventy-five species of *Alisma* occur in tropical and temperate latitudes, several throughout the United States. Water-plantains are monocotyledons; they are not related to the dicotyledonous land plantains, genus *Plantago. Alisma subcordatum* occurs throughout the Northeast, but is currently considered endangered in Pennsylvania.

Some authors list this plant as *Alisma Plantago-aquatica.*

SHALLOW WATER NATIVE

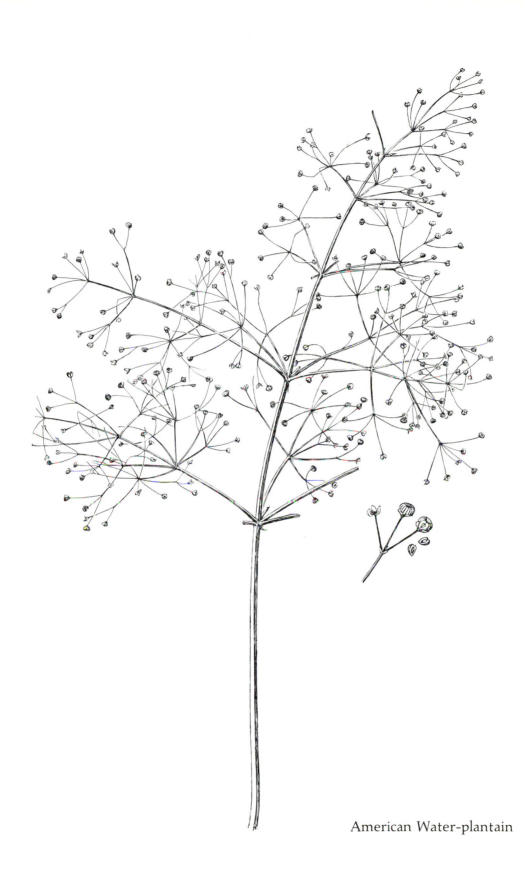

American Water-plantain

Juncaginaceae: Arrow-grass Family

SEASIDE ARROW-GRASS

Triglochin maritima Linnaeus (three points) (of the sea)

Triglochin maritima grows among rushes (genus *Juncus*) in saline marshes and also inland in alkaline soils of freshwater shores. It has a perennial, somewhat woody rootstock wrapped in the remnants of the sheaths of old leaves. Leaves are linear, fleshy, and cylindrical with one flat side. A straight, slender flower stock rises from the sheathing leaves to a height of 6 to 24 inches (15 to 61 cm), terminating in an elongated raceme of small, dull green flowers in spring or summer. Each flower has three sepals and three similar petals, and is held erect by an upcurving pedicel.

Arrow-grass fruit is oblong to ovoid, about 1/8 to 3/8 inch (3 to 9 mm) long, consisting of three to six carpels that narrow at the apex into recurved beaks. At maturity the united carpels split open from the bottom and separate from the central axis, which persists even after the seeds have dispersed. The generic name refers to the "three points" of the fruit of another species. These plants contain the mildly poisonous prussic acid and selenium, a nonmetallic toxic element that is absorbed by the roots from the soil.

Triglochin maritima occurs from Labrador along the coast to Georgia and locally around the Great Lakes. It is now considered a species of concern in Maryland, critically imperiled in New Jersey, threatened in Ohio, and endangered in Illinois. This species also occurs in Mexico, Patagonia, Eurasia, and northern Africa.

MARSHES NATIVE

Iridaceae: Iris Family

BLUE FLAG

Iris versicolor Linnaeus (rainbow) (variously colored)

This brown stalk, diverging at the top to hold three-lobed, beaked capsules, calls forth a mental picture of the exotic flowers of summer, waving in a green meadow like blue-violet, purple, yellow, and white banners. The plant is 2 to 3 feet (61 to 91 cm) tall and has a few flat, stiff leaves, mostly basal, that sheathe the lower part of the oval stem. The flowers are cross-pollinated primarily by bees, and visited by hummingbirds and butterflies for nectar. Many species of the Iridaceae are horticulturally important ornamentals.

The large capsules open by splitting at the top when mature; some open early in winter, others much later, so that seeds are dispersed over a long period of time. Each capsule holds two rows of large, D-shaped, dark brown seeds, stacked like poker chips on either side of the keel inside each segment.

Due to spreading underground rhizomes, a sunny meadow, peatland, shore, or marsh may be home to a well-established colony. The rhizome is said to be extremely poisonous; it was used cautiously by the Indians and early colonists as a diuretic and cathartic.

Iris has long been used as a symbol of wisdom, faith, and courage; it was the flower chosen by Charles V of France for the royal emblem, the Fleur-de-lis. The genus was named after Iris, the Goddess of the Rainbow in Greek mythology. "Flag" is from Middle English *flagge,* meaning "reed."

Iris versicolor occurs from Labrador to Minnesota south to Virginia, although it is currently designated as extremely rare in Delaware and Virginia. See also Blue-eyed Grass, page 206, in this family.

MARSHES AND MEADOWS NATIVE

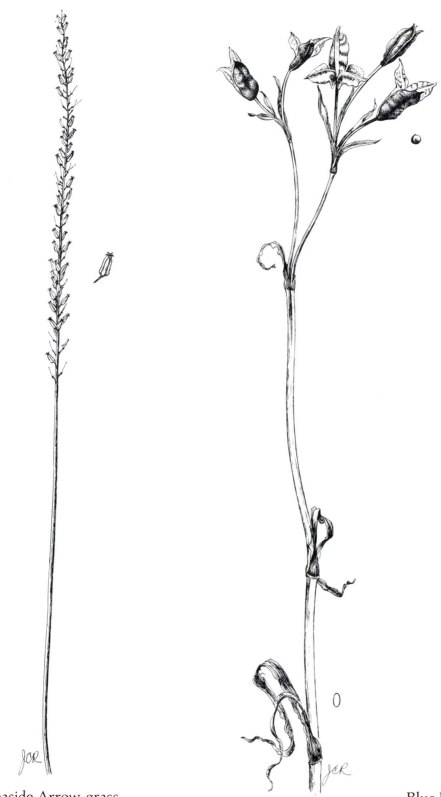

Seaside Arrow-grass

Blue Flag

Araceae: Arum Family

SKUNK CABBAGE ✿

Symplocarpus foetidus (Linnaeus) Nuttall (compound fruit) (fetid)

We like to think of Skunk Cabbage as the first flower of spring, but it actually blooms in the calendar winter. Pale, pointed buds, formed on the stout perennial rhizome in autumn, melt their way through the snow and ice of swamps, bogs, and fens with the heat of their own growth to flower from January through March in various areas. As the spathe grows 2 to 6 inches (5 to 15 cm) tall, it gains its distinctive color, yellow-ochre or green marked with irregular stripes in dark red or purple, and is amazingly difficult to see when the plants are among tangled dried grasses, with or without snow.

The tiny, creamy-yellow flowers are set on a spongy, oval spadix about 1¾ inch (4.5 cm) high within the cowl-shaped spathe. They are well protected against cold by the spathe's tough outer surfaces, which enclose a layer of white, pulpy insulation. The spathe's interior maintains a constant temperature of 72 degrees, as long as the surrounding air temperature does not fall below freezing for more than 24 hours. The first insects of the year to emerge are attracted by the fetid odor we call "skunk" and find an early life-saving supply of pollen in this sheltered place in exchange for pollinating the flowers.

Soon the leaves emerge beside the spathes. Although Arums are monocotyledons, the leaves are net-veined. By summer they are handsome and huge, possibly 2 feet (61 cm) in length. The spongy spadix matures into a single dark purple-brown compound fruit about 3 inches (7.5 cm) tall. Just under the surface are large seeds, fed upon by Ring-necked Pheasants and other ground-feeding birds. The generic name is from the Greek words *symploce,* meaning "connection," and *carpos,* "fruit," alluding to the joining of all the ovaries into one fruit.

Symplocarpus foetidus is a single American species, a plant we share with eastern Asia. It once occurred throughout the Northeast, most commonly in glaciated areas where the habitat is boggier, but with the draining of swamps for highways, housing, and commercial areas, it is found less and less frequently.

SWAMPS NATIVE

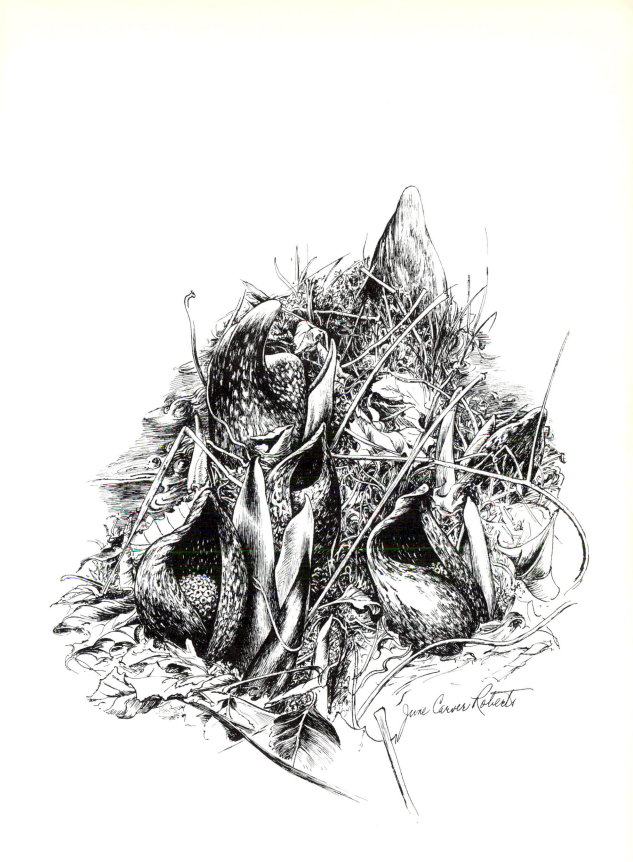

Skunk Cabbage

Orchidaceae: Orchid Family

SMALL WOODLAND ORCHIS, GREEN WOOD ORCHIS

Habenaria clavellata (Michaux) Sprengel (rein or thong) (little club)

This Rein Orchid is a native plant of bogs, wet woods, and shores, perhaps found on humps of sphagnum (page 4) in company with Round-leaved Sundew (page 16), ❋Skunk Cabbage (page 10), and other bog plants. In summer it has a spike of small pale green flowers, each with a long slender spur ending in a slight swelling, the "little club" of the specific name. The flower stalk has one clasping parallel-veined leaf and two or three small bractlike leaves higher on the stalk that are deciduous.

In its dried state, this fragile plant may remain standing all winter. The light brown capsules are each 3/8 inch (9 mm) long and have three slits for release of their powdery seeds. Orchid seeds are minute because they lack endosperm, food for the developing embryo, which in orchids is nourished by mycorrhizal fungi living in soil. This is why so few of the thousands of dust-fine seeds germinate; only those that fall upon soil containing these fungi can live.

Habenaria clavellata occurs from Maine to Minnesota south to Florida and Texas, but is now considered threatened in Massachusetts, rare in Indiana, and endangered in Illinois because its habitat is disappearing as bogs and marshes are drained for new man-made developments.

SWAMPS NATIVE

Orchidaceae: Orchid Family

ROSE POGONIA, SNAKEMOUTH ORCHID

Pogonia ophioglossoides (Linnaeus) Bellenden (bearded) (like Adder's-tongue)

Not often today does one see a fen studded with Rose Pogonia. These lovely rose-pink orchids seem to float above the sphagnum mosses (page 4) growing in rich fens, or on wet, mossy shores. ❋Skunk Cabbages (page 10), Large Cranberries (page 24), and other bog plants also could be growing there. Rose Pogonia has a single, slightly nodding, fragrant flower in midsummer that sits on the exposed, upright ovary at the summit of the stem. Three large pink sepals and three pink petals make up the perianth; the showy lower lip, 3/4 inch (1.9 cm) long, has fringed margins and a yellow beard.

The plant stands 4 to 20 inches (10 to 51 cm) tall. One erect, lance-shaped leaf sheaths the slender stem and a small, green bract ascends from the base of the ovary to accompany the flower. At maturity, slits open between the capsule's valves and air currents spread the seeds abroad.

Pogonia is a small genus of North America and east Asia with only this species in the Northeast, and it is currently on the endangered lists of eight of these eighteen states! Rose Pogonia is sensitive about its living conditions, requiring the kind of open wet habitat that is being drained, filled, and developed at an alarming rate.

The specific name refers to Adder's-tongue, genus *Ophioglossum,* a fleshy fern that has a single lanceolate leaf sheathing the stem below a spike of sporangia.

FENS NATIVE

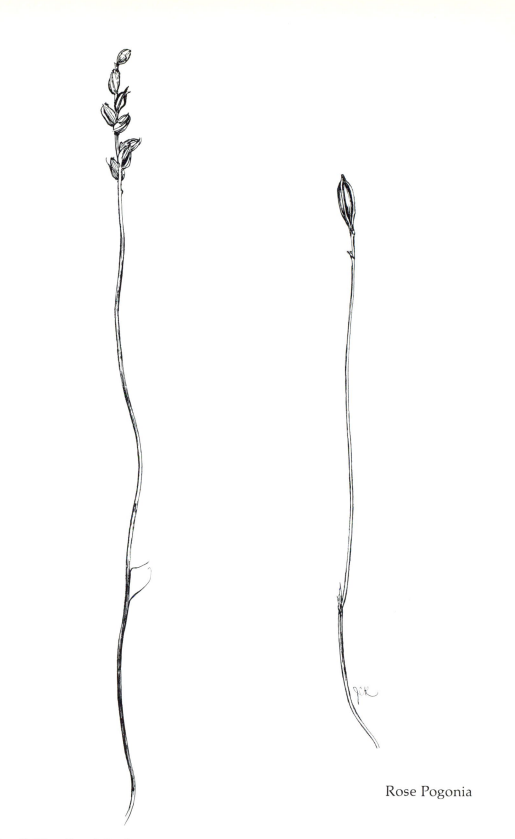

Rose Pogonia

Small Woodland Orchis

Chenopodiaceae: Goosefoot Family

SLENDER GLASSWORT, SAMPHIRE

Salicornia europaea Linnaeus (salt/a horn) (European)

Slender Glasswort is a small erect or sprawling, translucent and succulent plant 2 to 15 inches (5 to 38 cm) tall that is found along coastal salt marshes and shores, in the same habitat as Seablite, *Suaeda maritima,* and Sea-lavender (page 28). It also grows in salt licks and salt marshes inland. Linnaeus logically named this genus "salt," and added "a horn" because of the many opposite cylindrical branches with tapering tips.

From August to November the plant has groups of three minute green flowers in the upper joints of the branches. Pollination is by tiny insects and regeneration by one-seeded fruits; the plant is annual. There are no leaves, only sheaths in groups of three at the joints, the central one larger than the two lateral ones. The joints are farther apart than they are wide, an aid in distinguishing this species from the three others in this genus. On northern tidal flats Slender Glasswort often turns red in fall and persists into winter.

Salicornia europaea contains essential and trace minerals, and although very salty, can be eaten raw in salads. Slender Glasswort is frequent along the coast from Nova Scotia south to Georgia, and found locally in Michigan, Wisconsin, and Illinois. This species also occurs in the Old World.

SALINE SHORES NATIVE

Ranunculaceae: Buttercup or Crowfoot Family

GOLDTHREAD

Coptis groenlandica (Oeder) Fernald (cut) (of Greenland)

The low-growing evergreen leaves of Goldthread can carpet a large rug-sized area, and thereby attract attention, but an individual plant is a miniature, easily overlooked. The leaves are an inch (2.5 cm) or less across, lustrous and divided into three leaflets that arch backward, catching the light. Out of the rosette of leaves, in early spring, a flower stalk 2 to 5 inches (5 to 13 cm) high and as fine as a filament, holds a solitary white-sepaled flower—petals are merely nectaries. Three to five stalked pistils mature into tiny beaked follicles that will remain on the stalk even after they open to drop their seeds; to see them it is usually necessary to kneel. Small fungus gnats and beetles that inhabit this lower region are Goldthread's chief pollinators.

Coptis groenlandica requires cool mossy woods, swamps, or bogs, occurring from Greenland to Manitoba south through New England to North Carolina in mountains—wherever these conditions still exist. At present it is reported to be highly rare in Maryland and imperiled in West Virginia.

The common name refers to the golden yellow, threadlike underground stem, which is a pure astringent and a bitter tonic. Before modern medicines, and when native plants were abundant and people were fewer, native Americans and early colonists used Goldthread as a mouthwash and eyewash.

SWAMPS AND WOODS NATIVE

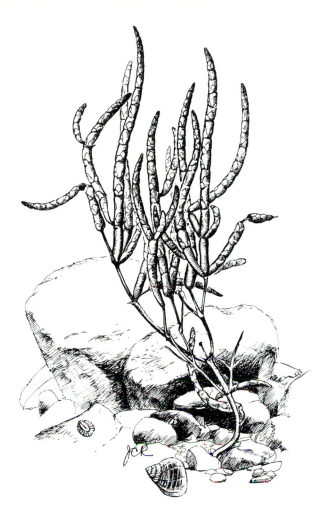

Slender Glasswort

Goldthread

Cruciferae: Mustard Family

TRUE WATERCRESS

Nasturtium officinale R. Brown (twisted nose) (of the shops)

The Mustard family gives us mustard seeds for a popular condiment, potherbs such as Common Winter-cress (page 216), vegetables like broccoli and cabbage, several garden flowers such as candytuft and alyssum, and also watercress, a sharp-tasting herb prized for salads, soups, and sandwiches. True Watercress is a perennial aquatic herb that was introduced into this country from Europe, where it has long been cultivated and once was used in the treatment of scurvy. It is now both cultivated and naturalized in this country.

Nasturtium officinale can be found in cold springs and streams, submerged or floating in shallow water. Its crisp leaves remain fresh and may be gathered all winter—but beware of polluted water. The leaves are pinnately divided into three to eleven segments, the terminal leaflet largest and nearly round. Succulent stems, rooting at the nodes, have only a loose hold on the stream bottom, so that care is required when picking a sprig not to uproot the whole plant; of course, if the find is not abundant, none should be picked. In springtime, small, white, four-petaled flowers are followed by a two-valved silique, about an inch (2.5 cm) long, enclosing small seeds.

The generic name is from *nasus tortus,* a "wry" or "twisted nose," in reference to the plant's pungency. This plant is also variously known as *Nasturtium aquaticum* or *Radicula Nasturtium-aquaticum.*

STREAMS ALIEN

Droseraceae: Sundew Family

ROUND-LEAVED SUNDEW

Drosera rotundifolia Linnaeus (dewy) (round-leaved)

Some summer day, in a boggy area, a close look at this insectivorous, low-growing plant will reward you with its sparkling beauty. The stalked leaves are in a basal rosette; those of this species are almost circular. On the upper surface and around the margin of the yellow-green leaves are red hairs, each tipped with a drop of clear, sticky liquid, "dewdrops" glistening in the sun and bending the light into prismatic colors to attract the attention of small insects. Once an insect is caught on the sticky glands, the leaf slowly folds in half over it and the marginal hairs interlock. The plant then absorbs this food with the help of a gastric juice similar to that found in the stomach of animals, and thus with this supplement is able to exist in nutrient-poor soil.

Early writers considered this method a reversal of "the natural order" of animal eating vegetable, and termed such plants evil. Mrs. William Starr Dana, in her 1893 book *How to Know the Wildflowers,* gently suggests that what we *should* feel about the carnivorous plants' method of survival is kinship.

Drosera rotundifolia is perennial, overwintering by live roots on which tiny leaf buds are formed in autumn. The single flower stalk reaches 8 inches (20 cm) at most, bearing small, white, five-petaled flowers on a coiled stalk. By summer's end, the stalk is erect and the three-part capsules contain numerous seeds. The leaves are sensitive to frost and blacken early, but the stalk dries and persists.

Species of *Drosera* are found on all continents; *Drosera rotundifolia* grows in acid bogs and marshy ground, often forming large colonies. This species is the most common of the Sundews, occurring throughout North America, although it is no longer widespread, due to the continual draining of bogs. At present it is listed in Delaware as historic only, in Ohio and New York as potentially threatened, in Illinois as endangered, and is on the watch list in Indiana. Hopefully, the value of a marshy piece of land soon will be better understood.

BOGS NATIVE

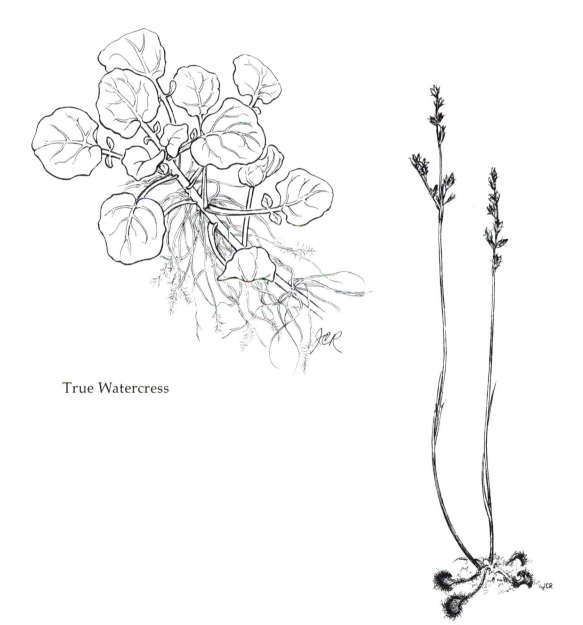

True Watercress

Round-leaved Sundew

Sarraceniaceae: Pitcher-plant Family

NORTHERN PITCHER-PLANT

Sarracenia purpurea Linnaeus (for M. Sarrasin de l'Etang) (purple)

If you should find the stiff, weathered leaves of this extraordinary plant in a sphagnum bog some winter day, that would be a place worth revisiting in late spring or early summer to see the glossy red buds and the red-and-rose flowers atop their long stems. Labrador Tea, Sundew, and Skunk Cabbage may possibly be seen there as well.

In summer the Northern Pitcher-plant's leaves are 2 to 12 inches (5 to 30 cm) long, red at first, becoming yellow-ochre to green with red or purple veins. Nestled in the grass and mosses, they are broad blades with their side edges joined in front to form a hollow vessel that holds plant juices and rainwater. The leaf top flares, and a keel runs down the front of the hollow portion. Stiff, down-pointing bristles cover the inner surface, where a sugary secretion (another unusual feature) attracts insects. Landing on the edge of the pitcher to hunt for the sweet scent, insects try to follow the paths of the veins, slide down the hairs and fall into the well; it is then almost impossible for them to climb out. The drowned insects decompose and are absorbed in liquid form, supplying part of the plant's food, thereby allowing the plant to survive in nutrient-poor soil. The raw-meat color of the leaf and the dead insects attract carrion flies, the plant's major pollinators.

Should a flower stalk survive into winter (many plants are browsed and many are picked—or worse, dug) the broad, umbrella-shaped style will be seen, covering the five-valved, many-seeded capsule. The leaves dry to brown, then weather gray and harden, keeping their shape. Native Americans used these dried leaves as drinking and berry-gathering cups.

This is the only Pitcher-plant in the Northeast, and it is becoming rare as bogs are destroyed; it is now designated as extremely rare in New Hampshire and Virginia, rare in Maryland and Delaware, threatened in Ohio, and endangered in Illinois. Crimson Pitcher-plant, *S. leucophylla,* native to northern Florida, Alabama, and Mississippi, is being "harvested from wild populations for international and national florist markets," a problem "comparable in magnitude to the ginseng trade"* and with the same disastrous results for the future of the plant. A boycott of these pitchers by the florist trade is being organized. Let us spread the word to admire, and *leave* our Northern Pitcher-plants, to save them from a similar fate.

The generic name honors Dr. Michel Sarrasin de l'Etang (1659-1734), court physician at Quebec, who sent specimens to Linnaeus.

BOGS NATIVE

* Report from Faith T. Campbell, Natural Resources Defense Council, to Endangered Species Act contacts, 15 November, 1988.

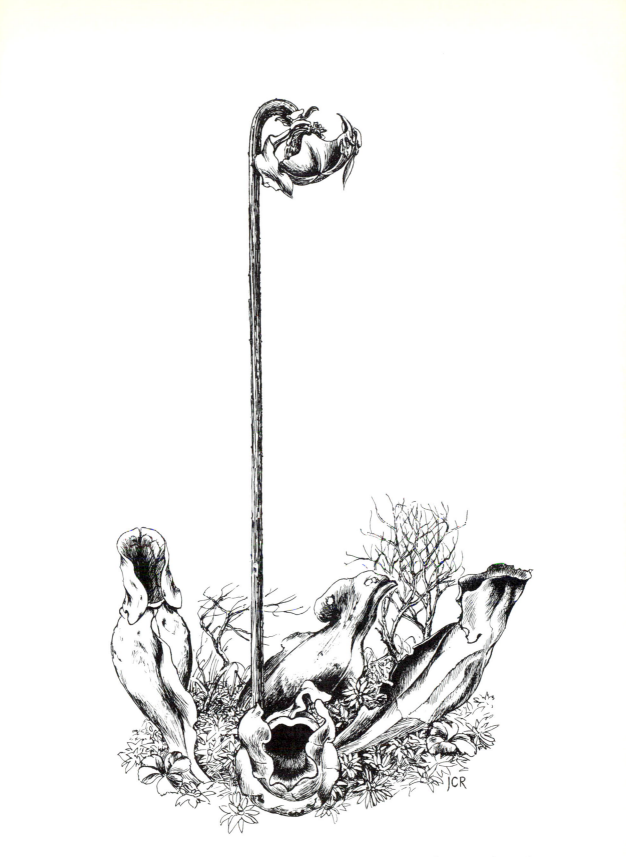

Northern Pitcher-plant

Lythraceae: Loosestrife Family

PURPLE LOOSESTRIFE

Lythrum salicaria Linnaeus *(Lytron)* (like a willow)

Beginning in July, miles of marshland along superhighways in the East are colored with the lovely magenta of this introduced European wildflower. Unfortunately, *Lythrum salicaria* crowds out diverse native species of aquatic plants that are important to waterfowl and other marshland inhabitants (see Cattails, page 2). Bees and butterflies, finding abundant nectar, are the only beneficiaries of this single species crop.

The magneta flowers are in whorls around the long dense spikes terminating the square, downy stem that is 2 to 4 feet (61 to 122 cm) tall or taller. The corolla usually has six twisted or slightly wrinkled petals, a pistil, and two rows of three stamens. The pistil and stamens have three different arrangements, depending upon their lengths. Charles Darwin studied *Lythrum* and proved that pollen from the stamens of a certain length, carried on an insect, will pollinate only a pistil of a similar length, assuring cross-pollination.

The calyx is sub-cylindrical, grooved, and has five to seven lobes, or teeth. Stem leaves are 1½ to 4 inches (4 to 10 cm) long, opposite or in whorls of three, downy and lanceolate with heart-shaped bases that clasp the stem. The numerous, small whorled capsules scatter early in the season, leaving bare branches.

Colonies of *Lythrum salicaria* are now found from Newfoundland to Minnesota south to Virginia, Ohio, and Missouri. *Lythrum* is from *Lytron,* the name used by Dioscorides for this species.

MARSHES ALIEN

Malvaceae: Mallow Family

SWAMP ROSE-MALLOW

Hibiscus palustris Linnaeus (mallow) (of swamps)

In summer the clusters of Swamp Rose-mallow's 6-inch (15-cm) flowers rise above most other marsh plants on canelike stems that sometimes reach 7 feet (2 m) in height. These plants grow singly or in groups or crowns. In summer the flower's five spreading rose-pink petals cup the long, white style with its collar of golden-anthered stamens around five golden stigmas in typical hibiscus fashion. Hummingbirds and bees are the plant's principal pollinators. Approximately twelve narrow bracts surround the flower beneath its five velvety sepals; these persist on the winter capsule.

Leaves are alternate, the blade rounded to heart-shaped at the base and accuminate at the tip. Leaf margins are serrated and the underside of the blade is downy, as is the upper part of the stem. The Painted Lady Butterfly feeds on the plants of this family.

The capsule is appropriately large for a flower of such size, and clusters of them at the tips of the gray stems are part of the marsh winter landscape. The five-valved capsule is dark brown on the outside and honey-tan inside with light brown fuzz along the sutures; each valve contains several dark, warty seeds. Although the stalk dies back, the fibrous perennial roots live through the cold season, holding the formula for building more Rose-mallows when spring returns.

Other well-known members of the Mallow family are cotton, *Gossypium,* and okra, *Hibiscus esculentus,* whose mucilaginous fruits are used as a vegetable and as thickening, as in gumbo—another word for okra. Many other mallows, including *Hibiscus palustris,* also contain this mucilage; the confection "marshmallow," now made from gelatin and albumen, was previously made from the mucilaginous root of *Althaea officinalis,* commonly known as Marsh-mallow.

Hibiscus palustris may be found from Massachusetts to Michigan and Illinois southward to North Carolina.

MARSHES NATIVE

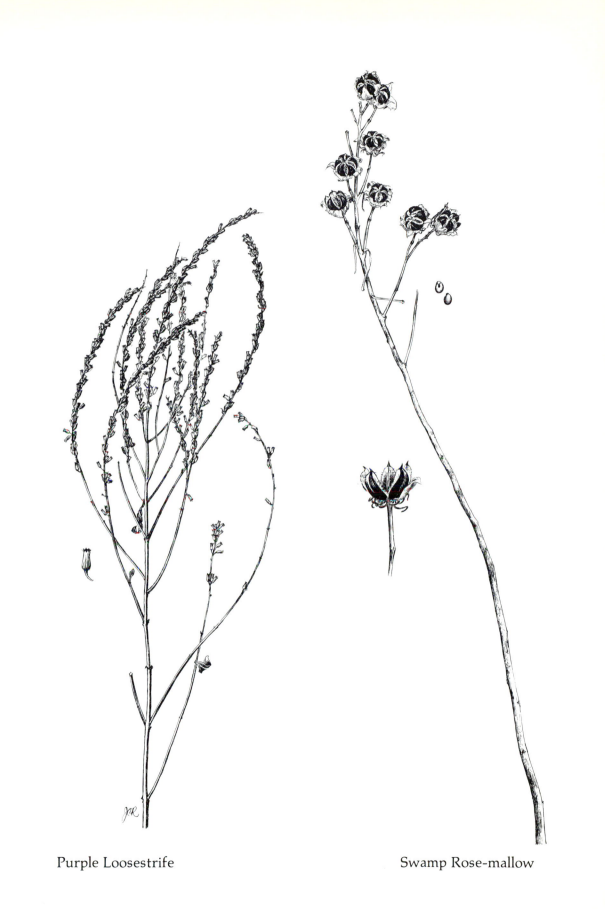

Purple Loosestrife Swamp Rose-mallow

Onagraceae: Evening-primrose Family

SEEDBOX

Ludwigia alternifolia Linnaeus (for C. G. Ludwig) (alternate-leaved)

Observing the seed capsules on the slim, smooth branches of Seedbox, it is not difficult to imagine that elves have been at work, fashioning and burnishing miniature wooden boxes. Summer flowers are solitary on short pedicels in the axils of the upper leaves; leaves are opposite and lanceolate. The flowers have four almost round, light yellow petals, 1/2 to 3/4 inch (1.3 to 1.9 cm) across, four stamens and four broad, unequal calyx lobes. The latter soon fall, leaving the cubical, green, 1/4-inch (6 mm) calyx to ripen into this polished brown capsule. At full development a pore opens in the top of the capsule, through which tiny golden seeds escape as the plant is buffeted by fall and winter winds. In the event of a calm winter, the capsule walls eventually disintegrate and the seeds are thus dispersed.

Ludwigia alternifolia is perennial and grows from 1 to 3 feet (30 to 91 cm) tall; I have shown the branching top only. It is found in swampy ground, often forming clumps, and even groups of clumps, which present a fine appearance with so many elfin boxes together. The plant occurs from Massachusetts to Iowa southward, although it is now listed as threatened in Michigan.

Ludwigia is named for Christian Gottlieb Ludwig, a professor of botany at Leipzig University in the time of Linnaeus. The specific name points up the fact that some species of this genus have opposite leaves, while those of Seedbox are alternate. See also Common Evening-primrose on page 230.

SWAMPS NATIVE

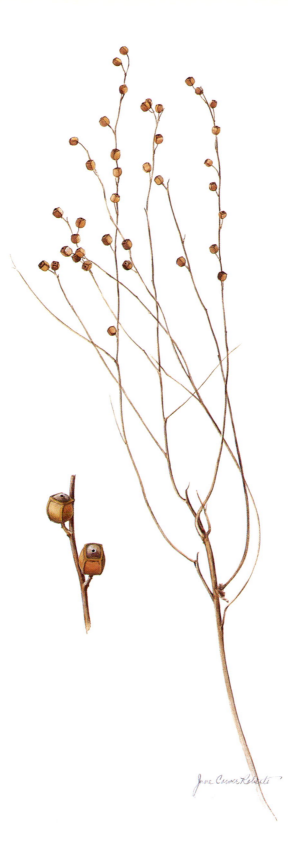

Seedbox

Ericaceae: Heath Family

LABRADOR-TEA

Ledum groenlandicum Oeder (Ledon) (of Greenland)
 See color illustration on page 267.

Labrador-tea is a small evergreen shrub 1 to 3 feet (30 to 91 cm) tall, growing in cool northern bogs, especially in glaciated areas. In springtime, clusters of fragrant white flowers terminate the twigs; each five-petaled flower is 1/3 to 1/2 inch (8 to 13 mm) wide with long stamens and pistils. Branches are almost erect and densely hairy when young. The thick, aromatic leaves are 1 to 2 inches (2.5 to 5 cm) long, narrow and blunt, their lateral edges rolled under. New leaves are upright, their undersides covered with white, woolly hairs that turn brown as the leaves age and droop. Many bog plants have such wool under their leaves, believed by botanists to help the plant retain moisture through the drying heat of summer and the drying cold of winter. Colonists used the leaves of this species for their tea during the American Revolution.

The 1/4-inch (6-mm) capsule is five-valved and oblong, opening from the base. The styles are persistent, even after the capsule valves have fallen. The presence of Labrador-tea indicates poor, acidic soil conditions to which this and other bog heaths have adapted by gaining additional nutrients from mycorrhizal fungi in the soil.

In earlier times *Ledum groenlandicum* ranged from Greenland and Labrador to Minnesota southward to northern New Jersey and Ohio, but is now listed as rare in Connecticut and Pennsylvania, and endangered in Ohio. *Ledum* is from *Ledon,* an ancient Greek name for a similarly aromatic plant.

BOGS NATIVE

Ericaceae: Heath Family

LARGE CRANBERRY

Vaccinium macrocarpon Aiton (of cows) (large-fruited)
 See color illustration on page 285.

Cranberry and blueberry are native species in the genus *Vaccinium* that have been cultivated for over 150 years. Under cultivation *Vaccinium macrocarpon* covers thousands of acres of man-made bogs to provide us with fresh cranberries for sauces, pies, puddings, muffins, and cakes from Thanksgiving to New Year's, and with canned cranberry juice and sauce year round. We owe the enjoyment of these treats to the native Americans, who taught the Pilgrims how to prepare this pretty, tart fruit.

In the wild, the berry is smaller than that of the cultivated varieties, about 1/2 inch (1.3 cm) in diameter, but it is good to see these plants in their natural homes, creeping over rocks, or growing in sandy soils or bogs. In summer solitary flowers nod on long pedicels that rise from the axils of a few reduced leaves midway along the stem; these subtending leaves fall off by winter. Each corolla has four pink petals that are strongly recurved, exposing the red and yellow stamens that form a cone, the "crane's bill" of the common name, which began as "Crane-berry."

Branches grow 6 to 24 inches (15 to 61 cm) tall from ruddy trailing stems. Their blunt-tipped, evergreen leaves are 1/5 to 2/3 inch (5 to 17 mm) long, alternate, glossy above and paler beneath; side margins are parallel and rolled under. Large Cranberry is the exclusive host for the Bog Copper Butterfly, whose eggs overwinter and whose larvae feed on the leaves in spring.

Vaccinium macrocarpon ranges from Newfoundland to Manitoba south to Virginia and Arkansas. Due to continual loss of habitat, however, especially of bogs, the species is now designated as declining in Maryland, rare in Virginia, potentially threatened in Ohio, on the watch list in Indiana, and endangered in Delaware and Illinois.

Ericaceae is a family of woody, shrubby plants that also includes Rhododendrons (page 26) and Bearberry (page 284).

BOGS NATIVE

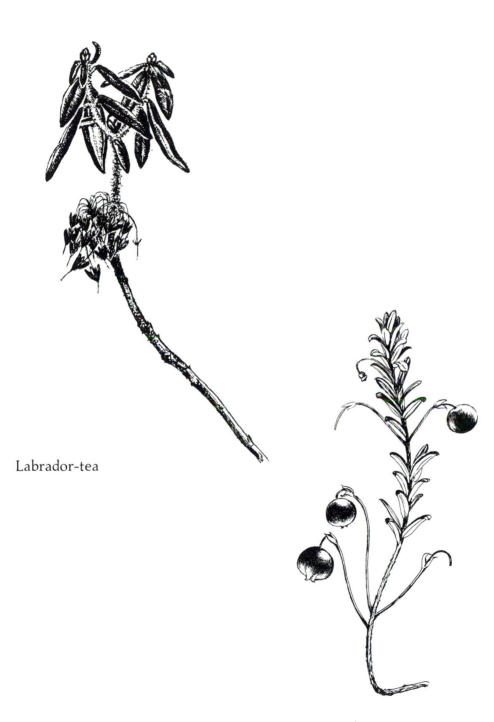

Labrador-tea

Large Cranberry

Ericaceae: Heath Family

RHODORA

Rhododendron canadense Torrey (rose-tree) (Canadian)

A delicate beauty is this wild azalea, growing in cool acid bogs, in old pastures, and on rocky summits. It is a slender, erect shrub, usually about 30 to 36 inches (75 to 91 cm) tall; I have shown one branch in the illustration. Flower buds, formed in autumn, are terminal and have a few scales that fall early as the showy magenta flowers open in early summer before the leaves appear. The corolla is 1 to 1½ inches (2.5 to 3.8 cm) long, with a very short tube, unlike other azaleas, so that the ten curving stamens and the pistil are exposed for most of their length. Large nectar-seeking insects such as butterflies and bumblebees can hardly avoid being brushed with pollen by mature stamens, or leaving pollen from another flower on a mature pistil.

Winter leaf buds are hairy, the twigs smooth. Leaves are oblong, entire, and light gray-green above, paler beneath. The many-seeded capsule is vase-shaped and covered with short hairs. At maturity the capsule and the pistil split into five parts at the apex, become dark brown, and remain on the plant all winter, giving the seeds every opportunity to disperse.

In our area the genus *Rhododendron* includes the evergreen rhododendrons and the deciduous azaleas. Many species of both have been hybridized for ornamental planting. Wild plants have suffered from picking and Rhodora is now listed as vulnerable in New York and critically imperiled in New Jersey.

WET ACID SOIL NATIVE

Primulaceae: Primrose Family

SWAMP CANDLES, YELLOW LOOSESTRIFE

Lysimachia terrestris (Linnaeus) Britton, Sterns & Poggenberg
 (for Lysimachus) (terrestrial)

Swamp Candles, found throughout our region, stands in groups along grassy fresh-water shores and in streams. The stem is smooth and slender, 1 to 3 feet (30 to 91 cm) tall with a candlelike raceme of yellow flowers in summer, at the summit of the stem above the leaves and branches. The star-shaped corollas, held away from the stalk by the pedicels, form a cylinder of flowers that tapers slightly toward the top. Leaves are usually paired, lanceolate, and sharp-pointed.

Small bulblets (suppressed branches) sometimes grow in the leaf axils of Swamp Candles after flowering time. It is said that these bulblets caused Linnaeus to mistake this plant for a mistletoe, in which genus he originally placed it; mistletoe has pale green axillary flowers. When he found that *Lysimachia* did not grow in the trees but on the ground, he recorded his discovery in the specific name. Legend has it that the generic name commemorates King Lysimachus of Thrace, who, being chased by a maddened bull, waved some of these plants and thus pacified the bull.

The slender stalks of Swamp Candles are perhaps not noticeable in winter until snow reveals their delicate pattern of dark brown capsules and five-pointed calyxes. The species spreads by seed and by stolons. This family also includes cyclamens, primroses, and other ornamental plants grown in greenhouses.

SHORES AND STREAMS NATIVE

Rhodora Swamp Candles

Plumbaginaceae: Leadwort Family

SEA-LAVENDER, MARSH ROSEMARY

Limonium Nashii Small (marsh) (George V. Nash)

To walk the eastern shores in winter recalls the summer there, where Sea-lavender's blue-violet flowers adorn coastal marshes from July to October. To find this souvenir of those days gives promise of another summer to follow, for its root is perennial and its seeds are many. The plant stands in salt water at high tide, where Slender Glasswort (page 14) also may be growing.

The flowering stalk of *Limonium Nashii* is 6 to 24 inches (15 to 61 cm) tall, branching rhythmically in alternate cadence. Flowers are along the upper side of the branches, each five-petaled corolla surrounded by a dry tubular calyx that is pubescent at the base. A cluster of spatulate, long-stemmed leaves, 2 to 10 inches (5 to 25 cm) long, rises from the root; these leaves have a prominent midrib and are smooth and somewhat rubbery, as are the leaves of many salt-tolerant plants. In winter the leaves shrivel and darken, but persist. Stalks that survive still hold the five-toothed calyxes that enveloped the flowers and contain the seeds.

The Plumbaginaceae has many members in the tropics and in deserts, but is represented by only the Sea-lavenders among our flora. Gathering this plant for home and even restaurant decoration is depleting its numbers, because the entire plant is picked before any seeds are dispersed. If we stop picking *now* (I have), perhaps we can save Sea-lavender from appearing on the endangered species lists.

The family is named for a lavender-blue-gray color known as "plumbago," after a lead ore that is made into graphite—a name that does not apply to this beautiful blue-flowered species. *Limonium* comes from an ancient Greek word for Sea-lavender, thought to mean "marsh." The specific name honors George Valentine Nash (1864-1921).

SALINE SHORES NATIVE

Sea-lavender

Asclepiadaceae: Milkweed Family

SWAMP MILKWEED

Asclepias incarnata Linnaeus (for Asclepius) (flesh-colored)

Asclepias incarnata is a more slender, yet more branched Milkweed than either Common Milkweed or Butterfly Weed (pages 202, 232), and its sap is less milky; the family name derives from the milky sap in the leaf veins of most species. Swamp Milkweed can be seen along shores and in marshy places, occurring from Quebec to Wyoming south to South Carolina and Texas. The plant is 1 to 4 feet (30 to 122 cm) tall and leafy in summer with narrow lance-shaped leaves.

The follicles are spindle-shaped when green, 2 to 4 inches (5 to 10 cm) long, upright on paired, ascending stalks. At maturity they open along one side and their plumed seeds are scattered by summer breezes. The empty follicles become dry and paper thin, beige to weathered gray; eventually the plant releases its fast hold on them and they begin to fall off. In late winter, you may find a plant with only one or two empty follicles, or with none.

The Milkweed family ranges over the temperate, tropical, and sub-tropical regions, and includes shrubs and vines as well as herbs. Milkweed butterflies, for example the Monarch, lay their eggs on these plants and the larvae feed on the leaves, which contain toxins that cause them and the adults to be unappetizing to birds.

The genus was named for Asclepius, a Greek physician-hero sometimes worshipped as a god of healing; various species of *Asclepias* have been used as cures for intestinal ailments. *Incarnata* alludes to the color of the flower, which varies from creamy pink to rose-purple.

SWAMPS NATIVE

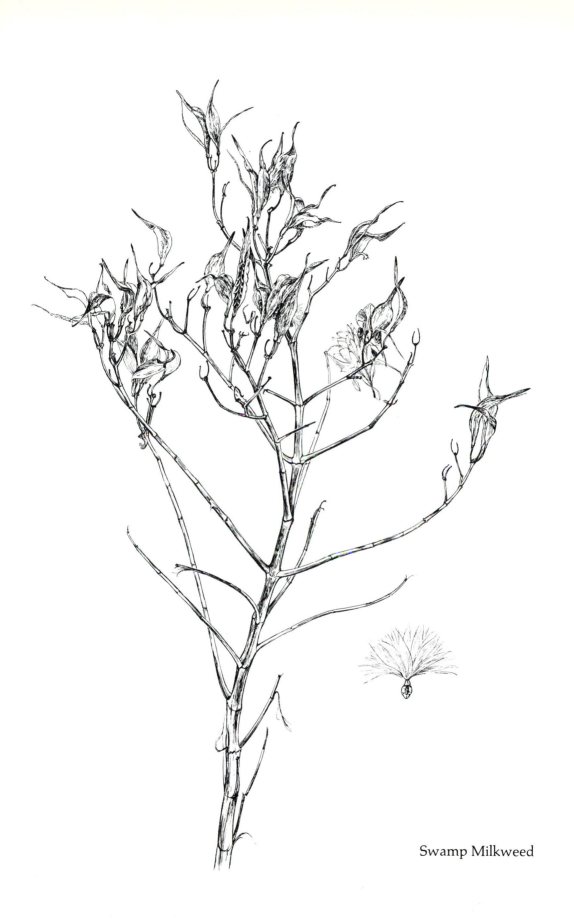

Swamp Milkweed

Plantaginaceae: Plantain Family

SEASIDE PLANTAIN

Plantago juncoides Lamarck (footprint) (rushlike)

This native species of plantain has its perennial root deep in the beaches and marshes of the Atlantic coast, where it may be found from Greenland and Labrador to New Jersey, although currently the plant is considered critically imperiled in that state. Varieties of this species also grow along the Patagonian, Pacific, European, and Asian coasts.

The leaves of summer are ascending, fleshy, and narrow, and have one nerve. A scape 2 to 9 inches (5 to 23 cm) tall rises from a tuft of leaves bearing a slender, cylindrical spike of flowers similar to that of English Plantain. Each small, pale olive-green flower in the spike has four keeled sepals that persist around a four-part corolla, subtended by bracts.

The calyx is conical and has two to six seeds in each of its two locules. When ripe the capsule splits apart along a transverse line and the thin outer top comes off, often with the withered corolla attached so that it resembles a cap with a tassel. This top falls easily, but it takes much buffeting to shake loose the inner cap that covers the seeds. When that falls, the oblong, 1/8th-inch (3-mm) seeds are free to disperse from the capsule's cuplike calyx.

Common Plantain, *Plantago major,* and English Plantain, *Plantago lanceolata,* are more prevalent species of waste places, lawns, roadsides, dooryards, etc. Their spikes of fruit and their seeds are similar to those of Seaside Plantain, although smaller. Common Plantain has a long spike on a short stalk and broad leaves; English Plantain has a short spike on a long stalk and narrow leaves; all three species are introduced. Plantain leaves were once highly esteemed for the treatment of all kinds of skin irritations.

The generic name is Latin for "sole of the foot," inspired by the broad leaves of species like Common Plantain.

SHORES ALIEN

Compositae: Composite or Daisy Family

SEASIDE GOLDENROD

Solidago sempervirens Linnaeus (make whole) (evergreen)

Goldenrods are perennial herbs that have variously arranged inflorescences made up of numerous small, usually yellow flower heads, and seeds with short, white or tawny pappi. Their starry calyxes remain on the dry plant all winter. Possibly 75 species of *Solidago* occur in the Northeast, growing in a variety of habitats.

Solidago sempervirens is a handsome perennial with a stout stem, many bright green leaves and a showy, golden, one-sided flower cluster. Salt or brackish marshes and sandy soils near the Atlantic coast are enlivened with colonies of this goldenrod in summer. This is a highly variable species and both plumelike and clublike plants occur. Quite often all the heads of a colony incline in the same direction, resulting in a curious windblown appearance on a still day.

Leaves grow thickly at the base and along the stem. They are smooth, leathery, and slightly fleshy, as are the leaves of many salt-tolerant plants. By winter, stem leaves have withered or broken off and flower heads are dark brown. New basal leaves form early in the spring and stay green until late in the year, perhaps even through winter in the South, thus explaining the specific name.

Solidago sempervirens may reach 8 feet (2.4 m) in height, but is usually no more than 3 or 4 feet (91 or 122 cm) tall in the North. This species has been used in making yellow dyes, now successfully produced synthetically—a help in preserving this native wildflower. See other Goldenrods in Sections III, IV, V, and VI.

SHORES NATIVE

Seaside Plantain Seaside Goldenrod

Equisetaceae: Horsetail Family

ROUGH HORSETAIL, COMMON SCOURING-RUSH

Equisetum hyemale Linnaeus (horse/bristle) (of winter)

Horsetails are related to a prehistoric order of treelike plants in the Carboniferous period whose spores became beds of cannel coal and jet. *Equisetum hyemale* is a highly variable, perennial species, growing on alluvial banks of rivers and streams, in sun or shade. The plant is common throughout most of our area and beyond, although it is currently listed as a species of concern in Rhode Island.

Performing photosynthesis without leaves, the usually unbranched Rough Horsetail is all stem, and blue-green year round, unlike ❊Field Horsetail, *Equisetum arvense.* The stems are 2 to 4 feet (61 to 122 cm) tall, erect in summer, sometimes bent or broken in winter. They sprout from widely creeping rhizomes that produce dense colonies. The center of this tubular, jointed plant is hollow except at the nodes, which are sheathed on the outside in ash-gray crossbands of silica. The surface is fluted with ridges and contains more silica, making it rough to the touch—American Indians and early colonists used the plant for scouring, and the ashes as a disinfectant.

In summer a solitary cone-shaped structure, a strobilus, with a sharp pointed tip and a whorl of small fused leaves at the base, develops at the top of each fertile stem. Horsetails reproduce by spores instead of seeds. When mature, the cone expands slightly, causing the scales to separate enough to allow the release of the spores. Each scale of the cone bears a few green spores with four hydroscopic "arms" that uncoil and coil in response to various amounts of moisture, helping them disseminate.

ALLUVIAL BANKS NATIVE

Section 2
PLANTS OF LOWLANDS
**Banks of Rivers • Lakes • Streams • Swales
Meadows • Low Ground • Wet Ditches**

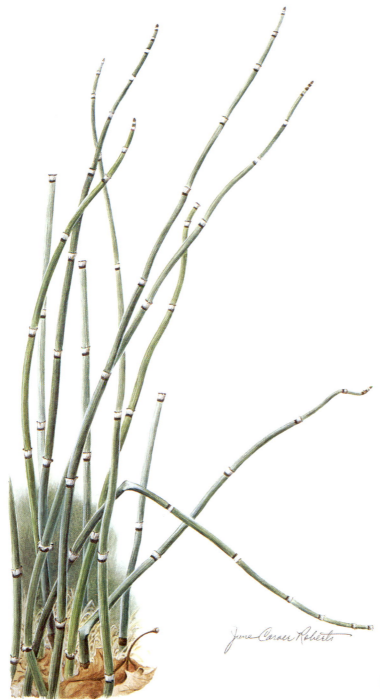

Rough Horsetail

Polypodiaceae: Fern Family

SENSITIVE FERN, BEAD FERN

Onoclea sensibilis Linnaeus () (sensitive)

On any winter's day, in wet or moist open ground, one may see a few or an extensive colony of the dark, stiffly erect fertile fronds of Sensitive Fern, especially visible against a background of ice or snow. Deep purple-brown and somewhat woody, these fronds are 1 to 1 1/2 feet (30 to 46 cm) tall, growing from creeping rhizomes. In late summer their contracted pinnae are rolled into hard sporangia that resemble rows of dull green beads borne on closely ascending branches at the stipe's apex.

The spores mature between August and November, but are held safely over winter to be released into the moisture and warmth of springtime. After discharging its spores, a stalk may continue to stand into a second winter—one may find a few of these empty gray fronds among the tightly closed new ones.

Fertile and sterile fronds grow from different places on the rhizome. The sterile fronds sprout early in spring to gather sunlight so the rhizome can produce the fertile fronds. They are 1 to 4 1/2 feet (30 to 137 cm) tall, with broad, yellow-green, triangular blades on long stipes. The blades are cut only once into as many as sixteen pairs of elliptical net-veined pinnae. These broad fronds continue to manufacture food reserves which are stored in the rhizome for the following year's fronds and die back at the first frost of autumn. Come spring, a late frost can catch the first pink fiddleheads starting to push up through the wet ground. This sensitivity to cold is referred to in both the specific and colloquial epithets.

Onoclea sensibilis is a single species; it is prevalent from Newfoundland to Minnesota and South Dakota southward to Florida and Texas. *Onoclea* was the classical name of an unknown plant applied to this fern by Linnaeus. See other ferns in Woodlands, Section III.

WET GROUND NATIVE

Orchidaceae: Orchid Family

NODDING LADIES'-TRESSES

Spiranthes cernua (Linnaeus) Richard (coil/flower) (nodding)

Nodding Ladies'-tresses is often the last orchid of late summer and early autumn to flower in the Northeast. It grows 6 to 24 inches (15 to 61 cm) tall in acid soils of fields, damp meadows, and open woods. Perennial tuberous roots send up small clumps of leaves in mid-summer that are thick and firm, up to 10 inches (25 cm) long, but shorter than the flowering stalk. Stem leaves sheathe the stalk and decrease rapidly toward the spike, which is tightly packed with fragrant white flowers arranged in a double or triple spiral. Each hooded, lipped corolla arches out from its sepals in a slightly nodding position for the convenience of visiting bees.

Asa Gray and Charles Darwin exchanged much correspondence about their studies of a bee's journey among the flowers of this species. The bee moves from lower, older flowers on one spike, where it leaves pollen on the receptive pistils, upward to the younger flowers near the summit of the spike, from whose anthers the bee receives more pollen that it carries to the base of the next spike, and so forth.

As the fertilized flowers develop into small, ellipsoid, brown capsules the pedicels straighten so that the capsules are erect when ready to disperse seeds. Capsules are composed of three ribs and three valves, typical of orchid fruits, that open so that wind and air currents can disperse their fine seeds. Leaves die back after fruiting time and all that is left above ground in winter is the dry flower stalk holding its seeds for the future. See Pink Lady's-slipper, page 98, for more on orchids. *Never pick or dig wild orchids.*

Eleven species of *Spiranthes* are recognized in our area, none of which are plentiful. At present *Spiranthes cernua* is considered a species of special concern in Delaware.

MEADOWS NATIVE

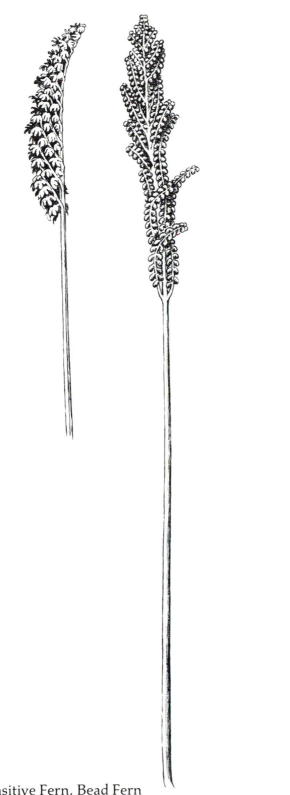

Sensitive Fern, Bead Fern

Nodding Ladies'-tresses

Salicaceae: Willow Family

LARGE PUSSY WILLOW

Salix discolor Muhlenberg (willow) (two-colored)

In March we look to Pussy Willows to tell us that winter is losing its grip. Growing in moist places along creeks, ditches, or ponds, Pussy Willow roots detect the earliest stages of thawing. The plant may be a short bush or a small shrubby tree up to about 20 feet (6.1 m) tall. Buds formed the previous autumn hug the slender upper twigs in regimented alternation until late winter, when bud coverings brighten to red or orange. Soon the catkins emerge, the staminate ones covered with silky gray hairs, the "pussy fur" (branch on the left in the illustration); it is at this stage that the plants are sought for bouquets. Male and female flowers are on different plants; the female's green tips and the male's golden pollen, protruding beyond the gray hairs, can soon be seen (branch on the right). At maturity the capsules on female catkins open to release white cotton-tufted seeds as young leaves stretch out of their buds.

Browsing animals feed on the tender twigs and bark in winter; some songbirds line their nests with the soft, cottony hairs in spring; the larvae of many butterflies feed on *Salix* leaves, and the Viceroy Butterfly lays its eggs among Willow-leaf Galls. Shrubs of every kind provide cover for birds and animals all year; native Americans used the wood of *Salix discolor* for hoops and handles; the supple twigs have been woven into baskets; and the shrubs are planted to check erosion due to their fast-growing and wide-spreading roots.

Salix, the classical Latin word for "willow" is a large genus of over fifty species in our area; *discolor* makes reference to the leaves, which usually have white hairs on the underside, a help in distinguishing this species from other willows.

Willow Pine Cone Galls (center of the illustration) are often seen at the tips of twigs, holding the larva of a gnat that laid its egg in a new branch tip, stimulating the plant to build the gall around it. In springtime the insect pupates and the adult emerges. Other gnats, wasps, and grasshoppers have been found to use the galls for nurseries and winter homes. The Petaled Willow and Beaked Willow Galls also may be found on willows.

Salix discolor ranges from Newfoundland and Labrador to British Columbia south to New Jersey, Maryland, Missouri, and Idaho.

WET BANKS NATIVE

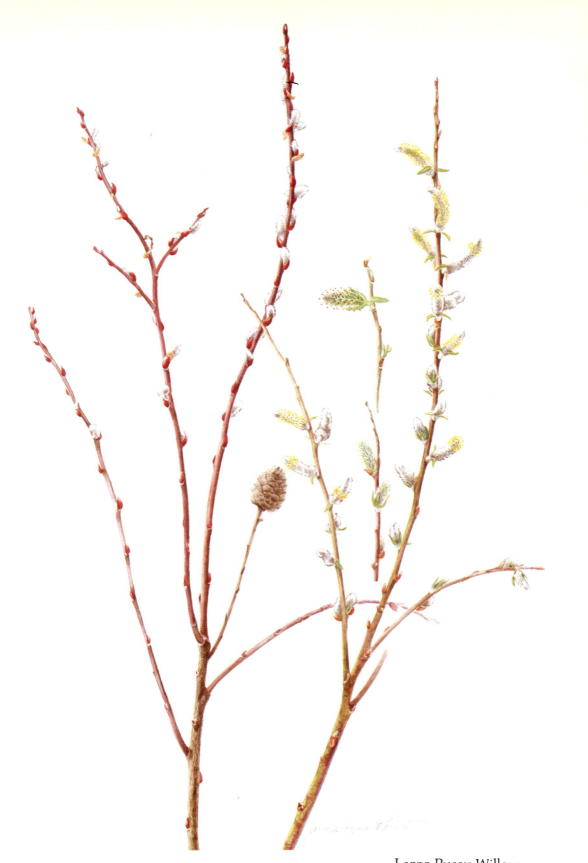

Large Pussy Willow

Urticaceae: Nettle Family

BOG-HEMP, FALSE NETTLE

Boehmeria cylindrica (Linnaeus) Swartz (for G. R. Boehmer) (cylindric)

In winter Bog-hemp is coppery-brown and the axillary fruiting spikes are not hidden by the plant's leaves, as they are in summer. Flowering from July to October, this perennial has a stiff, tough stem that may be rough or nearly smooth. It grows in moist ground, and is 1 to 3 feet (30 to 91 cm) tall. Such plants as skullcaps (page 52) are found in the same habitat. Summer leaves are opposite, long petioled and ovate, with toothed margins. Flowers are tiny and yellow-green, clustered on spikes that usually curve upward from the leaf axils, and diminish in size toward the top, resembling nettle flowers spikes. Male and female flowers are separate, on the same or different plants, staminate flower clusters usually interrupted on the stalk and carpellate clusters continuous.

Boehmeria cylindrica is in a genus by itself in the Nettle family because it differs from other nettles, the "true nettles," in not having stinging hairs. The name Hemp refers to the tough stem-covering that can be peeled off, as can that of true hemp, *Cannabis sativa,* whose fibers are made into cloth and twine, and whose leaves and flowering tops are the source of marijuana.

Bog-hemp occurs from Maine to Minnesota, south to Florida and Texas. The generic name honors Georg Rudolph Boehmer (1723-1803), Professor at Wittenberg University in Germany.

DAMP GROUND NATIVE

Caryophyllaceae: Pink Family

RAGGED-ROBIN

Lychnis flos-cuculi Linnaeus (flame) (cuckoo-flower)

A single Ragged-robin plant is very slim, but a colony of plants colors wet meadows, roadsides, fields, and swales with a delicate rose-pink blush in early summer, declaring the family name. The hairy stem, to 4 feet (122 cm) tall, is sparingly leaved and terminates in a cluster of flowers whose corollas sit atop the narrow closed calyxes; these are not inflated as are the calyxes of *Lychnis alba* and *L. dioica* (page 210). Each petal of the corolla is 3/4 to 1 inch (1.9 to 2.5 cm) long and deeply cleft into four unequal ribbonlike lobes, creating a fringed or "ragged" appearance. Bumblebees and butterflies are the chief pollinators of these flowers. The ascending, lanceolate leaves are opposite and sessile, and have wavy margins; basal leaves are more spatulate in shape.

At full development the stem dries but remains standing on the perennial root to hold the oval, ribbed, five-toothed capsules. Each capsule is enclosed by an open, persistent calyx that serves as a cup from which the seeds gradually disperse.

Lychnis flos-cuculi originated in Europe but is now naturalized here, occurring locally from Quebec and Nova Scotia south through New England and New York to Pennsylvania. The generic name was applied to some brightly colored European species; I can find no explanation for the specific epithet.

MEADOWS ALIEN

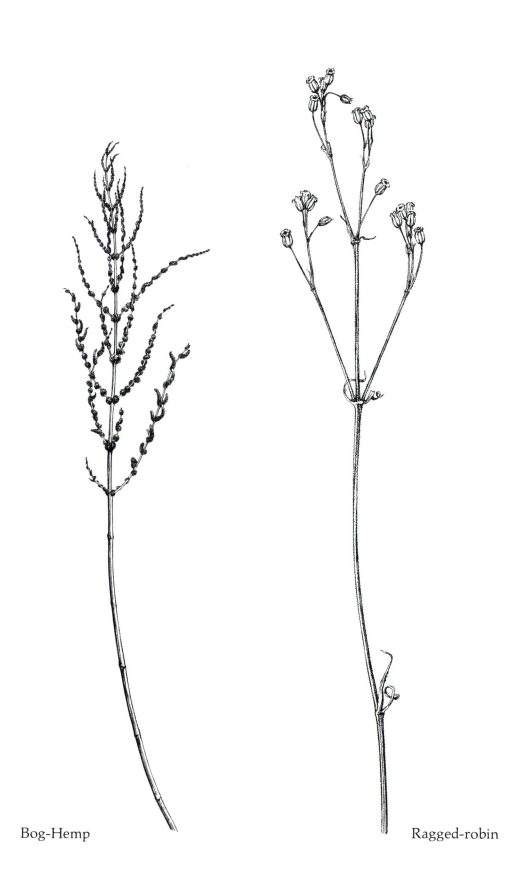

Bog-Hemp Ragged-robin

Ranunculaceae: Buttercup or Crowfoot Family

TALL MEADOW-RUE, KING-OF-THE-MEADOW

Thalictrum polygamum Muhlenberg () (polygamous)

The delicate pattern of these dark brown branches and their beaked fruits, seen in winter, reminds us of the billowy clouds of white flowers of summer, constantly supplying bees and butterflies with nectar in exchange for cross-fertilization. The numerous stamens of the male flowers are prominent, the female flowers less noticeable; there are no petals. A few flowers may be perfect.

Tall Meadow-rue rises above most other plants in sunny swamps, wet meadows, and roadside ditches, to a height of about 7 feet (2 m). This places the head of flowers high enough to allow every breeze to blow some ripe pollen across any mature pistils; unlike many wildflowers, this species employs both insects and wind to pollinate.

Large compound leaves are alternate on the slender stem and branches; they are divided three or four times into small three-lobed leaflets resembling the leaves of Columbine (page 280). Clusters of beaked achenes about 1/4 inch (6 mm) long develop from the flowers and are dispersed gradually as they are knocked off by winter winds and rains. Tall Meadow-rue occurs from Newfoundland to Ontario south to Georgia and Tennessee, but is currently listed as threatened in Indiana.

Thalictrum was a name used by Dioscorides, a first-century Greek physician; Muhlenberg applied the name to this wildflower. See also Thimbleweed on page 156 for more on the Buttercup family.

WET MEADOWS NATIVE

Saxifragaceae: Saxifrage Family

DITCH STONECROP

Penthorum sedoides Linnaeus (five/mark) (like *Sedum*)

The flowers of *Penthorum sedoides* are in branching clusters of one-sided spikes, a growth form that resembles species of the genus *Sedum,* the Stonecrops. We can see this resemblance in the dried stalks of winter, except that the spikes of *Penthorum* become more erect when they are dry (compare *Sedum ternatum,* page 106). *Penthorum* also differs from *Sedum* in that the flowers are yellow-green, not white or pink, and the leaves are not succulent as in *Sedum.* However, some floras still list this wildflower in the *Crassulaceae,* the Sedum family.

From July to October, the small flowers line the upper sides of two or three diverging branches that spread from the top of the stalk, which grows 8 to 36 inches (20 to 91 cm) tall. Flower parts are usually in fives, referred to in the generic names: five sepals, ten stamens with orange anthers, and five pistils with a united base; rarely are there any petals. The light green leaves are 2 to 4 inches (5 to 10 cm) long, alternate, thin and lance-shaped; their margins are finely toothed.

In autumn the plant turns deep pink as it matures and then dries to red-orange brown— a pleasing color to find in a winter landscape. When the tiny angled seeds ripen, the horns of the five-angled, five-horned capsules fall away, revealing the seeds and a pale interior.

Ditch Stonecrop grows in wet spots and on banks of lakes, rivers, and streams. It is the only species of *Penthorum* on this continent, occurring from New Brunswick to Minnesota south to Florida and Texas. It is currently listed as threatened in Rhode Island.

WET PLACES NATIVE

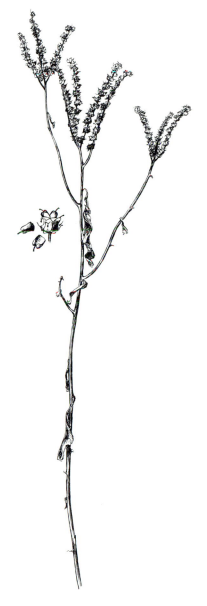

Tall Meadow-rue Ditch Stonecrop

Rosaceae: Rose Family

MEADOWSWEET

Spiraea latifolia (Aiton) Borkhausen (a wreath) (broad-leaved)

Meadowsweet is a woody shrub, 2 to 5 feet (0.6 to 1.5 m) tall, with pale pink or white terminal flower clusters in summer. The clusters are pyramidal, those on side branches smaller than the apical one. In the illustration I have shown the apical cluster of a 4-foot (1.2-m) plant. Individual flowers are tiny and have five sepals, five rounded petals, and numerous stamens, typical of members of the Rose family.

The deciduous leaves are alternate, smooth, and elliptical with coarsely-toothed margins; Bridal Wreath, an introduced cultivated species of this genus, has shorter but similar leaves. Stems are smooth, red- to purple-brown and tough, with thin bark that tends to flake. Unlike perennial herbaceous plants that in winter are alive underground only, these stems are alive year round and new leaves and branches will grow from the twigs in springtime. The Spring Azure Butterfly feeds on species of *Spiraea*.

Spiraea latifolia spreads by rooting, horizontal branches, thus producing dense stands on damp roadsides, in meadows, pastures, and woodland borders. The tiny, dark brown, woody follicles remain on the shrub over winter, allowing ample time for seed dispersal. *Spiraea latifolia* occurs from Newfoundland to Michigan south to the mountains of North Carolina. At present this species is listed as rare in Virginia.

STEEPLEBUSH, HARDHACK, *Spiraea tomentosa* Linnaeus. A deciduous shrub 2 to 4 feet (61 to 122 cm) high, Steeplebush does not form dense colonies—it is Meadowsweet that is "hard to hack." In late summer Steeplebush has deep rose-pink, tightly-packed flowers in a slender pyramidal cluster that terminates a stiffly erect, woody stem or stems. The flowers, leaves, and fruits are smaller than those of Meadowsweet and much of the plant is felted with short, soft hairs. *Spiraea tomentosa* occurs from Nova Scotia and Quebec to Minnesota southward.

MEADOWS AND PASTURES NATIVES

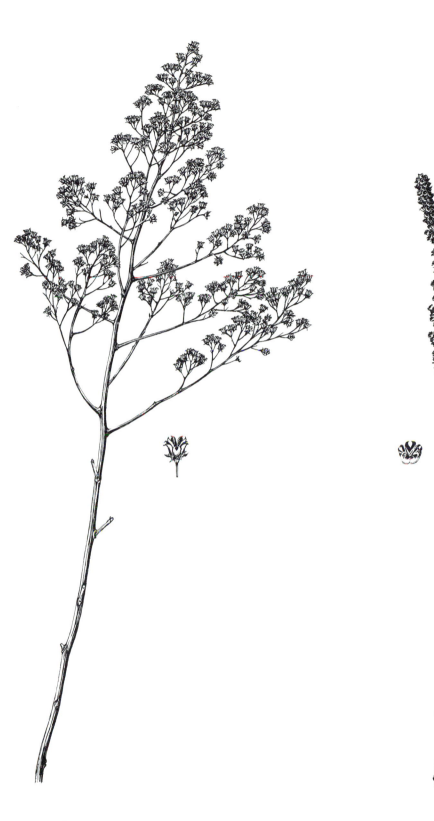

Meadowsweet Steeplebush

46

Hypericaceae: St. Johnswort Family

DWARF ST. JOHNSWORT

Hypericum mutilum Linnaeus () (cut off)

A plant of low open ground, Dwarf St. Johnswort is a slender, erect summer wildflower with opposite branches and leaves typical of the genus. This species is between the large Common St. Johnswort (page 228) and the diminutive Pineweed (page 282) in size. The plant may reach 30 inches (76 cm) in favorable locations. It is said that Linnaeus named this species from a cut-off specimen that was sent to him, hence *mutilum*.

The small yellow flowers at the tips of branches are less than ¼ inch (6 mm) across, dwarf compared to those of Common St. Johnswort. Typically they open for only a day. Leaves are sessile, broadly oval, and have smooth margins. These little plants are nearly lost to view amid summer foliage, but winter stalks are distinctively burnt orange from the pointed capsules to the ground.

Green leafy basal shoots grow from the perennial rhizome in autumn and overwinter. *Hypericum mutilum* is found throughout our area and beyond. *Hypericum* is from the ancient Greek name for this genus.

DAMP GROUND NATIVE

Umbelliferae: Parsley Family

WATER-HEMLOCK, SPOTTED COWBANE

Cicuta maculata Linnaeus (poison hemlock) (mottled)

Every part of this herbaceous plant, and all species of this genus, are deadly poisonous. *Cicuta* was the ancient Latin name for Poison Hemlock, now known as *Conium maculatum*, the infamous poison given to Socrates in ancient Greece, and an alien species that occurs in our region. That *Cicuta maculata* is a member of the Parsley family is apparent, with its flat-topped umbels of small white flowers at the ends of the branches in summer and fall. The umbels are 2 to 4 inches (5 to 10 cm) across, each made up of many smaller umbels with pedicels of unequal length. Beneath these heads are slender, unbranched bracts (compare the branched ones of *Daucus carota*, page 232). The small fruits are ovate to globose with corky ridges running from the prominent calyx teeth to the base.

Water-hemlock grows 3 to 6 feet (91 to 183 cm) tall with a stout, erect stem; I have shown the fruiting top only. The large alternate leaves usually are cut into three segments having smooth, narrow pointed leaflets with serrated margins. They are long-petioled and their bases sheathe the hollow, ridged stem, which is mottled with purple when fresh. Tuberous roots resembling small sweet-potatoes with the fragrance of parsnips may be 4 inches (10 cm) long. This is the most poisonous portion of the plant.

Water-hemlock grows in wet ground of swales, low meadows and roadside ditches, and occurs from Nova Scotia to Manitoba south to Maryland and in the uplands of Virginia and Missouri. Water-hemlock is not related to the hemlock tree, genus *Tsuga*.

WET GROUND NATIVE

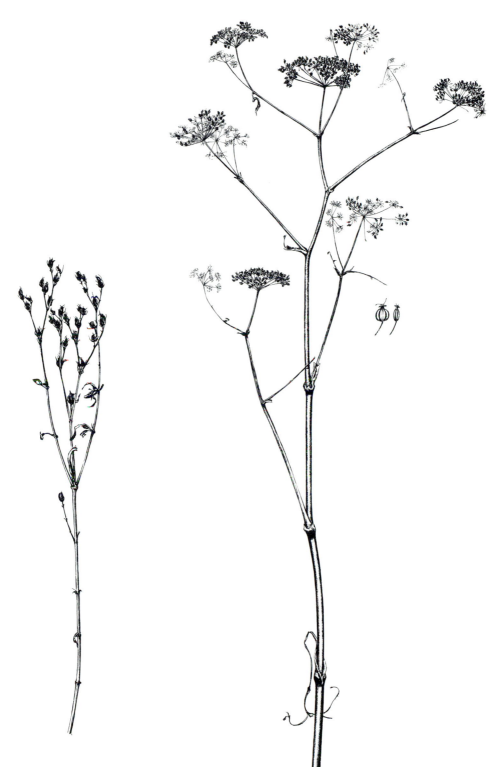

Dwarf St. Johnswort Water-Hemlock

Umbelliferae: Parsley Family

COW-PARSNIP

Heracleum maximum Wm. Bartram (for Hercules) (largest)

A virtual Hercules of alluvial fields, Cow-parsnip is a stout perennial, capable of reaching 10 feet (3 m) in height, to tower over grasses and other wild plants of swales and shores. In summer its branches hold dull white or purple-tinged flowers in a flat-topped compound umbel 4 to 8 inches (10 to 20 cm) across, a firm landing strip and feeding station for insect visitors.

Seeds are brown, flat, oval, and slightly winged, like parsnip seeds. Leaves are compound, divided into three-toothed segments; a broad inflated sheath at the leaf's base clasps the large stem, which is hollow, grooved, and woolly when fresh; over winter the wool often wears away. The stem serves as homes and/or food for insects: holes drilled from the outside tell of woodpecker activity. Moose, who feed mostly on aquatic plants, eat this dryland one. American Indians used it in cooking and in medicine.

The popular name possibly comes from the dung scent of the flowers. In Maine the plant is known as "Wild Celery"; the stalks smell like celery and sections of young ones are sometimes used as swizzle sticks. Pliny thought that another species of *Heracleum* was of the highest importance medicinally and dedicated the genus to Hercules, a Greco-Roman mythological hero, who was also big and strong. However, several members of this family are extremely poisonous if ingested (see about Poison-hemlock, page 46).

Heracleum maximum occurs in Canada and throughout the Northeast but is currently listed as declining in numbers in Maryland and as endangered in Kentucky. This species is also known as *Heracleum lanatum.*

LOW GROUND NATIVE

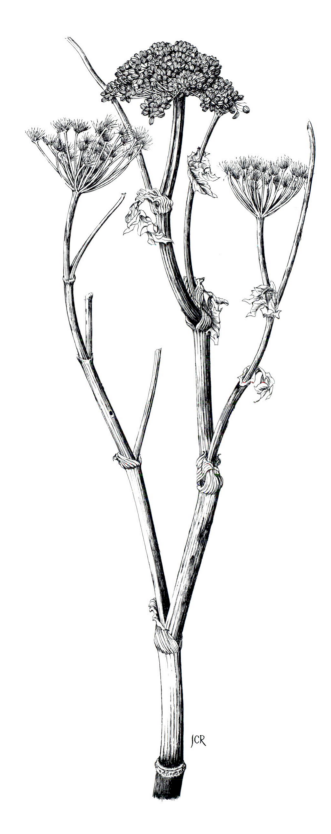

Cow-parsnip

Convolvulaceae: Morning-glory Family

HEDGE-BINDWEED

Convolvulus sepium Linnaeus (to entwine) (of hedges)

The Morning-glory family includes about fifty genera, seven in our area. Among these are *Ipomoea* (page 234), *Cuscuta* (page 176), and *Convolvulus*. All of these are vines but the family also includes tress, shrubs, and herbs, many in tropical regions. *Convolvulus* and *Ipomoea* both are known colloquially as Morning-glory.

Convolvulus sepium has smooth or slightly hairy stems that bear many solitary pink or white, funnel-shaped flowers on long peduncles in the leaf axils. Each flower is about 2 inches (5 cm) across and has two large green bracts below the calyx that fall before winter. The leaf is petioled and arrow-shaped with extended lobes at the base of the blade.

Hedge-bindweed grows from a deep perennial root. Its stem may be 10 feet (3 m) long and may trail on the ground or twine over tall herbs, shrubs, walls, or fences. It grows in moist thickets, on stream banks, and on damp roadsides. In autumn the stem hardens into its last twining shape and the smooth, light brown capsules with their darker calyxes persist. The capsule is two-celled, containing two to four seeds that usually have a rounded back and two flat sides, to fit perfectly between thin divisions inside the spherical fruit.

MOIST GROUND NATIVE

Hedge-bindweed

Labiatae: Mint Family

MARSH SKULLCAP, COMMON SKULLCAP

Scutellaria epilobiifolia A. Hamilton (a dish) (leaves of willow-herb)

Labiatae is a large family of herbs, many aromatic, that have square stems, opposite leaves, and axillary two-lipped flowers; Labiatae is from *labium,* "lip." Species of *Scutellaria* are cultivated for their essential oils, and as cooking herbs such as basil, thyme, sage, and marjoram.

Marsh Skullcap is a common wildflower of marshy ground, growing 1 to 3 feet (30 to 91 cm) tall. In spring and early summer the plant has a branched raceme of blue-violet and white hooded flowers on short pedicels terminating a sturdy stem. The flower is ½ to 1 inch (1.3 to 2.5 cm) long, and the mature calyx we find in winter is proportionately large, persisting around the ovary and its four small nutlets. The stem is almost smooth with two to five pairs of ovate, short-petioled leaves that somewhat resemble willow-herb leaves. Branches, if present, are upright and similarly leaved and flowered.

Scutellaria epilobiifolia is perennial, spreading by creeping underground rhizomes and stolons as well as by the nutlets, which sink into the soft marshy earth around the parent plant. This species occurs throughout most of our area. See also the Hairy Skullcap of woodlands, page 134.

MARSHY GROUND NATIVE

Labiatae: Mint Family

MAD-DOG SKULLCAP

Scutellaria lateriflora Linnaeus (a dish) (lateral-flowered)

Mad-dog Skullcap, straw-colored and delicate in winter, grows near water's edge, in meadows, or in swampy woods. It is perennial by underground stems, becoming 6 to 30 inches (15 to 76 cm) tall. We identify it in winter as possibly a mint by its square stem and opposite leaves, and as one of the Skullcaps by the appendage on the upper half of each of its small paired calyxes. The shape and size of the appendage, likened variously to a dish, a skullcap, a crest, a hump, or a helmet, differs slightly from species to species. This upper part of the calyx falls off when the seeds are ripe. The lower half remains on the plant; *it* is said to resemble a dish, a Roman drinking bowl, a tray, or a scoop. The four tiny seeds roll off this persistent half as down a chute—my simile!

In summer pairs of hooded flowers measure off the elongated stalk of the lateral racemes that rise from the axils of the toothed leaves. They are light blue or violet, rarely white, on a short pedicel, each flower about ½ inch (1.3 cm) long.

Scutellaria lateriflora occurs throughout our area and beyond. It was once thought to cure rabies, hence the popular name's modifier.

DAMP GROUND NATIVE

Marsh Skullcap Mad-dog Skullcap

Labiatae: Mint Family

BEE-BALM, OSWEGO TEA

Monarda didyma Linnaeus (for N. Monardes) (in pairs)

The showy scarlet flowerheads of *Monarda didyma* are a balm in summer not only for bumblebees, but also for butterflies and the red-loving hummingbirds whose long tongues are able to reach the nectar at the ends of the long corolla tubes. The large heads at the tips of the stem and branches, with an occasional second head below the first, are composed of two-lipped flowers 1½ to 2 inches (4 to 5 cm) long that have two projecting stamens. This arrangement prompted Linnaeus to name this species *didyma,* "in pairs." The flowers are arranged in whorls on the large receptacle, which is surrounded by red-tinged bracts.

The square stem arises from a deep perennial root. Petioled leaves and ascending branches are opposite, the leaf blades hairy underneath and their margins serrated. In fruit, each tubular calyx terminates in five teeth with sharp-pointed bristles. Many calyxes form the domed head, ¾ to 1½ inches (1.9 to 4 cm) broad, and remain on the dry stalk all winter to disperse their seeds.

Monarda didyma grows 2 to 5 feet (61 to 152 cm) tall, in rich moist ground, often on the banks of streams. This species is widely cultivated and has escaped from gardens in New England and extended its range from Quebec to New Jersey. Originally the plant occurred from New York to Michigan southward in uplands to Georgia and Tennessee. It is now considered vulnerable in New York.

The Oswego Indians of New York made a tea from the leaves of this species and early colonists followed the practice. The generic name is in memory of Nicolás Monardes, a Spanish physician and botanist in the late sixteenth century. See also *Galeopsis,* page 240, *Lycopus,* below, and *Leonurus,* page 238, in the Mint family.

LOW GROUND NATIVE

Labiatae: Mint Family

WATER-HOREHOUND, CUT-LEAVED HOREHOUND

Lycopus americanus Muhlenburg (wolf/foot) (American)

In winter Water-horehound's erect brown stem is smooth and slender, 1 to 2 feet (30 to 61 cm) tall, simple or sparingly branched. Paired clusters of tiny brown fruits punctuate the stem at intervals. The stalk's spare simplicity is eye-catching in contrast to the branched, bushy plants growing nearby in the low-lying ground.

Eight species of *Lycopus* may be found in our area; *Lycopus americanus* occurs throughout the Northeast. It is perennial by leafy stolons and has the Mint family characteristics of a square stem, opposite leaves, or leaf scales in winter, and axillary flower clusters. These miniature florets of summer are white and protrude from the green calyx only slightly; clusters of them ring each leaf axil. Species of mint with small flowers are in the genera *Lycopus* and *Hedeoma,* page 240; for contrast see *Monarda.* The summer leaves of Water-horehound are smooth and long-pointed with large, deeply-cut teeth on the margins. True Horehound, *Marrubium vulgare,* is an aromatic mint with pubescent leaves.

The genus was named for a European species whose leaves were thought to resemble a wolf's footprint.

LOWLANDS NATIVE

Bee-balm

Water-horehound

Scrophulariaceae: Snapdragon or Figwort Family

TURTLEHEAD

Chelone glabra Linnaeus (a tortoise) (smooth)

In the low, wet ground of swales, thickets, and streamsides from August to October, you may find Turtlehead almost anywhere in the Northeast, although it is not common. The white or lavender-tinged flowers are 1 to 1½ inches (2.5 to 4 cm) long and are in a tight cluster at the top of the square stem, which may be 3 feet (91 cm) tall. Each corolla has a broad, keeled upper lip that arches over the lower one in a remarkable semblance to a turtle's head. It takes a vigorous insect to push through the lips to the nectar, necessarily brushing past the ripe stigma or anthers in the serious business of survival of both the insect and the plant. Neltje Blanchan gives an amusing account of watching a bumblebee cause the flower's upper lip to spring up and down several times as the insect tried to enter, giving the appearance of the flower chewing on the bee.

The opposite, nearly sessile leaves are 3 to 6 inches (7.6 to 15 cm) long, ovate to lance-shaped, and have a prominent midrib and serrated margins. Turtlehead is one of the plants on which the black and orange Baltimore Butterfly lays its cluster of eggs. Young caterpillars feed in a silk nest and overwinter half grown.

The capsule is ovoid and also suggests a turtle's head when it opens by splitting in half; each half seems to be edged with lips. The capsule contains many black seeds with gray corky wings that assist in the seeds' dispersal, and perennial roots live through winter to sprout again in spring.

WET SHADED GROUND NATIVE

Turtlehead

Scrophulariaceae: Snapdragon or Figwort Family

SQUARE-STEMMED MONKEY-FLOWER
Mimulus ringens Linnaeus (little buffoon) (gaping)

Mimulus ringens flowers all summer. The corolla, usually violet, is two-lipped and has two yellow ridges that close the throat until a sufficiently heavy insect alights upon it, gaining access to the nectar and picking up or depositing pollen in return. That this handsome flower was imaginatively likened to a grinning monkey's face is reflected in both the Latin and the English names.

Mimulus ringens grows 1 to 4 feet (30 to 122 cm) tall; in the illustration I have shown the fruiting top of the plant only. Its stem is branched and ridged, causing it to appear square. Paired leaves are sessile, smooth, 2 to 4 inches (5 to 10 cm) long, pointed and shallowly toothed. Long pedicels in the leaf axils bear the flowers and now the angular fruits at their tips. A five-angled calyx fits closely around the capsule at first, with five unequal teeth extending beyond it. Over winter the calyx wears away, exposing the two-valved capsule with its many seeds.

Squared-stemmed Monkey-flower grows in damp or wet ground, usually beside water. It occurs throughout our region and beyond, although it is not common and not many plants are seen together. Another species, Sharp-winged Monkey-flower, *Mimulus alatus,* as its English name declares, has sharp wings on the stem and pedicels shorter than the petioles, which are less than ½ inch (1.3 cm) long.

DAMP, WET GROUND NATIVE

Campanulaceae: Bluebell or Harebell Family

CARDINAL-FLOWER
Lobelia cardinalis Linnaeus (for M. de L'Obel) (of the Cardinals)

The winter stalk of *Lobelia cardinalis* is inconspicuous in contrast to the tall spike of scarlet flowers on the late summer plant. The flowers are in a raceme that may be 16 inches (41 cm) long terminating the simple stem; the whole plant may reach 5 feet (152 cm) in height; I have shown the top 26 inches (66 cm) of the plant in the illustration. The flower has a long floral tube, a broad, drooping, three-lobed lower lip and a slender ascending upper lip with the unique feature of a split through which the long stamen tube and pistil project skyward. Linnaeus likened the shape of the corolla to a Cardinal's miter.

The Ruby-throated Hummingbird and red flowers such as Cardinal-flower, Bee-balm (page 54), Trumpet Creeper (page 184), and Wild Columbine (page 280) have adapted to each other. The flowers' bright color catches the eye of the long-tongued hummer; the nectar is safe at the base of the long tube, out of reach of most insects. The flower tubes are narrow, and the stamens and pistils so placed that the hummer serves the flowers as cross-pollinator in return for nectar.

Below the flower spike are numerous lanceolate, toothed leaves with prominent veins; lower leaves may be 6 inches (15 cm) long. In autumn the capsules are usually obscured by dried corolla parts; when these wear away one can see the opening between the two valves through which numerous tiny seeds will scatter as the tall stalk is buffeted by winds over winter.

Lobelia cardinalis is perennial, spreading by basal shoots, favoring stream banks, damp shores, and swampy meadows. It occurs throughout our region, although the decline of wetland habitats and possibly of hummingbirds, plus the picking of this flower, have reduced its numbers. Legislation against shooting songbirds has saved some species; if more laws are passed against picking and digging wildflowers soon, perhaps some of our native plants can be saved.

See also Tall Bellflower on page 146 in this family.

WET GROUND NATIVE

Square-stemmed Monkey-Flower Cardinal-flower

Compositae: Composite or Daisy Family

TALL IRONWEED

Vernonia altissima Nuttall (for W. Vernon) (very tall)

Ironweeds are perennial wildflowers of North and South America, Africa, and southern Asia, with at least seven species in our area. *Vernonia altissima* is a variable species that has a tough (like iron), leafy, ribbed stalk 3 to 7 feet (0.9 to 2.1 m) tall, and an open terminal cluster of deep purple flower heads from August to October. These showy flowers are high enough to be clearly visible to late pollinating insects at that season of heavy competition. Each head contains thirteen to thirty disk florets, and no rays. Leaves are alternate, 6 to 10 inches (15 to 25 cm) long, lance-shaped, and downy beneath, with finely-toothed margins.

At maturity overlapping bracts that enclose the tightly packed developing achenes loosen and curl outward to release them. The achenes are narrow, have rough hairs along vertical ribs, and are crowned with a double pappus of tan bristles that will parachute them on the wind to new sites. I have observed cardinals pulling the seeds from these heads as the dry stalk stands throughout winter; other birds also may feed on Ironweed. Five-pointed calyxes persist, after the seeds and bracts have scattered, like clusters of beige stars.

Vernonia altissima grows in damp rich soils of meadows, pastures, and wastelands, and ranges from New York to southern Michigan southward. New York Ironweed, *Vernonia noveboracensis,* is similar but shorter and its floral bracts have elongated tips. The genus is named for William Vernon (d. 1711), a British botanist who traveled in North America.

MOIST GROUND NATIVE

Tall Ironweed

Compositae: Composite or Daisy Family

HOLLOW JOE-PYE WEED, TRUMPETWEED

Eupatorium fistulosum Barrett (for M. Eupator) (tubular)

Hollow Joe-Pye Weed is a stately perennial wildflower, growing 3 to 10 feet (0.9 to 3 m) tall; I have shown the top 3 feet (0.9 m) of a 6½-foot (2-m) plant in the illustration. The stem is topped in summer with a great dome-shaped open cluster of flowers that may be 12 inches (30 cm) high and the same wide—a veritable feast-offering for cross-pollinating bees and butterflies. Each of the numerous rose-lavender flower heads in a cluster is made up of five to eight small, tubular florets with long, branching styles that produce a fuzzy appearance. The stout, hollow stem is smooth, glaucous, and suffused with purple. The large leaves are arranged in whorls of four to seven. They are lanceolate, blunt-toothed, and have one main vein.

In autumn the head retains its fuzziness with tawny pappus bristles on the five-angled achenes. Winds and rains slowly scatter the seeds, leaving the tiny conical receptacles at the tips of the pedicels bare. By winter the stem's purple has faded and its bloom has become a waxy white coating, probably protecting the stem from rotting as it stands in the damp meadows or along streamsides. This is no ordinary weed; would not "Hollow Joe-Pye Plant" be a better name?

New England Indians are said to have made a concoction from this and similar species of *Eupatorium* to cure fevers; early colonists learned the cure from the Indians and named the plant after one of them, Joe-Pye. However, no medicinal properties yet have been found by modern scientists. *Eupatorium fistulosum* is a native of North America, in the same family as Boneset (page 64) and Mistflower (page 188). This species did occur from southwestern Maine to Iowa south to Florida and Texas but is now considered extirpated from Maine and endangered in Kentucky. *Fistulosum* is from the Latin word *fistula,* a "pipe" or "tube," referring to the hollow stem, also alluded to by the popular name Trumpetweed.

The small Joe-Pye Weed Blossom Bud Gall, formed by the Joe-Pye Weed Blossom Midge, can be seen in two places on the drawing.

LOW GROUND NATIVE

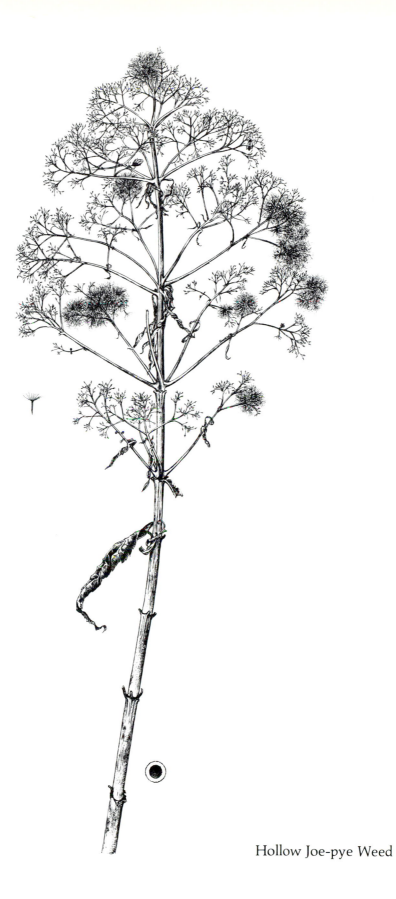

Hollow Joe-pye Weed

Compositae: Composite or Daisy Family

BONESET

Eupatorium perfoliatum Linnaeus (for M. Eupator) (through/leaves)

Bonesets are tall, handsome wildflowers of late summer and fall, found throughout the Northeast. The plants rise from a thick perennial rhizome in damp or wet locations, even standing in shallow water. *Eupatorim perfoliatum* has a woolly-haired stem 2 to 5 feet (61 to 152 cm) tall, terminating in a wide, somewhat flat inflorescence of small, dull white flowers crowded into heads. Each head contains many tiny tubular disk florets, visited by flying insects such as beetles, flies, and wasps, its major pollinators. A flower head is surrounded by two or three ranks of pointed bracts that spread at maturity to release the ripe fruits, and then persist on the dry stalk. Boneset fruits are five-angled achenes with a short pappus of dull white hairs that harness the wind to help in their dispersal.

As the specific name describes, the stem appears to go through the paired leaves because their wide bases are joined. Thoroughwort, another common name for this genus, is thought to be a corruption of Throughwort, alluding to these perfoliate leaves on some species. Boneset's leaves are 4 to 8 inches (10 to 20 cm) long, roughly hairy above, softly hairy beneath, and finely toothed, tapering from the fused bases to elongated tips. In winter they break off, leaving ragged bases.

Eupatorium perfoliatum historically was used by the Indians to induce sweating and as a treatment for fevers; the plant also is known as Feverweed and Agueweed. Some fevers, such as influenza, were known as "break-bone fevers." Boneset tonic and boneset tea, for colds, have long been valued. It is also thought that the plant may have been used for broken bones in an application of the Doctrine of Signatures (see Glossary) of medieval times because of the fused leaves. See also Hollow Joe-Pye Weed, page 62, and Mistflower, page 188, for more on this genus.

Wet Places Native

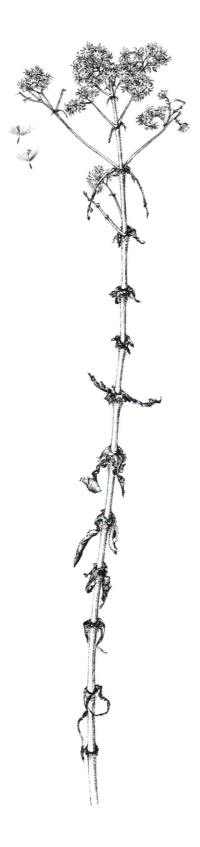

Boneset

Polypodiaceae: Fern Family

CHRISTMAS FERN

Polystichum acrostichoides (Michaux) Schott (many/row) (like *Acrostichum*)

Can anyone imagine our woods without ferns? Their green fronds help cool the air and shade smaller plants in summer, their roots aid in holding the soil, and their living green offers nourishment to wildlife. Beyond all of these, they beautify the places where they grow. Most species of fern prefer moist, shaded habitates; a few grow in open sun along roadsides or in fields; some live in water; and there are epiphytic ferns.

Polystichum acrostichoides is an evergreen fern of damp woodlands, occurring from Nova Scotia to Wisconsin southward to Florida, Texas, and Mexico. This species is large and conspicuous, enriching wooded slopes and rocky ravines with its dark lustrous green all year long. The fronds rise in clumps from a short but stout scaly rhizome with many old stalk bases and numerous roots.

The stipe is grooved and densely scaly, brown and swollen at the base, green above; it is about one-quarter the length of the blade. The blade is 1 to 3 feet (30 to 91 cm) long, and 3 to 5 inches (7.5 to 13 cm) wide at the middle, leathery, glossy, and lance-shaped, tapering to a pointed tip and narrowing slightly toward the base. It is divided into alternate uncut pinnae that spread from the rachis at right angles and are prominently eared on the upper edge. Margins have forward-pointing bristly teeth and the underside is light green and hairy.

In summer, fertile fronds grow taller, stiffer, and more erect than the sterile fronds. The pinnae toward the tip of these fronds are much reduced and their undersides are covered with round, red-brown sori. By winter the mature asexual spores have been carried away on the wind and the pinnae that bore them are now brown and curled, resembling dead tips; the lower section of the frond remains green, although leaning or prostrate. Silver-haired crosiers push up through the forest leaf-litter in early spring from the perennial rhizome to begin new sterile and spore-bearing fronds.

The generic name refers to the many rows of sori on some species; the specific name likens this fern to *Acrostichum,* a genus of tropical Leather-ferns.

WOODLANDS NATIVE

Christmas Fern

Usneaceae: a Lichen Family

OLD MAN'S BEARD

Usnea cavernosa Tuckerman (lichen) (hollow)

Old Man's Beard lichen festoons trees along the northeast coast and inland at high elevations, where cool fog and moisture-laden clouds periodically drape over them and the air is not polluted. The pale gray-green consists of tangled mats of slender, branched stalks attached to the trees. The main stems are less than $1/16$ inch (1.6 mm) wide and are covered with prongs and nobs, becoming wrinkled and honeycombed in age; the branchlets have a strong, white, cordlike core. When moist, these pendulous strands are soft and blow in the wind; when dry the whole plant is hard and stiff.

Growth occurs at the tips and strands may become 16 inches (41 cm) long. Reproductive bodies form on these living tips. This genus is in the fruticose group of lichens—the thallus is neither crusty nor leafy but branched and shrubby. Some fruticose lichens stand erect, as in British Soldiers (page 272), and some hang, as in this species.

John H. Bland wonders that we do not find a way to turn lichens into a crop. They grow where herbaceous plants will not, in arid and frigid areas; they are lightweight, keep well, and contain glucose and other nutrients as well as acids long used by man. However, with the present world population and our ability to harvest gross quantities of anything we want, it would be necessary to cultivate them—we could deplete wild lichens all too quickly.

Usnea cavernosa occurs from eastern Canada to the Great Lakes south to Massachusetts, northern Michigan, and Wisconsin.

ON TREES NATIVE

Old Man's Beard

Sarcoscyphaceae: Cup Fungus Family

SCARLET CUP

Sarcoscypha coccinea (Fries) Lambotte (flesh/a cup) (scarlet)

Near the end of winter this small red spot on the forest floor is one of the signs that spring is near. Scarlet Cup fungus is found in wet woods on debris of hardwood trees, growing sessile or on a very short stalk. The fruiting cup is ¾ to 2½ inches (1.9 to 6 cm) across; the outside of the cup is white or tan with a nap of minute hairs. The inner, scarlet surface is fertile, composed of a layer of closely-packed tubular spore-bearing sacs, or asci. The higher fungi are divided into two major subdivisions: fungi that bear their spores on stalks, or basidia, the Basidiomycetes, and those that bear their spores in sacs, or asci, the Ascomycetes.

There are usually eight spores in each cylindrical ascus of this species, piled one upon another like microscopic eggs in a sock. When mature the sacs open at the top and eject the spores with a miniature explosion, and a little cloud of dust-fine spores rises into the air.

Fungi take many forms and have a wide variety of colors. Often beautiful and always interesting, they are also vitally important to our world. Because they are nonvascular and rely on organic material for nutrients, they function as housecleaners, helping to transform dead matter into the humus that nourishes vascular plants. Some fungi function as partners with trees, shrubs, and herbaceous plants such as orchids and heaths.

HARDWOOD FORESTS NATIVE

Scarlet Cup

Xylariaceae: a Flask Fungus Family

DEAD MAN'S FINGERS

Xylaria polymorpha (Persoon ex Marat) Grevill (wood/ground) (many/form)

These black clubs, or swollen fingerlike forms, ¾ to 3¼ inches (2 to 8 cm) tall and about ½ inch (1.3 cm) thick, are the fruiting bodies of the fungus *Xylaria polymorpha* that grows on dead deciduous wood, especially beech and maple. This species is one of the flask fungi of the Ascomycetes, which bear their spores in asci. In spring the plant has a white stalk, a white or buff powdery surface, and tough, white flesh. As the spores mature to dark brown or black, the ends of the asci open, perforating the club's surface and by late autumn the club is black, hard, and cracked. In this state the fungus persists all winter.

Earth Tongues, of the genus *Trichoglossum* and *Geoglossum,* also are club-shaped sac fungi whose mature stage is black. The fruiting bodies of these species are about the same size as *Xylaria polymorpha* but have a flattened head, suggestive of a tongue.

Xylaria polymorpha ranges throughout North America.

DEAD WOOD NATIVE

Cantharellaceae: Chanterelle Fungus Family

HORN OF PLENTY

Craterellus cornucopioides Persoon (a bowl) (horn of plenty)

In its fresh state, in late summer or in autumn, Horn of Plenty is a tall, erect trumpet-shaped or petunia-shaped mushroom; *Craterellus* is from Greek and Latin words for crater, cup, and bowl. The plant is 2 to 4 inches (5 to 10 cm) high and 1 to 2 inches (2.5 to 5 cm) across the top. The flared rim may be smooth, wavy, or cracked; the color is violet- or ash-gray to dark gray-brown, even darker in damp weather. This chanterelle grows in groups among mosses or fallen leaves under deciduous trees, where it is not easily spotted. The plant is fragrant, and is considered by mushroom hunters good eating when young if stewed until tender—of course, *no* fungus should be eaten unless its identification is *certain.*

Craterellus cornucopioides is in the subdivision Basidiomycetes. It has neither gills, tubes, nor teeth, but bears its spores on the smooth or slightly wrinkled outer surface of the fungus, where they appear as a white bloom (see also Rock Tripe, page 268). The spores of this species make a white spore print, which distinguishes it from its look-alikes. By winter the spores have dispersed and the plant is dry, black, ragged, and woody—a curiosity on the forest floor.

WOODLANDS NATIVE

Dead Man's Fingers

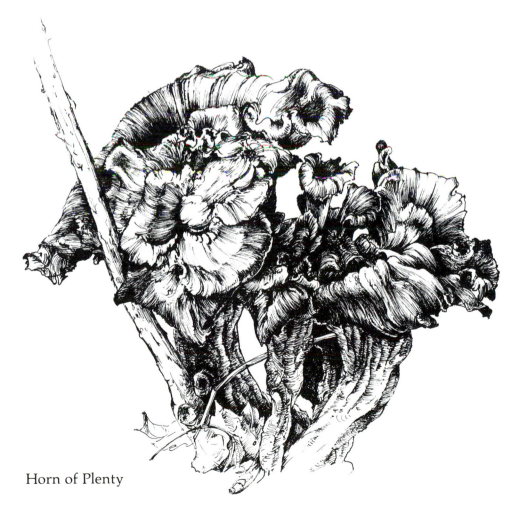

Horn of Plenty

Polyporaceae: Polypore Fungus Family

ARTIST'S FUNGUS, ARTIST'S CONK

Ganoderma applanatum (Persoon ex Wallroth) Patouillard (brightness/skin) (flattened)

Artist's Fungus, or Conk, is a tough, woody to corky shelf fungus that grows on dead deciduous wood, ever converting forest debris into reusable humus. Occasionally it grows on dead conifers and on wounded trees as well. The cap is 2 to 20 inches (5 to 51 cm) wide, barely convexed to hoof-shaped, with a smooth, hard crust that cracks in age. It is brown to gray with darker zones marking the growth layers. The fungi of this genus are among those able to grow around blades of grass and over twigs without disturbing them. Two twigs have been engulfed by the plant in the illustration, making ridges in a contrary direction.

The fertile undersurface is white during the growing season, aging to tan or beige each year; it has a fine texture made by the many pores, and inrolled margins. When the pore surface is bruised, a brown mark results that will remain unchanged as long as the fungus lasts. The colloquial name arose when people drew pictures on this flat surface, producing a brown image.

The fungi in this family are perennial and form new tubes for several years under favorable conditions. *Ganoderma applanatum* may be found throughout North America.

ON WOOD NATIVE

Polyporaceae: Polypore Fungus Family

BIRCH POLYPORE

Polyporus betulinus (Fries) Karsten (many/pore) (of birch)

The rounded, semi-circular fruiting body of this fungus appears to squeeze out of the bark of birch trees, usually dead ones. Its vegetative body, underneath the bark, helps to decompose and clean up dead trees, returning their nutrients to the soil. The mushroom is white or tinged with tan; it can grow to a width of 10 inches (25 cm). The cap's surface is smooth in youth, cracking in age.

Polypores are Basidiomycetes that are usually tough or woody, and bear their microscopic spore-producing basidia in a layer of tubes that is not easily separated from the flesh of the fruiting body. The mouths of the tubes, the "many pores," form the fertile undersurface; in *Polyporus betulinus* the pore surface is flat, edged by the rolled-under cap. The flesh is white; the spores are colorless but make a white spore print (see under Turkey-tail, page 78).

In earlier times this species was used as a razor strop, an anesthetic, and as a fire starter before matches, since it has the capacity to smoulder long and slowly if kept in a tin. We can see *Polyporus betulinus* at any time of the year in the Northeast because it overwinters. This fungus is also known as *Piptoporus betulinus.*

ON BIRCH NATIVE

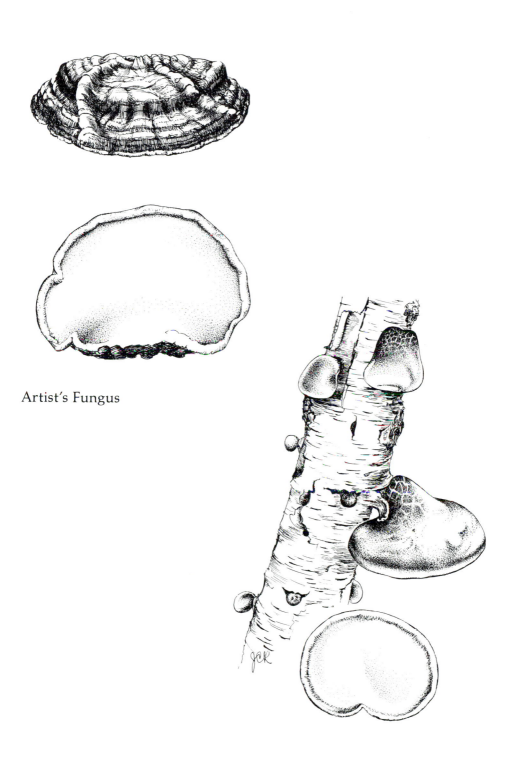

Artist's Fungus

Birch Polypore

Stereaceae: Parchment Fungus Family

STEREUM

Stereum sp. Fries (solid)

The parchment fungi are thin, leathery or woody, shell-like mushrooms of late summer and fall that live on and help decompose dead deciduous wood, returning it to the soil as humus. A *Stereum* fruiting body may measure 2 3/4 inches (7 cm) in width. The vegetative part of the plant, the mycelium, is under the tree's bark, and the fruiting bodies usually grow from the bark without a stalk. The upper surface is silky or hairy and has concentric zones that may be coppery or silvery. The underside is as smooth as a baby's skin; this is the fertile surface, or the hymenium, a layer of microscopic spore-producing basidia that are exposed, not inclosed in tubes as in the polypores. This surface is often buff-color, but may be white, tawny, orange, or gray. The spores of the fungi in this genus are colorless and make a white spore print (see under Turkey-tail, page 78).

There are about eight species of *Stereum,* all of which range throughout North America. All shelf fungi with smooth fertile surfaces were originally placed in this genus, but some have recently been listed in separate genera.

ON DEAD WOOD NATIVE

Boletaceae: Bolete Fungus Family

OLD MAN OF THE WOODS

Strobilomyces floccopus (Vahl ex Fries) Karsten (pine cone/fungus) (floccose-stemmed)

The intriguing and once-mysterious fungi have figured in legend, lore and fiction for centuries, in both real and imaginary capacities. This common eastern bolete matures from July to October, standing 2 to 5 1/2 inches (5 to 14 cm) high. The cap is almost circular, flat or convex, 1 1/2 to 4 inches (4 to 10 cm) wide, and covered with soft gray, brown, or black tufted scales that have white chinks between them. The stem has tufts of soft woolly hairs, mentioned in the specific name. Eventually the stem weakens and the head rests on the ground. In its early stage the mushroom is said to be tough and bland but edible; in winter the plant is inedible.

Fungi of the Boletaceae produce their spores on basidia in countless, tightly-packed tubes underneath the cap, facing straight down, their tiny mouths giving the undersurface a stippled appearance. The tubes of this species are gray in youth, turning brown as the spores mature to dark brown. Tubes around the stem are shorter, causing a circular depression there, distinguishing this species from *S. strobilaceus.* Another identifying feature is that the tubes are not easily separated from the cap because they penetrate the thallus to different depths.

Strobilomyces floccopus growns on the ground along old wooded trails, in humus and beds of moss. It is found from Nova Scotia to Michigan southward to Florida and Texas.

WOODS NATIVE

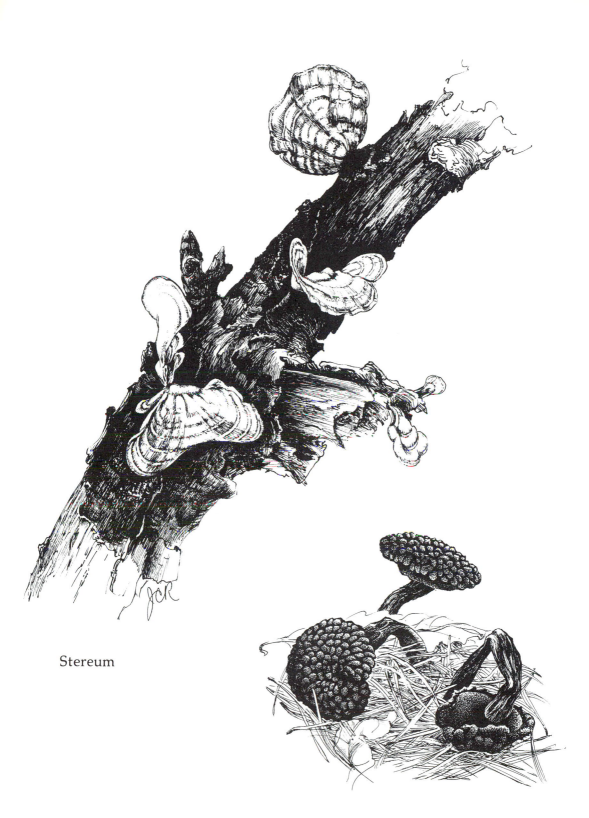

Stereum

Old Man of the Woods

Polyporaceae: Polypore Fungus Family

TURKEY-TAIL

Trametes versicolor (Fries) Pilát (weft) (variously colored)

This shelf fungus has elegant concentric growth zones of rich colors and textures. Colors vary; they may be cinnamon, buff, gray, lilac, dark red, chestnut, and/or green; winter colors are the same but less vivid. Textures resemble velvet, satin, and fur; margins may be smooth or ruffled. The plant's thallus is thin and leathery, and 1 to 4 inches (2.5 to 10 cm) wide. The lower, fertile surface is pitted with many pores—"polypore." Each pore is the mouth of a cylindrical tube in which are borne the microscopic spore-bearing basidia.

The spores of *Trametes versicolor* are colorless, making a white spore print, made by laying a fungus on a sheet of dark or light paper, whichever will contrast with the spores' color, and covering it with a bowl to eliminate drafts for about twenty-four hours. Microscopic examination of spores is necessary for positive identification of fungi, but a spore print also can be an image of loveliness in itself.

Turkey-tail is widespread throughout North America. Its growing season is from June to December and, unlike some fungi, it can overwinter and continue to produce new tubes for another season or two. This species forms semicircles or whorls, like a turkey's tail, the individual plants often overlapping. *Trametes versicolor* grows on and helps decompose dead wood, particularly oak, thereby playing an important role in woodland ecology.

The generic name means "woof" or "weft" and refers to the loosely woven filamental threads, the microscopic hyphae, among the wood fibers that make up the invisible vegetative body of a polypore fungus. This species is alternately known as *Coriolus* and *Polyporus versicolor.*

On Dead Wood Native

Nidulariaceae: Bird's-nest Fungus Family

STRIATE BIRD'S-NEST FUNGUS

Cyathus striatus (Hudson) Persoon (cup) (striate)

The likeness of the fruiting body of this small fungus to bird's eggs in a miniature nest is delightfully inescapable. The "nest" is a vase- or cup-shaped fungus with a yellow-gray or ochre-brown shaggy exterior, matted with hairs that may wear off in age. Many plants are crowded together on decayed wood, twigs, sawdust, straw, or fallen leaves, the humus upon which the vegetative part of the plant lives. Each plant is less than 1/4 inch (6 mm) high and holds three to eight sporecases—the "eggs." Young plants have rounded, hairy tops, later showing a pale, fibrous lid. As the mushroom grows, the lid becomes very thin, finally splitting when the spores are mature in midsummer or autumn, to expose the glossy sporecases in the cup.

The interior of the open fungus is lavender-gray and vertically grooved, or "striate." The sporecases are disc-shaped, less than 1/8 inch (3 mm) in diameter, and brown, gray, or black, with a silvery sheen. Each is attached to the wall of the cup by a white elastic cord called a funiculus. *Cyathus striatus* is one of the Splash Cup fungi, relying on raindrops to dislodge the egg-shaped bodies. The funiculi then help entangle and hold them to a surface until they split and release their dust-fine spores with all their potential for growing into new Bird's-nest fungi. The short stem is attached to the substratum by a dark cinnamon-brown mycelial pad, the vegetative body of the fungus.

This species is widely distributed in North America.

On Dead Wood Native

Turkey-Tail

Striate Bird's-nest Fungus

Geastraceae: a Puffbull Fungus Family

BEAKED EARTHSTAR

Geastrum pectinatum Persoon (earthstar) (comb-like)

Beaked Earthstar is a delightful little plant, found throughout most of our region, that appears to be standing on tiptoe. The fruiting body of this species begins as a sub-globose ball. The outer peridium splits from top to bottom at maturity and the sections recurve to lie on the ground around the sac of spores like the rays of a star, or they reflex so strongly that they raise the spore sac into the air. Presumably *Geastrum pectinatum* evolved this maneuver to be able better to intercept any breezes for spore dispersal.

The thin, papery spore sac thus revealed is 3/8 to 3/4 inch (1 to 1.9 cm) wide and its mouth is "beaked" or pursed up into uneven points, so that the ripe powdery spores may be puffed out by any slight touch of wind or other agent. Earthstars, with Puffballs, Bird's-nest Fungi and Stinkhorns, belong to a group of fungi, the Gasteromycetes, whose spore-bearing basidia are covered, not exposed as they are in gill, pore (see Birch Polypore, page 74), and parchment (see *Stereum,* page 76) fungi.

Geastrum pectinatum varies from light gray to purple or brown; the spores are white when young in summer, becoming red-brown and powdery by winter. The rays are 5/8 to 3/4 inch (1.6 to 1.9 cm) long. This species grows on soil in open woods, especially near conifer trees, rising from a fibrous, much-branched mycelium.

WOODS NATIVE

Lycoperdaceae: a Puffball Fungus Family

GEM-STUDDED PUFFBALL

Lycoperdon perlatum Persoon (wolf fart) (enduring)

Those of us who respond to shapes and textures are delighted when we find this mushroom fresh in the autumn woods. It has a top- or turban-shaped cap on a tapering sterile base. The plant is white, becoming tinged with yellow, pink, brown, or gray as it ages; and the cap is studded with soft conical spines of different lengths, giving it a gemmed appearance. The plant stands about 1 to 3 inches (2.5 to 7.5 cm) tall, and the cap is 1 to 2 inches (2.5 to 5 cm) in diameter. In its very young state, this species is listed as edible, although said to have an unpleasant flavor and to become bitter as soon as it turns even slightly yellow.

As the spores develop, they change from white to yellow-green and finally to dull olive or ochre-brown. The peridium becomes light brown and a pore develops at the apex of the cap, opening to coincide with the maturation of the spores, which can easily be expelled, as the generic names describes. The spines on the cap eventually fall off, leaving small circular scars; the plant "endures" in this state into winter.

Lycoperdon perlatum, found around the world, grows on the ground in forest leaf-litter, on decayed wood, or in fields.

WOODLANDS NATIVE

Beaked Earthstar

Gem-studded Puffball

Astraeaceae: a False Puffball Fungus Family

BAROMETER EARTHSTAR

Astraeus hygrometricus (Persoon) Morgan (starlike) (taking up water)

We are familiar with flowers that open their petals when the sun shines and close them when it rains to prevent pollen from washing away. Here we have a mushroom that reverses the process, closing its rays in dry weather and opening them when it is damp, relying on raindrops to help scatter spores. Rays result when the peridium of the mushroom, the hygromorphic outer skin, splits at maturity into segments that spread starlike on the ground whenever moisture is adequate. A dry plant is closed and hard with a dull, buff-brown surface, the shape and texture of a tiny leather change-purse.

With moisture the plant expands, the rays become soft and flexible and open to expose the globose inner sac, or peridium, that has a softly felted texture. The sac's color changes from off-white to gray or buff as it matures, at which time it tears open at the top to release the powder-fine spores, at first white, ripening to brown.

This little natural barometer can break away from its base disk and roll about in the wind. Of further interest is the crackle pattern on the inside of the rays, resulting from repeated openings and closings, for Barometer Earthstar persists after it matures, even into the following summer, opening and closing at every change of humidity.

In autumn *Astraeus hygrometricus* is in the button stage and often underground. It is considered edible at that time, but according to Coke and Couch the fungus is tasteless and odorless, and may have a poisonous look-alike. The plant growns in sandy soil in fields and woods, often near conifers. It is common throughout the world. This species was previously placed in the genus *Geaster*.

WOODS AND FIELDS NATIVE

Sclerodermataceae: a False Puffball Fungus Family

EARTHSTAR, DEAD MAN'S HAND

Scleroderma geaster Fries (hard/skin) (resembling earthstars)

In summer, the fruiting body of the Earthstar is a firm, dull yellow, irregular ball, 1 to 5 inches (2.5 to 13 cm) across, half buried in sandy or clay soil in woodlands. Its scaly outer peridium is rough, hard, and thick, enclosing the developing spores. Beneath this fertile mass is a sterile base of plates and fibers.

Sometime between August and November *Scleroderma geaster* reaches maturity and the peridium ruptures at the top into varying numbers of irregular lobes that open and curl back as they dry, resembling untidy earthstars. Unlike earthstars, however, the spore mass, or gleba, is then exposed; no inner peridium encloses the purple-brown mass that contains the spore-bearing basidia, as in Beaked Earthstar (page 80). At maturity the dark brown powdery spores loosen from the basidia and gradually disperse as the peridium, now black, persists.

Scleroderma geaster is widespread throughout North America, but is not common. Pigskin Poison Puffball, *S. citrinum,* is puffball-like and dull yellow, but its thick skin is covered with rough warts. This species is known to be poisonous to humans.

Elias Magnus Fries, a Swedish botanist who lived from 1794 to 1878, devoted his life to mycology and originated the modern classification of fungi and lichens.

WOODS NATIVE

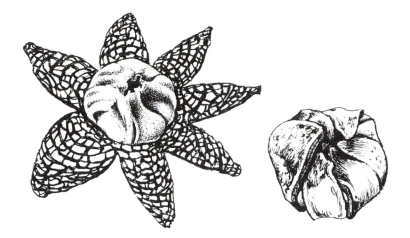

Barometer Earthstar

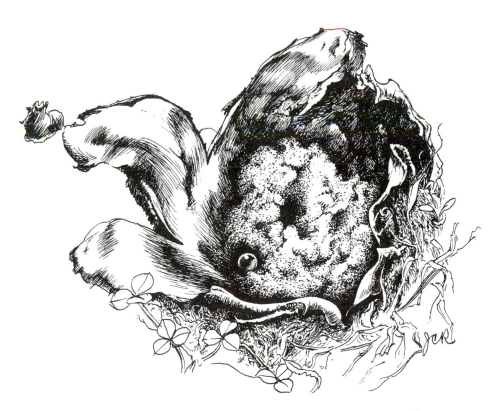

Earthstar

Climaciaceae: Tree Moss Family

AMERICAN TREE MOSS

Climacium americanum Bridel (small tree) (American)

True mosses are plants that have no flowers since they reproduce by spores instead of seeds. They are attached to the substrate by simple or branched filaments rather than by true roots, and have a clean-cut alternation of asexual and sexual stages. Tree Mosses are branching true mosses. Individual plants are large and distinct; colonies of Tree Moss resemble Lilliputian evergreen forests and are found in a variety of habitats. The three frost-tipped plants in the illustration were growing in an extensive colony on a wooded slope.

American Tree Moss grows 4 inches (10 cm) high at the most, from a creeping rhizome that produces an erect, scaly, trunklike stem. Spreading leafy branches taper to a pointed tip and diminish in size from the lowest ones upward, conifer tree fashion. This is the photosynthesizing gametophyte stage of the moss, having chlorophyll and remaining green year round. In summer this part of mature plants supports and nourishes the sporophyte stage, a spore capsule on a slender stalk, a seta, at its apex.

American Tree Moss is common in woodlands east of the Rocky Mountains. A second eastern species, *Climacium dendroides,* has a more northerly distribution; the combined range of the two species is from Canada and Alaska south to Florida and Arkansas.

WOODLANDS NATIVE

Lycopodiaceae: Clubmoss Family

STIFF CLUBMOSS

Lycopodium annotinum Linnaeus (wolf/foot) (a year old)

Clubmosses, genus *Lycopodium,* have evergreen needlelike or scalelike leaves arranged spirally on the branches and bear their sporangia in the axils of these leaves or on specialized leaves that are clustered in a cylindrical cone, or strobilus. Stiff Clubmoss is of the latter kind; it has solitary sessile strobili 1 to 1 1/2 inches (2.5 to 4 cm) long at the tips of its leafy stems. These conelike fruiting heads are composed of translucent, toothed sporophylls interspersed with straw-colored pointed bracts. The sporophylls bear asexual spores that are able to germinate into the sexual or gametophyte stage of the plant's life. Spores ripen in autumn and are released from the sporangia in golden puffs.

Stems are horizontal and run along the ground to a length of 7 feet (2.1 m) or more, often under humus, rooting at intervals. Aerial stems are numerous, 4 to 10 inches (10 to 25 cm) tall, and unbranched or with a few erect branches. Stems are stiff with bristly leaves in whorls of two sets of four around the stem. New branch sections grow from the summit of the stems annually, leaving a small space and a change in direction of the leaves, marking the beginning of each year's growth—hence the specific name.

Lycopodium annotinum grows in acid soils of moist woods and bog margins, ranging across southern Canada south to the uplands of Virginia and West Virginia. However, the plant is now designated endangered in Rhode Island, critically imperiled in New Jersey, rare in Connecticut, and potentially threatened in New York.

There are approximately four hundred species of clubmosses in the temperate and tropical regions. If we imagine these plants the size of large trees we will have a picture of early plant life on Earth. They had evolved a more complex system than the fungi and possessed vascular tissue through which water and nutrients could travel from roots to leaves. Those prehistoric clubmosses are still with us today in the form of coal beds.

WOODLANDS NATIVE

GROUND-PINE, GROUND-CEDAR, RUNNING EVERGREEN, *Lycopodium digitatum* A. Braun. Just under the leaf litter, the horizontal stems of *Lycopodium digitatum* creep or run along the ground, branching so that many square feet of forest floor may be carpeted with this evergreen Clubmoss, which is not a moss, a pine, nor a cedar. The pros-

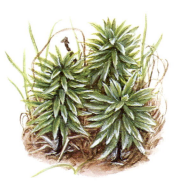

American Tree Moss

Stiff Clubmoss

Ground-Pine

trate stems root often and aerial stems rise from the horizontal ones at intervals. These bear a series of flattened branches that fork several times to form spreading, drooping fans a few inches high. The whole plant is leafy; the dark blue-green, glaucous leaves are in four ranks around the stem and branches, their tips free and pointed.

In summer one to four cylindrical cones, or strobili, stand 5 to 10 inches (13 to 25 cm) tall on specialized branches. Each strobilus is composed of many tightly packed sporophylls, tiny spore-bearing leaves, around a central axis. In this species the sporophylls are nearly round with a sharp, pointed tip and rough edges. When mature their sporangia discharge puffs of yellow spores into the air.

Clubmosses are called Fern Allies because their life cycles are the same as that of ferns, reproducing by spores rather than seeds. If the spores settle on ground in which they can germinate they will develop into the sexual, or gametophyte, stages that in turn produces another sporophyte generation, a cycle that may require up to twenty years.

Lycopodium digitatum grows in dry woods, thickets, pastures and their adjoining woods, often under conifers. It occurs from southwestern Newfoundland to Minnesota south to South Carolina, Kentucky, and Iowa. In many floras this Clubmoss is still listed as *Lycopodium complanatum*.

WOODLANDS NATIVE

Ophioglossaceae: Adder's-tongue Family

CUT-LEAF GRAPE-FERN

Botrychium dissectum Sprengel (cluster of grapes) (dissected)

The Adder's-tongue family is comprised of small succulent plants that bear a solitary, sterile leaf and a fertile spike on a single stem. The fleshy Grape-ferns are classified here. Cut-leaf Grape-fern's smooth stalk sheathes next year's bud at its base below ground level, at the top of a short perennial rhizome. In late summer or early fall, the stalk divides just above or below the ground into the sterile frond and the fertile spike. The fertile spike is erect and may be 8 inches (20 cm) tall, branching at the top into a grapelike cluster with narrow divisions, each bearing a double row of golden-green sporangia. These are large and globose, opening transversely at maturity into two valves that release their spores sometime between mid-September and the onset of winter. The fruiting stalk then withers.

The frond we see in winter is the sterile one. Its blade is 2 to 5 inches (5 to 13 cm) wide, triangular in shape, and has a somewhat leathery texture. It is cut into three sections with oblong, pointed pinnae and pinnules; veins are unforked and margins are lobed, serrated, or lacy—this is a variable species. The blade is cocked at an angle to the stipe facing the sky, better to photosynthesize sunlight into food for the rhizome to build next year's plant.

Cut-leaf Grape-fern often becomes bronze or purple in winter. Such evergreen ferns are important winter food for wildlife. This species occurs throughout our region in one form or another, growing in fields and sandy areas but most often in open woods under oaks and pines.

Virginia Grape-fern, or Rattlesnake Fern, *Botrychium virginianum*, resembles *B. dissectum* but matures in spring and both the sterile and the fertile fronds die back to the root after the spores are discharged, leaving no part above ground in winter.

WOODS NATIVE

Polypodiaceae: Fern Family

OSTRICH FERN

Matteuccia struthiopteris (Linnaeus) Todaro (for C. Matteucci) (ostrich/feather)

A stand of Ostrich Fern is a noble sight in its native habitat, catching the dappled light of open woodlands along shaded streams and riverbanks in summer. These are secluded spots, now a dwindling habitat. This was once a favorite landscaping fern, and often persists out of its native environment, many times providing a clue to the location of an old house site.

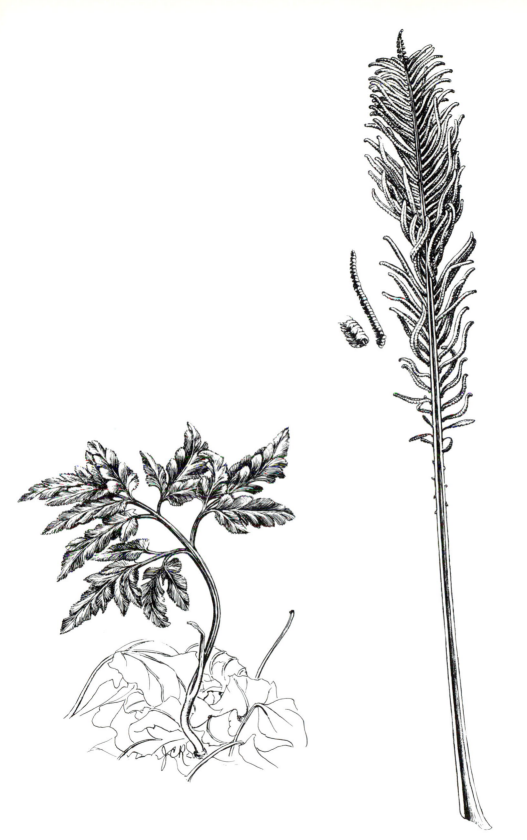

Cut-leaf Grape-fern Ostrich Fern

The sterile fronds grow in crowns up to 5 feet (152 cm) or more tall. They form a narrow ring on the erect rhizome that is covered with old frond bases and sends out numerous underground stolons from which new plants sprout. Summer's sterile frond has the shape of a feather, widest near the top, narrowing quickly to a pointed tip, and tapering gradually to within about an inch (2.5 cm) of the base of the stipe. Both the stipe and the blade's rachis are lustrous brown and deeply grooved on the upper surface. The blade is divided into twenty to forty narrow pairs of pinnae that are cut again into about thirty pairs of pinnules. These lacy, sterile fronds wither with the first touch of frost.

The fertile fronds appear later in summer, inside and shorter than the circle of sterile fronds. There may be several of them to a crown, each around 2 feet (61 cm) tall. Their pinnae are small and rolled inward; at maturity they loosen and the sporangia discharge their spores. These fronds also are somewhat feather-shaped, their crowded pinnae ascending in reverse curves, the tips often overlapping each other. This part of the plant stands firm over the winter, as the sterile fronds return to the soil at the base of the plants.

Matteuccia struthiopteris grows throughout our region except where the species has declined through loss of habitat. It is now listed as being of special concern in Rhode Island, rare in Maryland, extremely rare in Virginia, imperiled in West Virginia, and on the watch list in Indiana. It is also in danger of becoming over-picked wherever it is growing because the fiddleheads of Ostrich Fern are sought for a spring vegetable.

Some authors list Ostrich Fern as *Pteretis pensylvanica*.

WOODLANDS NATIVE

Polypodiaceae: Fern Family

MARGINAL WOOD-FERN, MARGINAL SHIELD-FERN

Dryopteris marginalis (Linnaeus) Gray (oak/fern) (marginal)

Evergreen ferns such as Marginal Wood-fern are visible proof of the vitality of certain herbaceous plants during the cold season. We find this handsome fern among rocks and tree roots on rich wooded slopes or draped from a crevice in a rocky ravine. The fronds are 15 to 30 inches (38 to 76 cm) long, have a scaly stipe, and wide, flat blades 6 to 10 inches (15 to 25 cm) across at the widest place. Six or more fronds form a crown, or a "bouquet," as Boughton Cobb calls these graceful clumps. The crown rises from a perennial rhizome that may be partly exposed and is densely covered with overlapping scales and the bases of old stipes. A skirt of brown dead fronds often hangs beneath the live green ones.

The blade tapers to a point at the tip and narrows only slightly toward the base. It is divided into twelve to twenty pairs of mostly alternate pinnae that are deeply cut into blunt, shallow-toothed pinnules whose veins are curved and forked. The frond's stipe is shorter than the blade, grooved on the face, red-brown, and tufted with golden-brown scales that darken in winter.

Fertile fronds of Marginal Wood-fern bear their sori under the margins of the pinnules, hence *marginalis;* the sori are round, large, and prominent—sori means "heaps"—covered until mature by indusia, tissues that are outgrowths of the frond. In summer the sori ripen to brown and begin to expel their spores. Years may pass before a spore becomes a new crown of fronds; meanwhile, furry golden-brown fiddleheads of new plants on established rhizomes continue to emerge through forest leaf-litter every spring.

Fourteen other species of *Dryopteris* occur in the Northeast. *Dryopteris marginalis* occurs from the Gaspé Peninsula to British Columbia southward to Georgia, Arkansas, and Kansas.

WOODLANDS NATIVE

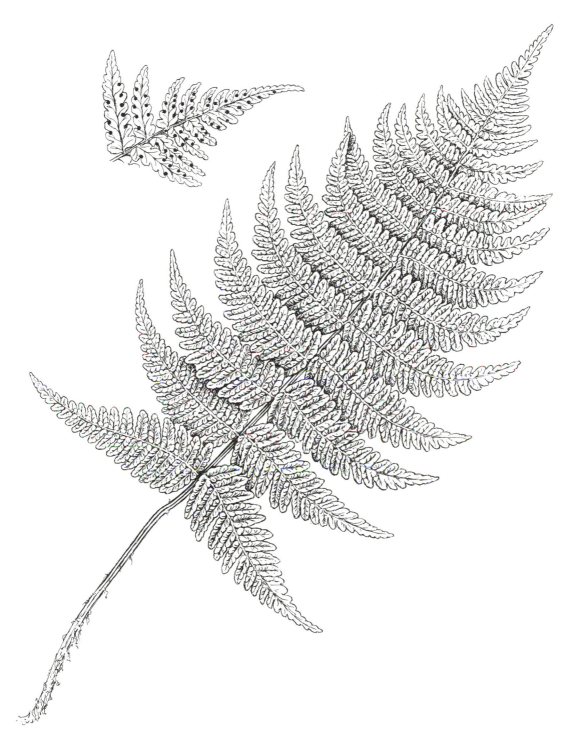

Marginal Wood-fern

Polypodiaceae: Fern Family

WALKING FERN

Camptosorus rhizophyllus (Linnaeus) Link (flexible fruitdot) (rooting leaf)

Walking Fern is a small, low-growing fern that has an uncut evergreen blade whose tip elongates until it arches and touches the ground. There it tip-roots and eventually forms a new plant, and thus it "walks" in radiating lines from the parent. Young plants walk to produce grandchildren, and so on, resulting in mats of overlapping plants. A rooting frond remains attached to the new plant, supplying nutrients until it dries up with age and becomes severed. The fronds rise from a slender scaly rhizome that is usually erect and has a few shallow roots. The stipe is short, green, and smooth with a groove on the face.

Mature fronds may be 12 inches (30cm) long and about an inch (2.5 cm) wide at the base where the lobes are short or extended into "ears." Long, narrow sori are borne on the underside of fertile fronds, along the veins in an irregular pattern; some are joined at the top to form an inverted V, or "flexible fruitdot." By winter the sporangia have opened and discharged their spores and we find them empty.

This interesting fern grows in shaded ravines, on mossy boulders, or on cliffs with a northern exposure, preferring limestone areas. Walking Fern once ranged from Quebec to Minnesota southward, but now is designated as having only one extant site in Rhode Island, possibly being extirpated from Maine, endangered in New Hampshire, potentially threatened in New York, and of special concern in Michigan. There is one other species of Walking Fern in the world, and it is in Asia.

Camptosorus rhizophyllus is sometimes classified in the large genus *Asplenium,* partly because it hybridizes with *Asplenium* species.

WOODLANDS NATIVE

Polypodiaceae: Fern Family

EBONY SPLEENWORT

Asplenium platyneuron (Linnaeus) Oakes () (broad-nerved)

The slim evergreen sterile frond of Ebony Spleenwort unfolds in summer to about 12 inches (30 cm) in length, tapering toward both ends. These fronds arch or spread horizontally. The blade is cut into thirty to fifty oblong, pointed, dark green pinnae that have finely-toothed margins and are eared on the upper edge; only rarely is a pinna eared on the lower edge as well. The pinnae are more or less alternate on a glossy dark brown or black rachis. The stipe, also black, is short, stiff, and brittle. Toward the base of the blade the pinnae are smaller and nearly triangular.

Fertile fronds emerge later in the summer and are taller and more erect than the sterile fronds. Their pinnae are farther apart and they bear their long, narrow, curving sori on the underside, along forking veins. Fertile fronds found in winter may be erect or prone, or broken by heavy snows; and they may be green or brown and dry. The cinnamon brown sporangia are open, having ejected their spores before cold weather. Sterile fronds are more numerous than fertile ones; they are the photosynthesizing part of the plant. In the center, under protective leaf-litter, are a few small crosiers, already anticipating spring.

Eight species of *Asplenium* may be found in our area; *A. platyneuron* is a variable one, and it hybridizes with other species. Growing on rocky slopes and in rock crevices of open woods, it occurs from Maine to southern Michigan, southern Wisconsin, Iowa, and Kansas south to Florida and eastern Texas. At present this species is designated as threatened in Maine.

The name *Asplenium* was used by Dioscorides for a fern that was thought to cure diseases of the spleen. The specific name was mistakenly applied—the nerve, or axis, of Ebony Spleenwort is not broad.

WOODLANDS NATIVE

Walking Fern

Ebony Spleenwort

Polypodiaceae: Fern Family

MAIDENHAIR FERN

Adiantum pedatum Linnaeus (unwetted) (palmately forking)

Adiantum pedatum is not an evergreen fern; in autumn the stem weakens at the base and the frond falls. In winter we find the black skeleton of stalk and branches stretched on the leaf-litter of hardwood forest floors, the pinnae brown and rolled like tiny scrolls. Seeing the skeleton brings to mind the graceful fern of summer when the blade spreads in a wide semicircle or fan shape at the summit of the erect stipe. The colloquial name is appropriate; this fern usually grows on shaded slopes, and the supple, delicately-cut blade blows in the summer wind like a maiden's long hair.

The stipe is slender, lustrous, and black, 10 to 20 inches (25 to 51 cm) tall, longer than the blade. At its summit the black axis divides into two branches that diverge and recurve again until their tips almost meet. Each branch bears five to nine thin, spreading pinnae on its outer side. These are cut into about twenty-five pinnules whose ribs are along the lower edge with forking veins that flow toward the rounded lobes of the upper margin. In spring the sori are borne on the underside of some of these lobes, their margins folded over them to form a protective flap until maturation in summer. At that time the flap unfolds and the spores are forcibly ejected by the sporangia onto currents of air.

This flat frond may reach 10 inches (25 cm) in length under favorable conditions. Raindrops roll from its surface, hence the generic name; the specific name is a loose description of the frond. *Adiantum pedatum* occurs throughout our region, but is now listed as potentially threatened in New York and endangered in Delaware.

SHADED SLOPES NATIVE

Maidenhair Fern

Polypodiaceae: Fern Family

COMMON POLYPODY FERN, ROCKCAP FERN

Polypodium virginianum Linnaeus (many/foot) (of Virginia)

The sturdy little Polypody Fern caps shaded ledges, cliffs, and flat boulders with year-round living green, preferring shallow sub-acid soils. The stipe is smooth, green, and slender, 4 to 10 inches (10 to 25 cm) long—a third to a half the length of the total frond. The blade varies from elliptical to triangular and is usually divided into ten to twenty pairs of alternate pinnae that gradually diminish in length toward the tip and taper little if at all toward the base. These leathery fronds are proof against winter cold or snow, although they curl in cold or dry weather to protect themselves against dehydration.

The sori are red-brown, large, and round, in rows or scattered on the undersurfaces of the fertile fronds; they are not covered by an indusium and therefore are referred to as naked. Ferns and fern allies (see Stiff Clubmoss, page 84) have two stages, sometimes called generations; the sporophyte and the gametophyte. The fronds are the sporophyte or the spore-bearing stage. At maturity, in midsummer, the sporangia of the fertile fronds open, then contract with a snap, ejecting the asexual spores.

When one of these microscopic spores falls on moist ground suitable for germination, it grows into a prothallus, a green body about 1/4 inch (6 mm) long, on whose undersurface develop microscopic male and female organs; this is the gametophyte stage. After a sperm, moving in rain- or dewdrops, has fertilized an egg, the prothallus produces and nourishes a new root and the first leaf of a new sporophyte. From spore to spore-bearing fern may be a span of several to many years. Meanwhile fronds continue to grow from perennial rhizomes.

Common Polypody's rhizome, often exposed, is cinnamon-colored and clad in rounded scales where previous stipes grew. It is ropy, creeping and branching to form mats; the generic name alludes to this much-branched underground stem. Botanists once referred to the root or stem of a plant as a "foot."

Polypodium virginianum is common and widespread throughout the Northeast and in uplands to Arkansas.

ROCKY WOODS NATIVE

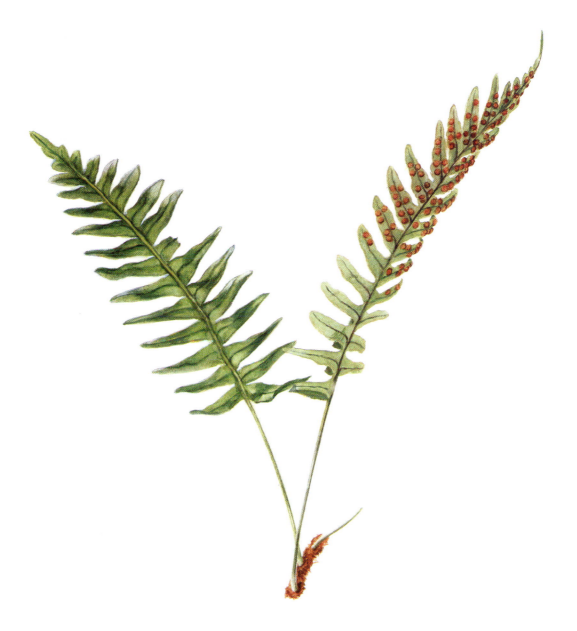

Common Polypody Fern

Dioscoreaceae: Yam Family

WILD YAM
Dioscorea villosa Linnaeus (for Dioscorides) (soft hairy)

Wild Yam is an herbaceous twining vine that may reach 10 feet (3 m) in length, climbing trees, shrubs, or any nearby plant, to hang out its loose panicles of tiny flowers in late spring. Staminate and pistillate flowers are separate, with the pistillate in a drooping cluster of five to eighteen flowers. They may be difficult to see amid the foliage of damp woods and thickets, but pollinating insects find them, and by fall large, three-winged capsules dangle from the bare stalks, rattling their seeds in the wind. Each capsule is about 1/2 to 1 inch (1.3 to 2.5 cm) long and the same in width, or slightly wider. At maturity the valves with their translucent wings open across the top to release two flat, brown seeds; these also are winged and about 1/4 to 1/2 inch (6 to 13 mm) broad.

Leaves may be 4 inches (6 to 10 cm) long. They are alternate, glossy, and heart-shaped with nine to thirteen veins that sweep from base to tip in parallel curves, a clue that the plant is monocotyledonous. Upper leaves rise singly on long, slender petioles; lower leaves may be widely spaced and in whorls of three. *Dioscorea quaternata* has larger leafblades, the lower ones possibly in whorls of four to seven.

Dioscorea, named for Dioscorides, a Greek naturalist of the first century A.D., is a large genus of warm and tropical regions. *Dioscorea villosa* is one of four species that occurs in the Northeast, ranging from Maine to Minnesota south to Virginia, Tennessee, and Arkansas. The plant has a starchy rootstock; cultivated yam is *Dioscorea alata.*

WOODS AND THICKETS NATIVE

Wild Yam

Liliaceae: Lily Family

RAMP, WILD LEEK

Allium tricoccum Aiton (garlic) (3-locular)

Allium tricoccum differs from other Alliums, including Wild Onions, Wild Garlics, and several Wild Leeks, in having leaves and flowers above ground at different times, in having broad instead of narrow leaf blades, and in being the most edible. In early spring the slender, succulent bulbs put up fresh green, parallel-veined leaves, at first tightly rolled, to form colonies on wooded slopes, often near rock outcroppings.

Expanded leaves are elliptical, 8 to 12 inches (20 to 30 cm) long and 3/4 to 2 inches (1.9 to 5 cm) wide—attractive verdant patches on the brown forest floor. This is the time of the Ramp Festivals, part of American folklore in the Appalachian Mountain and Plateau regions, when the foliage and bulbs are both cooked and eaten raw in salads. Chippewa Indians used Ramps as an emetic.

By early summer the leaves have died down and the 20-inch (51-cm) scape appears, with a cluster of buds at its apex that open into a hemispherical umbel of creamy white flowers on long pedicels. At maturity the three-valved capsules split open, their walls curl down and harden, showing pale beige linings in contrast to the large, glossy black seeds, one in each locule. In winter we may find the dry scape holding the cluster of capsules and seeds, or later, only the pedicels.

Allium tricoccum occurs from Nova Scotia to Minnesota south in mountains to North Carolina, Tennessee, and Iowa. It is, however, currently on the watch list in Maine and endangered in Delaware.

WOODLANDS NATIVE

Orchidaceae: Orchid Family

PINK LADY'S-SLIPPER; MOCCASIN-FLOWER ❋

Cypripedium acaule Aiton (Venus/shoe) (stemless)

Cypripedium acaule is our most common Lady's-slipper, yet realizing something of the difficulties of reproduction for orchids explains why a dried capsule is a rare find. Pink Lady's-slipper grows in wet or dry acid soils of mountains, rocky ravines, and coastal areas, most often in the vicinity of evergreen or oak trees, flowering in spring. Orchid seeds carry no endosperm and therefore a germinating seed and its subsequent developing plant are very dependent upon mycorrhizal fungi in the soil with which they have a symbiotic association. Even when these are present, the development of roots and the two broad stemless leaves takes years.

When the plant has gained the reserves to do so, it produces one flowering stalk with a solitary "slipper" at the summit of its downy scape, 6 to 20 inches (15 to 51 cm) tall. This is the familiar pink-veined lip, 2½ inches (6 cm) long, with narrow green or bronze side petals and sepals and a green bract arching over the fully opened flower like an awning. If the flower and its leaves are picked or browsed, another span of years passes before the plant is able to flower again. It is illegal to pick or dig this orchid in some areas. *Never pick or dig any wild orchids,* anywhere.

Once the flower is pollinated and the seeds mature, the capsule splits along the three ribs and thousands of dust-fine seeds are carried aloft on air currents, even high into the atmosphere. The chances of making a good landing, where soil conditions include the necessary mycorrhizal fungi, are thousands to one. Luckily the plant is perennial and spreads vegetatively from fibrous roots.

Cypripedium acaule ranges from Newfoundland to Saskatchewan south to Georgia and Alabama; however, it is now designated as being of special concern in New Hampshire, on the watch list in Indiana, and endangered in Illinois. Lady's-slippers have been and still are being dug from the wild and sold to companies that manufacture medicinals, but the practice is now being fought by the National Resources Defense Council in Washington, D.C. as well

Ramp, Wild Leek Pink Lady's-slipper

as by other environmental organizations. Demands for orchids by wildflower fanciers also contribute to the practice of collecting wild plants for trade. It is hoped that soon all companies will refuse to buy dug plants. Orchids enjoy some protection under the Convention on International Trade in Endangered Species.

Linnaeus saw this flower as a goddess' shoe left on Earth, and therefore named it after Venus, *Cypris*, "the Goddess of Love and Beauty," and *pedilon*, "shoe."

WOODS NATIVE

Orchidaceae: Orchid Family

DWARF RATTLESNAKE-PLANTAIN ORCHID

Goodyera repens (Linnaeus) R. Brown (for J. Goodyer) (creeping)

Under conifers in mossy northern forests, this diminutive evergreen orchid hugs the ground. Slender creeping runners produce roots with thick fibers and basal rosettes of tiny leaves 1/2 to 1 inch (1.3 to 2.5 cm) long that have five veins outlined in white. A small version of the Downy Rattlesnake-plantain, this species is sometimes called "Lesser Rattlesnake-plantain."

The bracted flower stalk is 4 to 10 inches (10 to 25 cm) tall and holds a one-sided spike of white to pale green flowers in July and August. After pollination the flowers develop into light brown, oval capsules that open by three valves along their sides to release powdery seeds with the slightest touch of breeze—yet, this species occurs infrequently. See under Pink Lady's-slipper (page 98) and Small Woodland Orchis (page 12) for the difficulties of orchid reproduction; and *never pick or dig wild orchids.*

Goodyera repens occurs in Canada and the northern states, southward in mountains, but is currently listed as endangered in Massachusetts, possibly extirpated from Connecticut, and rare in Virginia. John Goodyer was a British botanist who lived from 1592 to 1664. See other orchids in Sections I, II, and V.

WOODLANDS NATIVE

DOWNY RATTLESNAKE-PLANTAIN ORCHID, *Goodyera pubescens* (Willdenow) R. Brown. On a winter walk in the woods, should you find a dried stalk of *Goodyera pubescens*, brush aside the snow or dead leaf litter (temporarily) to see the rosette of basal leaves, still fresh and green, marked with an intricate pattern of white reticulations. Fine, flat-lying hairs give this surface a satiny sheen; the underside is smooth, light green, and without pattern. The leaves are 1 to 2 inches (2.5 to 5 cm) long and lie close to the earth—it may have been their prone position and their shape that earned the plant the popular name Plantain. The leaf pattern is thought to have recalled a snake's belly to the Indians—some tribes revered snakes. Other authors think that the common name refers to the resemblance of the fruiting spike to the rattle of a rattlesnake.

Downy Rattlesnake-plantain grows 6 to 20 inches (15 to 51 cm) tall. The slender, downy scape is terminated in summer by a densely crowded cluster of small white flowers. The oval, light brown capsules that follow pollination are fragile and resemble tiny balloons 5/16 inch (8 mm) long. Each capsule is closed at the ends, with valves along the sides that open when the myriads of powdery brown seeds are mature. Petal remnants usually hang from the tips of the capsules.

Goodyera pubescens is perennial and grows on dry wooded slopes under oak or conifer trees in soil that contains humus and mycorrhizal fungi, a requirement of all wild orchids. If the practice of digging this wildflower for terrariums does not STOP, *NOW*, our native populations will not survive; an orchid plant removed from its native habitat will not live long.

Goodyera pubescens occurs from eastern Canada to Ontario southward beyond our region.

WOODLANDS NATIVE

Dwarf Rattlesnake-plantain Orchid

Downy Rattlesnake-plantain Orchid

Orchidaceae: Orchid Family

AUTUMN CORAL-ROOT, LATE CORAL-ROOT

Corallorhiza odontorhiza (Willdenow) Nuttall (coral/root) (tooth/rooted)

The Coral-roots are leafless, non-green saprophytic orchids that live in dry woods, drawing nourishment from dead leaves and other plant detritus—nature recycling again! From August to October the tawny or purple-tinged scape of *Corallorhiza odontorhiza* rises from a ruddy to pink rhizome that is irregularly toothed or branched and has been likened to coral. The scape bears a raceme of three to twenty small, two-lipped, dull purple and white flowers that droop on short recurved pedicels. The pedicels remain deflexed in fruit so that the capsules resemble deflated balloons hanging from a pole. These capsules are 1/2 to 5/8 inch (1.3 to 1.6 cm) long and may have dried sepals and petals at their tips.

Today, *Corallorhiza odontorhiza* has little opportunity to recycle; its original range was from southwest Maine to Minnesota southward beyond our area, but currently it is listed as endangered in Maine, rare in New Hampshire and in Vermont, of special concern in Massachusetts, threatened in Rhode Island, historic only in Delaware, and vulnerable in New York.

CRESTED CORAL-ROOT, *Hexalectris spicata* (Walter) Barnhart, more showy than Autumn Coral-root, is not listed in many wildflower guides—an indication of its rarity. Its range tends to be southerly, the northern limits once reaching into our area, but now it is on the rare and endangered lists of eight states in the Northeast. Its dull yellow or red scape is 8 to 20 inches (20 to 51 cm) tall, bearing a raceme of eight to twelve bronze-purple flowers, each at least an inch (2.5 cm) long. The lower lip has five or six red or purple ridges that form a crest; there is no spur at the base of the corolla as on that of many orchids—one reason this species was placed in a genus by itself—and there are no leaves.

Dry Woods Natives

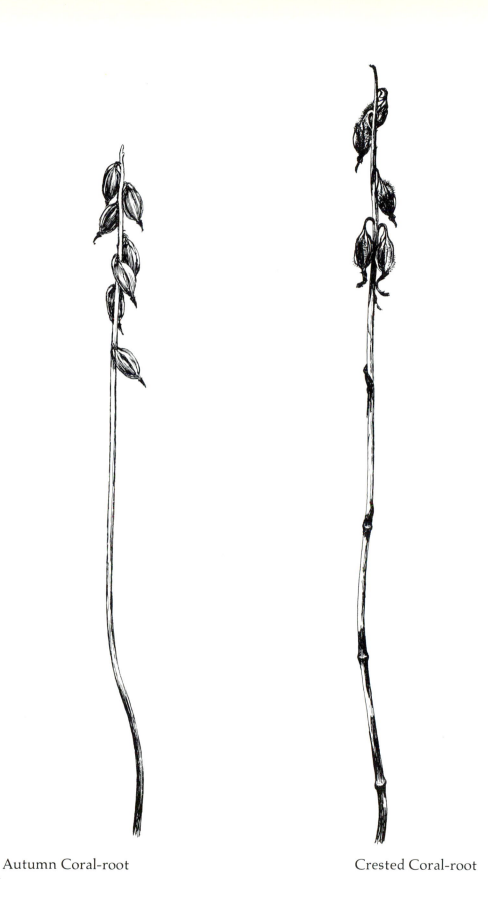

Autumn Coral-root Crested Coral-root

Orchidaceae: Orchid Family

PUTTY-ROOT, ADAM-AND-EVE

Aplectrum hyemale (Muhlenberg) Torrey (without/spur) (of winter)

Any green leaf is appreciated in winter and the Putty-root leaf is an interesting one. The solitary, fresh green leaf pushes up through the leaf-litter of rich, damp woods in autumn, and withers in early spring. The leaf bud emerges folded like an accordion from petiole to tip along the midrib and two of the main veins. All veins are parallel—Putty-root is mono-cotyledonous. Main veins are white and raised; between them are pinstripes of smaller veins. The leaf's underside is smooth, has no white lines, and is sometimes tinged with pur-ple. Its petiole is about as long as the leaf-litter is deep, its base wrapped in a brown sheath.

Over winter the leaf gradually grows to a length of 4 to 7 inches (10 to 18 cm), unfold-ing to a broad ellipse as it lengthens. It stays fresh and green all winter, gathering nourish-ment for the new corm that is developing underground at the end of a slender stalk out of the existing corm. The corms of one to four previous years are thus strung together, inspir-ing the common name Adam-and-Eve. It is believed that the youngest corm in these strings may receive added nutrients from the older one(s). A strong glutinous matter in the corms was thought to be a cement, or putty, giving rise to the name Putty-root.

By spring the leaf is spent and returns to the soil, but the new corm, now about an inch (2.5 cm) in diameter, sends up a flowering stalk 1 to 2 feet (30 to 61 cm) high that termi-nates in a loose raceme of seven to fifteen small, yellow-brown, purple-tinged orchids. Each flower is about 1/2 inch (1.3 cm) long on a short, erect pedicel, and like the related Coral-roots (page 102) is crested but not spurred. There are a few leaf scales on the scape, but no other leaves at flowering time. As the fruit matures after pollination, the pedicels recurve to hold the ripe, ovoid capsules pendant.

Aplectrum hyemale once could be found from Quebec to Saskatchewan south to Georgia and Arkansas, but was becoming rare when *Gray's Manual of Botany,* 8th Edition was pub-lished in 1950. It is now listed as reduced to one site in Vermont, threatened in Massachu-setts, presumed to be extirpated from Connecticut, critically imperiled in New Jersey, potentially threatened in New York, and endangered in Delaware.

WOODS AND SWAMPS NATIVE

Putty-root

GREEN LEAVES IN WINTER

(See also More Green Leaves in Winter on page 236).

Here are a few of the herbaceous leaves that live through the winter. Some are biennials and perennials that grew from live roots in autumn—Garlic-mustard, Common Winter-cress, Appendaged Waterleaf, and Dame's Rocket are of this kind. Others are last summer's leaves on perennial roots; these often turn red or purple as photosynthesis ceases—Foamflower, Alumroot, and Acute-leaved Hepatica are in this group. Wild Stonecrop leaves also persist in protected sites, often turning red; occasionally the dried flower stalks may be seen as well.

a. Garlic-mustard, *Alliaria officinalis* Roadsides and woodlands
b.❀ Foamflower, *Tiarella cordifolia* Woodlands
c. Alumroot, *Heuchera* sp. Woodlands
d.❀ Wild Stonecrop, *Sedum ternatum* Woodlands
e.❀ Acute-lobed Hepatica, *Hepatica acutiloba* Woodlands
f.❀ Common Winter-cress, *Barbarea vulgaris* Woodlands
g.❀ Appendaged Waterleaf, *Hydrophyllum appendiculatum* Woodlands
h.❀ Dame's Rocket, *Hesperis matronalis* Damp Ground

Still other green leaves (not shown) that can be found in winter are those of: various species of Aster; ❀Wild Columbine, *Aquilegia canadensis;* ❀Wild Ginger, *Asarum canadense;* ❀Golden Ragwort, *Senecio obovatus;* ❀Bluets, *Houstonia caerulea;* ❀Blue-eyed Mary, *Collinsia verna;* ❀Blue Woodland Phlox, *Phlox divaricata;* ❀Common Blue Violet, *Viola papilionacea;* ❀Wood-betony, *Pedicularis canadensis.*

a.

b.

c.

d.

e.

f.

g.

h.

Green Leaves in Winter

Lauraceae: Laurel Family

SPICEBUSH, WILD ALLSPICE

Lindera benzoin (Linnaeus) Blume (for Johann Linder) (benzoin)

Seemingly to celebrate the end of winter, Spicebush decks its boughs with spicy, lemon-yellow flowers around the time of the spring equinox. A smooth shrub, growing in low damp woods, its fresh petals are a welcome sight in the dark, leafless understory. Pussy Willows have already blossomed along more open creeks, Hazelnut catkins are stretching in woodland borders, and Red Maples may be tinged with red flowers overhead—this is the beginning of the fulfillment of the promises of winter buds that have overwintered, waiting for the lengthening light and increasing warmth of March or April.

Olive-brown twigs bear the alternate, nearly spherical flower buds in pairs on a very short stalk. These contain clusters of tiny umbels of four to six flowers each. Leaf buds, also alternate, are small, covered by two or three scales. The leaves emerge after the flowers, and are 2 to 6 inches (5 to 15 cm) long, entire, and elliptical. The larvae of the large, beautiful Promethea Moth and those of the equally large and lovely Spicebush Swallowtail Butterfly feed on the leaves of Spicebush. This butterfly has two generations a year, so both summer and winter chrysalides can be found.

Staminate and pistillate flowers are on separate plants. By July the fertilized female flowers are developing into bright red, oval drupes that have one large seed. Spicebush seeds are relished by birds, especially wood thrushes and veeries, and deer and small animals browse on the twigs. The common and specific names allude to the fact that all parts of *Lindera benzoin* have a spicy aroma similar to that of benzoin, a resin obtained from trees in the genus *Styrax*. Colonists learned from the native peoples to dry and grind the fruits as a substitute for allspice, and to use Spicebush tea as a remedy for various ills.

John Linder was a Swedish botanist who lived from 1676 to 1723.

DAMP WOODS NATIVE

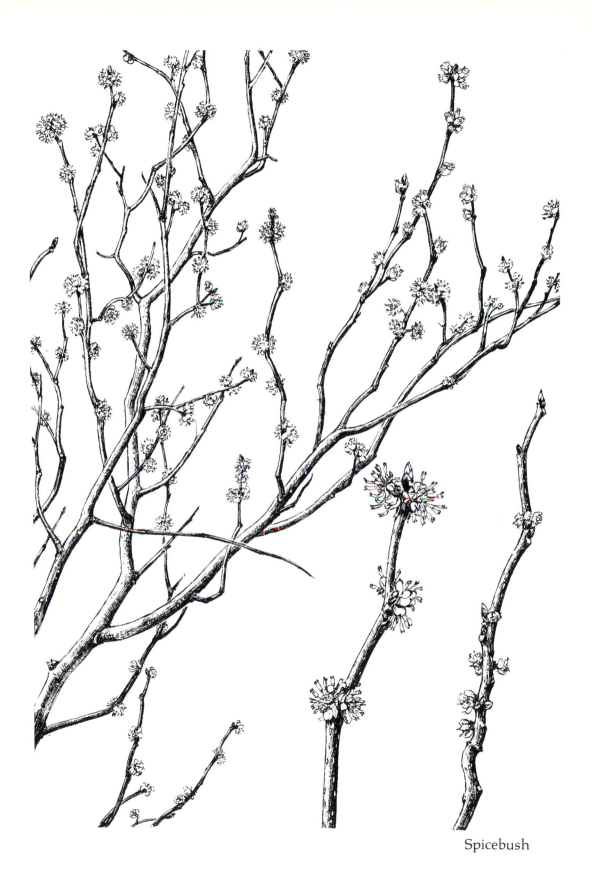

Spicebush

Ranunculaceae: Buttercup or Crowfoot Family

BLACK COHOSH, BLACK SNAKEROOT, BUGBANE

Cimicifuga racemosa (Linnaeus) Nuttall (a bug/to drive away) (with racemes)

In summer Black Cohosh has one or more upright racemes of flowers that are fuzzy with many white stamens; there are no true petals and the sepals fall early. The racemes, 6 to 20 inches (15 to 51 cm) long, are held well above the large leaves so that they often seem to glow like long, white flames at the summit of stalks 3 to 8 feet (0.9 to 2.4 m) tall; in the illustration I have shown only the top half of the plant. Each flower in the cluster is about 1/2 inch (1.3 cm) wide. The flower's fetid odor attracts green flesh flies, which are thought to assist in the plant's pollination. Black Cohosh is among the plants that serve as host to the Spring Azure Butterfly, which lays its egg in the buds and flowers.

The large, alternate, compound leaves are twice divided into threes, resulting in many leaflets 1½ to 4 inches (4 to 10 cm) long. They are long-stalked and sharply toothed. *Cimicifuga racemosa* is a perennial, growing from a thick knotted rhizome. This rootstock has been used medicinally but it is reported to cause dizziness, nausea, and other ills if ingested. With many medicinals, the line between poison and medicine is a fine one.

Winter's dried stalk is attractive with its long rows of little taupe-brown, oval follicles. Each has a small curved beak and contains several three-angled seeds with minute wings on the angles. At maturity the seeds loosen and rattle in the wind, giving rise to another common name, Rattletop. To help unravel a confusion of colloquial names: *Sanicula canadensis,* in the Parsley family, is also known as Black Snakeroot; Blue Cohosh, *Caulophyllum thalictroides,* is in the Barberry family. Cohoshes are medicinal plants; all of these have compound leaves.

Cimicifuga racemosa occurs from western Massachusetts and southern Ontario to Missouri south to Georgia in mountains. Currently the plant is considered endangered in Massachusetts and rare in Virginia.

WOODLANDS NATIVE

Rosaceae: Rose Family

GOAT'S-BEARD

Aruncus dioicus (Walter) Fernald (goat's beard) (dioecious)

This tall arching stalk, 3 to 7 feet (91 to 200 cm) high, hung with clusters of glossy brown fruits, is the winter stance of *Aruncus dioicus.* Its flowering posture is erect with spreading or ascending spikes, an ornamental of the natural gardens in woodlands. In late spring or early summer the long, slender spikes bear tiny, creamy white, five-petaled flowers. The species is usually dioecious; male plants have flowers with many stamens, giving the clusters a fuzzy appearance; female plants have flowers with three distinct pistils that develop into three tiny follicles, each holding two minute seeds.

The plant may be smooth or pubescent. Its compound flower spike is accompanied by large compound leaves to 15 inches (38 cm) in length that are pinnately divided into toothed leaflets. Goat's-beard differs from most members of the Rose family in that it lacks stipules. The Sooty Azure Butterfly feeds on this species exclusively.

Two popular horticultural species, *Astilbe arendsii* and *A. japonica,* are similar to *Aruncus dioicus. Aruncus* is a two-species genus with the second species in the West. This eastern one grows in rich wooded ravines, in mountains, and along stream banks; it is found from Pennsylvania to Iowa south to Georgia.

WOODLANDS NATIVE

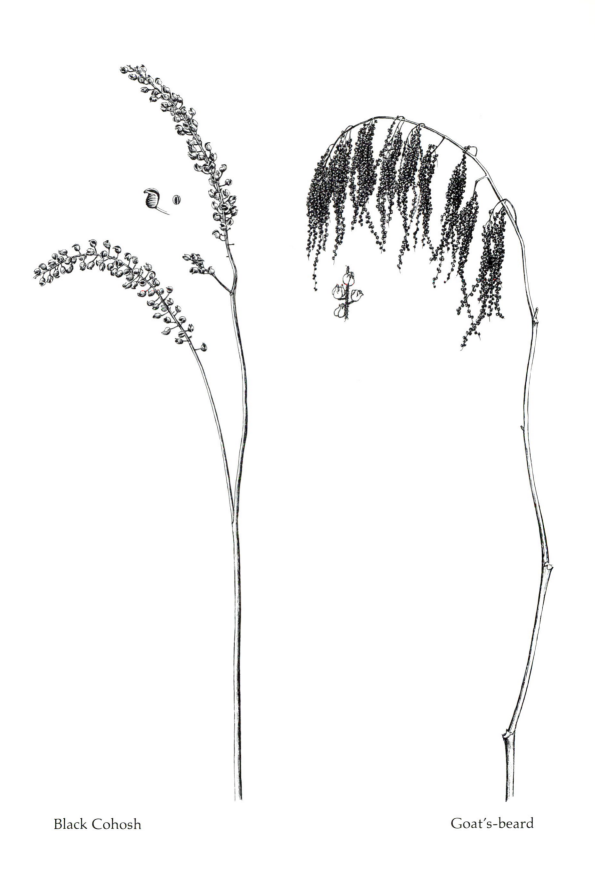

Black Cohosh Goat's-beard

Saxifragaceae: Saxifrage Family

WILD HYDRANGEA, SEVEN-BARK

Hydrangea arborescens Linnaeus (water/a vessel) (becoming treelike)

Wild Hydrangea is a medium-sized shrub of shaded rocky slopes and ravines that is usually 3 or 4 feet (91 or 122 cm) tall but can grow to 10 feet (3 m). Its lacy, flat or round-topped terminal clusters of fruits on smooth, slender branches can be seen all winter. The clusters and the branches are bronze-brown. Ice crystals have been seen on these stems, an interesting phenomenon that also occurs on Dittany (page 136). Each small, ribbed capsule holds numerous tiny seeds that are dispersed through a hole between two diverging styles at the apex. Linnaeus likened this small capsule to a water vessel.

In early summer the umbellate inflorescence measures 4 inches (10 cm) or more across and is composed of small, creamy-white flowers that are all fertile except for a few larger sterile ones around the perimeter. The leaves, 2 to 6 inches (5 to 15 cm) long, grow from the smooth twigs in pairs on long petioles; the blade is somewhat heart-shaped and has saw-toothed margins.

There are four native species of *Hydrangea,* all eastern. The large dome-headed species we see in gardens are imported from China and Japan. Gooseberry, Current, and Mock Orange are also Saxifrage family members. *Hydrangea arborescens* occurs from southern New York to Missouri south to Georgia and Oklahoma, although it is now listed as rare in New York.

WOODLANDS NATIVE

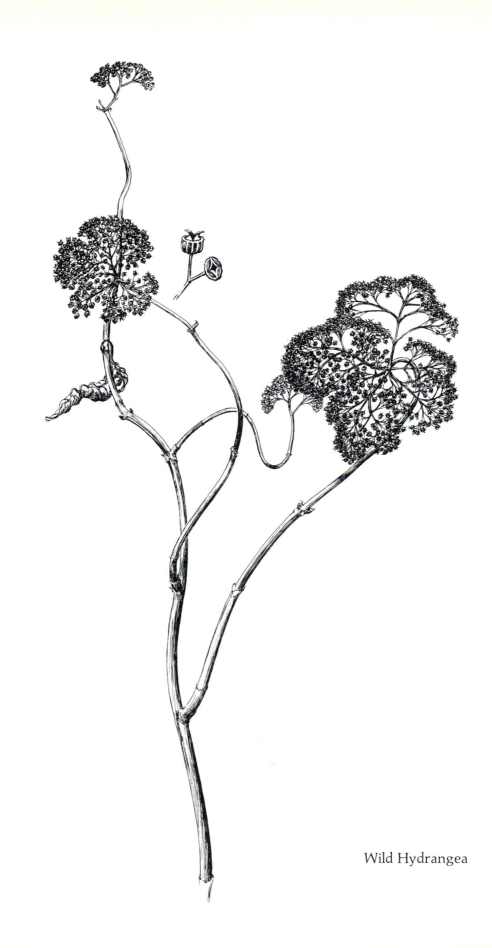

Wild Hydrangea

Celastraceae: Staff-tree Family

WAHOO, BURNING-BUSH

Euonymus atropurpureus Jacquin (good/name) (dark purple)

Wahoo, or Burning-bush as several species of *Euonymus* are called, is a shrub or small tree that may reach 25 feet (7.6 m). It grows in rich valleys, thickets, and woodland borders, occurring from southern Ontario, central New York, and Minnesota south to northern Georgia. At present it is considered vulnerable in New York. In late spring cymose flower clusters have seven to fifteen dark red-purple florets on diverging pedicels. Leaves are 2 to 4½ inches (5 to 11 cm) long, elliptical with pointed tips and finely serrated margins. In autumn they turn a blazing scarlet.

The bark is thin and gray, becoming slightly fissured in age; new twigs are green and slightly four-angled, often with thin, light green to tan lines running between the nodes on young twigs. Winter leaf scars are crescent-shaped, and leaf buds small and scaly. Deer browse on the twigs in winter.

After leaf fall the shrub looks as though it is hung with Christmas ornaments. The closed fruit is magenta and has four (occasionally three or five) large, lobed, woody bracts that are laterally elongated. At maturity the lobes open and one or two scarlet arils on white stalks hang beneath the magenta bracts. Clusters of the fruits dangle on purple pedicels that in turn hang from the green twigs. This festive color combination causes the observer to exclaim "Wahoo," which is actually a Creek Indian word whose meaning seems to be unknown—perhaps it indicates a use, as do Wicky and Kinnikinick; several large trees and a fish also are called Wahoo.

By Christmas much of the exuberant color may have faded, but the bracts persist during winter, brown. Eventually all of the seeds fall to the ground where they are protected by leaf litter and snow during the necessary period of cold required by seeds of this species before they can germinate.

WOODS NATIVE

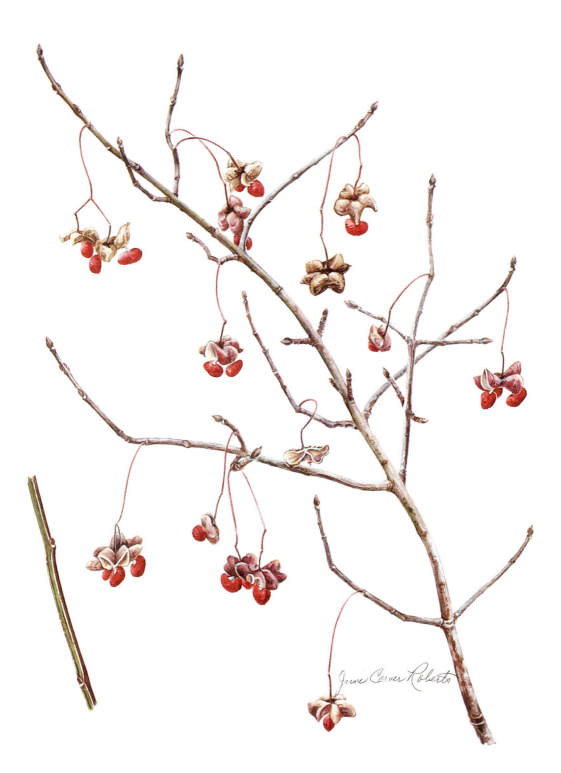

Wahoo

Celastraceae: Staff-tree Family

BURNING-BUSH, WINGED EUONYMUS

Euonymus alatus (Thunberg) Siebold (good name) (winged)

The fruits of Burning-bush are smaller than those of Wahoo (page 114) and not as noticeable from a distance, but at closer range the beauty of the winter colors can be appreciated. The square twigs are green and from their four edges grow purple-brown, satiny wings that are broad and corky, a unique feature not present on any other shrub in our region. Dark purple capsules hang on slender peduncles from the twigs; their three to five valves open in autumn to expose the vermilion ariled seeds. These fruits may persist on the shrub most of the winter.

In late spring pairs of axillary flower clusters adorn the corky twigs, two to five small, yellow-green flowers in a cluster. Smooth, finely serrated leaves are also opposite. In autumn the leaves turn scarlet before falling; Burning-bush is a popular name for several *Euonymus* shrubs that take on this scarlet hue in fall.

Euonymus alatus is a native of Eurasia that has been much planted as an ornamental and has escaped into the wild to grow in woods and thickets. The plant may be found from Massachusetts to Wisconsin southward. The generic name is an ironic one; the plants of this species have a bad name resulting from its toxic qualities, which have been known to poison cattle.

WOODS AND THICKETS ALIEN

Burning-bush

Staphyleaceae: Bladdernut Family

BLADDERNUT

Staphylea trifolia Linnaeus (a bunch of grapes) (three-leaved)

Bladdernut is an upright shrub or small tree whose large, inflated fruits are conspicuous in winter, and can be audible as well. These 2-inch (5-cm) capsules are pendulous and usually have three cells containing several shiny, toffy-colored seeds about 3/16 inch (5 mm) long that become loose at maturity and rattle inside their papery sacs until the capsule's pointed lobes burst open to release them.

In spring the white, bell-shaped flowers are in a drooping cluster about 4 inches (10 cm) long; the generic name is said to allude to these flowers. Each has five sepals, five petals, and a pistil with three united carpels. The leaves are composed of three elliptical, pointed leaflets arranged in a triangle—two opposite, short-stalked ones, and a terminal one on a longer stalk. Very small serrations on the margins help distinguish them from the leaves of Poison Ivy. The warm gray bark is finely fissured; it is often green with white vertical streaks. Small, opposite, brown buds hold the ingredients for next year's foliage, as do all winter buds on woody deciduous plants. Leaf scars are small, crescent-shaped or half-round.

Staphylea trifolia is the only species of this genus in our region. It grows in woodlands and along their borders and is found from southwest Quebec to Minnesota southward through Massachusetts to Georgia, although it is now listed as threatened in New Hampshire.

WOODLANDS NATIVE

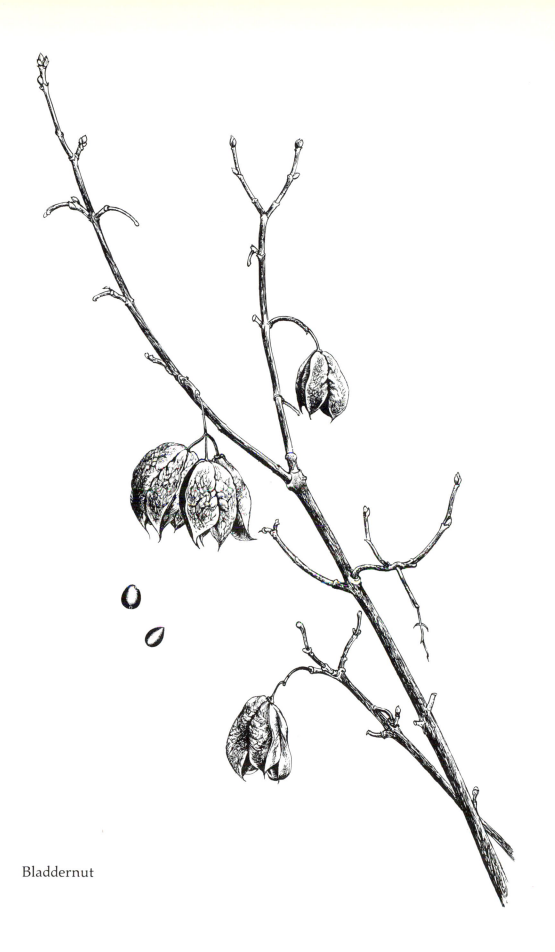

Bladdernut

Vitaceae: Vine Family

VIRGINIA CREEPER, WOODBINE

Parthenocissus quinquefolia (Linnaeus) Planchon (virgin/ivy) (five-leaved)

Virginia Creeper is a common high-climbing vine that grows in woods and thickets, and on rocky banks, climbing trees, fences, rocks, or walls by means of aerial roots and by branched tendrils whose tips produce adhesive disks when they come in contact with a surface. The tendrils are opposite the leaves—or leaf buds in winter—and each has three to eight branches; the adhesive disks are about 1/8 inch (3 mm) long and have an amazingly strong hold.

In summer, clusters of small, pale green flowers are along the sides and at the ends of branches. Leaves are compound, palmately divided into five leaflets that spread from short, equal stalks. The leaflets are 2 to 5 inches (5 to 13 cm) long, non-glossy, medium green above and somewhat paler beneath; their margins are toothed, at least above the middle, and the tips are pointed.

In autumn, *Parthenocissus quinquefolia* has drooping clusters of blue-black glaucous berries on bright red pedicels, and scarlet leaves that fade to pink before they fall. Each berry is about 1/4 inch (6 mm) in diameter and holds one to three seeds. Beyond propagating the species these fruits are important fall and winter food for wildlife, especially for many songbirds and the Pileated Woodpecker. This species also is host to sphinx moths.

Virginia Creeper cannot cover the crowns of trees, thereby killing them, as do Japanese Honeysuckle, page 184, and Wild Grape, page 160. A similar species, *P. inserta,* has no adhesive disks.

WOODS NATIVE

Anacardiaceae: Cashew Family

POISON IVY

Rhus radicans Linnaeus (Sumac) (rooting)

Rhus radicans is common and widespread, growing in many guises. The plant contains an oil that helps protect it from browsing animals. If any part of the plant, in any season, comes in contact with many humans the oil causes burning, itching, and weeping skin eruptions. This species is resourceful; it may take the form of an erect shrub about 3 feet (91 cm) high, sparingly branched or simple; or it may be a ground-creeping, a leaning, or a high-climbing vine. Climbing is done by aerial rootlets at intervals along the stem if the support is not a continuous surface, or by dense aerial roots spreading from the sides of the vine for a firm grip on a solid support surface.

New leaves in spring are glossy; full-grown leaves have three spreading or drooping leaflets that are entire, wavy-edged or coarsely-toothed; the terminal leaflet has a longer stalk than the two lateral ones and is sometimes narrower. Inconspicuous panicles of small, yellow-green flowers, 1 to 3 inches (2.5 to 7.5 cm) long, open in spring. Leaves, flowers, and fruits are alternate and are borne in the leaf axils. The gray or tan stems and branches are usually smooth with brown buds; winter leaf scars are large and V- or U-shaped.

The fruits ripen from early August to November and persist; birds find them a nutritious source of winter food. Each small, one-seeded drupe is 1/4 inch (6 mm) in diameter, almost spherical, and dingy white or ivory-colored.

Poison Ivy also is known as *Toxicodendron radicans.*

OPEN WOODS AND FENCEROWS NATIVE

Virginia Creeper

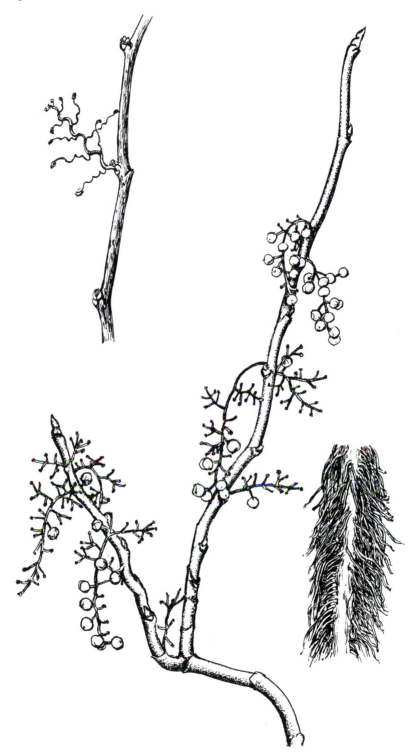

Poison Ivy

Leguminosae: Legume or Pea Family

TICK-TREFOIL, TICK-SEED, STICKTIGHT

Desmodium sp. Desvaux (chain)

The fruits of this plant are well-known to those who have removed them from socks and trouser legs after a walk in the woods. The plant that produced them is usually slender, under 4 feet (122 cm) tall, holding its flat, triangular pods, termed loments, in loose terminal racemes. The pods are in jointed chains of two to six, and detach readily when their hooked hairs come in contact with any passing mammal. These fruits vary in shape and texture from species to species, but since the leaves do not persist into winter, this means of positive identification is not available to us.

Tick-trefoils are native perennial members of the Legume family, with pink, purple, or white typical flowers and three-part, usually stipulate leaves in summer. The flowers are pollinated by honeybees and other small bees. Several species of *Desmodium* are hosts to butterflies, particularly the Hoary Edge, the Eastern Tailed Blue, and the Silverspotted Skipper. The last lays its egg on Tick-trefoils and builds a shelter of the leaves; the cocoon is made among ground litter.

DRY WOODS NATIVE

Onagraceae: Evening-primrose Family

ENCHANTER'S NIGHTSHADE

Circaea quadrisulcata Franchet and Savatier (for Circe) (four-furrowed)

The Enchanter's Nightshades are the only wildflowers of the Northeast that have only two sepals and two petals; they are classified in the Evening-primrose family, most of whose species are four-petaled, and not in the Nightshade family, whose species have flower parts in fives. *Circaea quadrisulcata* is a perennial herb that occurs throughout our region in cool moist woods and ravines, measuring 1 to 2 feet (30 to 61 cm) in height. In northern forests one may find the diminutive Dwarf Enchanter's Nightshade, *Circaea alpina,* a mere 3 to 8 inches (7.5 to 20 cm) tall.

The flowers of Enchanter's Nightshade are in a terminal raceme; each small flower has two white, deeply-cleft petals that quickly develop into tiny, burry fruits after pollination. Opposite leaves are long-petioled and ovate with pointed tips and shallowly toothed margins; few persist into winter. The 1/4-inch (6-mm) fruits are two-seeded, furrowed, and clothed in pale hooked bristles. The pedicels hold them as though at arm's length, to catch onto anyone or anything that chances by.

Circaea is from Circe, the mythical enchantress who turned men into beasts. Dioscorides, in his first-century *Herbal,* used this generic name for a poisonous plant; this species is not poisonous.

WOODS NATIVE

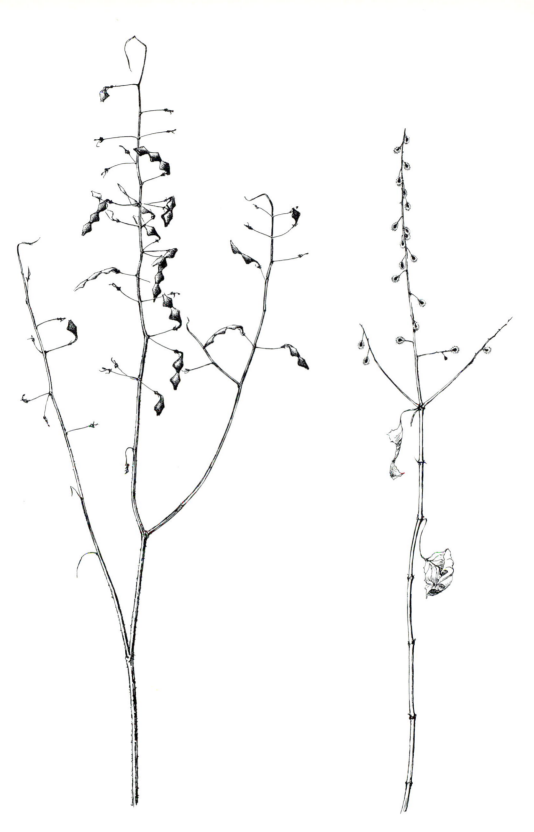

Tick-trefoil Enchanter's Nightshade

Umbelliferae: Parsley Family

SWEET CICELY

Osmorhiza Claytoni (Michaux) C.B. Clarke (a scent/a root) (for J. Clayton)

In spring and early summer Sweet Cicely has at its branch tips a loose cluster of dainty white flowers cross-pollinated by many small bees and flies. The whole plant is softly hairy when young, becoming less so by late June. The stem and widely ascending branches are slender and graceful, bearing large fernlike leaves that are two- or three-times compound with toothed segments. Small green leaves that sprouted in autumn can be found growing among the leaf-litter of woodlands all winter, ready to enlarge and produce flowering stalks in spring, before the canopy of tree leaves closes out the light. These leaf sprouts are sometimes mistaken for ferns, but Sweet Cicely leaves found in winter have an unmistakable aroma of anise.

The large perennial root is lightly scented with licorice or anise; *Osmorhiza longistylis,* a smooth species, is more strongly scented; True licorice is extracted from a leguminous herb of the Mediterranean area.

Sweet Cicely's fruit is dark brown, slender, and composed of two jointed seedlike parts about 1/2 inch (1.3 cm) long, narrow and ribbed; the ribs are set with stiff, sharp hairs that point backward, forming hooks. When ripe, the fruit separates into two parts, the axis to which they were joined splits from the top, and each half suspends a seed from its summit. These barbed seeds persist on the dry stalk, catching onto chance passers-by for rides to new locations. In winter woods, dry plants under 3 feet (91 cm) tall with empty forked tips are probably Sweet Cicely.

Osmorhiza Claytoni occurs from Maine to Minnesota and beyond, and southward through mountains to North Carolina. The deadly poisonous Poison Hemlock, *Conium maculatum,* resembles Sweet Cicely slightly, but grows in waste places, not in woods, and Water-hemlock (page 46) grows in wet ground. Nevertheless, *no* wild member of the parsley family should ever be eaten if identification is not certain.

WOODS NATIVE

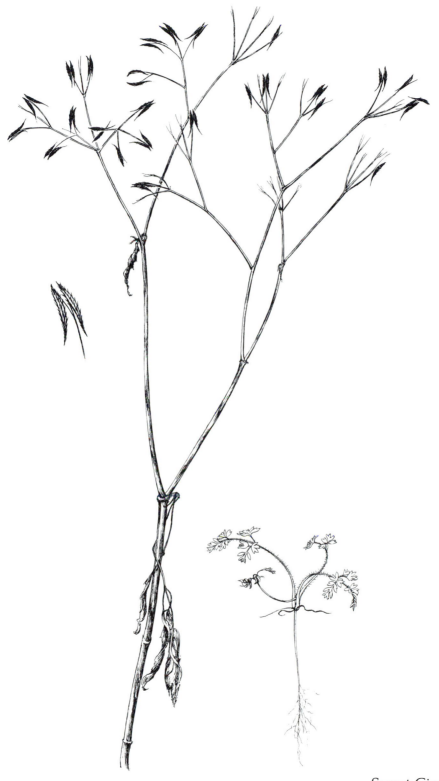

Sweet Cicely

Pyrolaceae: Wintergreen or Pyrola Family

PIPSISSEWA, PRINCE'S-PINE, *Chimaphila umbellata* (Linnaeus) Barton. It is a joy to come upon a patch of these native wildflowers in a winter woods, growing in dry soil with the protection of forest leaf-litter. Pipsissewa is found under mature conifer, oak, or hickory trees—places usually too dark for other undergrowth. It's glossy evergreen leaves are 1 to 2½ inches (2.5 to 6 cm) long, have short petioles and toothed margins; the current year's leaves are rich green, those of previous years are tinged with red or lavender as chlorophyll breaks down. Two or three tiers of leaves spread out around the somewhat woody branches that rise from long underground shoots. A dense colony of plants can result.

In summer a stalk with several fragrant, white or pale pink flowers arises from the leaves; the flowers are not in an umbel, as the specific name implies, since their pedicels grow from different places on the stalk. The pedicels are reflexed to hold the waxy flowers nodding or facing outward to accommodate their hovering pollinators. After petal-fall, the pedicels turn upright so that the mature capsules are held erect and can catch air currents more easily to disperse the seeds—this sequence is performed by most of the plants in this family. The capsule is brown, wrinkled, and five-parted, splitting from the apex downward to open slits for the seeds' release.

This species ranges from Maine to Georgia west to Ohio and northern Illinois, although currently it is listed as threatened in Ohio and Indiana, endangered in Illinois, and potentially threatened in New York.

The common name comes from the Cree Indian word *pipsisikweu,* referring to an ancient belief that its juice would break a stone in the bladder. *Chimaphila* is from the Greek, meaning "to love winter." The Wintergreen, or Pyrola, family is made up of plants that have nodding flowers on leafless stalks, some with leaves at the base and some with no leaves and no green pigment.

WOODLANDS NATIVE

STRIPED WINTERGREEN, SPOTTED WINTERGREEN, *Chimaphila maculata* (Linnaeus) Pursh. Finding Striped Wintergreen is like winning a treasure hunt, for only a few of these plants are seen in one place at a time. Its branches rise through the insulating leaf-litter of pine, oak, and beech forests from long underground stems to hold a few leaves, each with a pointed tip and sharp marginal teeth. The leaf's surface is as matte as those of Pipsissewa are glossy. A pattern of pale markings around the midrib and veins is the distinguishing feature. Flowering branches each bear a few fragrant, white or pink flowers in summer, similar to those of Pipsissewa but larger, on stalks 4 to 10 inches (10 to 25 cm) tall.

The five-parted, brown, wrinkled capsule also is larger, on a stiffly erect pedicel. Its dust-fine seeds, many chances for the hope of a continued population, disperse in puffs as they are bumped or blown about over the winter.

Chimaphila maculata occurs from southern Maine, New Hampshire, and Vermont to Michigan and Illinois southward through uplands, but is now designated a species of special concern in Maine, rare in Vermont, endangered in Illinois, and on the watch list in Indiana. In some regions *Chimaphila maculata* is known by the common name Wintergreen, in others by Pipsissewa, with either Spotted, *maculata,* or Striped as the modifier in each case. To our eyes, perhaps "striped" is more on the mark—with colloquial names the choice is ours.

WOODS NATIVE

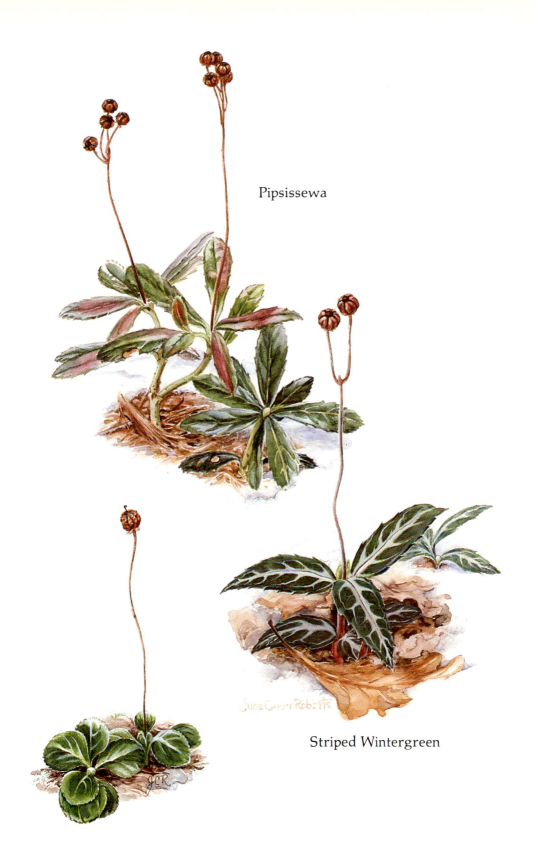

Pipsissewa

Striped Wintergreen

One-flowered Wintergreen

Pyrolaceae: Wintergreen or Pyrola Family

ONE-FLOWERED WINTERGREEN, ONE-FLOWERED PYROLA

Moneses uniflora (Linnaeus) Gray (single/delight) (one-flowered)

In dark northern evergreen forests One-flowered Pyrola finds enough light to exist. In summer a scape 2 to 5 inches (5 to 13 cm) tall holds a single fragrant, white or pale rose flower with a long pendulous style nodding at its apex. The corolla is 1/2 to 3/4 inch (1.3 to 1.9 cm) across, large for so small a plant and a delight indeed! In winter one usually has to be looking for it to see the brown stalk and single capsule, now upright with the style on top. The capsule is light brown, five-parted, and wrinkled, with the five sepals persisting around its base. At maturity the powder-fine seeds leave the capsule in puffs when blown or knocked.

Small round leaves on a short petiole are an inch (2.5 cm) or less in length, with a pale midrib and finely toothed margins. They form a basal rosette that lies quite flat on the forest floor amid fallen tree needles and mosses. Flower buds always seem to be present in the center of the rosettes, ready to burst forth whenever weather conditions permit. Perennial creeping underground shoots send up new leaves close to existing rosettes.

Moneses uniflora is the only species in this genus. Its range spans Canada, dipping into the States through New England to Pennsylvania, Michigan, and Minnesota. In Rhode Island it is currently considered a threatened species, but happily, a previously unknown population of *Moneses uniflora* has been discovered in Ohio.

See also genera *Chimaphila, Pyrola,* and *Monotropa* in this family.

WOODLANDS NATIVE

SHINLEAF

Pyrola elliptica Nuttall (little pear tree) (elliptic)

Shinleaf is perhaps the most prevalent species of the Pyrolaceae, a small family of Northern Hemisphere plants, found in woodlands across Canada and our northern states southward in mountains to West Virginia. Recent surveys, however, have reported this species as rare in West Virginia and Indiana, and endangered in Delaware. The smooth evergreen leaves in basal rosettes are longer than they are wide in this species, and more rectangular than they are elliptical. A scape 5 to 10 inches (13 to 25 cm) high rises from the leaves in summer to bear a simple raceme of fragrant, waxy, white flowers on short deflexed pedicels. Each flower is an open nodding bell with a long pendant style that becomes the clapper to complete the simile.

When mature the capsule splits open between the five carpels so that the countless minute seeds may disperse on air currents. The stalk and its fruits dry stiff and brown by winter and stand, often leaning, until spring.

Several other species of *Pyrola* occur in northeastern woodlands, varying in flower arrangement, leaf shape, and size. The family also includes non-green species such as Indian Pipe and Pinesap (page 130). Shinleaf, a name sometimes applied to the whole genus, recalls the time when any plaster used to ease pain was known as a shin-plaster and leaves of species of this genus were believed to heal wounds. *Pyrus,* Latin for "pear tree" with a diminutive ending, is thought to be the base of *Pyrola,* likening the leaf of some species to that of a pear tree.

WOODS NATIVE

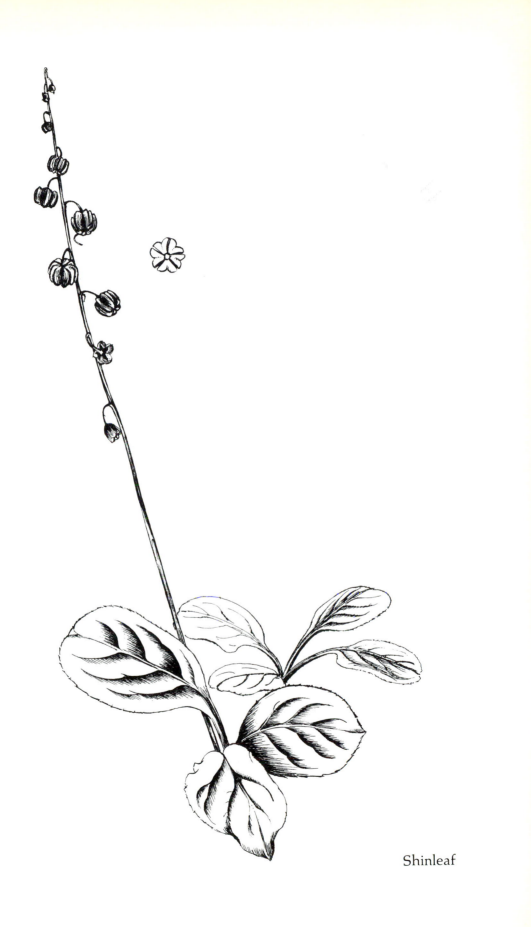

Shinleaf

Pyrolaceae: Wintergreen or Pyrola Family

INDIAN PIPE

Monotropa uniflora Linnaeus (one/turn) (one-flowered)

If you know this little perennial in its fresh, summer state, growing in the dim light of humus-rich forests, you may find it hard to believe that such a fragile, translucent plant would harden into this woody, brown or black stalk. However, the upright capsule at the summit is unmistakable. In summer the stalk emerges with its one large bud nodding, resembling the bowl of an upside-down pipe. Indian Pipe can be 4 to 10 inches (10 to 25 cm) tall, and is ghostly white, or occasionally pale pink or lavender. As the plant grows the head turns upright *(Monotropa)* and the likeness to a pipe ceases. There are no leaves, only scales on the stem.

After pollination and petal-fall the plant quickly dries and its stalk and ovoid capsule remain standing as air currents gradually scatter the minute seeds. The plant grows singly or in clumps, able to live in dark shade because it makes no chlorophyll but gathers nourishment from decomposed vegetable matter through fungal mycelia in the soil. Other members of this family may be found growing in the same wooded area.

Monotropa uniflora is found throughout the United States, in Mexico, and in Asia.

WOODS NATIVE

Pyrolaceae: Wintergreen or Pyrola Family

PINESAP

Monotropa hypopithys Linnaeus (one turn) (under pine)

Pinesap can be found fresh and colorful, growing in forest leaf mold or on a cushion of green moss, from June to November throughout our area. Like Indian Pipe, it is devoid of chlorophyll, a saprophyte of oak or pine forests, with alternate scales on the fleshy stem in place of leaves. The plant differs from Indian Pipe in several ways: Pinesap is strongly colored, tawny yellow to crimson red; a summer-flowering plant is usually yellow, an autumn one red. Also, there are three to ten flowers in a curled raceme at the summit of the stalk instead of one. These urn-shaped flowers are slightly fragrant and about 1/2 inch (1.3 cm) long. Usually, lateral flowers have four petals and the terminal one has five.

Monotropa hypopithys grows 4 to 12 inches (10 to 30 cm) tall. The coiled raceme unfurls as successive buds open, are pollinated, and form fruits as the pedicels make the "one turn" of the generic name to hold the capsules nearly erect. Mature capsules are globular or ovoid and have five locules that bear innumerable seeds to be dispersed by air currents. The plant has a relationship with soil fungi, as do other saprophytic and parasitic plants, to gain added nutrients. After maturation Pinesap blackens quickly, becomes rigid, and persists into winter for the gradual dispersal of its minute seeds.

WOODS NATIVE

Indian Pipe

Pinesap

Gentianaceae: Gentian Family

AMERICAN COLUMBO, MONUMENT PLANT

Swertia caroliniensis (Walter) Kuntze (for E. Sweert) (of Carolina)

American Columbo is indeed a monumental wildflower, whatever the origin of that colloquial name. The stalk can be 7 or 8 feet (2.1 or 2.4 m) tall, growing in open woods or meadows; in the illustration I have shown only the top of the plant. This species begins when a seed sprouts and grows into a basal rosette of oval leaves that enlarges and gathers strength for the root over two, three, or more years, becoming as much as 3 feet (91 cm) in diameter. One spring a flowering stalk appears in the center with an elongated panicle of light green, purple-spotted flowers at its summit.

Each flower, on a long ascending pedicel, is about an inch (2.5 cm) across; the corolla is four-lobed, each lobe with a large fringed gland below the middle. Stem leaves, in whorls of four, are ovate with pointed tips, smooth and entire, decreasing in size toward the inflorescence. Capsules are appropriately large, the two flat valves pressed together like praying hands. When ripe, the tips of the valves part to release the four to fourteen paper-thin, margined seeds. These seeds require a long period of chilling before their dormancy is broken, which means they germinate in the spring.

Swertia caroliniensis is the only species of this genus in the Northeast, occurring from western New York to Wisconsin south to Georgia and Louisiana. "Columbo" came from the name for an Old World drug applied to this native New World species by the colonists. *Swertia* was named for Emanuel Sweert (b. 1552), a Dutch herbalist.

OPEN WOODS NATIVE

American Columbo

134

Labiatae: Mint Family

HAIRY SKULLCAP

Scutellaria elliptica Muhlenberg (a dish) (elliptic)

This species of *Scutellaria* is found in dry woodlands. In spring and early summer *Scutellaria elliptica* has blue-violet flowers 1/2 to 3/4 inch (1.3 to 1.9 cm) long in a branched raceme at the summit of a sturdy stem. There are two to five pairs of short-petioled, ovate leaves with scalloped margins on the stem below the inflorescence. The curious appendage on the mature capsule is 1/4 to 1/3 inch (6 to 8 mm) long on this species, larger than on most Skullcaps. The stem persists over the winter, holding the dry calyxes as they scatter their small nutlets. The whole plant is hairy.

Scutellaria elliptica grows 1 to 3 feet (30 to 91 cm) high, occurring from southeastern New York across Pennsylvania and southern Ohio to Missouri southward. See also Marsh and Mad-dog Skullcaps of lowlands, page 52.

WOODLANDS NATIVE

Labiatae: Mint Family

WOOD-MINT

Blephilia sp. Rafinesque-Schmaltz (eyelash)

The Wood-mint stalk we find in winter, if much weathered, could be either *Blephilia ciliata* or *B. hirsuta,* the Downy or the Hairy. These are the two species of the genus, distinguished in summer by a downy versus a hairy stem and by a difference in the leaves: those of Downy Wood-mint are sessile and downy underneath, and those of the Hairy Wood-mint are long-stalked and sharply toothed. Both species have dense globose whorls of lavender, hooded flowers encircling the upper stem.

The calyx has three spine-tipped teeth on the upper side and two short blunt ones on the lower side. A circle of broad outer bracts cups around each cluster of the tightly packed flowers and persists around the calyxes. The bracts are fringed with long teeth, the "eyelashes" of the generic name. At flowering time these bracts are dark purple; they and the calyxes persist, drying to dark gray-brown by winter.

Both species of Wood-mint produce vegetative offshoots of leaves with long petioles. Both grow in woods, Downy in dry and Hairy in moist; and both occur throughout our area, except that Hairy Wood-mint is not found in Maine or New Hampshire. Downy Wood-mint is at present considered threatened in New York and rare in Maryland; both species are listed as historic only in Delaware, extirpated from Vermont, and endangered in Massachusetts.

WOODLANDS NATIVE

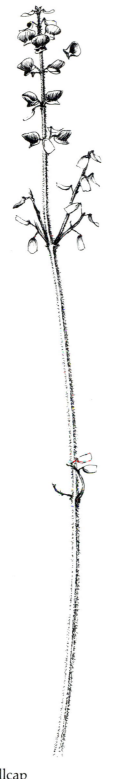

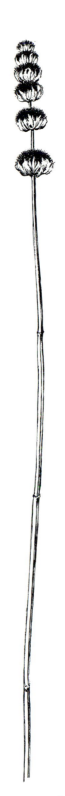

Hairy Skullcap

Wood-mint

Labiatae: Mint Family

DITTANY

Cunila origanoides (Linnaeus) Britton () (like *Origanum)*

The hiker may come upon this appealing little wildflower at almost any time of year in dry acid woods, thickets, or clearings, from the flowering plant in summer, through fruiting in autumn, to the dry plant in winter. Dittany disperses its tiny nutlets gradually over winter, unless heavy snows knock over plants growing on slopes, thereby sowing the nutlets all at once. I am told that ice crystals form on Dittany stems in very cold weather, although none may appear on other species near-by. Look for this phenomenon on Wild Hydrangea (page 112) also.

A dainty aromatic plant, *Cunila origanoides* grows 6 to 18 inches (15 to 46 cm) tall from a perennial root. It has a smooth stem and wiry, opposite, wide-spreading branches. From July to October small, tubular, lavender flowers are clustered in tufts at branch tips and in leaf axils, each with five nearly equal lobes; a five-toothed tubular calyx persists on the winter plant. Leaves are 1 to 1½ inches (2.5 to 4 cm) long, opposite, sessile or nearly so, ovate, and serrated on the margins. Dried leaves remain on the plant in winter, brown but still spreading and only slightly wrinkled.

Dittany is the only species of *Cunila* in our region. *Cunila* is an ancient Latin name for some aromatic plant; the specific name likens this plant to Wild Marjoram, another mint. Dittany may be found from southeastern New York to Missouri southward.

DRY WOODS NATIVE

Scrophulariaceae: Snapdragon or Figwort Family

FALSE FOXGLOVE

Gerardia sp. Linnaeus (for J. Gerarde)

About seven species of False Foxgloves occur in our area, although the genus is currently listed as diminishing in Delaware. Early herbalists probably were the ones to term these handsome native plants "false" in their search for the plant with the medicinal properties, the true Foxglove, *Digitalis.* The capsules of False Foxglove resemble those of *Digitalis.*

These are large plants, some species may be more than 8 feet (2.4 m) tall; I have shown only the branching top of the plant. The pure yellow, funnel-shaped flowers, with five wide-spreading lobes, are in pairs on terminal spikes in late summer and autumn. Leaves are opposite or nearly so; lower ones sometimes have lobed margins; small upper ones subtend the flowers.

The paired capsules are black, ovoid to globose, each with a beak and a long style. At maturity this many-seeded capsule splits into two valves, each part recurving and carrying half of the persistent style; over winter the styles usually break off. Many winged seeds scatter from the capsules by spring.

Species of *Gerardia* are woodland perennials, semi-parasitic on the roots of trees (black capsules are often a clue to this characteristic). False Foxgloves are also classified under *Aureolaria* and *Tomanthera.* See also Slender Gerardia, page 182, for more on this family.

WOODS NATIVE

Dittany

False Foxglove

Orobanchaceae: Broomrape Family

BEECHDROPS

Epifagus virginiana (Linnaeus) Barton (upon/the beech) (Virginian)

Beechdrops grow under beech trees and nowhere else because they are totally dependent upon beech for their sustenance. The plant lacks green pigment, relying on the leaves of the host tree to do the photosynthesizing. Early writers declared the lack of green pigment in such plants to be a sign of guilt, branding a plant that did not work for its food, as they put it, "degenerate."

Although not showy, *Epifagus virginiana* is an attractive plant. It usually grows in small groups; the tough, gracefully branched, upright stem is 6 to 20 inches (15 to 51 cm) tall. From August to October the 1/2 inch (1.3 cm) tubular flowers may be seen along the upper portion of branches that rise from the axils of small leaf scales; there are no leaves. The flowers are buff to pale magenta, lined with purple stripes when fresh; the branches and stems are buff to rust or umber. These flowers are generally sterile, a few being cross-pollinated by bees; it is believed that cross-pollinated flowers keep species strong. Smaller flowers that never open, set in the lower leaf scales, are self-fertilizing; such flowers are termed cleistogamous and are also found on violets, jewelweed, and wood-sorrels.

Epifagus virginiana is a single species genus. It ranges from Nova Scotia to Ontario southward beyond our area. Species names such as "virginiana" or "virginica" were given to plants by early botanists in this country to indicate the location in which the plant had first been found. Virginia was, at that time, a belt of land extending west far beyond the area we know as the state. The botanical family name means "to strangle vetch," which, like Broomrape reflects the earlier idea of violence applied to wildflowers that live on food produced by green plants—as most humans do, eating both the plants and the animals that feed upon them.

ON BEECH NATIVE

Orobanchaceae: Broomrape Family

SQUAWROOT

Conopholis americana (Linnaeus) Wallroth (cone/scale) (American)

Members of the Broomrape family are small parasitic wildflowers in a variety of colors, although never green, since they lack chlorophyll. Squawroot forms knobs on the roots of oak and hemlock trees, from which several unbranched stems rise 4 to 10 inches (10 to 25 cm) high. In spring, the stems are densely covered with fleshy yellow-ochre scales that overlap in the manner of a White Pine cone, with pale yellow, hooded flowers in the axils of the upper scales.

In autumn the plant dries and hardens; its capsules, holding many small, glossy brown seeds, turn dark brown. At this stage the plant resembles an old corn cob, according to Carolinians, who call the plant "Bear Corn." It persists all winter in this condition, often difficult to see among the forest leaf-litter. Capsule walls at length wear away and those seeds not already dispersed or eaten reach the ground.

Conopholis americana is the only species of *Conopholis* in the Northeast, occurring throughout our region, although currently considered to be rare in Vermont and of special concern in Rhode Island. The specific as well as the generic names are descriptive and apt; the colloquial name comes from the plant's use by native Americans as a remedy for female disorders. In another example of the confusion arising from common names, a caraway and a trillium have also been called Squawroot, but this is the only *Conopholis americana*.

WOODS NATIVE

Beechdrops

Squawroot

Rubiaceae: Madder or Bedstraw Family

PARTRIDGEBERRY ❀

Mitchella repens Linnaeus (for J. D. Mitchell) (creeping)

One of the happiest discoveries on a winter walk is the deep living green of Partridge-berry vines hanging from a rock ledge or carpeting the ground in cool evergreen woods. This ground-hugging wildflower has trailing stems that root at the nodes and are lined with pairs of small rounded evergreen leaves. Leaf margins are smooth and the midribs nearly white.

In summer fragrant, twin pink or white flowers open at the branch tips. Their ovaries united, each pair of flowers results in a single scarlet fruit with the calyx teeth of both flowers on top. These double drupes are nearly round, 1/3 inch (8 mm) wide, and contain several stony seeds. They persist through winter, even into the next flowering season, offering food for birds and wildlife. Unfortunately, these attractive native plants are diminishing due to loss of habitat and to being dug from the wild for terrariums.

There are only two species of *Mitchella* in the world, one in Japan and this one, which occurs throughout our region and beyond. Linnaeus named the species for Dr. John D. Mitchell (1676-1768), a botanist of Virginia who corresponded with him and most likely sent him specimens of our plant. Linnaeus characterized it as *repens,* "creeping." This American wildflower is now known around the world as *Mitchella repens,* in the binomial system Linnaeus originated. It is known colloquially as Twinberry, Two-eyed Berry, Running Box, Wintergreen, and Checkerberry. *Gaultheria procumbens* (page 286) also is commonly called Wintergreen and Checkerberry.

COOL WOODS NATIVE

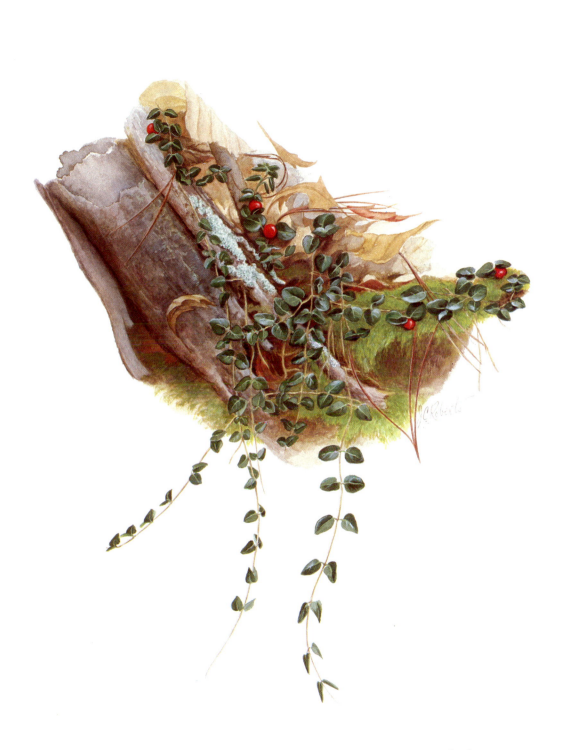

Partridgeberry

Caprifoliaceae: Honeysuckle Family

TWINFLOWER

Linnaea borealis Linnaeus (for Linnaeus) (northern)

The semi-woody, terra-cotta colored stems of Twinflower creep over rocks or mosses in cool peaty woodlands. Their small, paired evergreen leaves on short branches attract attention at any season. The flower stalk of summer is 3 to 6 inches (7.5 to 15 cm) tall, slender and hairy, dividing at the top into two diverging pedicels, each with a 1/2-inch (1.3-mm) pink, bell-shaped flower hanging from its tip—it is worth kneeling to inhale their sweet fragrance. After the corolla falls, the miniature stalk persists until both tiny, globose, one-seeded fruits have been released. Ruffed Grouse and other ground-feeding birds include Twinflower fruit in their diets.

Linnaea borealis is recorded as occurring from Canada south to Long Island and the mountains of West Virginia, across northern Ohio and Indiana. However, it is now listed as possibly extirpated from Connecticut, Rhode Island, Ohio, and Indiana. This also may be true of some other parts of its original range, since we are continually impinging on the habitats of our native wildflowers with new developments, highways, and shopping malls as our population expands.

The botanist Jan Fredrik Gronovius (1672-1762), Linnaeus' teacher and the author of *Flora Virginica* (1739), originally named this wildflower for Linnaeus, who was especially fond of its European variety and often had his portrait painted holding or wearing a sprig of it. Some floras list our species as *Linnaea americana.*

See also Japanese Honeysuckle, page 184, and Coralberry, page 186, in this family.

WOODLANDS NATIVE

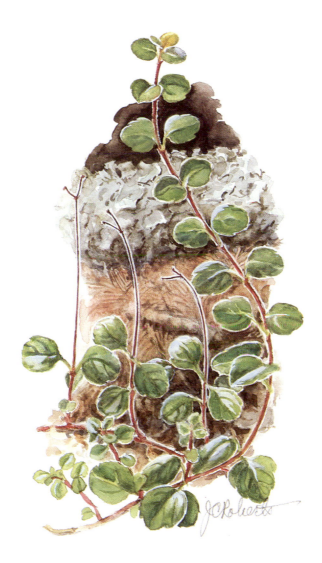

Twinflower

Cucurbitaceae: Gourd or Cucumber Family

WILD CUCUMBER, BALSAM APPLE

Echinocystis lobata (Michaux) Torrey & Gray (a hedgehog/bladder) (lobed)

Wild Cucumber, although inedible, is an annual herbaceous vine in the same family as the cucumber, pumpkin, squashes, melons, and gourds of our gardens. Wild Cucumber is cultivated, not for its fruit, but to climb and spill its masses of pale green blossoms over garden arbors all summer. A compound raceme of small staminate flowers and one or a few pistillate flowers rise from the same leaf axil, as well as a three-forked, tightly coiled tendril. The leaves are broadly lobed, similar to maple leaves.

Green globular fruits follow pollination; they are 2 inches (5 cm) long, bristling with benign prickles, the "hedgehog" of the generic name. *Cystis,* "bladder," refers to the fruit's inflated shape. At maturity, this unusual berry opens at the summit, releasing two large, flat seeds (occasionally three) from each of the two (or three) locules. A layer of fibrous network surrounds the locules, covered by the skin of the berry—an example of the remarkable packaging so often found in nature. The fruit eventually dries, becomes straw-colored, paper thin, and feather light, easily blown about to disperse the seeds.

Echinocystis lobata grows in moist woods and thickets, and along streams in rich soil, and is found throughout our area, although infrequently. It has been called Balsam Apple after the Balsam Apple of East India, *Momordica balsamina,* in the same family, which has red or orange, oblong, warty fruits. *Cucurbita* is ancient Latin for a gourd.

WOODS NATIVE

Wild Cucumber

Campanulaceae: Bluebell or Harebell Family

TALL BELLFLOWER, AMERICAN BELLFLOWER

Campanula americana Linnaeus (little bell) (American)

Tall Bellflower is an annual wildflower growing in moist shady places; it occurs from New York to Minnesota south to Florida, Alabama, and Missouri. Its erect stem may reach 6 feet (1.8 m) in height as its pale blue flowers open in the leaf and bract axils from June to August. Flowers have five lobes and spread an inch (2.5 cm) or more wide. A white ring at the throat of the corolla surrounds the stamens and the long curved style, which insects seeking nectar and pollen cannot avoid touching, thus effecting pollination.

Leaves are alternate, perhaps 6 inches (15 cm) long near the bottom of the stem, decreasing in size upward to small bracts in the flower spike. They are ovate to lanceolate, tapering to a sharp point at the tip. At maturity each small capsule has three to five pores near the top from which numerous slightly winged, dark brown seeds are shaken as the wandlike flower stalk is buffeted during winter.

The plants of this genus are named for the tubular flowers that resemble bells in most of its species, such as Creeping Bellflower, *Campanula rapunculoides,* an introduced species that has bell-shaped, blue-violet flowers on an extended terminal raceme. It spreads readily by runners and may grow to 40 inches (102 cm) tall. The capsule has pores that open at the base rather than at the top, but the fruit nods, positioning the basal pore at the top, so seed dispersal still is gradual.

See also Cardinal-flower, page 58, in this family.

WOODS NATIVE

Compositae: Composite or Daisy Family

SILVERROD, WHITE GOLDENROD

Solidago bicolor Linnaeus (make whole) (two-colored)

If yellow-flowered species are Goldenrods, then a white-flowered one is, of course, Silverrod. *Solidago bicolor* is the only species of Goldenrod that has no yellow form. It has a hairy, red-purple stem 1 to 3 feet (30 to 91 cm) tall terminated in summer and fall by a wandlike or pyramidal branching panicle of flower heads. Each short-stalked flower is approximately 1/4 inch (6 mm) wide with seven to nine white or cream rays around a light yellow disk; the floral bracts are white or straw-colored with green tips.

Leaves are alternate, softly pubescent, and toothed. Stem leaves decrease in size upward, becoming more pointed and stalkless toward the inflorescence. Basal leaves are 2 to 4 inches (5 to 10 cm) long, oblong with blunt tips, narrowing at the base into long, margined petioles. Fruits are smooth, light brown achenes with a tuft of white or tan pappus hairs to facilitate air travel to new locations. Several species of songbirds feed on these achenes.

Solidago bicolor is a wildflower of dry open woods, especially in sandy or rocky soil. It is found from Nova Scotia to Wisconsin south to Georgia and Arkansas. The generic name refers to the use of this genus in early medicine. See also other species of *Solidago* in Sections I, IV, V, and VI.

DRY OPEN WOODS NATIVE

Tall Bellflower Silverrod

Compositae: Composite or Daisy Family

WHORLED WOOD ASTER
Aster acuminatus Michaux (star) (tapering to a point)

Asters and goldenrods glorify late summer landscapes and befuddle the amateur botanist. About 67 species of *Aster* are recognized, yet identifying a flowering plant is far easier, with many more clues, than attempting to identify an unknown dry winter stalk. This Aster grows singly or in groups, in rocky woods and moist shaded thickets, flowering from July to October. It may be less than a foot (30 cm) or as much as 3 feet (91 cm) in height. In summer the composite flowers have white rays and yellow disks that soon turn purple. The slender, flat seeds of the mature plant are small with a white pappus twice as long. Wilted ray flowers often hang on, wrapped around the calyx.

In summer the spreading leaves are in approximate whorls on the downy stem, and are 2 to 4 inches (5 to 10 cm) long, toothed, and sharply pointed, as mentioned in the specific name. Upper leaves are larger than lower ones—a reversal of the usual, but the whorling probably keeps the upper leaves from shading those below.

The stem is unbranched, usually zigzagging from leaf to leaf; it is the bare zigzagging stem that we find in winter. Other aster stalks that zigzag are Crooked-stem Aster, *Aster prenanthoides,* whose leaf bases clasp the stem, and Heart-leaved Aster (page 194). *Aster acuminatus* occurs from Newfoundland to eastern Ontario southward in mountains. The *Aster* genus was named for its starry flowers.

See other species of *Aster* in Sections IV and V.

WOODS NATIVE

Compositae: Composite or Daisy Family

SPANISH NEEDLES
Bidens bipinnata Linnaeus (two-toothed) (twice pinnate)

Both the generic and the popular names for this annual wildflower describe the fruit. The yellow, rayless flowers of late summer are inconspicuous, but the cluster of radiating fruits, the "Spanish needles," 1/2 inch (1.3 cm) or more long, not only are noticeable, but may ride home with you. Latching onto clothing or fur is this plant's method of seed dispersal—a method that has earned other species in the genus the nickname "Beggar-ticks."

There are eight or more dark, slender fruits in a cluster; they are four-angled and tipped with two, three, or four spined barbs or awns. *Bidens,* meaning "two-toothed," is more aptly applied to other members of this genus—the achene of Beggar-ticks (page 256), for example, never has more than two. *Bipinnata* refers to the leaves, which are usually twice-pinnately divided.

The plant is freely branched, its stem square and stout, growing to a height of 1 to 3 feet (30 to 91 cm) in wet or dry rocky woods, waste places, and roadsides. It may be found from Rhode Island to Kansas southward. The dry plant stands firmly until all the fruits are carried away to new locations.

Spanish Needles' seeds germinate in the spring. Such seeds often require a spell of freezing, followed by specific amounts of light, moisture, and warmth in order to sprout.

ROCKY WOODS AND WASTE PLACES NATIVE

Whorled Wood Aster Spanish Needles

Celastraceae: Staff-tree Family

CLIMBING BITTERSWEET

Celastrus scandens Linnaeus (an evergreen tree) (climbing)

Climbing Bittersweet's orange and crimson fruits become conspicuous in autumn, but in January the bright colors begin to fade and darken. A woody vine, *Celastrus scandens* climbs by twining its stem around trees and shrubs, over walls and fences. The stem is round and slender with small sessile winter buds and alternate leaf scars. The terminal racemes of small, pale green flowers in late spring or early summer are hardly noticeable, but insects find them and almost every flower is pollinated, so the fruits hang heavy in autumn. The orange outer shell of each capsule opens into three or four valves to expose the pulpy scarlet arils that cover one or two large seeds. These fruits offer autumn food for birds.

Climbing Bittersweet is in the same family as Wahoo (page 114), a small tree, and Burning-bush (page 116), an alien shrub. Both of these plants have fruits similar to Climbing Bittersweet; none of these species is an evergreen tree, as the originally named species must have been.

Celastrus scandens once grew from Maine to North Carolina west to the Dakotas and New Mexico, but is becoming more rare due to over-picking; it is currently listed as potentially threatened in New York. If the tradition of gathering Bittersweet fruit in autumn is changed to one of looking and leaving *NOW*, the species may be saved.

An introduced species, Asiatic Bittersweet, *Celastrus orbiculatus,* has escaped from cultivation and is said to be replacing *Celastrus scandens* in the East, becoming a pest in some areas. Its fruit is dull yellow; its flowers grow from the leaf axils along the stem, instead of at the ends only. These leaves are rounded, alternate, and have serrated edges.

WOODLAND BORDERS NATIVE

Section 4
PLANTS OF SEMI-SHADE
Woodland Borders • Thickets • Shaded Slopes
Clearings • Prairies • Old Fencerows

Climbing Bittersweet

Corylaceae: Hazel Family

AMERICAN HAZELNUT

Corylus americana Walter (helmet) (american)

Corylus americana is a much-branched shrub that may reach 10 feet (3 m) in height, forming clumps from underground stems. It grows in wooded borders, thickets, forest understories, and on roadsides, in sun or shade, and is fairly frequent throughout our region. In late winter we watch the catkins of American Hazelnut as well as those of willow and alder for signs of awakening spring. The small, tightly closed male catkins that have hung stiffly on the Hazelnut shrub since the previous autumn begin to expand as winter wanes, stretching and loosening until they become flexible and 3 or 4 inches (7.5 or 10 cm) long. When the tiny flowers in these cylindrical clusters are fully developed, in March or April, one author has estimated that more than five million grains of golden pollen are released on the wind from each catkin.

At this time the pistillate flowers, near the ends of the branches, emerge from their scaly buds. Since wind carries the pollen, no petals are needed to attract insects, only a scarlet tassel of stigmas to catch some of the airborne pollen. Then the leaves open from their rounded buds; they are alternate, double-toothed, short-petioled, and covered with rough pink hairs, as are the involucre and twigs. Older bark is smooth and brown.

Ripening in late summer, the fruit remains on the shrub into winter if not removed. Two downy, leaflike bracts form a husk with ragged fringed margins around the brown nut, which is sometimes called a filbert because it resembles the European filberts, *Corylus avellana* and *C. maxima,* in taste and in nutritive value. The nuts of *Corylus americana* are an important food source for wildlife, having more nutrition than acorns. Chipmunks are especially fond of them; squirrels, mice, deer, bluejays, grouse, pheasants, and quail also eat them. O. P. Medsgar believes that this native nut would rival the European species as food for humans if it were cultivated.

The generic name is thought to be from Greek *corys,* "a helmet," in reference to the caplike involucre of the staminate catkins.

WOODED BORDERS NATIVE

American Hazelnut

Phytolaccaceae: Pokeweed Family

POKEWEED, POKEBERRY

Phytolacca americana Linnaeus (plant/crimson-lake) (American)

In summer and autumn Pokeberry is a large and colorful plant, bringing to mind the fact that *Phytolacca* is a tropical and semi-tropical genus with only this species in the Northeast. Its thick, branching stem, which may reach 10 feet (3 m) by autumn, emerges in spring as a white or pale green shoot, and soon is tinged with its characteristic red-purple.

Throughout summer the plant has small flowers in upright clusters about 8 inches (20 cm) long. Each flower has five rounded, white or pale green sepals, frequently tinged with pink; there are no petals. After maturation an ovary of five to twelve carpels united in a ring forms a berry with as many seeds. The alternate leaves are long-stalked, elliptical, prominently veined, and about a foot (30 cm) in length at full growth.

Autumn is Pokeberry's fruiting time and its most colorful season. Shining purple-black berries on crimson peduncles hang heavy with seeds and crimson juice. "Poke" is from an Algonquian word meaning "a plant for staining or dying," and these berries were used by the Indians and early colonists in that way, especially for staining baskets.

The perennial root, the purple stem, the leaves, and the seeds of this species are poisonous to humans, and it may be well to avoid even handling them without gloves. Gathered before the leaves unfurl or any touch of red appears, young shoots are sometimes prepared and eaten as one does asparagus; very young leaves are said to be edible after cooking with at least two changes of water. However, anyone not accustomed to wild foods should eat them with caution; parts of the plant were once used as an emetic and for other medicinal purposes. At present researchers are discovering new medicinal uses for this plant. The primary consumer of the berries is the Mourning Dove, for whom it is an important food source. Other songbirds also fancy them, sometimes becoming intoxicated on overripe berries. The leaves seem to be relished by deer.

At year's end, Pokeberry dies back to the deep taproot, drained of color, and stands or leans propped by its wide-spreading branches, like old bleached bones. *Phytolacca americana* grows in thickets and clearings, fencerows and waste places, and occurs from Maine and Ontario to Minnesota southward to Florida and Texas.

THICKETS AND WASTE PLACES NATIVE

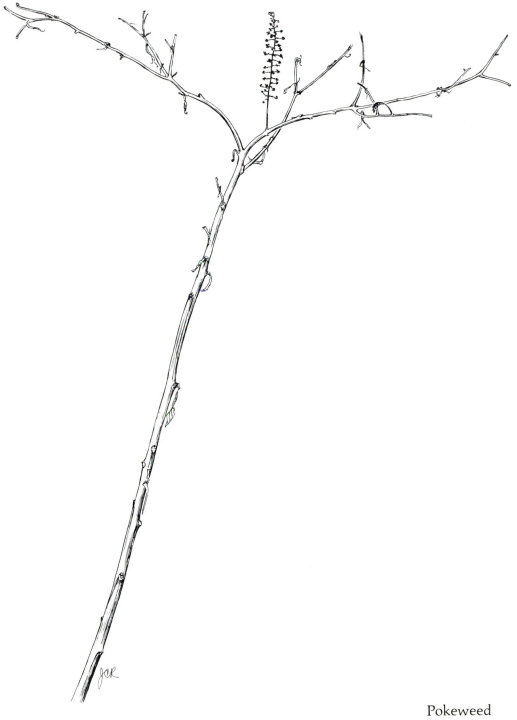

Pokeweed

Ranunculaceae: Buttercup or Crowfoot Family

THIMBLEWEED, TALL ANEMONE

Anemone virginiana Linnaeus (from name for Adonis) (of Virginia)

Anemone virginiana is a tall summer perennial that has five white or pale green petal-like sepals, many pistils, and numerous stamens on a large receptacle. After pollination, the green oval head enlarges to about an inch (2.5 cm) in length and 1/2 inch (1.3 cm) in width. Spiraling pistils form a pattern similar to that on silver thimbles—Thimblewort would be a better name for this wildflower. At maturity the fruiting head bursts open and the plant becomes visible from afar. Each hooked achene has a tuft of hair the color and texture of lamb's wool and their mass glows against the gray of winter woods. The wool clings to any passing agent that will transport the seeds to new locations. At winter's end many heads still hold some achenes, but eventually all are carried or blown away.

Thimbleweed is a slender, hairy plant 2 to 3 feet (61 to 91 cm) tall, with a circle of two to nine compound, toothed leaves at the top of the stem. Two long peduncles arise from this point with a solitary flower head at the tip of each; often one or both of these peduncles divides midway again from a node with a set of yet smaller leaves. Basal leaves are similar to stem leaves but long-stalked; all of the leaves have prominent veins. The name Crowfoot for the family and for some of the species refers to the divided leaves.

Anemone virginiana grows in dry open woods, in thickets, and on shaded slopes, occurring from central Maine to North Dakota south to Georgia and Kansas. About 10 species of Anemone occur in our region. The name *Anemone* is derived from a Hebrew epithet for Adonis and refers to the myth in which the crimson-flowered Anemone of the Orient sprang from his blood. Species in this country are rarely crimson, so the exotic name calls forth visions of distant lands. Pliny thought the flower buds were opened by the wind and called the plants Windflowers.

THICKETS AND SHADED SLOPES NATIVE

Thimbleweed

Ranunculaceae: Buttercup or Crowfoot Family

VIRGIN'S-BOWER, WILD CLEMATIS

Clematis virginiana Linnaeus (Clematis) (Virginian)

From late autumn into winter clusters of the plumed seeds of Virgin's-bower festoon shrubs, fences, and low trees. They are borne on a long, soft-wooded vine whose root is perennial but whose stem grows new each year. In summer flat-topped clusters of creamy white flowers, each with four or five sepals, no petals, and numerous stamens, adorn the green stem. They rise on long peduncles from axils of young, lobed, three-part leaves. The leaves' long petioles hook over available supports to enable the vine to climb into the light, some making several turns, showing us the evolution of tendrils, which began as leaf or flower stalks and adapted to a climbing habit. In autumn the leaf blades of Virgin's-bower wither and fall, but the petiole/tendrils remain until the stem dies.

Many species of buttercup have an achene with a persistent style that develops into a hook, but the style on the brown or rust-colored achene of *Clematis virginiana* elongates into a curly tail with fine, pale gray hairs that fluff into a plume at maturity. Autumn and winter winds and rains eventually loosen the achenes from their receptacles, and the plumes serve as parachutes, assuring the fruits of a wide dispersal. *Clematis virginiana* occurs throughout our region.

Leatherleaf, *Clematis viorna,* a species whose more southerly range overlaps ours from southern Pennsylvania to southern Ohio, has a leathery, pink, bell-shaped flower in summer, followed by clusters of achenes with light brown hairs that do not spread plumelike.

WOODLAND BORDERS NATIVE

Virgin's-Bower

Vitaceae: Vine Family

WILD GRAPE

Vitis sp. Linnaeus (vine)

Half or more of the grapes of the world are native to the United States, with twelve species in our region. There are small differences between species, and all hybridize freely. Most wild grapes are high-climbing, woody vines that grow in moist fertile soils of stream banks, fencerows, and woodland borders. Small fragrant flowers in a cylindrical panicle open in summer. Full-grown leaves are simple, rounded or heart-shaped, almost as broad as they are long with three to five lobes.

Anchoring tendrils allow grape vines to reach the top of the tallest trees in their search for sunlight, sometimes shading the trees sufficiently to kill them. Tendrils originally evolved from modified leaf or flower stalks, and occasionally a tendril will hark back and bear flowers and fruit. Flower clusters and tendrils are in leaf axils; their specific arrangement helps distinguish some species. Tips of the tendrils, often forked, wrap around branches tightly and then become woody. The tendrils die annually and the vines hang primarily from each year's new tendrils.

Grape stems are rather hard-wooded, those of old vines growing in forests can be as thick as young tree trunks. Stems have brown pith; in some species the pith is interrupted at the nodes by a woody diaphragm. Grape bark is usually loose and shreds into long strips. Wild Grapes begin to ripen in September or October; their pulpy fruits, black with a bloom, are sour but edible; made into jelly or juice they are delicious. Both the grapes of summer and the raisins of autumn and winter are valuable to wildlife as food. The pear-shaped seeds have hard, undigestible coatings; a symbiotic relationship exists between the vine and the birds and animals who eat and scatter them.

WOODLAND BORDERS NATIVE

Liliaceae: Lily Family

COMMON GREENBRIER, CATBRIER

Smilax rotundifolia Linnaeus () (round-leaved)

Smilax rotundifolia is a brier in the Lily family whose woody stem is green, whose thorns can scratch like a cat, and whose presence makes few people smile. However, tangles of Greenbrier, or Catbrier, provide excellent cover and protection for rabbits and other small wildlife, and nesting sites for Catbirds, Mockingbirds and Brown Thrashers—all fine singers. New shoots and young leaves in spring, as well as berries in winter, are an important source of food for birds, especially those three mockers and the Ruffed Grouse; deer browse on the stems.

In late spring Common Greenbrier has umbels of six to twenty-five green to bronze florets on 1 inch (2.5 cm) peduncles in the leaf axils. Leaves are at first tinged with bronze, and are highly glossy, leatherly, broadly ovate with attenuated tips, and have five nerves with net veining between them even though the plant is monocotyledonous. Each leaf is 2 to 6 inches (5 to 15 cm) long on a short petiole. In autumn the leaves are deep red to red-purple; some remain on the vine quite late, accenting the graying woods.

The blue-black glaucous berries are about 1/4 inch (6 mm) in diameter. Under their skin is a layer of brown pulp surrounding two light brown seeds encased in a sac of rubbery substance that stretches like dried rubber cement. Perhaps this sac helps the seeds go through the digestive tract of birds intact, still capable of germinating.

Smilax rotundifolia is a vine of woods, thickets, and riverbanks, occurring throughout our area. It is capable of becoming a thicket itself, climbing trees or its own branches as it strives toward sunlight. Its green stem and branches are four-angled and bear stout triangular thorns and pairs of strong tendrils that grow from the enlarged bases of the petioles. Tendril tips attach to anything at hand and draw the vine up by coiling in both, therefore opposite, directions from the middle. Greenbrier is the only eastern plant that has both thorns and tendrils.

WOODS NATIVE

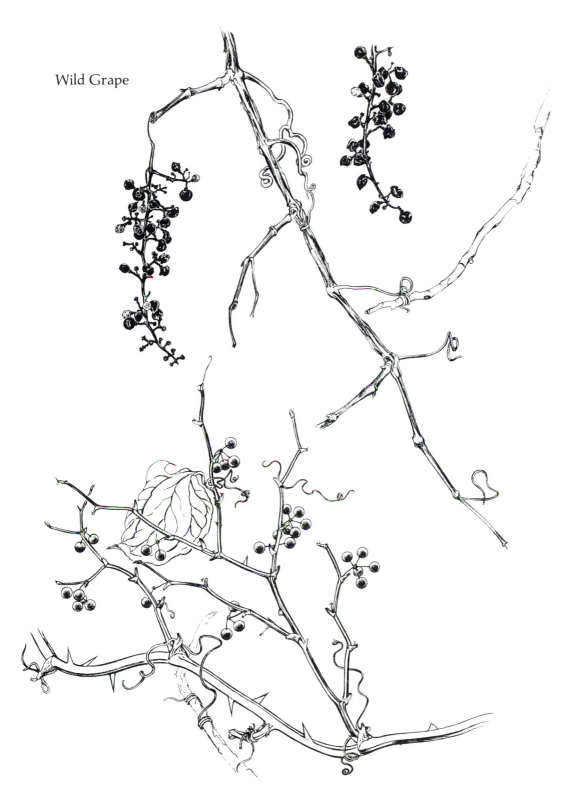

Wild Grape

Common Greenbrier

162



Hamamelidaceae: Witch-hazel Family

WITCH-HAZEL
Hamamelis virginiana Linnaeus (tree with pear-like fruit) (Virginian)

In late autumn or early winter, when tree leaves have fallen and most herbaceous plants are in fruit or are finished for this year altogether, Witch-hazel comes into flower! *Hamamelis virginiana* is a woody shrub or small tree that grows to about 30 feet (9 m) in dry or moist woods. Its twigs are smooth and somewhat zigzag; winter leaf-buds are hairy. In the North, the deciduous leaves, oval to almost round with a pointed tip, wavy margins, and unequal basal lobes, fall before the flowers open.

Two or three flowers cluster together close to the twig. Each flower consists of four hairy recurved sepals, four stamens, two styles, and four ribbon-like yellow petals that unroll from the bud and can roll back into it if the temperature drops too radically. Small late-season bees and flies find a feast of nectar here before the deep cold of winter in exchange for carrying pollen from one flower to another.

After the temperature-tuned petals fall, the calyxes, resembling tiny wooden flowers, persist around the pollinated ovaries. The following summer, these fruits will ripen and still may be present when the shrub flowers again in autumn. A capsule is about 1/2 inch (1.3 cm) long with four curved beaks and the two persistent styles. At its appointed moment, it bursts open with enough energy to fling the two to four dark, glossy seeds as far as 50 feet (15 m), and then drops off. Small spiny black galls, caused by an aphid, may be seen on the tree (upper left section of the branch in the illustration).

A belief was held, and still is held by some, that a forked branch of Witch-hazel could be used to "divine" the presence of underground water. Those for whom the branch performed were known as "dowsers," and were said to "have the witching gift." The Indians made bows of Witch-hazel wood, and a mild astringent lotion is made from the bark, twigs, and leaves of this slightly aromatic shrub and sold under its colloquial name—in this case no witchery is involved. In fact, Witch-hazel lotion is probably in every medicine chest.

Hamamelis is an ancient name for this plant. Homesick colonists gave this North American native the popular name of an English hazel tree with similar leaves.

WOODLAND BORDERS NATIVE

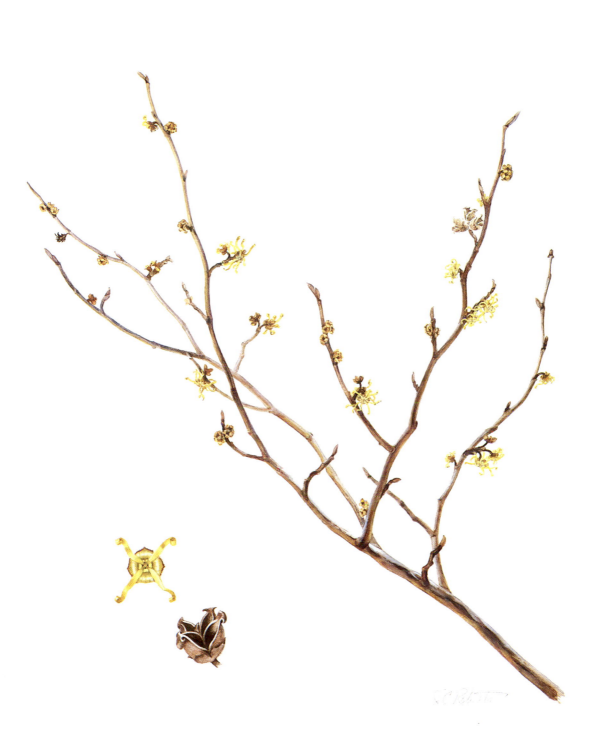

Witch-hazel

Rosaceae: Rose Family

WHITE AVENS

Geum canadense Jacquin () (Canadian)

Species of Geum are common wildflowers with white or yellow, radially symmetrical flowers, angular-forking branches, and compound, toothed leaves. White Avens stands 1 to 3 feet (30 to 91 cm) tall in shaded woodland borders and thickets, with fairly inconspicuous flowers in summer. They are solitary at the tips of branches, about 1/2 inch (1.3 cm) across, and have five small rounded white petals and five pointed green sepals that spread from under a green receptacle. Fine hairs cover the slender, slightly zigzag stem and the branches, on which short-petioled or sessile leaves are alternate. Principal leaves are divided into threes (sometimes fives or sevens); small upper leaves are toothed but undivided in this species. Basal leaves are not rounded, as in Large-leaved Avens (leaf on page 236).

By fruiting time the dry receptacle is covered with short bristles and numerous hairy achenes with barbed styles. These attract our attention more than do the flowers in summer as they persist over winter, catching onto animals' coats and our clothing for transportation to new sites.

There are about eight species similar to this one in our region. *Geum* was the name used for this genus by the Roman naturalist Pliny (A.D. 23-79).

WOODLAND BORDERS NATIVE

Rosaceae: Rose Family

AGRIMONY

Agrimonia sp. Linnaeus (Argemone)

In summer we seldom notice the small yellow flowers of this genus; nor do we often notice the fruits, until we remove them from our clothing after a walk in woods or thickets. The flowers have five radially symmetrical petals and are wide-spaced along the branches' terminal spikes. The somewhat conical calyx is trimmed with spreading, hooked bristles that catch onto passers-by to disperse the ripe fruits; two achenes are enclosed in each fruit. Pinnately compound leaves have pairs of tiny lateral leaflets between larger leaflets and a large terminal one. They resemble the leaves of Avens, but these leaflets are lance-shaped and coarsely toothed, not lobed as in Avens.

A branching Agrimony plant may attain 5 feet (152 cm) in height, and its branches stretch in all directions. Seven species of *Agrimonia* occur in our area, most of them perennials. Some species have been used medicinally for a variety of ailments, such as colds and diarrhea.

Agrimony, once *Argemone,* is an ancient plant name mentioned by Pliny (A.D. 23-79).

THICKETS AND WOODS NATIVE

White Avens

Agrimony

Rosaceae: Rose Family

AMERICAN IPECAC, INDIAN PHYSIC

Gillenia stipulata (Muhlenberg) Baillon (for A. Gillen) (bearing stipules)

When no leaves are found on the winter plant, it is difficult to distinguish American Ipecac from Bowman's-root, *Gillenia trifoliata.* Neither species is found in New England, but Bowman's-root occurs north from New York into Ontario and south to Georgia and Ipecac occurs from southwestern New York to Kansas southward. At present, however, Ipecac is listed as extremely rare in Virginia and regionally rare in Maryland. The difference between the two species is helpfully stated in the specific Latin epithets: Bowman's-root has a three-part leaf and Ipecac has in addition two large stipules that appear to be two more leaflets.

Gillenia stipulata grows in woods and on rocky slopes, flowering from May to July. The flowers are at the tips of branches and have five long, narrow, white or pink petals. The stem is dark red-brown to umber and has fine hairs. Capsules are darker brown, made up of five carpels that open on the inner side at maturity to release two to four seeds each. This dry stalk adds a delicate note to a winter bouquet, but be sure to shake out any seeds for regeneration of the species before gathering.

Ipecac is short for *Ipecacuanha,* the South American Portuguese word for a similar plant, *Cephaelis ipecacuanha.* The Portuguese word came from the Tupi word; the Tupi people of Brazil dry the roots of their plant to use as a laxative and emetic. North American Indians applied the names and uses to *Gillenia stipulata,* which has the same properties as *Cephaelis,* although milder. Ipecac is sold in pharmacies today, an inexpensive safeguard for households with small children who may swallow harmful substances.

Arnold Gillen was a German botanist and physician of the seventeenth century.

WOODS AND ROCKY SLOPES NATIVE

Leguminosae: Legume or Pea Family

WILD INDIGO, RATTLEWEED

Baptisia tinctoria (Linnaeus) R. Brown (to dye) (used for dyeing)

In summer, and sometimes into autumn, Wild Indigo has attractive yellow bilateral flowers 1/2 inch (1.3 cm) long, growing in loose racemes at the ends of its many branches; I have shown one outer branch. This perennial wildflower may be 3 feet (91 cm) tall, luxuriantly bushy while young, becoming straggly in age. Wedge-shaped leaflets, less than an inch (2.5 cm) long, are in triads on a minute stalk. Stem, branches, and leaves are gray-green with a blue bloom when young, and dark blue or blue-black when the fruits are mature.

These dark withering but persisting leaves are not the result of a blight but of the natural process of the species. A poor indigo-blue dye can be made from them, but true Indigo, *Indigofera,* from which a blue vat dye is obtained, is a genus of tropical plants. Wild Indigo is among the host plants of the Hoary Edge Butterfly and the Wild Indigo Duskywing Butterfly, whose young caterpillars overwinter.

The fruit is a swollen pod with a long persistent style. The flattened calyx has one large tooth and three or four short ones; both pod and calyx are jet black. At maturity the pod hardens, the seeds loosen and rattle in the wind. Surely, man-made children's rattles were designed after these.

Baptisia tinctoria occurs from southeastern Canada and southern Maine to Minnesota south to Florida and Louisiana, growing in dry soils of fields, open woods, and clearings. It is currently listed as endangered in Maine, rare in Vermont, and threatened in Kentucky.

DRY SOIL NATIVE

American Ipecac Wild Indigo

Linaceae: Flax Family

WILD YELLOW FLAX

Linum virginianum Linnaeus (flax) (Virginian)

The fine wiry stem and wide-spreading branches of Wild Yellow Flax are studded in winter with small globose capsules where the small yellow five-petaled flowers blossomed in early summer. Each capsule has five united carpels that split apart at maturity like orange sections, and five pointed, persistent sepals. By winter's end, when all of the seeds have dispersed, only the star-shaped five-part calyx is left. Any remaining leaves can be seen to be sessile and narrowly oblong. The Variegated Fritillary Butterfly lays its egg on species of *Linum,* among other plants.

There are three hundred species of *Linum* throughout the world; eleven in our region. Several native species are known commonly as Wild Flax. *Linum virginianum* is a perennial wildflower related to the annual cultivated flax, *Linum usitatissimum,* from which linseed oil is obtained and linen is made, practices that are centuries old. The words "linseed" and "linen" are derived from *Linum.*

Wild Yellow Flax grows 6 to 30 inches (15 to 76 cm) tall in open woods and clearings. The plant occurs from Maine to Iowa southward to Georgia and Alabama but is now considered threatened in Michigan.

GROOVED YELLOW FLAX, *Linum sulcatum* Riddell, is an annual, glandular species with a slender, usually unbranched stem. The yellow summer flowers are nearly 1/2 inch (1.3 cm) wide on short pedicels; leaves are alternate and linear. Sepals persist on the 1/8-inch (3-mm), nearly globose capsule. This pretty species grows in sandy or rocky soil of dry prairies and upland woods. It once ranged from Massachusetts to Ontario southward but is currently listed as rare or endangered in several of those states.

PRAIRIES NATIVES

Grooved Yellow Flax Wild Yellow Flax

Primulaceae: Primrose Family

SHOOTING-STAR

Dodecatheon Meadia Linnaeus (twelve gods) (for R. Mead)

In spring a smooth, hollow scape, straight as an arrow, rises out of a basal rosette of lance-shaped, 6-inch (15-cm) leaves to culminate in a burst of spring flowers, poetically called Shooting-stars. The umbel of buds is held erect by long, slender pedicels that arch as the buds open to hold the flowers upside down, thus discouraging crawling insects that steal nectar without carrying pollen. The pink, lilac, violet, or white petals are strongly recurved so that the protruding cone of five yellow stamens and the pistil are more conspicuous, and provide a landing place for pollinating bumblebees. The Arctic Blue Butterfly lays its eggs on the plants of Shooting-star.

When the plant is in fruit, the pedicels become erect once again, holding the mature capsules upright. Each capsule is about 1/2 inch (1.3 cm) long, dark red-brown, narrowly ovoid, and woody, opening at the apex by five barely flaring lobes. Sepals persist for a time, but may wear away over winter.

Dodecatheon Meadia grows from fibrous perennial roots, occurring from the District of Columbia and western Pennsylvania to Wisconsin southward. Most other species of this genus occur west of our region, more abundantly in earlier times, before the prairies were farmed. In our region Shooting-star is now reported to be declining in numbers in Maryland, endangered in Pennsylvania, potentially threatened in Ohio, and threatened in Michigan. It is often cultivated and sold by commercial nurseries, who propagate the plants and do not dig them from the wild—at least one should make sure that this is the case before purchasing any.

The generic name comes from the Greek *dodeca* "twelve," and *theos* "god," originally given to primroses by Pliny and applied to this genus by Linnaeus who imaginatively saw the umbel of hanging flowers as miniature Greek gods gathered around their Olympus. The specific name honors Dr. Richard Mead (1673-1754), an English physician.

PRAIRIES AND WOODS NATIVE

Primulaceae: Primrose Family

WHORLED LOOSESTRIFE, FOUR-LEAVED LOOSESTRIFE

Lysimachia quadrifolia Linnaeus (for Lysimachus) (four-leaved)

In summer, colonies of Whorled Loosestrife create a delicate repeat pattern of yellow stars on a background of green curves by the four yellow flowers that rise from the axils of tiers of four whorled leaves on long arching peduncles. Each flower has five pointed petals and a red ring encircling the stamens and the protruding pistil. Leaves are pointed, 2 to 4 inches (5 to 10 cm) long, and sessile. The plant grows 8 to 30 inches (20 to 76 cm) tall and has an erect, smooth or minutely hairy, unbranched stem.

In winter the starry flowers and symmetrically curving leaves are gone and the peduncles droop or are broken off, but the dry stalks with their spherical capsules and five-lobed calyxes are quickly recognized as they form another, even more delicate pattern of stars, in dark brown.

Lysimachia quadrifolia grows in dry or moist soil in open woods, in thickets, and along shores and roadsides, occurring throughout our region. Note that this Loosestrife is in the Primrose family. Purple Loosestrife, *Lythrum salicaria* (page 20), is in the Loosestrife family, Lythraceae. See also Swamp Candles on page 26 to read about King Lysimachus.

OPEN WOODS NATIVE

Shooting-star Whorled Loosestrife

Oleaceae: Olive Family

COMMON PRIVET

Ligustrum vulgare Linneaus () (common)

 Common Privet is a tall European shrub that has escaped from cultivation to become common here along roadsides, in thickets, and in open woods, growing as tall as 16 feet (5 m). Its opposite leaves and branches with terminal clusters of flowers or fruit are easily recognized at any time of year. The bark is warm gray, the twigs smooth, and the leaf scars raised, below the dark red buds on winter branches. Privet leaves are among the first to appear in early spring, and they cling to the branches late into autumn. They are 1 to 2½ inches (2.5 to 6 cm) long and firm but not leathery.

 In June or July panicles of small white flowers droop slightly from the ends of the branches. The panicles are about 2½ inches (6 cm) long; each small flower has a short tube and long petal lobes. Insects find their nectar and pollen attractive and many flowers are pollinated. Berries are dark gray or black, ovoid to almost round, 1/4 to 1/3 inch (6 to 8 mm) in diameter, and hard. They ripen in September or October and are still on the shrub in spring. Birds do not seem to fancy them, perhaps because they *are* so hard; also Muenscher reports cases of children in Europe being poisoned by eating them. Branch clippings can be used to obtain a yellow or gold dye.

 Three other species in our area that are less frequent have very hairy twigs or leathery evergreen leaves. *Ligustrum* is the classical name for this genus.

THICKETS ALIEN

Common Privet

Gentianaceae: Gentian Family

STIFF GENTIAN, AGUE-WEED

Gentiana quinquefolia Linnaeus (for Gentius) (five-leaved)

Gentians are often grown in gardens for their showy blue, purple, pink, or white flowers. Of the twenty-three species occurring in our region, the best-known are Closed, *Gentiana andrewsii* and Bottle, *G. clausa. Gentiana quinquefolia* inhabits prairies and woodlands. It has attractive violet-blue or lilac flowers that grow in clusters of four to seven at the summit and at tips of opposite branches rising from the leaf axils. The corollas are funnel-shaped; their five lobes, each tipped with a bristle, do not spread; the calyx is deeply cleft.

The stem is 8 to 22 inch (20 to 56 cm) tall and stiffly erect—four winged angles help keep it so. Leaves are dark green, opposite and ovate, each with a pointed tip; they are sessile or clasp the stem slightly with rounded bases. Lower leaves are oblong, their tips more blunt. The specific name probably refers to the five-lobed corolla, since the leaves are in pairs.

This is an annual or biennial species that flowers from August to October, and sometimes even later, so that fading flowers and green leaves still may be seen at the onset of winter. The capsule is slender and glandular, with globose seeds.

The genus was named in honor of Gentius, King of Illyria, who, according to Pliny, discovered the medicinal properties of these plants. The second English name implies that the plant was used in the treatment of ague. *Gentiana quinquefolia* occurs from southwest Maine to Missouri south to Florida, Tennessee, and Louisiana, but is now designated as rare in Connecticut and Maryland.

PRAIRIES AND WOODLANDS NATIVE

Stiff Gentian

Apocynaceae: Dogbane Family

SPREADING DOGBANE

Apocynum androsaemifolium Linnaeus (far from/a dog) (with leaves of *Androsaemum)*

Long, slender, dark brown seed vessels, often paired, hanging from the tips of this branched plant give it a graceful, somewhat Oriental appearance. Spreading Dogbane stands 1 to 4 feet (30 to 122 cm) tall on ruddy stems that turn dark brown and shred in winter. In June and July, fragrant pink and white bell-shaped flowers nod in terminal and axillary clusters. Each flower has two ovaries that produce, after pollination by bees and butterflies, a pair of these follicles, 3 to 8 inches (7.5 to 20 cm) long, that are joined at first by the style. When heat and moisture are sufficient they open and their plumed, spindle-shaped seeds become airborne.

Leaves are smooth, ovate, and opposite; in early autumn they turn a soft yellow before falling. Both stem and leaves have a bitter milky sap during summer that helps protects the plant from browsing insects and animals, hence "far from a dog." In the past, herbalists and American Indians used this plant medicinally to treat a variety of ailments.

Approximately 2000 species of Dogbane are recognized in the Northern Hemisphere. Some are herbaceous, some woody, and many are tropical. *Apocynum androsaemifolium* is perennial, colonizing in dry ground of roadsides, shaded borders, and thickets throughout our area and beyond. In Delaware, however, it is currently listed as historic only.

Indian hemp, *Apocynum cannabinum,* is similar to Spreading Dogbane but is more erect and has smaller flowers that are white or pale green. Strips of the bark of this species were made into twine at one time. Its juice is reported to be more poisonous than that of Spreading Dogbane. True Hemp is *Cannabis sativa* in the Hemp family.

A dried Dodder vine wraps around the stem of the plant in the illustration.

FIELDS AND THICKETS NATIVE

Convolvulaceae: Morning Glory Family

DODDER, LOVE VINE

Cuscuta sp. Linnaeus ()

A Dodder vine is shown twined around the stem of the Dogbane, where it flowered and fruited, drawing nourishment from its host by means of suckers that penetrated the plant's stem. This is a parasitic species of the Morning-glory family, an annual whose seeds germinate and sprout in the ground. The sprout finds a host plant by elongating and gyrating at the tip, and penetrates the host with suckers. The root and lower stem then wither away and the Dodder plant spends the rest of its life totally parasitic, eventually becoming a tangle of bright yellow or orange ropy stems.

There are about fifteen species of *Cuscuta,* all leafless plants with clusters of small, white, bell-shaped flowers in summer and fall. The fetid odor of the flowers attracts small flies, their chief pollinators. Capsules are almost spherical and contain many seeds. In winter the stems are black and broken, the fruits gray-brown. Dodders, among other plants, are host to the Brown Elfin Butterfly, which feeds upon its flowers and fruits.

Dodder meant "yolk" in Middle High German, doubtless a reference to the egg yolk yellow of the stems. The origin of the name *Cuscuta* is unknown.

LOW GROUND NATIVE

Dodder

Spreading Dogbane

Labiatae: Mint Family

YELLOW GIANT HYSSOP

Agastache nepetoides (Linnaeus) Kuntze (much/ear of grain) (resembling *Nepeta)*

Giant Hyssop has three color forms, Purple *(Agastache scrophulariaefolia),* Blue *(A. foeniculum),* and Yellow, this one. All are tall summer-flowering mints with crowded terminal spikes that somewhat resemble ears of a grain, like corn or wheat. All have Mint family characteristics of square stems, opposite leaves, and small bilateral flowers. Yellow Giant Hyssop is likened in its names to two other mints: Hyssop, in the genus *Hyssopus,* and Catnip, *Nepeta.* Yellow Giant Hyssop grows twice as large as Catnip, 2 to 5 feet (61 to 152 cm) tall; in the illustration I have shown the top half of the Hyssop.

In summer the flower spikes, to 18 inches (46 cm) long, are crowded with small, yellow, tubular florets (Catnip flowers are violet) and numerous ovate, pointed bracts. Four elongated stamens project beyond the corolla, the upper pair curving downward to cross the lower, upward-curving pair. The five-part calyx with blunt oval teeth persists.

The square stem and branches of this species are mostly smooth with sharp, or winged, angles. Leaves may be 5 inches (13 cm) long and have rounded bases and coarsely-toothed margins. Growing in thickets and borders of woods, *Agastache nepetoides* ranges from southwest Quebec and Vermont to South Dakota southward. In Delaware it is currently listed as endangered.

TICKETS AND WOODLAND BORDERS NATIVE

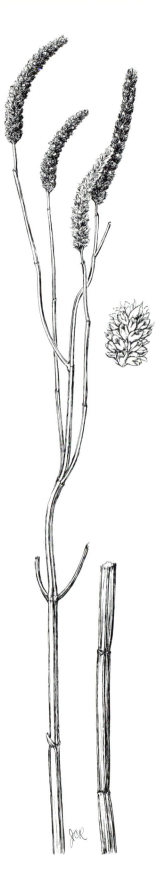

Yellow Giant Hyssop

Scrophulariaceae: Snapdragon or Figwort Family

CARPENTER'S-SQUARE, MARYLAND FIGWORT
Scrophularia marilandica Linnaeus (scrofula) (of Maryland)

Carpenter's-square is a tall summer perennial wildflower with a large, somewhat pyramidal inflorescence of numerous small flowers that are green-brown and dull-textured outside, magenta-brown and glossy inside. The erect stem is smooth, square, and usually grooved. Flowering branches and leaves are opposite, alternate pairs spreading east/west and north/south from the stem, an arrangement seen on many plants to ensure all leaves an equal share of sunlight. Leaves are 4 to 16 inches (10 to 41 cm) long and have toothed margins. The light brown, ovoid capsule has a short beak, typical of this genus. At maturity the two parts of the capsule separate at the top for dispersal of the wrinkled seeds over winter.

Scrophularia marilandica grows to about 9 feet (2.7 m), preferring thickets and rich woodland borders. This species occurs from New Hampshire to Ohio south to Georgia and the Mississippi River.

The names *Scrophularia* and Figwort refer to the use of the plants of this family in the treatment of scrofula, a swelling of the lymph glands of the neck, under the medieval Doctrine of Signatures (see Glossary); there are fleshy nobs on the rhizomes of some species of this genus. Snapdragon comes from a fanciful likeness of the flowers to the face of a dragon. These plants also were used in treating piles, once known as "figs;" -wort means plant. A more certainly effective use is as a host for the beautiful Buckeye Butterfly.

WOODLAND BORDERS NATIVE

Scrophulariaceae: Snapdragon or Figwort Family

FOXGLOVE BEARDTONGUE, WHITE BEARDTONGUE ❀
Penstemon digitalis (Sweet) Nuttall (five/stamen) *(Digitalis)*

Foxglove Beardtongue is a handsome wildflower. It is perhaps the most widespread of the eight or more white or nearly white species of *Penstemon* in the Northeast; the same number are lavender or pink. The plant grows 3 to 4 feet (91 to 122 cm) tall and has a slender, lustrous stem that rises from a short perennial rhizome. Between May and July the plant is topped with an open cluster of paired showy flowers on long ascending peduncles that rise from the axils of small upper leaves. Each tubular flower is about 1¼ inches (3 cm) long. As in all species of *Penstemon,* there are four fertile stamens and a conspicuously curled fifth one that is sterile and has a tuft of hairs, the "beard" on the "tongue."

Leaves diminish upward; those on the lower stalk may be 6 inches (15 cm) long, lance-shaped, opposite, sessile or clasping; basal leaves are petioled. The brown capsules are upright; each is 1/4 to 1/2 inch (6 to 13 mm) long, splitting at maturity into two valves with a cleft at the apex. The capsules hold numerous pitted seeds that are dispersed over winter to germinate in spring when conditions are favorable.

Penstemon digitalis is found in meadows, woodland borders, prairies, and open woods. The majority of the northeastern species occurs in the western section of our region. *Penstemon digitalis* originated in the Mississippi River basin and has spread to occur from Maine to Minnesota south to Alabama and Texas. The plant resembles Foxglove, genus *Digitalis.*

WOODLAND BORDERS NATIVE

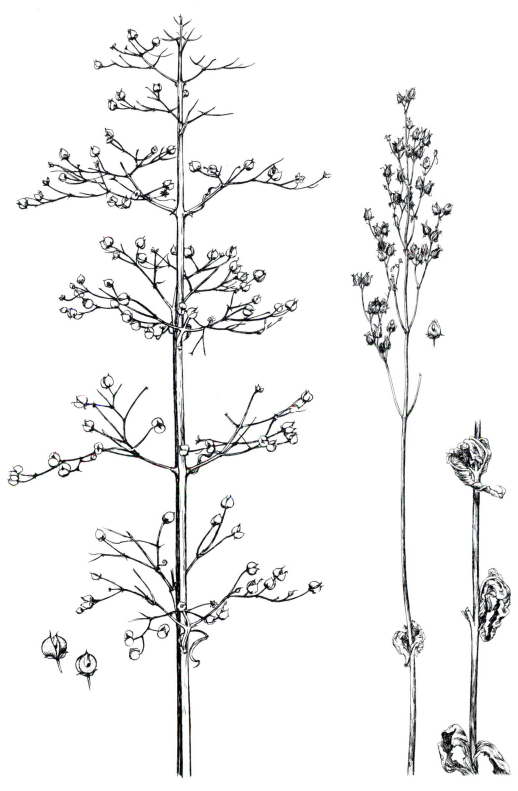

Carpenter's-square　　　　　　　　　　Foxglove Beardtongue

Scrophulariaceae: Snapdragon or Figwort Family

SLENDER GERARDIA

Gerardia tenuifolia Vahl (for J. Gerarde) (slender-leaved)

One would not expect the dried stalk of this delicate, branched plant to survive, yet it may be found in dry woods, thickets, fields, prairies, or on moist shores all winter and even the following spring beside the new plant. *Gerardia tenuifolia* is perennial and grows 6 to 32 inches (15 to 81 cm) tall. The species is well-named for it is slender in stem, branches, and leaves. Showy, five-petaled, rose-lavender flowers, about 1/2 inch (1.3 cm) across on long pedicels, rise from the leaf axils in mid to late summer. Leaves are sessile and opposite on the stem. The fruit is a globose papery capsule that opens by two valves to release minute dark seeds.

There are about 220 genera in this large family, found throughout the world, with a total of approximately 3,000 species in all, growing in a wide variety of soils and habitats. Many species have showy flowers, some of which are grown in gardens for their beauty. Currently *Gerardia tenuifolia* is federally listed as a threatened species.

This plant is also known as *Agalinis tenuifolia.*

WOODS AND FIELDS NATIVE

THYME-LEAVED SPEEDWELL ❊ *Veronica serpyllifolia* Linnaeus. Thyme-leaved Speedwell is a smooth plant with small, less than 1/2 inch (1.3 cm) long, oval leaves that are reminiscent of thyme leaves. The species is a mat-forming, creeping perennial of grassy places, roadsides, and damp open woods, as well as a competitor in gardens. In summer, racemes of small pale blue flowers with four rounded lobes terminate its upturned branches, which are 2 to 10 inches (5 to 25 cm) long. Capsules are 1/8 inch (3 mm) wide and notched at the top, making them appear heart-shaped. After maturation the capsules dry, turn brown, open across the notched edge, and persist while scattering seeds.

All of the more than twenty species of *Veronica* in the Northeast have heart-shaped fruits; most species are under 6 inches (15 cm) tall. Three other introduced Speedwells, Field, *Veronica agrestis,* Corn, *V. arvensis,* and Persian or Bird's Eye, *V. persica,* also have flowers in various shades of blue. During a winter thaw these ground-hugging plants may be found in flower, even in snow.

OPEN WOODS AND FIELDS ALIEN

COMMON SPEEDWELL, *Veronica officinalis* Linnaeus. Common Speedwell is a small perennial wildflower of open woods, fields, and cultivated areas, found throughout our area and beyond. The whole plant is woolly. Prone stems and leaves form mats from which erect flowering stalks rise 3 to 10 inches (7.5 to 25 cm) high. In late spring, and on and off all summer, these stalks hold racemes of pale lavender, four-petaled flowers 1/4 inch (6 mm) wide. The leaves are short-stalked, elliptical, 1 to 2 inches (2.5 to 5 cm) long, and remain somewhat green throughout the winter. Capsules are indented at the top so that they appear to be heart-shaped; those of this species are pubescent and about as long as they are broad.

It is popularly believed that the genus was named for the weeping Saint Veronica who, legend says, wiped Christ's face with her handkerchief when he was on his way to Calvary, and the handkerchief miraculously received the "true image" of Christ's features. In the early Christian era many plants were given religious names.

Officinalis is a name often seen for species that were once available from apothecaries' shops for medicinal use; it was believed that *Veronica officinalis* possessed diuretic and astringent properties. The plant also is native to the British Isles, Europe, and Asia.

OPEN WOODS AND FIELDS NATIVE

Thyme-Leaved Speedwell

Slender Gerardia

Common Speedwell

Bignoniaceae: Bignonia Family

TRUMPET-CREEPER, TRUMPET-VINE

Campsis radicans (Linnaeus) Seemann (curvature) (rooting)

This high-climbing, woody vine is in the same family as the Catalpa tree and is sometimes planted for its terminal clusters of large orange and crimson tubular flowers, which attract hummingbirds. The slender corolla, 2½ to 3 inches (6 to 7.5 cm) long, has a slightly projecting pistil to receive pollen from the head of a visiting Ruby-throated Hummingbird, its chief pollinator. Four short stamens with a "curvature" bend the anthers into the path of the hummer's head so that it may carry ripe pollen to the mature stigma of another flower. Leaves are alternate and pinnately compound, usually cut into seven to eleven ovate leaflets with sharply toothed margins and an elongated tip.

The fruit is a narrow, woody capsule 6 inches (15 cm) or so long, splitting at maturity into two boat-shaped valves, revealing the placenta bearing many winged seeds. These fruits are not open at the onset of winter, but later we find only empty ones, all the seeds having glided off in their annual gamble for the survival of this species.

Campsis radicans climbs by aerial rootlets on the stems near the nodes. The plant has escaped from cultivation to grow freely on fence posts, stumps, old buildings, trees and other plants in the open or in woods. Although the plant's original range was south of a line from New Jersey to Illinois, it is now frequent northward as far as Connecticut and Michigan.

WOODS AND THICKETS NATIVE

Caprifoliaceae: Honeysuckle Family

JAPANESE HONEYSUCKLE ❀

Lonicera japonica Thunberg (for A. Lonitzer) (Japanese)

Honeysuckles are woody shrubs or vines that are identified by their opposite branches with leaves, flowers, and fruit in pairs. About seventeen species of *Lonicera* are found in the Northeast. Japanese Honeysuckle is one of the seven introduced species, recognized in winter by its semievergreen leaves and glossy black berries borne in the axils of leafy bracts along the sides of branches and at their tips. In summer the heavily scented flowers that fill warm evenings with their sweet aroma are usually white, aging to yellow.

Branches are distinctively yellow-brown; petioles and new twigs are short and hairy. The ovate, pointed leaves are 1 to 3 inches (2.5 to 7.5 cm) long and entire except for some early ones that are lobed. In sheltered places they may remain green in winter, or turn yellow, red-purple, or brown—but only a deep freeze of long duration will kill these leaves. In fact, surface pubescence lengthens in winter, becoming a visible fur coat.

Lonicera japonica offers cover and food for birds and small mammals, and prevents soil erosion, the characteristic that originally led to its being imported from Asia and widely planted. However, because it thrives in neglected places, such as thickets, roadsides, old fencerows, and woodlands, rooting and branching to spread across the ground or climbing by twining, it can exclude herbaceous plants and ultimately smother trees. The Kudzu Vine, *Pueraria lobata,* of the South, also introduced from Asia, is similarly aggressive. Several other species of *Lonicera* planted as ornamentals also have become ecological problems.

Adam Lonitzer, a sixteenth century German herbalist, is honored in the generic name.

WOODS AND THICKETS ALIEN

Trumpet-Creeper, Trumpet-Vine

Japanese Honeysuckle

Caprifoliaceae: Honeysuckle Family

CORALBERRY, INDIAN-CURRANT

Symphoricarpos orbiculatus Moench (to bear together/fruit) (round)

Coralberry is a slender native shrub in the Honeysuckle family that sometimes grows to a height of 5 feet (152 cm), but usually not more than 3 feet (91 cm). It is found in open woods and thickets and on shaded dry, rocky banks, and ranges from New Jersey, Pennsylvania, and western New York to Minnesota southward. Lately it has escaped from cultivation eastward into New England.

In summer the spreading or arching branches are dressed with opposite pairs of ovate, dark green leaves that are 1 to 1½ inches (2.5 to 4 cm) long, short-petioled, and downy underneath. Dense clusters of 1/8-inch (3-mm) bell-shaped flowers are borne in the leaf axils from July to August.

By September or October the pollinated flowers have developed into a cluster of berries about 1/4 inch (6 mm) long at the base of each pair of spreading leaves, which dry slowly but eventually fall. The berries are ovoid to globose and beaked with persistent calyx lobes. These fruits are usually more magenta than coral, but in either case it is an unexpected and pleasing color in the winter landscape until the bright color darkens with age. They remain on the shrub most of the winter, offering food for birds and animals.

WOODLAND BORDERS NATIVE

Coralberry

Campanulaceae: Bluebell or Harebell Family

INDIAN TOBACCO

Lobelia inflata Linnaeus (for M. l'Obel) (inflated)

Indian Tobacco, a delicate annual herb, dries a pale straw color and, unless weathered gray, remains so all winter. It is easily identified by its inflated oval capsules, about 1/3 inch (8 mm) long, on stalks of the same length. These stalks arise from the axils of ovate, toothed leaves, which often persist on the dried plant. The stem is 8 to 36 inches (20 to 91 cm) tall, simple or much-branched, and hairy in summer; in winter a hand lens may reveal some remaining hairs. The capsules contain brown seeds about the size of ground pepper.

In summer this lobelia's pale violet and white flowers, although small, are as lovely as those of larger species, some of which are cultivated as ornamentals. *Lobelia inflata* grows in poor soil of open woods, fields, and roadsides, and may be found throughout our area.

In naming this species, Linnaeus dedicated it to Matthias de l'Obel (1538-1616), a Flemish herbalist. The common name is said to refer to the belief that American Indians chewed and smoked the leaves. Like tobacco, the plant is known to be extremely poisonous, even fatal.

See also Cardinal Flower on page 58.

OPEN WOODS AND FIELDS NATIVE

Compositae: Composite or Daisy Family

MISTFLOWER

Eupatorium coelestinum Linnaeus (for M. Eupator) (sky blue)

In late summer the fuzzy, flat-topped flower clusters of this comparatively small *Eupatorium* are indeed heavenly blue; in fall the pappus hairs are white and fuzzy, and in winter the empty calyxes are tan and resemble flowers, as do those of many members of the Composite family. Mistflower's tan calyxes are set off by the dark brown dried leaves, branches, and stem. Some remnants of petioles or leaf scars on the stem indicate that the leaves are opposite; some flower stalks may remain in their axils, and stem hairs may persist into winter, an aid in identification.

Eupatorium coelestinum grows 1 to 3 feet (30 to 91 cm) tall; small groups are found in damp thickets, clearings, and woodland borders. The plant occurs from New Jersey to Missouri southward—a more southerly range than that of the other species of *Eupatorium* discussed here. This immense genus of mainly tropical herbs was dedicated to Mithridates IV Eupator (132-63 B.C.), King of Pontus, now Turkey, who is said to have used a species in medicine.

Mistflower is sometimes cultivated; a garden flower with a similar inflorescence is Ageratum. See also Joe-Pye Weed, page 62 and Boneset, page 64, in this genus.

WOODLAND BORDERS NATIVE

Indian Tobacco Mistflower

Compositae: Composite or Daisy Family

CYLINDRIC BLAZING-STAR, GAY FEATHER

Liatris cylindracea Michaux () (cylindric)

Cylindric Blazing-star is a beautiful summer wildflower that is also lovely in early winter, resplendent with plumed seeds. The slender stalk, rising 8 to 24 inches (20 to 61 cm) tall from a perennial corm, bears one to several heads of many tiny, rose-purple, tubular florets. All are disk flowers, each with five lobes and numerous, projecting, branched styles that give the flower head a feathery appearance. Pollinated flowers develop into slender, tapering achenes, crowned by one or two rows of pale gray, plumose hairs about 1/2 inch (1.3 cm) long.

Each head is surrounded by a tight cylinder of narrow overlapping bracts. The design of these bracts is a help in separating the eighteen species of *Liatris* in our region. When fresh, the bracts of this species are upright and end in an abrupt point. The tips of the inner bracts curl slightly on the dried plant. At maturity the floral bracts loosen and the achenes are released to parachute to new sites, leaving the small receptacle bare.

For comparison I have shown a winter head of Scaly Blazing-star, *Liatris squarrosa,* whose broader bracts have sharply pointed tips that spread horizontally and remain so on the dried plant. The achenes have dispersed from this head and all but four bracts have fallen.

The alternate, linear leaves of Blazing-stars dry pearly gray, curl gracefully, and remain on the stalk. This delicate dried plant, standing among the Big Bluestem grasses of a prairie in early winter, draws a picture for us of its summer achievement, and displays its feathered promises for repeat performances in future years.

Liatris cylindracea grows in open, dry, limy soil and was abundant before the vast prairies were plowed. It is now found infrequently, occurring from western New York and southern Ontario to Minnesota south to the Ohio River and Missouri. Both Cylindric and Scaly Blazing-stars currently are listed as threatened in Ohio.

DRY LIMY SOIL NATIVE

Compositae: Composite or Daisy Family

WREATH GOLDENROD, BLUE-STEM GOLDENROD

Solidago caesia Linnaeus (make whole) (blue-gray)

Goldenrods are grouped based upon the shape of the inflorescence: wand, club, plume, elm, or flat-topped. Wreath Goldenrod is placed in the wandlike group, but differs from them in usually having an arching posture and in having tufts of small golden florets in the leaf axils along the stem. The stem is 1 to 3 feet (30 to 91 cm) tall and is smooth with a waxy bloom that causes it to appear blue when fresh. Slender alternate leaves are 1½ to 5 inches (4 to 13 cm) long, smooth, lance-shaped, and sharply toothed.

Not until the end of autumn or early winter do the petals of this late-flowering species wither, the leaves droop and turn brown, and the pappus hairs expand in readiness to carry the seeds wherever winds and rains may take them. The plant remains in this condition for some time, the seeds offering food for birds and some small mammals.

Solidago caesia is found in rich deciduous open woods, thickets, and clearings, seeming to prefer a slope from which to arch out, sometimes almost horizontally, so that the leaves all hang below the stem. Turned into a ring, the plant would somewhat resemble a wreath.

Solidago caesia ranges from Nova Scotia and Quebec to Wisconsin southward, although it is now considered endangered in Wisconsin. The name *Solidago* derives from *soldare,* "to make whole," reflecting an ancient belief in the healing power of these plants when applied to wounds. American Indians also once used this species medicinally, to treat convulsions and diseases of women.

THICKETS NATIVE

Cylindric Blazing-Star

Wreath Goldenrod

192

GRASS-LEAVED GOLDENROD, LANCE-LEAVED GOLDENROD

Solidago graminifolia (Linnaeus) Salisbury (make whole) (grass-leaved)

Separating the species of *Solidago* in winter is difficult, since they hybridize freely and vary within species; it is often necessary to have seen the flowering plant for positive identification. Grass-leaved Goldenrod has a flat-topped inflorescence in summer, composed of small, fragrant, lemon-yellow florets in a compound corymb. Many long slender leaves are on the stem; smaller ones are among the flowering branches. The leaves are stalkless, have three to seven nearly parallel veins and slightly rough edges.

Mature seeds are tipped with a short pappus of white hairs that parachute them to new locations on the wind. Starry calyxes, similar to those of a dried aster, remain on the stalk. Asters differ in having circles of bracts surrounding the receptacle.

Solidago graminifolia is perennial by stolons, growing 2 to 5 feet (61 to 152 cm) tall, the largest of the narrow-leaved species. It thrives in moist or dry ground of open thickets, roadsides, fields and streambanks, and may be found throughout most of our area.

Slender Fragrant Goldenrod, *Solidago tenuifolia,* is a similar although smaller and more slender plant, whose leaves usually have a single nerve and smooth edges. This species occurs in sandy soil from Nova Scotia to Florida along the coast, and in the region southeast of Lake Michigan. See other species of *Solidago* in Sections I, III, V, and VI.

THICKETS AND ROADSIDES NATIVE

FLAT-TOPPED ASTER

Aster umbellatus P. Miller (star) (umbellate)

In late summer, in the cooler regions of the Northeast, one of the first asters to flower is Flat-topped Aster. This species grows in damp thickets and along borders of woods and streams; it can reach 7 feet (2.1 m) in height, sprouting from last year's stolons. Often colonizing, many heads are put together to display numerous white-rayed blossoms with yellow disk florets that turn purple in age. Each flat or convex cluster of flower heads may measure a foot (30 cm) across in a year of ample rain; massed together they provide a huge airstrip for nectar-seeking, pollinating insects.

The stiffly ascending branches of the inflorescence rise from alternate positions on the dark red-purple stem, thus holding the flowers in a corymb—not an umbel as the specific name implies. The tall stem has many lance-shaped, rough-margined leaves. The Harris' Checkerspot Butterfly lays its cluster of eggs on this species and the caterpillars feed on the plants.

In September the disk and ray florets are succeeded by smooth achenes with their white pappus hairs by which they ride on autumn winds to begin new colonies. In winter the stem is leafless and holds only the branches of the inflorescence, now somewhat curled in upon themselves; the domed receptacles are bare, and the bracts of the involucre are recurved. In this dry state the plant may be confused with Grass-leaved Goldenrod, but the Goldenrod branches rise from lower on the stem and its dried heads are bristly with bracts.

WOODLAND BORDERS NATIVE

Grass-leaved Goldenrod Flat-topped Aster

Compositae: Composite or Daisy Family

HEART-LEAVED ASTER, BLUE WOOD ASTER

Aster cordifolius Linnaeus (a star) (heart-leaved)

About sixty-eight species of *Aster* occur in the Northeast and are found in a wide range of habitats. *Aster cordifolius* is a perennial species of woods, clearings, and thickets, especially of shaded slopes, occurring throughout our range. Although variable, the leaves generally are 2 to 6 inches (5 to 15 cm) long, heart-shaped, thin and long-petioled, with large pointed teeth on the margins and slight wings on the petioles. These leaves often persist in a dried state, a great help in identification.

Terminal clusters bear small starry flowers, each with yellow disks that soon turn magenta, and ten to twenty pale blue or violet rays. Smooth, narrow bracts that persist on the winter plant surround the flower heads. After pollination, the flowers mature into numerous two-ribbed, light brown achenes with a tuft of bristles to aid in their dispersal. I have read that the pollen grains of species of *Aster* are indistinguishable from each other and from those of Goldenrods, *Solidago*. The plants of both genera have copious flower heads to keep bees busy carrying pollen from flower to flower within each cluster as they feed. Asters are also hosts to Pearly and Field Crescentspot Butterflies; the half-grown caterpillars of the latter overwinter after feeding on the plants.

See other Asters in Sections III and V for more on this genus.

SHADED SLOPES NATIVE

Heart-leaved Aster

Compositae: Composite or Daisy Family

SWEET EVERLASTING

Gnaphalium obtusifolium Linnaeus (tuft of wool) (blunt-leaved)

In late summer and early autumn the branched inflorescences of Sweet Everlasting can be seen in fields, woodland borders and clearings, its flower heads the color and texture of ivory satin. The tubular florets at the tips of the branches are each about 1/4 inch (6 mm) long and 1/8 inch (3 mm) wide, surrounded by involucral bracts in three to five lengths that overlap in several rows. The florets remain unexpanded until maturity, when they spread to allow the bristly achenes to disperse. Finally they become dry and "everlasting." (See also Pearly Everlasting on page 290). The "sweet" aroma is everlasting as well; it does not diminish with drying, but remains fragrant indefinitely. It has been likened to the scent of slippery elm or tobacco, but to me it smells of new-mown hay or caramel.

The erect stem of *Gnaphalium obtusifolium* is 1 to 2 feet (30 to 61 cm) tall; both the stem and the leaves are covered with silky white hairs. Leaves are linear, narrowing at the base, sessile but not clasping the stem. The American Painted Lady Butterfly larva feeds on and makes its nest of silk on the soft leaves of everlastings. The butterfly may overwinter as an adult or as a chrysalid on the plant.

The American Indians used this plant in the treatment of paralysis and in local applications for healing. It is a variable species of a wide-ranging genus, and occurs from Maine to Minnesota south to Florida and Texas.

WOODLAND BORDERS AND FIELDS NATIVE

Compositae: Composite or Daisy Family

PURPLE CONEFLOWER

Echinacea purpurea (Linnaeus) Moench (sea-urchin) (purple)

In summer and fall Purple Coneflower is a striking wildflower with its rose-purple rays that droop from the perimeter of the large, orange and green central disk. The flower head is 2½ to 4 inches (6 to 10 cm) across; the disk becomes a dome rather than a cone as the disk florets mature; the florets are interspersed with stiff, sharp-pointed bracts. *Echinos,* meaning both "sea-urchin" and "hedgehog" in Greek, likens the disk to one of these spiny creatures; in winter the aptness of the simile is especially evident. Lance-shaped floral bracts spread beneath the head in three to five overlapping rows; these bracts persist in winter, gray and wrinkled.

The plant grows 2 to 5 feet (61 to 152 cm) tall; I have shown the top half in the illustration. The stem widens at the summit to support the receptacle. Principal leaves, near the base of the stem, are alternate, long-petioled, rough above and serrated on the margins; they have three to five main veins. Upper leaves are small, short-petioled, and toothless. The short four-sided achenes of the fruiting head each has a crown of small teeth.

Echinacea purpurea dies back to the perennial root but remains standing all winter to disperse the achenes. Most Coneflower species in the Northeast occur in the western section; this species occurs from Pennsylvania to Iowa south to Georgia and Louisiana, growing in prairies and dry open woods. It is currently considered endangered in Wisconsin.

PRAIRIES AND OPEN WOODS NATIVE

Sweet Everlasting Purple Coneflower

Compositae: Composite or Daisy Family

JERUSALEM ARTICHOKE

Helianthus tuberosus Linnaeus (sun/a flower) (tuberous)

About 20 species of Sunflowers grow in the northeastern United States. If you see plants up to 10 feet (3 m) tall, with branches only at the top, terminating in bristly, brown, 1-inch (2.5-cm) heads, look to see if the stem is rough and hairy, and if the leaves are or were opposite near the bottom of the stem and alternate above. In addition, if any remaining leaves show three prominent veins, you may be certain the plants are *Helianthus tuberosus.*

This yellow sunflower, with heads 2 to 3½ inches (5 to 8.8 cm) across, may brighten moist fields, thickets, or roadsides from August to October. The mature head of winter is composed of smooth achenes interspersed with dry chaff, both attached to a small receptacle. Pointed bracts under the flower heads persist and are an aid in identification. These heads disperse achenes over most of the winter. They provide birds with winter food, although these seeds are smaller than the cultivated sunflower variety. The Silvery Crescentspot Butterfly feeds on many species of sunflower.

Jerusalem Artichoke has enlarged fleshy tubers on the roots of the perennial rootstock that are edible and for which the plant is sometimes cultivated. The tubers contain no starch while being highly nutritious. Originally, this native American plant was raised by the native peoples and subsequently introduced into Europe. The Indians cooked the tubers, and parched and ground the seeds into a meal that they rolled into balls or made into a mush. They also made a drink from roasted seeds.

Jerusalem is a corruption of the Italian word *girasole,* meaning "turning to the sun." Perhaps Artichoke refers to the bristly winter seed heads.

DAMP THICKETS NATIVE

Jerusalem Artichoke

Compositae: Composite or Daisy Family

WINGSTEM

Actinomeris alternifolia (Linnaeus) De Candoll (a ray/a part) (alternate-leaved)

In winter the dried stalks of Wingstem rise above most other plants growing in roadsides, waste places, and woodland borders. The plant may be 8 feet (2.4 m) tall; I have shown the top of the plant only. Dark brown heads of achenes are at the tips of the slender branches. At a distance the plant may appear to be a Sunflower, *Helianthus,* but the remnants of "wings," thin flanges extending between the upper leaves or leaf scars on the stem, show that this is *Actinomeris alternifolia,* the only species in this genus.

Wingstem is a late summer perennial. Its flowers are 1 to 2 inches (2.5 to 5 cm) wide with fewer than ten drooping yellow rays; involucral bracts below the head also droop. Disk flowers are large, golden-green, and interspersed with chaff. After pollination, broad, flat achenes develop; they are somewhat pubescent, usually with wings and two or three terminal spines, or awns. They and the chaff are in no definite pattern on the receptacle.

Leaves are alternate, although the lowest ones are sometimes opposite or in threes. They are lance-shaped or oblong and slightly rough with hairs on both sides; their bases are confluent with the stem's wings. The Silvery Crescentspot Butterfly lays its eggs under the leaves of Wingstem and the caterpillars overwinter half grown.

Actinomeris alternifolia occurs from New York to Iowa southward. It is also known as *Verbesina alternifolia.*

WOODLAND BORDERS NATIVE

Wingstem

Asclepiadaceae: Milkweed Family

COMMON MILKWEED

Asclepias syriaca Linnaeus (for Asclepius) (Syria)

This commonest of the milkweeds in our area is a familiar sight in dry open fields and roadsides. In winter the unbranched stem stands erect, 2 to 6 feet (61 to 183 cm) tall with leaf scars showing the opposite position of the large oblong leaves of summer. At the stem's summit the flowering stalk ends in a clump of knobs and one or more warty fruits on deflexed pedicels.

The knobs and fruits tell of many fragrant, dusty-pink flowers that perfumed the summer air. Strangly, only a few flowers of an umbel form fruit, probably due to the difficulty insects have in entering the complicated flower structure, but the continued health of the plant is aided by this selective fruiting. One or two follicles form from the two ovaries of a flower, and just as each head provides an abundance of flowers, so each follicle produces a quantity of seeds. This combination of birth control and fecundity reflects a complex evolutionary history. Botanists now believe that abortion may adjust the quantity of new growth to available resources.

The follicles are 2¾ to 5 inches (7 to 13 cm) around and 3 to 5 inches (7.5 to 13 cm) long, and usually are upright. In autumn they begin to split open on one side, revealing the flat, brown, margined seeds, precisely overlapped like fish scales, and each tipped with a tuft of silken hairs tightly folded. At maturity the seeds peel off and are carried by their spread hairs on successive breezes until they catch on a twig or some grasses, when they separate from their parachutes and drop to the ground. If the soil is right they will sprout in spring. The empty fruits remain on the stalk, soft gray outside and shining honey-color inside—interesting and beautiful in bouquets without robbing the plant of seeds.

Asclepias syriaca has a wide-spreading perennial root system that helps hold erosion-prone ground. During World War II, the Allies used the silky pappus in life preservers as a substitute for kapok, a silky fiber from a Malayan tree. The silk is used by birds and mice as nest linings; Monarch Butterfly larvae feed on milkweed foliage exclusively, absorbing an enzyme from the plant that renders them and the adults toxic to birds; native Americans used milkweed as food and medicine; paper has been made from milkweed stalks, and natural dyes from the flowers. We call this marvelous plant a weed—why not call it "Milkplant?" Today, roadside spraying of herbicides still is being done in some areas, killing the milkweeds among other wild plants, and consequently killing the butterfly larvae that feed upon them. This species once was thought to have originated in Syria and Linnaeus kept the old designation.

FIELDS NATIVE

PLANTS OF OPEN, DISTURBED GROUND

Fields • Roadsides • Lawns
Pastures • Waste Places

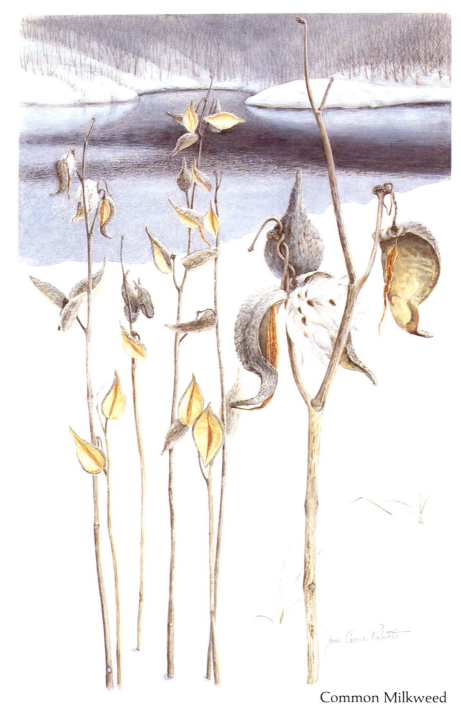

Common Milkweed

Lycoperdaceae: a Puffball Family

GIANT PUFFBALL
Calvatia gigantea (Bataille ex Persoon) Lloyd (bald) (gigantic)

A white ball that appears on the ground in late summer or fall where none was before is a wonderful event even today, when we have named and classified this object. How amazing it must have seemed in ancient times! Giant Puffball is aptly named; it is the largest of the fungi, measuring as much as 2 to 3 feet (61 to 91 cm) in diameter in America, and growing even larger in Europe. The cortex is smooth and thin, and remains attached to the inner peridium, which is fragile and falls away at maturity, unlike those of Beaked and Gem-studded Puffballs (page 80).

White at first, the spore mass, or gleba, turns dingy yellow or yellow-green and finally olive-brown at full development, as does the whole plant. The outer casing peels or cracks as the fungus becomes a dust-bag of dark spores. While still white and firm, *Calvatia gigantea,* like most puffballs, is esteemed as food, but any found in winter are by no means edible.

One to several Giant Puffballs may be found together, sometimes in arcs or even in circles; it is one of the species that forms "fairy rings" by the spreading of the mycelium underground from an original starting point, drawing nourishment from the grass. This species grows in such places as fields, meadows and openings in mixed woodlands. It is widely distributed here and in Europe and Asia.

Man has made use of *Calvatia gigantea* over the centuries, not only as food but as a sponge, a styptic for hemorrhages, and as tinder.

FIELDS AND MEADOWS NATIVE

Giant Puffball

Iridaceae: Iris Family

BLUE-EYED GRASS ✳

Sisyrinchium angustifolium P. Miller () (narrow-leaved)

Blue-eyed Grass is a small Iris that often grows among grasses, its blue flowers in summer seeming to be on the grasses because its stiff flat leaves resemble and merge with them. The spathe at the summit of the scape bears one to five flowers, each on a long slender pedicel. Flowers are 1/2 inch (1.3 cm) across, composed of three petal-like sepals and three petals, all violet-blue and each tipped with a sharp point. The spathe is subtended by a long bract that may be shorter or longer than the flowers. The winged, slightly twisted scape, 6 to 18 inches (15 to 46 cm) tall, occasionally forks to bear another spathe.

Both leaves and stems are glaucous when fresh. Leaf blades are usually shorter than the flower stalk and between 1/8 and 1/4 inch (3 and 6 mm) wide in this species. The globose capsules, about 1/4 inch (6 mm) or less in diameter, at first green tinged with purple, are dark brown by November and have opened into three segments to allow their black spherical seeds to scatter.

This species is perennial and is wide-ranging, occurring from southern Canada southward, growing in fields, meadows, and thickets. At present *Sisyrinchium angustifolium* is listed as rare in Vermont. Seven or more species of *Sisyrinchium* are found in our area, all very much alike, and varying within species. Except for two white-flowered ones, and an occasional yellow form of *S. campestre,* all species have blue or blue-violet flowers. *Sisyrinchium* is an ancient plant name, transferred to this genus.

See also Blue Flag on page 8 in this family.

FIELDS AND MEADOWS NATIVE

Orchidaceae: Orchid Family

RAGGED FRINGED ORCHIS

Habenaria lacera (Michaux) Loddiges (rein or thong) (torn)

The long thin spur on the flowers of this genus gave the plants the common name Rein Orchids. The flower of *Habenaria lacera* has the spur plus long fringed, or "torn," petals that make identification easy in summer. The flowers are pale yellow or green, arranged in a spike at the top of an erect stalk 10 to 32 inches (25 to 81 cm) tall. Four to nine elliptical, parallel-veined leaves sheathe the stem, diminishing in size upward.

To distinguish the dried stalk of winter may be more difficult. The flowers mature into typical brown oval capsules with slits on the sides for dispersal of the minute seeds by air currents; the capsules of this species are 1/2 inch (1.3 cm) long. Remnants of the leaves can be seen in winter, or if the stem covering is worn off, marks on the stem will prove their previous presence—a help in recognition, since there are species of *Habenaria* with no stem leaves.

Habenaria lacera is not restricted in its habitat, growing in wet or dry meadows, fields, clearings, or open woods. It occurs throughout our area, although infrequently. This orchid is currently designated as a species of concern in Delaware, and is on the watch list in Indiana. *Never pick or dig wild orchids.*

FIELDS AND MEADOWS NATIVE

Blue-eyed Grass

Ragged Fringed Orchis

Polygonaceae: Buckwheat Family

CURLY DOCK, CURLED DOCK, YELLOW DOCK

Rumex crispus Linnaeus () (curled)

Docks are common plants of waste ground that have jointed stems, coarse alternate leaves, and elongated terminal racemes of numerous small red or green flowers that develop into heart-shaped fruits. There are twenty species of *Rumex* in our region. The dense clusters of flowers spiraling up the branches on short pedicels in summer are often ignored or labelled "weed," but by autumn the whole plant brightens to an eye-catching rust color and is considered attractive enough for winter bouquets.

Stem leaves are lance-shaped and bluntly pointed at the tip, and have strongly waved or curled margins. They may be 12 inches (30 cm) long with their petioles sheathing the ribbed stem. Curly Dock is a host plant for the American Copper and the Bronze Copper Butterflies.

The flowers mature into drooping fruits 1/8 to 1/4 inch (3 to 6 mm) long, composed of three glossy achenes with broad veiny heart-shaped wings; the achenes are referred to as grains in some floras. Species vary; in this species the edges of the wings are smooth or slightly wavy. After the fruits disperse, clusters of reflexed pedicels persist at intervals along the branches, and in winter may be all that remain of the approximately 25,000 achenes possible on a single plant. Some were winter food for birds, goldfinches and siskins especially, and some lie on the ground awaiting conditions favorable for germination. It is claimed that Curly Dock fruits can germinate after a dormancy of fifty years. This introduced European species is now common throughout the world.

Rumex crispus grows 1 to 5 feet (30 to 152 cm) tall from a long, yellow, perennial taproot and a basal rosette of leaves that formed the previous year. The root yields a black dye, long valued by weavers in the Outer Hebrides. Young leaves of *Rumex* are said to be edible as a salad green or a potherb, high in Vitamin A and protein; older leaves are bitter. Seeds were ground by the Indians and used in combination with other flours.

WASTE PLACES ALIEN

Caryophyllaceae: Pink Family

DEPTFORD PINK ✸

Dianthus armeria Linnaeus (Jove's own flower) *(Armeria)*

A wanderer from Europe, this wild Pink was first classified with the thrifts, *Armeria,* members of the Leadwort family, natives of Canada, the Andes, and the British Isles. The colloquial name is for Deptford, England, now a part of London, where the plant once grew abundantly before the industrial revolution. *Dianthus* is a corruption of *Dios,* "Jupiter" and *anthos,* "flower."

Dianthus armeria is an annual or biennial that grows in poor soil of old fields or roadsides to a height of 8 to 20 inches (20 to 51 cm); it occurs throughout our area. In spring and early summer the deep pink flowers, whose five petals are dotted with white and have saw-toothed edges, form tight clusters at the tips of the branches. There are long bracts under each flower and longer ones under each cluster of flowers. The soft hairy stem may have several branches.

Leaves are long and linear, opposite and sessile. The base of each leaf forms a bulge on the stem, similar to that on the stem of Carnation, *Dianthus caryophyllus.* In age the calyx lobes curl outward; the whole plant fades to pale beige as it persists into winter while dispersing seeds. Maiden Pink, *Dianthus deltoides,* less frequently found, is a similar but larger plant with a solitary flower at each branch tip.

FIELDS ALIEN

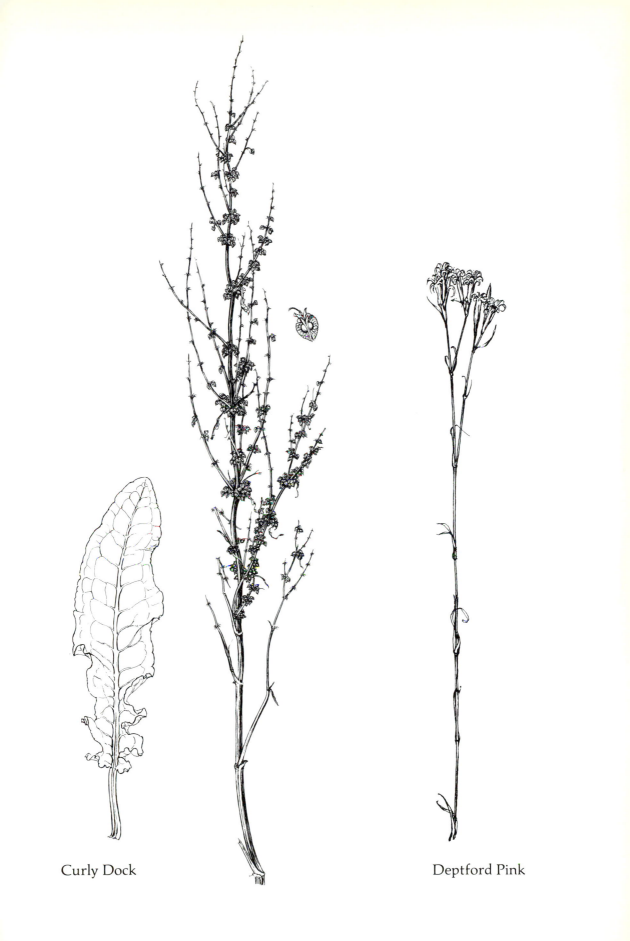

Curly Dock Deptford Pink

BOUNCING BET, SOAPWORT, *Saponaria officinalis* Linnaeus, of which I have shown one branch, is a Pink that escaped from gardens by means of seeds and spreading rhizomes to form dense colonies in the wild. Its pale pink flowers in late summer are showy and fragrant. Five notched petals bend away from the stamens and the protruding pistil to facilitate pollination by insects, especially night-visiting hawk moths. The thick-jointed stem and opposite leaves contain saponin, from Latin *sapo*, "soap," and will lather in water when fresh.

FIELDS ALIEN

RED CAMPION, *Lychnis dioica* Linnaeus. The rose-red, odorless summer flowers of Red Campion are dioecious, meaning "in two households," referring to the fact that the pistillate and staminate flowers are on separate plants. Leaves are opposite and have long petioles near the base of the erect stem and very short ones higher up. These leaves rise from enlarged nodes, seen in many species of Pink, an aid in identifying this family in winter. The plant grows to 2 feet (61 cm) tall with forking branches that are sticky-hairy when fresh. At maturity the hairy calyx sac surrounding the ovary and its five styles expands into an ovoid, ripe fruit that opens at the apex by small recurving teeth.

The Campions are northern plants, chiefly of Europe and Asia. *Lychnis dioica* is common in England along roadsides and in waste places; here it occurs throughout our area but is not common. The name Campion is applied to several species that have inflated calyxes, in both the *Lychnis* and the *Silene* genera. *Lychnis,* meaning "flame," refers to the bright color of the flowers of some other species.

See also Ragged Robin, page 40, in this genus.

WASTE PLACES ALIEN

EVENING LYCHNIS, WHITE CAMPION, *Lychnis alba P. Miller.* On summer nights *Lychnis alba* attracts large night-flying moths with its fragrant, white or pink flowers; but it is the smooth, brown, urn-shaped capsule that captures our attention in fall and winter. When its numerous flattened seeds are ripe this miniature urn opens at the top by six to ten recurved teeth. Like Red Campion, this species is dioecious; therefore some plants will have no fruits. The stem is somewhat taller than that of Red Campion, to 2½ feet (76 cm), but is usually leaning on neighboring plants instead of standing erectly. The plant is downy and loosely branched, with ovate or lanceolate leaves in pairs.

Early in autumn the capsule is enclosed in a hairy, finely veined, inflated calyx sac, which soon wears away. This is an Old World biennial, now naturalized in this country and found everywhere in our region, growing in borders of fields and in waste places.

Night-flowering Catchfly, *Silene noctiflora,* is similar, differing chiefly in having three styles, whereas *Lychnis alba* has five, a difference that distinguishes the two genera but that is impossible to discern from dry stalks.

WASTE PLACES ALIEN

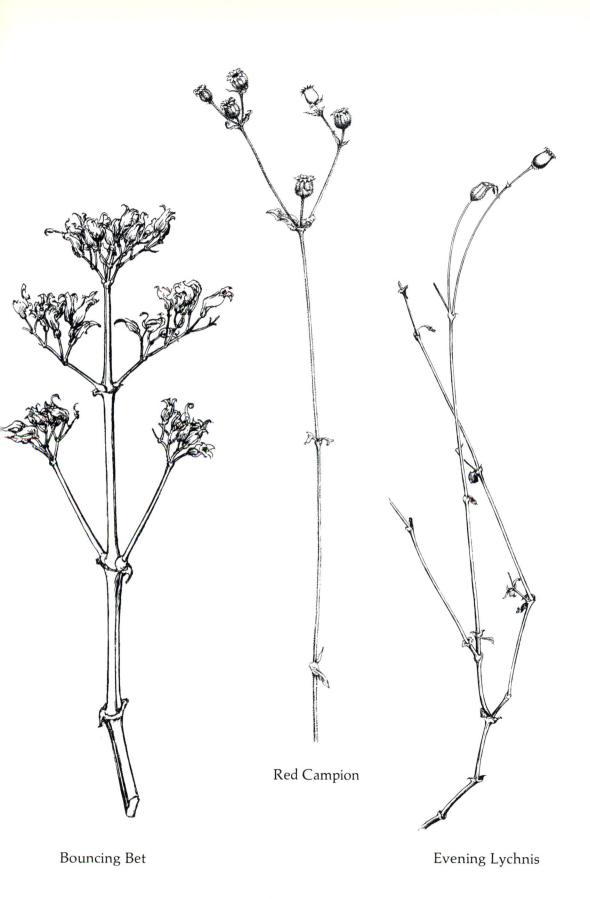

Red Campion

Bouncing Bet

Evening Lychnis

Cruciferae: Mustard Family

FIELD PENNYCRESS, FANWEED

Thlaspi arvense Linnaeus (to crush) (of cultivated land)

The Mustard family is a large one whose plants have four-petaled flowers that form a cross and are thus "cruciform," and whose juice is pungent or acrid. Field Pennycress is a spring and summer annual with a smooth, simple, or branched stem and terminal spikes of small, white or light purple flowers. Leaves are deeply or shallowly toothed and their bases clasp the stem. The broad, flat fruit, resembling a penny or a fan with imagination, is about 1/2 inch (1.3 cm) wide, composed of two valves, each with a wide wing. At maturity the valves dry, separate, and fall away, freeing the two to eight dark, ovoid seeds. A plant picked in autumn while the silicles are yellow-ochre will last for years in a dry bouquet; outdoors the plant withstands winter weather as it disperses seeds.

Thlaspi arvense inhabits fields and waste places, ranging throughout our area and beyond, although it is most abundant in the northern regions. A native of the Old World, this species is indeed an ancient plant; Field Pennycress seeds have been found in Bronze Age settlements. In parts of Europe it is cultivated as greens and its peppery seeds have been used as a seasoning. As always, beware of plants from a polluted area.

The generic name is thought to be from the Greek word *thlaein,* "to crush," referring to the flattened fruits.

FIELDS ALIEN

Cruciferae: Mustard Family

COW-CRESS, FIELD PEPPERGRASS

Lepidium campestre (Linnaeus) R. Brown (little scale) (of fields)

This small alien from Europe has made itself at home here in fields, waste places, and roadsides, and is now common throughout our region and beyond. These annual or biennial plants have dense terminal racemes of tiny white or pale green flowers all summer long. The flowers are quickly pollinated and form silicles as more buds develop at the summit. This process continues until the raceme is long, the fruits are many, and the plant is possibly 18 inches (46 cm) tall.

Fine hairs cover the leafy stem. Leaves are alternate, sessile, arrowhead-shaped, and have smooth or slightly toothed margins. Elongated lobes at the base of each leaf embrace the stem; basal leaves are petioled and spatula-shaped with smooth margins. Young leaves are edible, raw or cooked, if found in unpolluted areas. Seeds of early-flowering plants may germinate in autumn, in which case the sprout overwinters, for these seeds do not need to freeze in order to germinate.

The two-valved silicles form a column around the stalk. Each silicle is about 1/4 inch (6 mm) long, rough, dark gray, and concave at the top with a bulge at the bottom over two dark brown seeds, one in each valve. The generic name alludes to the shape of this fruit. Both green fruits and dried seeds have a peppery flavor.

A few birds and rodents eat the seeds of this species. Farmers consider it a weed because it sometimes prospers in grainfields.

WASTE PLACES AND FIELDS ALIEN

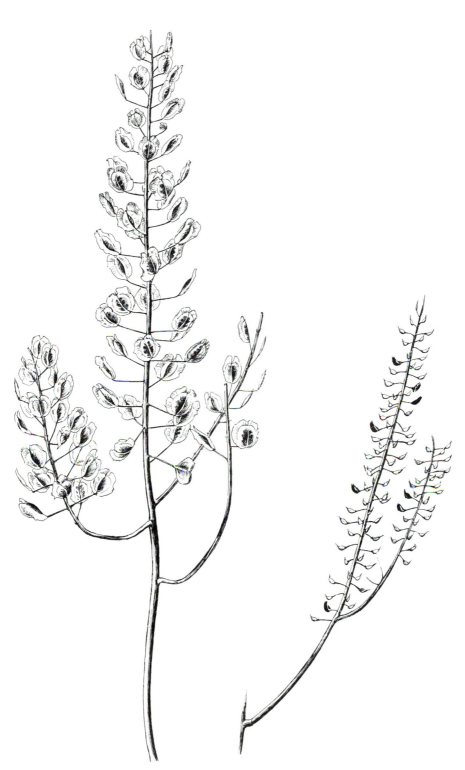

Field Pennycress Cow-cress

Cruciferae: Mustard Family

WILD PEPPERGRASS, POOR MAN'S PEPPER

Lepidium virginicum Linnaeus (little scale) (Virginian)

Wild Peppergrass is a native species of mustard similar to Cow-cress. This tough little annual or biennial grows in the dry, open soil of roadsides and waste places; it is often seen in cities. The plant may become 24 inches (61 cm) tall with terminal racemes of small, white, four-petaled flowers from June to November. Flowers quickly develop into fruits with the help of pollinating insects, and the racemes become ever longer and more densely fruited as summer progresses. Stem leaves have short stalks, are narrowly lanceolate and sharply toothed; basal leaves usually have a large terminal lobe with smaller ones below it on the midrib, and are smooth or slightly pubescent. The Great Southern White Butterfly lays its eggs on these leaves, and the caterpillars feed on them.

The flat, nearly circular silicles attract our attention in late autumn—the generic name alludes to these fruits. They are 1/8 inch (3 mm) long on short, stiff pedicels and surround the stalk in a twisting spiral. Each silicle has two valves that are minutely winged, and each contains one red-brown seed that has a peppery taste when fresh. At maturity the two valves dry and part from the translucent septum with a small explosion, scattering seeds.

WASTE PLACES NATIVE

Cruciferae: Mustard Family

SHEPHERD'S-PURSE

Capsella bursa-pastoris (Linnaeus) Medicus (little box) (shepherd's pouch)

It is reported that this unassuming little mustard has travelled around the world from its European beginnings. Certainly it has become naturalized here, growing in any disturbed ground, not only fields and waste places but also in cities and cultivated land. It is an erect, pungent plant 6 to 20 inches (15 to 51 cm) tall with a simple or branching stem rising from a basal rosette of deeply cut and irregularly lobed leaves that resemble dandelion leaves. Stem leaves are small and sessile, and clasp the stem with their basal lobes. Elongated racemes of tiny white four-petaled flowers, about 1/12 inch (2 mm) wide, on slender spreading or ascending pedicels, terminate the branches all summer.

Shepherd's-purse is a short-lived annual, having several generations in a growing season. Or it may be a winter annual, in which case a rosette of leaves from a fall-sprouted seed overwinters to start flowering for the earliest pollinating flies in spring. Fruits then form at the base of the raceme as buds continue to open at the top. Each silicle is flattened at right angles to the septum and has a slight indentation at the top where the two valves join, resembling a medieval shepherd's wee purse, containing ten to twelve coins represented by the tiny seeds. This and several other mustards are host to the Falcate Orangetip Butterfly.

DISTURBED GROUND ALIEN

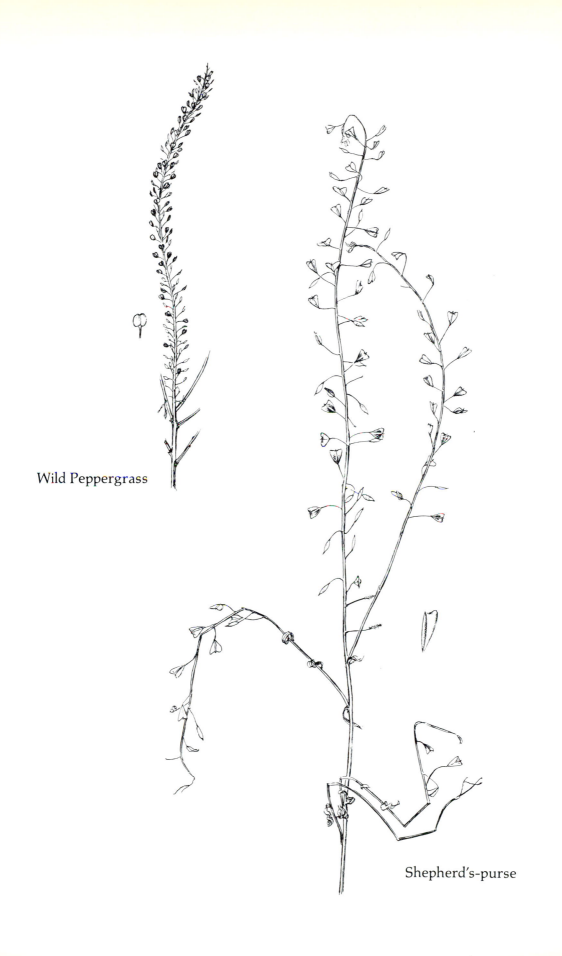

Wild Peppergrass

Shepherd's-purse

Cruciferae: Mustard Family

BLACK MUSTARD

Brassica nigra (Linnaeus) Koch (cabbage) (black)

Black Mustard plants grow in colonies with their many divergent branches interlaced. From June through October small, pale yellow, four-petaled, four-sepaled flowers in terminal clusters open a few at a time. Although considered a weed by some, I consider these yellow flowers a happy sight, often brightening an otherwise unsightly place. They are quickly pollinated, and develop into green fruits as the stalks ever lengthen.

By autumn the plants may exceed 5 feet (1.5 m) in height. Stems are hairy in summer and lower leaves are deeply lobed and toothed, usually with small side lobes below a large end lobe; upper leaves are lance-shaped. The fruits are slender, beaked siliques about 3/4 inch (1.9 cm) long. They stand erect, pressed close to the stalk and overlapping each other. At maturity, each silique splits into two valves that soon fall, freeing the black globose seeds to scatter from the translucent septum; in late winter these may be all that remain of the fruits.

An annual or biennial from Eurasia now naturalized here, *Brassica nigra* favors sunny shores and waste ground and is common throughout our area. This is the mustard of mustard plasters, once applied to the chests of respiratory sufferers; the seeds are those used in pickling and the preparing of table mustard. Songbirds and wildfowl seem to relish these tangy seeds. The *Brassica* genus also includes cultivated cabbage, broccoli, cauliflower, kohlrabi, turnip, rutabaga, and Brussels sprouts.

DAME'S ROCKET ✻, *Hesperis matronalis* Linnaeus, of which I have shown one branch, is a mustard of woods' borders and thickets, capable of reaching 4 feet (1.2 m) by autumn. In summer its four-petaled flowers are showy with pink, purple, or white corollas that are fragrant in evening. The siliques curve upward on divergent pedicels from the axis, becoming as much as 5 inches (13 cm) in length. See the overwintering leaf on page 106.

COMMON WINTER-CRESS, YELLOW ROCKET ✻, *Barbarea vulgaris* R.
Brown, of which I have shown one branch, is another yellow-flowered mustard, a short-lived perennial one. It grows 1 to 2 feet (30 to 61 cm) tall on roadsides, in fields or meadows, yielding much pollen and nectar for bees in spring. The siliques are 3/4 to 1½ inches (1.9 to 3.8 cm) long, ascending but not hugging the stalk. The sharp-tasting leaves of these overwintering rosettes traditionally are gathered in rural areas for a potherb and a spring tonic. See the leaf on page 106.

Dame's Rocket Black Mustard Common Winter-cress

Rosaceae: Rose Family

ROUGH-FRUITED CINQUEFOIL

Potentilla recta Linnaeus (little potent one) (upright)

Cinquefoils are mostly yellow-flowered plants with five-part leaves. Two low-growing species, Common and Dwarf Cinquefoils, *Potentilla simplex* and ✿*P. canadensis,* are familiar little yellow spring flowers in lawns, fields, and woodlands.

Rough-fruited Cinquefoil, a European species now found from Nova Scotia to Ontario south to Virginia, Tennessee, and Arkansas, is one of the more than twenty-five species in the Northeast. This species stands stiffly erect 1 to 2 feet (30 to 61 cm) tall, its stem stout and hairy, branching only at the top to hold a loose terminal cluster of showy 1-inch (2.5-cm) flowers in summer.

Leaves are 1 to 3 inches long (2.5 to 7.5 cm), palmately divided, their leaflets narrow, blunt-tipped, and coarsely toothed. Dried leaves are often found on the plant in winter, helping identification. The tiny, rough, brown achenes scatter soon, but the hairy calyxes that cup around them persist on the brown stalk. In groups or singly, these stalks stand dark among the dry grasses of fields, old gardens, waste ground, and roadsides—areas this wildflower helps beautify in summer.

A basal rosette of leaves from the perennial root overwinters for an early start on next summer's plant. The genus was labelled "potent" because at one time Silverweed, *Potentilla anserina* was regarded by herbalists as a powerful medicine.

FIELDS ALIEN

Rough-fruited Cinquefoil

Rosaceae: Rose Family

MULTIFLORA ROSE
Rosa multiflora Thunberg (Rose) (many-flowered)

 Rosa multiflora was imported from East Asia and now grows as an ornamental hedge, or as a wild plant in fields and pastures, along roadsides and woodland borders, occurring from southern New England southward beyond our range. The perennial stems rise from a crown, forming an impenetrable shrub, and the plant seeds-in freely, sometimes competing with native plants, or ruining pastures. Farmers have resorted to chemical eradication methods that are catastrophic to biotic systems.

 The blossoms of spring are fragrant and attractive, usually white with yellow stamens, and are abundant in pyramidal clusters at the ends of branches that rise from climbing or arching canes. The canes may grow to 15 feet (4.6 m), often rooting again at their tips, although only two canes, one each from two growing seasons, arise from the same place. Canes and branches have very sharp, curved thorns, inhospitable to man and large animals, so the shrub offers safe havens and homes for songbirds and small mammals. Mockingbirds particularly admire it for nesting sites, saying so in rapturous song, and rabbits use it for cover. The berries of all wild roses and brambles are at the top of the list of summer and winter food for birds and mammals.

 Multiflora Rose is used by nurserymen who graft less hardy roses onto its strong rootstocks. The fruit is a small, red, many-seeded hip with no persisting sepals; the red color may be almost black by March 1st. These are not the fleshy rose-hips from which tea and Vitamin C tablets are made; those are the fruits of *Rosa rugosa,* which do not persist into winter.

 In the illustration I have shown a *Rosa multiflora* cane early in the season and the base of an older stalk, turned dark, on the right. Also, for comparison, from left to right, are the brambles Wild Red Raspberry, *Rubus idaeus,* var. *strigosus,* Wild Black Raspberry, *Rubus occidentalis,* and Common Blackberry, *Rubus allegheniensis*—all native members of the Rose family. Both Common Blackberry and Wild Black Raspberry have the same arching and tip-rooting habit as Multiflora Rose, and both also form impenetrable tangles so useful to wildlife. Wild Red Raspberry does not tip-root, but puts up new shoots from underground stems.

 Approximately 205 species of brambles are recognized in the Northeast. These perennials are unusual in that they do not provide for winter by forming leaf or branch scars to close off their deciduous parts.

FIELDS ALIEN

Multiflora Rose

Anacardiaceae: Cashew Family

SMOOTH SUMAC

Rhus glabra Linnaeus (Sumac) (smooth)
See Frontispiece.

Both the Latin and English names of this large shrub point to the simplest way to distinguish it from Staghorn sumac, *Rhus typhina:* the branches of *Rhus glabra* are smooth, those of *R. typhina* are hairy. Other differences between them are comparative; Smooth Sumac generally is a smaller shrub, growing 15 to 20 feet (4.6 to 6.1 m) tall as opposed to the 30 feet (9.1 m) of Staghorn. Also, the red hairs on the fruits of Smooth Sumac are shorter and less velvety. Both species have conspicuous clusters of red fruits at the tips of their branches from late summer through fall and winter, offering food for wildlife. Both Sumacs grow rapidly and are short-lived.

In summer, the conical clusters of Smooth Sumac have small, pale green pistillate flowers and yellow staminate flowers, often in separate panicles. The flowers are usually abuzz with honeybees who pollinate as they feed. Each short-haired, brick red fruit is 1/8 inch (3 mm) long, a flattened ovoid drupe that tastes of lemon. A refreshing drink can be made from these fruits—another recipe we learned from the Indians.

Rhus glabra has a few alternate spreading branches that are light brown or gray with a waxy bloom; one side is frequently flattened. Next year's leaf buds are large and pale, in the center of the leaf scars, not above them as in Poison Sumac, *Rhus vernix.* From spring through fall the branches are lush with tropical-looking leaves a foot (30 cm) or more long, pinnately divided into about fifteen pairs of opposite, sharply-toothed leaflets plus one at the end. In autumn dry slopes and roadsides blaze where Sumac thickets change from green through orange to scarlet.

Beyond this gift of color, Sumac holds and builds soil, growing where other trees cannot. Sumac leaves and bark contain tannin, and were once used in the tanning of fine leathers, especially for shoes—the common name was originally "Shoemake." Tan and gray dyes may be obtained from the fruits.

Seven or eight species of *Rhus* occur in our region, and they can be divided into the red-berried, harmless species, and those with white berries, the harmful species. White-berried species include Poison Sumac, *R. vernix,* which grows in bogs; Poison Oak, *R. toxicodendron,* a strictly western species; and Poison Ivy (page 120), a vine. These poisonous plants bear their fruits in loose, open clusters that rise from leaf axils, not at the ends of branches.

Smooth Sumac ranges from the Gaspé Peninsula, Quebec, Ontario, and Minnesota southward.

OPEN SLOPES NATIVE

Smooth Sumac

Leguminosae: Legume or Pea Family

RED CLOVER ⚘

Trifolium pratense Linnaeus (three-foliate) (of meadows)

Red Clover: a crop raised by farmers as forage for cattle and to improve soil fertility because it stores nitrogen in its roots; a tea, made of the flowers, long used to ease coughs, asthma, bronchitis, and especially whooping cough; a foliage food for rabbits and other mammals; seeds for birds; and a part of the beauty of a summer's day—how could we do without this familiar and useful plant?

Trifolium pratense is a short-lived perennial herb introduced from Europe and now naturalized here, growing 8 to 24 inches (20 to 61 cm) tall in meadows as well as pastures, fields, lawns, and roadsides. These are places where bumblebees live, for they are almost the only insects other than butterflies with tongues long enough to reach the well of nectar at the base of the long tubular florets, and are therefore Red Clover's primary pollinators. The fragrant magenta flower heads, at the tips of the stalks, are open from May to September. After setting seed the dark brown ripe heads decompose, releasing the seeds; a given plant may have several generations of flowering stalks in a summer.

A fresh rosette of green leaves forms in the fall and waits over winter to continue growing come spring; in this way the root lives on for a few years. Leaves have soft hairs and as the Latin name points out, are divided into three leaflets; each leaf has two hairy stipules at its base. Mature leaflets have a light V mark across the middle, although rosette leaves may not. While very young, leaves picked from an unpolluted area are good in a salad.

The Leguminosae also includes other clovers, peas and beans such as lentils, peanuts, and soybeans; Acacia from which gum arabic is obtained; some exotic hardwoods of the tropics; and the Redbud Tree of our own midwestern and southern states.

FIELDS ALIEN

Red Clover

Malvaceae: Mallow Family

VELVET-LEAF, INDIAN MALLOW, PIE-MARKER

Abutilon Theophrasti Medicus () (for Theophrastus)

Not only the leaves, but the stem, branches, and fruits of this large annual are velvety with branched hairs, easily seen with a hand lens. The stem is stout and can remain standing all year; the large leaves are long-petioled and heart-shaped with acute tips and serrated margins.

The yellow mallow flower of summer develops into an extraordinary fruit; it is about 1 inch (2.5 cm) across and is composed of twelve to seventeen two-valved hairy carpels arranged in a ring around a spool-like axis, in the manner of the fruit of the smaller ❀Common Mallow, *Malva neglecta.* Each carpel of Velvet-leaf has a curved beak at the top outer edge, making the whole fruit somewhat resemble chocolate cups in pleated papers, or as someone earlier thought, pie-markers. Each carpel contains two to fifteen flattened seeds.

Velvet-leaf grows from 2 to about 5 feet (61 to 152 cm) tall in waste places, vacant lots, and cultivated fields and occurs throughout our range. Although *Abutilon* is a large genus in warmer climates, *Abutilon Theophrasti* is the only species found here. It was introduced to the United States from India as an ornamental, but has gone wild and is now labeled a noxious weed by its fickle public.

Theophrasti remembers the Greek scientist Theophrastus (370-285 B.C.), who wrote treatises on botany. The most famous member of the Mallow family is cotton, in the genus *Gossypium.* See also Swamp Rose-mallow on page 20.

WASTE GROUND ALIEN

Velvet-leaf

Hypericaceae: St. Johnswort Family

COMMON ST. JOHNSWORT
Hypericum perforatum Linnaeus () (perforated)

This wildflower, now thought of as a weed, was used in Europe at one time in connection with spring equinox festivals, in medicine, and to ward off evil spirits. Common St. Johnswort is a late summer and fall perennial of dry pastures, roadsides, and neglected fields, a common species throughout the Northeast. It grows 1 to 3 feet (30 to 91 cm) tall. The golden yellow, five-pointed flowers of summer are numerous in terminal cymose clusters. Each flower is about an inch (2.5 cm) across, has petals edged in tiny black dots and many long-filamented stamens. The plant has a ragged appearance as buds form, open into flowers, and fade daily. The four-angled stems and branches are smooth and slender, with numerous small elliptical leaves only an inch (2.5 cm) or so long that are dotted with translucent spots, hence "perforated." A yellow dye can be obtained from these plants.

Species of *Hypericum* have three-part capsules with a pointed apex and usually three styles. The capsules change from green to brick red in autumn, an identification clue, then to red-brown as they mature and open, each valve beaked with the persistent style. In this species the capsules are longer than wide, the seeds dark, lustrous, and reticulated. Leafy red-stemmed basal shoots grow from the rhizome in autumn and overwinter green at the base of the dry stalk.

Hypericaceae is a large family of herbs and shrubs; about 25 species in 2 genera are found in our area; *Hypericum perforatum* is the only alien species.

FIELDS ALIEN

Onagraceae: Evening-primrose Family

FIREWEED, GREAT WILLOW-HERB
Epilobium angustifolium Linnaeus (upon/capsule) (narrow-leaved)

Fireweed gives us a succession of lovely visual displays: first the tall raceme of showy rose-purple flowers in summer, followed after pollination by velvety capsules 3 inches (7.5 cm) long. These split lengthwise at maturity to cover the spike with white silky hairs attached to the countless tiny seeds. The four valves of each capsule gradually curl back and form red-purple rings by the time all of the seeds have parachuted to new locations.

By winter the stage is almost empty; the short pedicels hold only remnants of the capsules' septums, twisted and gray. Branches, if any, may be broken. The plant has done everything except return to the earth to help build new soil, which it eventually does. These dead standing stems remind us of a long full season gone by, and of the scores of seeds that give promise of other flowering seasons to come.

This perennial wildflower grows 2 to 8 feet (0.6 to 2.4 m) tall. Its willowlike leaves are alternate on the stem, lance-shaped, and have smooth or slightly toothed margins. Leaf ribs and veins are white; lateral veins are parallel, looping to join at the margins. An overwintering basal rosette similar to that of Common Evening-primrose (page 230) grows from the root in autumn.

Epilobium is a large genus of cool regions. This species prefers dry soil, especially that of newly cleared or burned ground. In England, after the conversion from agriculture to industry and later, after the World War II bombing of London, Fireweed grew profusely in the cleared and burned areas—the plant is known there as Rose-bay Willow-herb. Beekeepers have followed the Fireweed that follows lumbering operations, because the plant produces much nectar to lure its pollinators. After Mt. St. Helens erupted in 1980, Fireweed was one of the first plants to colonize the blackened slopes. In Europe and Canada, the plant has been boiled as a potherb and the leaves are reported to be effective in healing bruises.

Epilobium angustifolium occurs from Maine to Iowa and southward in mountains to North Carolina, although it is now considered imperiled in New Jersey.

FIELDS NATIVE

Common St. Johnswort Fireweed

Onagraceae: Evening-primrose Family

COMMON EVENING-PRIMROSE

Oenothera biennis Linnaeus () (biennial)

It takes a bit of observation to become aware of the nocturnal flowering of Common Evening-primrose. At some hour between late afternoon and dark on summer days, the long narrow bud POPS open as the four sepals fold down and the four lemon-yellow petals unfurl to 1 to 2 inches (2.5 to 5 cm) wide—all in less than a second. The showy flower remains open all night, gleaming in the darkness and exhaling its sweet fragrance as it awaits its nocturnal pollinators, the moths. The following morning its diurnal pollinators, the bumblebee and honeybees, visit the flowers, which then fade in the strong light of midday.

Calyx lobes form a tube above the flower's ovary that elongates to about an inch (2.5 cm) as the capsule develops. At maturity the four valves of the capsule open at the top, their tips curl back, and the fruit dries into a flowerlike form, its lining pale and smooth.

Oenothera biennis produces a basal rosette of leaves the first year that feed and build a strong fleshy root. The rosette overwinters and a leafy flower stalk develops from its center the second spring, growing to a height of 2 to 5 feet (61 to 152 cm) by summer. The stout, erect stem is simple or branching, with soft hairs that usually wear off over winter. Leaves are 4 to 8 inches (10 to 20 cm) long, smooth, and lance-shaped with wavy edges; lower ones have magenta midribs.

This sturdy stalk persists until spring, the many brown seeds offering birds, especially goldfinches, an important source of fall and winter food. The stalk and root, having completed their role for the species, decompose, releasing their nutrients into the soil to provide food for soil creatures—nature recycles.

Oenothera biennis is widespread east of the Rocky Mountains, growing in dry open soil—a pioneer plant of disturbed ground that beautifies as it heals the wounded earth. The plant was introduced into Europe from America as early as 1614 and grown there for its root, which was considered wholesome and nutritious when cooked.

WASTE GROUND NATIVE

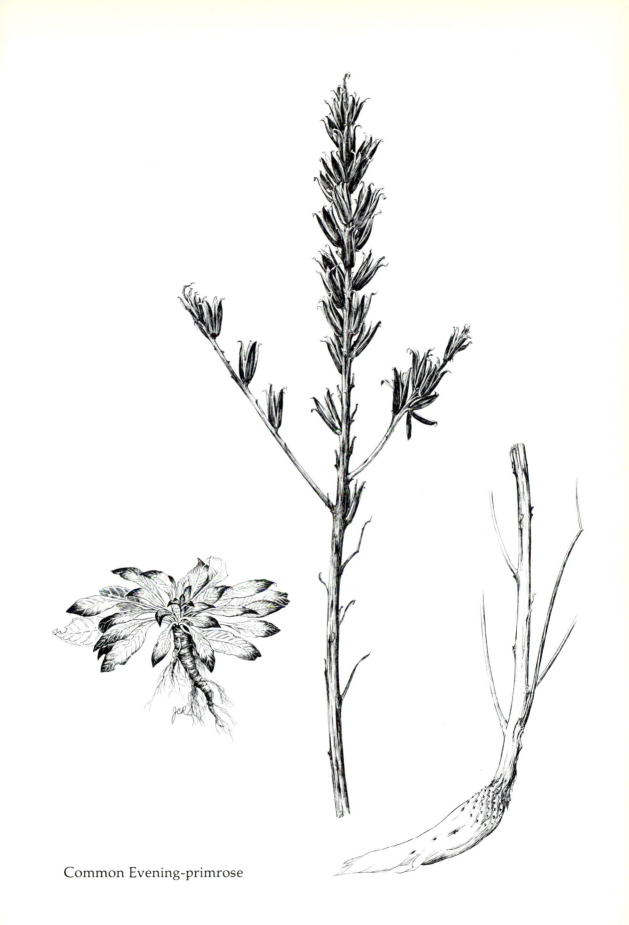

Common Evening-primrose

Umbelliferae: Parsley Family

QUEEN ANNE'S LACE, WILD CARROT, BIRD'S NEST

Daucus carota Linnaeus (wild carrot) (carrot)

Daucus carota transforms dry wastelands into summer gardens with its large flower heads terminating long ascending branches on bristly stems. Each flat-topped compound umbel is 2 to 4 inches (5 to 10 cm) or more across, composed of many small umbels of tiny white or occasionally rose-colored florets. Slightly larger flowers ring the head and one or two maroon or deep purple ones decorate the center. Legend has it that Queen Anne of England pricked her finger while making lace and a drop or two of blood stained the lace.

Narrow three-cleft bracts, just under the inflorescence, are unique; no other member of the Parsley family has them, and they persist on dry plants, helping us separate *Daucus carota* from its poisonous relatives. Although several members of this family are familiar herbs and vegetables, others may cause dermatitis if touched, and some are deadly poisonous, such as Water-hemlock (page 46), Fool's Parsley and the infamous Poison Hemlock, which causes immediate paralysis and death. *Never* eat any wild parsley-looking plants!

Bumblebees, honeybees, and non-hovering insects such as beetles, ants and wasps enjoy this large lace-covered dining table as they feed on the flowers, and the larvae of the Eastern Black Swallowtail Butterfly feed on the foliage. The plant's importance to such a large number of insects means that it is important to birds. Birds also use the seeds as emergency food in winter. Added to all of this is our enjoyment of the beauty of these plants, especially growing, but also in bouquets, summer or winter.

By fall the plant is much-branched and often more than 5 feet (1.5 m) tall; I have shown half of the stem. After pollination, the heads' pedicels curve upward, closing the cluster while the fruits mature—the "bird's nest." After maturation the pedicels spread once more to hold the ripe fruits where they can catch onto fur or clothing for dispersal. Each fruit is flattened dorsally and bristles with four rows of prickles. Ultimately the fruit splits into two one-seeded units.

Queen Anne's Lace is an annual or biennial with a long, narrow, yellow-ochre taproot and finely-cut leaves that resemble those of the garden carrot (a descendant) and smell of carrots and parsley. You may find small overwintering leaves that resemble young ferns; these are from the perennial root or are new plants from fall-germinating seeds.

FIELDS ALIEN

BUTTERFLY-WEED, BUTTERFLY-FLOWER, *Asclepias tuberosa* Linnaeus. The most brightly colored of the genera of *Asclepias, A. tuberosa* is crowned in summer with showy orange flowers in flat-topped corymbs, and often with butterflies as well, sipping the ample nectar. The intensity of the flower's color is somewhat determined by geography; a redder orange occurs on plants growing farther south and a more yellow orange on those farther north. The flowers have the complex structure characteristic of milkweeds but the stems and leaves lack the latex present in other species.

Growing 1 to 3 feet (30 to 91 cm) tall from a deep taproot, Butterfly-flower is quickly identified in winter by the rough-hairy stem and the few, slender, pubescent follicles sitting upright on short pedicels, which often form loops. Two or three antlerlike branches sweep upward from the top of the stem to hold these fruits. The seeds are flat and margined, each tipped with a tuft of long, silky, white hairs that parachute the seeds on the wind to new locations when the follicles open.

Asclepias tuberosa is a perennial that is frequently grown in home gardens from seed. In the wild it inhabits dry, open fields and slopes, from southern Maine to Minnesota southward. It is currently designated as endangered in Maine, Vermont, and New Hampshire, potentially threatened in New York, and a species of concern in Rhode Island. If you purchase seeds, make certain that the seed company has not taken its stock from the wild.

See also Swamp Milkweed, page 30.

FIELDS NATIVE

Queen Anne's Lace Butterfly-Weed

Asclepiadaceae: Milkweed Family

SANDVINE, HONEYVINE

Ampelamus albidus (Nuttall) Britton (sand/vine) (whitish)

Sandvine is a twining herbaceous member of the Milkweed family whose smooth, slender stem has milky juice and may exceed 10 feet (3 m) in length. In summer clusters of small white flowers rise on long peduncles from the axils of paired leaves. Each flower is deeply five-cleft with a five-lobed crown, typical of milkweeds. Smooth opposite leaves are 3 to 7 inches (7.5 to 18 cm) long, narrowly heart-shaped with deep indentations at the base, and long-petioled.

After pollination the flowers develop into follicles 4 to 6 inches (10 to 15 cm) long that are smooth and upright when young, often with a hooked tip. They are tightly packed with overlapping, margined seeds equipped with tufts of silky white hairs. At maturity the follicles hang heavy with their load of seeds until temperature, moisture, and light meet the species' requirements. They then split open along one side so that the seeds may be carried away on the wind by their silken parachutes. Empty follicles are feather light and wrinkled on the outside, tan or weathered gray.

Ampelamus albidus is a perennial, growing in sandy soil, alluvial thickets, and disturbed ground, snagged over shrubs and fences—quite noticeable in winter. This species occurs from Pennsylvania to Nebraska and Kansas across West Virginia, Ohio, Indiana, Iowa, and Missouri. In some floras Sandvine is classified as *Gonolobus laevis.*

DISTURBED SOIL NATIVE

Convolvulaceae: Morning-glory Family

IVY-LEAVED MORNING-GLORY

Ipomoea hederacea (Linnaeus) Jacquin (resembling a worm) (like English Ivy)

There is no difficulty with the identification of this annual vine. A twining stem 3 to 6 feet (91 to 183 cm) long with globose capsules suggests the Morning-glory family. The hairy calyx lobes that end in long slender tips settle the question of which member of the family. From June to October the 1½-inch (4-cm) funnelform flowers with their blue to rose-purple corollas may be seen in fields, roadsides, and waste places throughout our area. Alternate long-petioled leaves are cleft into three pointed lobes, resembling the leaves of English Ivy, *Hedera.* At maturity the capsules open by two to four valves to release four to six dark brown seeds; each has a rounded back and two flattened sides and fits perfectly into the spherical fruit.

Ipomoea is a large genus of mainly tropical plants. *Ipomoea hederacea* was introduced from South America and has become a pest in some locations, but its lovely flowers help glorify our many waste places. Another species, Common Morning-glory, *Ipomoea purpurea,* was imported from South America as an ornamental, and *Ipomoea batatas,* Sweet Potato, as a vegetable.

The reference to a worm in the Greek name no doubt refers to the growing tip of the vine that gyrates as it seeks a support on which to climb, in the same way that some caterpillars swing their heads in a circular motion. See also Hedge-bindweed, page 50, in this family.

FIELDS AND WASTE PLACES ALIEN

Sandvine Ivy-leaved Morning-glory

MORE GREEN LEAVES IN WINTER

(See also Green Leaves in Winter on page 106).

These small herbaceous leaves are green all winter. Some are last summer's leaves that continue to live on their perennial roots; some are new leaves on perennial roots; and some are from seeds that germinate early enough in autumn to produce a root and leaves before cold weather. These are now resting and perhaps gathering some strength by photosynthesizing over the winter, ready to spring into flower as soon as light and warmth are adequate. These plants, from seeds that do not need a period of freezing before they can germinate, are known as winter annuals.

Most overwintering leaves hug the ground where snow and leaf-litter hold in the earth's heat and protect the plants from cold and wind.

a. ✤ Lavender Bittercress, *Cardamine Douglassii* Woodlands
b. ✤ Common Chickweed, *Stellaria media* Fields
c. ✤ Ground Ivy, *Glechoma hederacea* Fields
d. ✤ Heal-all, *Prunella vulgaris* Fields
e. ✤ Dandelion, *Taraxacum officinale* Fields
f. ✤ Hairy Bittercress, *Cardamine hirsuta** Fields
g. Large-leaved Avens, *Geum macrophyllum* Woodlands
h. Purple Dead-nettle, *Lamium purpureum* Fields
i. White Clover, *Trifolium repens* Fields
j. ✤ Trailing Arbutus, *Epigaea repens* Woodlands
k. English Plantain, *Plantago lanceolata* Fields
l. ✤ Dwarf Cinquefoil, *Potentilla canadensis* Dry soil
m. ✤ Jacob's-ladder, *Polemonium reptans* Woodlands
n. ✤ Ox-eye Daisy, *Chrysanthemum leucanthemum* Fields

Other small green leaves that can be seen in winter (not shown) are: ✤Low Hop Clover, *Trifolium procumbens;* Yellow Corydalis, *Corydalis flavula;* Mouse-ear Hawkweed, *Hieracium pilosella;* Moneywort, *Lysimachia nummularia;* Common Plantain, *Plantago major;* ✤Pussytoes, *Antennaria plantaginifolia;* Kidney-leaved Buttercup, *Ranunculus abortivus;* ✤Purple Vetch, *Vicia cracca.*

*In "Born in the Spring" this plant was erroneously listed as Pennsylvania Bittercress, *Cardamine pensylvanica.*

a.

m.

n.

b.

l.

c.

k.

d.

e.

f.

h.

j.

i.

g.

More Green Leaves in Winter

Labiatae: Mint Family

MOTHERWORT

Leonurus cardiaca Linnaeus (lion's tail) (for the heart)

John Burroughs said that Motherwort follows man around, and indeed it has followed him from Asia to Europe and North America, growing near his neglected gardens, yards, fences and old buildings throughout the land. This mint grows from a perennial rootstock to a height of 2 to 5 feet (61 to 152 cm). The stem is erect and strongly four-angled with upsweeping branches; in the illustration I have shown the branching top of a 40-inch (100-cm) plant. In summer tiny pale lilac-pink flowers are crowded in dense axillary whorls encircling the stem. Each calyx has five rigid teeth that are persistent after petal-fall, now bearing mature seeds.

Leaf blades have narrow bases and three long, pointed lobes; those on the flowering stem are held out horizontally on long petioles. Lower leaves are palmately five-lobed, as are the basal leaves. Whether resembling a lion's tail or not, these leaves are handsome, but it is said that they may cause dermatitis if touched. Herbalists once prescribed this plant for menstrual disorders, which explains the common name, and as a stimulant for the heart, hence *cardiaca.*

Bee-balm (page 54), Dittany (page 136), and Yellow Giant Hyssop (page 178), show other flower arrangements found in the Mint family.

DISTURBED GROUND ALIEN

Labiatae: Mint Family

HEAL-ALL, SELFHEAL❈

Prunella vulgaris Linnaeus () (common)

Prunella vulgaris is an Old World species, now common in fields, lawns, and disturbed woodlands throughout the country. The plant may be 3 to 24 inches (7.5 to 61 cm) tall, depending upon the favorableness of the location, and whether or not it has been mowed. The plant grows singly or in small groups rather than in colonies, and has a simple or branching square stem that remains upright all winter, brown and weathered. These dry stalks add interest to a winter arrangement. Although there are several varieties in which leaf shape and flower color vary in summer, this winter state is always the same. A small green leaf is sometimes found at the base of the stem on the perennial root (see page 236).

In summer the stem and opposite branches bear terminal spikes of lovely blue-purple flowers and opposite stem leaves. As the flowers open sequentially upward, are fertilized and set seed, the elongated spike becomes coblike and perhaps 3 inches (7.5 cm) long. This mature head is composed of overlapping fan-shaped bracts and hairy, toothed capsules, each capsule holding four small brown nutlets marked with black vertical lines. New plants sprout from nutlets or grow from runners.

In pre-Linnaean times, the genus was written *Brunella,* the German word for "quinsy," an inflammation of the throat that this herb was thought to cure. Herbalists and American Indians historically valued *Prunella* as a physic, for healing wounds and for treating an array of other ailments. This species occurs throughout North America.

FIELDS ALIEN

Motherwort Heal-all

Labiatae: Mint Family

HEMP-NETTLE

Galeopsis tetrahit Linnaeus (weasel/appearance) (four-parted)

A fresh Hemp-nettle plant is thoroughly hairy; stem, leaves, and flowers are all covered with bristly hairs. An annual that grows 10 to 24 inches (25 to 61 cm) tall, Hemp-nettle has an erect stem that is square and is swollen below the joints; the dried plant has fewer hairs and a less pronounced swelling. In summer floral clusters are in the leaf axils; each white or pale magenta flower is about 3/4 inch (2 cm) long and has a hairy hood and a purple-striped lower lip. Linnaeus likened the corolla to the head of a weasel.

Opposite leaves are hairy on both sides, ovate with a pointed tip, and have serrated margins. The mature calyx is almost 1/2 inch (1.3 cm) long and has five weak, bristly teeth that are not quite equal. Six to ten calyxes form each of the clusters that encircle the stem.

The Mint family is a large one; about 39 genera occur in the Northeast. Species of *Galeopsis* are natives of Eurasia and North Africa that were introduced and have now spread across southern Canada and northern United States. They inhabit rocky shores, cultivated fields, and waste places.

WASTE PLACES ALIEN

Labiatae: Mint Family

AMERICAN PENNYROYAL

Hedeoma pulegioides (Linnaeus) Persoon (sweet scent) (like *Mentha)*

A fresh plant of American Pennyroyal has the pungent aroma and taste of Oil of Pennyroyal, an oil extracted from a European mint, *Mentha pulegium; pulegium* is derived from the word for "flea," an insect the plant was thought to discourage. Our native species is a small square-stemmed herb 4 to 16 inches (10 to 41 cm) high that is softly hairy; the stem may be simple or branched. In summer tufts of tiny blue-violet flowers seem to ring the stem as they spread from the axils of small paired leaves. The leaves are lanceolate or ovate, sometimes petioled, and have scalloped margins.

A dry winter plant has only a faint scent, but the calyxes help us recognize it. Each calyx has three short, broad teeth above and two longer, narrower ones below, and they hang from their ascending pedicels in a flouncing gesture around the branches. *Hedeoma pulegioides* grows in disturbed soil, gravel, dry woods, and fields and may be found from southern Quebec to Minnesota southward.

See also Skullcaps, pages 52 and 134, Heal-all, page 238, and Bluecurls, page 286, in the Mint family.

DRY SOIL NATIVE

Hemp-nettle American Pennyroyal

Solanaceae: Nightshade or Potato Family

HORSE-NETTLE

Solanum carolinense Linnaeus () (of Carolina)

Sharp prickles, tenacious root, attractive flowers—this describes Horse-nettle, a perennial we call weed when we find it in the garden, and wildflower when we see it along roadsides, shores, or in old fields. It grows 1 to 4 feet (30 to 122 cm) tall and its flowers have five white to violet petals and golden anthers that protrude in typical nightshade fashion. Both stem and lobed leaves are rough to prickly with star-shaped hairs. In autumn we begin to see the dingy yellow fruits, smooth juicy berries like wee tomatoes 5/8 to 3/4 inch (16 to 19 mm) in diameter, hanging on long pedicels. Late in the season, the stem may be broken over and most of its stem-covering worn off.

This is not a nettle, although gloves are needed to handle it, and some of its relatives are poisonous. The many-seeded fruits call to mind familiar members of the Nightshade family: tomato, potato, green pepper, eggplant, petunia, tobacco, and belladonna. Horse-nettle is said to be very bitter, but provides some food for wildlife. *Solanum* is the classical Latin name for this genus, which is mostly tropical; probably the species was first identified in Carolina. The plant occurs from New England to Nebraska southward.

See Jimsonweed, page 244, for more on this family.

ROADSIDES AND FIELDS NATIVE

Horse-nettle

Solanaceae: Nightshade or Potato Family

JIMSONWEED, THORN-APPLE

Datura stramonium Linnaeus () (a swelling)

From July to October this annual wildflower bears showy, funnel-shaped, ill-scented, white or purple flowers with five-pointed corollas that open in the afternoon, accommodating their major pollinator, the long-tongued Sphinx Moth. The flowers are 3 to 5 inches (7.5 to 13 cm) long and grow singly in branch axils on a short peduncle accompanied by a small leaf and surrounded by an angular tubular calyx, also five-pointed, which persists in winter. Several species of *Datura* are grown for their large lovely flowers.

The stout, branching stem is smooth and green or purple in summer, with thin alternate leaves 1 to 4 inches (2.5 to 10 cm) long that have large, jagged marginal teeth. A spiny ovoid capsule 1 to 2 inches (2.5 to 5 cm) in diameter develops from the fertilized flower. It is four-valved and opens at the apex to disperse the kidney-shaped, dark brown to black seeds.

Like some other members of the Nightshade family, this plant is highly poisonous to touch and/or to taste. It contains two powerful alkaloids that have been known to kill cattle. I have read that livestock usually leave it alone in favor of other forage, a proven method of protection for this plant species. The genus originated on this continent, where southwest Indians and those of tropical America used certain species medicinally; *Datura meteloides*, a large-flowered species, is known locally in the West as "sacred Datura" due to its use in a variety of Indian rituals. There is some question whether *Datura stramonium* was introduced from Asia or is a native species.

Although more common southward, Jimsonweed (or better, Thorn-apple) occurs throughout our region, growing in barnyards, vacant lots, fields, roadsides, and waste places. The generic name is derived from an Arabic or Hindustani name, and the specific from the old generic name. Jimson is believed to be a corruption of Jamestown, where this plant was found growing by that early Virginia colony.

Waste Places

Jimsonweed

Scrophulariaceae: Snapdragon or Figwort Family

COMMON MULLEIN, GREAT MULLEIN
Verbascum thapsus Linnaeus () (of Thapsus)

A familiar wildflower, standing sentinel straight on rocky or gravelly banks, in old fields and waste ground, Common Mullein occurs throughout the United States. Only a few of the yellow flowers of summer open at one time, but the stature of the plant, its robustness, and the wonderful leaves hold our attention.

Verbascum thapsus is an Old World biennial or triennial; some of its numerous seeds germinate in autumn and produce basal rosettes of leaves that overwinter one or two years to develop the root. These leaves can reach 2 feet (61 cm) in length by the time the flowering stalk appears, and the stalk may reach 7 feet (2.1 m) or more, with a simple or branched stem. The plant in the illustration had 18 inches (46 cm) more stalk than I have shown.

The whole plant is woolly or felted with white hairs that are branched like microscopic trees; the leaves are especially so, on both sides, resulting in an unusually soft texture— Flannel-plant is another common name. The hairs give the leaves a frosty gray-green color; dew, snow, and ice are unable to penetrate this wool and the leaves stay fresh all winter. Inversely, the woolly surface protects the plant from wilt in hot dry weather.

Basal leaves begin to wither as the flower stalk grows, having completed their job of photosynthesis, and by flowering time have returned to the earth; their recycled nutrients help feed future plants and soil creatures. Stem leaves decrease in size upward, and their petioles extend between the nodes on the stem, like wings. Only shreds of these wings are found in winter.

The globose or ovoid capsules are tightly packed together. When their many brown, ridged seeds mature, they open at the top into two parts, each with a cleft at the apex. Great Mullein has had many uses: in ancient times the fruit heads were dipped in tallow for torches; the dried leaves were used as lamp wicks, fresh ones for sore throats, rheumatism, and pulmonary ailments; the Indians and colonists lined moccasins and boots with the leaves for warmth; a bright yellow dye can be obtained from the plants, and hummingbirds have been known to line their nests with the woolly hairs.

Verbascum is the ancient Latin name for this genus, carried forward by Linnaeus. The species was thought to have originated in the African seaport of Thapsus.

ROADSIDES AND FIELDS ALIEN

Common Mullein

Scrophulariaceae: Snapdragon or Figwort Family

MOTH MULLEIN

Verbascum blattaria Linnaeus () (a moth)

From June to October Moth Mullein flowers are borne in a loose raceme on pedicels about 1/2 inch (1.3 cm) long. The erect, simple or branched stalk, 2 to 4 feet (61 to 122 cm) tall, is smooth or finely pubescent—quite different from its relative, Common Mullein (page 246). It is like Common Mullein in that it is a biennial, that it was introduced into this country from the Old World, and that the capsules are similar in shape. Moth Mullein grows in fields, waste places, vacant lots, and roadsides, and occurs throughout the United States, although not in abundance anywhere.

The large flowers are in an open spike and have five large, yellow or white, rounded petals whose centers and backs are tinged with lavender. Violet wool covers the filaments of the stamens, while the anthers produce orange pollen. Some see this colorful flower as an imitation of a moth, a lure for moths to cross-pollinate the flowers. Other authors think the specific name may come from *blatta*, "a cockroach," an insect the plant was thought to repel. Moths frequently are the pollinators, along with butterflies, bees, and other hovering insects—the corolla faces outward, providing no landing platform. Upper leaves are lance-shaped and toothed, partly clasping the stem; lower leaves are petioled, oblong, and doubly-serrated.

In winter *Verbascum blattaria* has an attractive pattern of long, slender, upcurving pedicels, each holding an almost spherical, dark brown capsule that opens at the apex to release its many seeds. These dry stalks, the seeds shaken out, can give accent to a dry bouquet.

FIELDS AND ROADSIDES ALIEN

Scrophulariaceae: Snapdragon or Figwort Family

BUTTER-AND-EGGS, COMMON TOADFLAX

Linaria vulgaris Hill (flax) (common)

The spikes of buttery yellow 1-inch (2.5-cm) flowers with egg yolk orange palates on the lower lip and a long tapering spur, are familiar wildflowers of late summer and fall. We see small colonies of them along roadsides and in old fields and city lots almost everywhere. The orange palate attracts the large pollinating insects such as bumblebees while preventing nonpollinating ants from entering to sip nectar from the spur. The axis of the raceme continually elongates as capsules develop.

Numerous pale green leaves, from 1 to 2½ inches (2.5 to 6 cm) long, are linear, entire, and alternate on the upper stem; lower stem leaves are opposite or whorled, and the leaves of sterile shoots around the base of the stalk in spring also are whorled.

In autumn a developing capsule is smooth and green, ovoid to oblong, two-celled and approximately 1/2 inch long (1.3 cm), held erect by an ascending pedicel. When mature, the capsule ripens to nut brown and splits open at the apex to release the many flat, brown seeds. These are nearly circular and have a notched wing that helps to carry them away from the parent plant.

Linaria vulgaris grows 1 to 3 feet tall (30 to 91 cm) on a smooth, erect stem that rises from a creeping perennial rhizome. This species originated in Europe, where it was a weed in flax fields, hence the derogatory epithet Toadflax. See also Old-field Toadflax on page 288.

FIELDS ALIEN

Moth Mullein Butter-and-eggs

Dipsacaceae: Teasel Family

TEASEL

Dipsacus sylvestris Hudson (thirst) (of the woods)

Where land is poor, stands of Teasel can be luxurious, if the location is a sunny one in the region between New York and Michigan southward to North Carolina and Mississippi. Teasel occurs in New England also, but more rarely. In summer, the small lilac flowers on the ovoid head open in an unusual way, beginning with a band around the middle that divides and progresses in opposite directions, one toward the top and the other toward the base, not always simultaneously.

Each flower has a bract cupped around its base terminating in a long, spined point. A wonderful geometric pattern is made by these bracts as they spiral around the head. Longer bracts encircle the whole head, curving out and upward from the base, sometimes with a little curlicue at the tip. Soon after flowering, the bracts elongate and harden, and the whole plant stiffens into its mature state. Over winter the color goes through taupe to weathered gray.

Teasel can reach 6 feet (1.8 m) in height, and has long upsweeping, opposite branches. It is a biennial, one of its seeds producing a flat basal rosette of puckered leaves the first year that overwinters green, and a stout flowering stalk the second year. Stem leaves are 4 to 16 inches (10 to 41 cm) long, toothed and opposite, the bases of upper ones joined around the stem, usually forming a cup capable of holding rainwater.

Introduced here from Europe, plants in this genus were called Teasel because the dried heads were once used by wool manufacturers to "tease" wool cloth, that is to raise the nap, or "full" the cloth. *Dipsacus fullonum* (of fullers), a subspecies with hooks at the tips of the floral bracts, was cultivated especially for this purpose, a practice in use since Roman times. Today Teasel provides seeds for wild birds and scaffolding for spiders, adds interest to the winter landscape, and makes fascinating winter decorations for those brave enough to rob it of a branch or two—where there are plenty for regeneration.

The name *Dipsacus,* from the Greek word *dipsa,* meaning "thirst," was given to this genus because of the large united, water-holding leaf-bases.

WASTE PLACES ALIEN

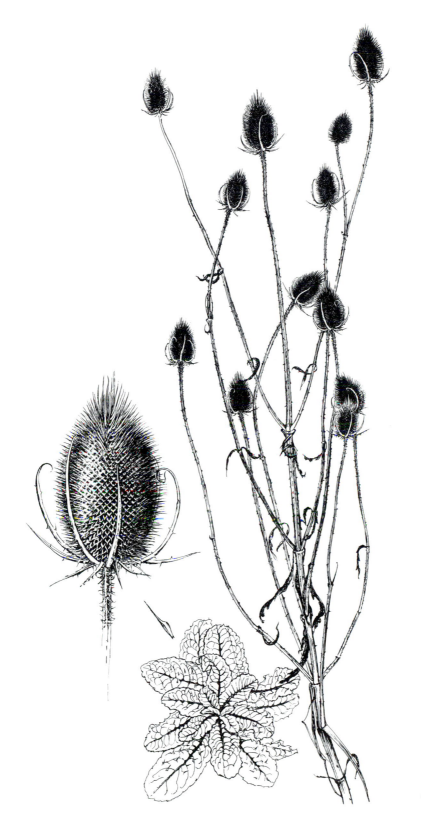

Teasel

HEATH ASTER; FROSTWEED

Aster ericoides Linnaeus (star) (resembling Erica)

More than half of the 250 species of *Aster* are found in the United States, about 68 in the Northeast. Heath Aster is a fall perennial, coming into flower with the late goldenrods and lasting through the first light frosts. An erect, bushy plant 1 to 3 feet (30 to 91 cm) tall, Heath Aster has small starry white flowers with yellow disks crowded together in dense panicles, often congregating on one side of the branchlets. Asters are highly successful propagators, having adapted perfectly to their insect pollinators, as the insects have adopted to them—a fine example of symbiosis. Heath Aster's profusion of late blossoms yields much nectar, which honeybees harvest for winter survival and on which several butterflies feed, in the same symbiotic exchange. A few butterfly species lay their eggs on asters as well.

Heath Aster has numerous, tiny, heathlike leaves, most of which persist through winter in a rigid state. This species grows singly or in colonies, star-studding dry open places, thickets, and borders of woods with its flowers. When the achenes disperse, after pollination, carried on winds by their short white pappus hairs to new locations, masses of glossy, starry flower bracts remain, the longer inner ones recurving over the shorter outer ones—dried "flowers" for winter roadsides.

Aster ericoides occurs from Maine to Minnesota southward. Originally it was found only in southern New York, New Jersey, and Pennsylvania. Now, although listed as rare in Pennsylvania, its range has been extended elsewhere through cultivation by beekeepers. Garden asters with their large, colorful heads are in a different genus—*Callistephus.*

DRY OPEN GROUND NATIVE

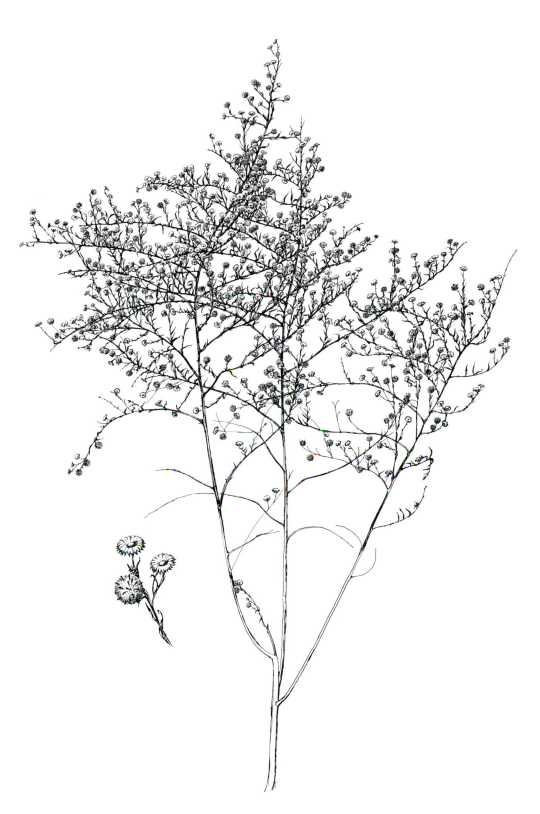

Heath Aster

Compositae: Composite or Daisy Family

COMMON RAGWEED

Ambrosia artemisiifolia Linnaeus (food of the gods) (with leaves of *Artemisia)*

Flowering time for Common Ragweed is from July to September. The flowers are green and have no petals to attract insects—wind does the pollinating. This is a much-branched, ragged annual with a fine-hairy stem and elongated spikes of staminate flower heads. At the base of the staminate spikes are clusters of one to three carpellate flowers in the axils of small leaves. If any part of this plant was used by the ancients as food, for gods or man, the fact has been lost. Some early Greek scientist applied this name to the plant, and Linnaeus kept it.

However, recently it was discovered that Common Ragweed is a valuable winter food plant for ground-feeding birds, especially for nine species of sparrows and many other song birds, shore birds, and quail as well as for deer and small mammals. Ambrosia it is for them, for the abundant seeds are oily and nutritious. The plant is also a pioneer of bare ground; seeds not eaten are capable of remaining dormant for several to many years, requiring only a loosening of the earth around them to germinate. In autumn colonies of Common Rag-weed color otherwise barren areas red-purple.

On the negative side, hay-fever sufferers are affected by the air-borne pollen of rag-weed, just when the showy goldenrods are flowering; usually it is the inconspicuous rag-weeds that are to blame. In winter, the plant is gray-brown and the achenes are enclosed in an ovoid to top-shaped fruit, 1/8 inch (3 mm) long, ringed with several short spines. Branch tips that held the staminate flowers in summer are usually bare at this time. Since the plant is gregarious, a stand of plants with numerous bare tips quickly identifies them.

The specific name refers to the leaves, which are divided into many segments, resem-bling those of *Artemisia,* Mugwort or Wormwood. Great Ragweed, *Ambrosia trifida,* the only other major species in the Northeast, grows to about 15 feet (4.6 m) and has leaves deeply divided into three to five pointed lobes.

DISTURBED SOIL NATIVE

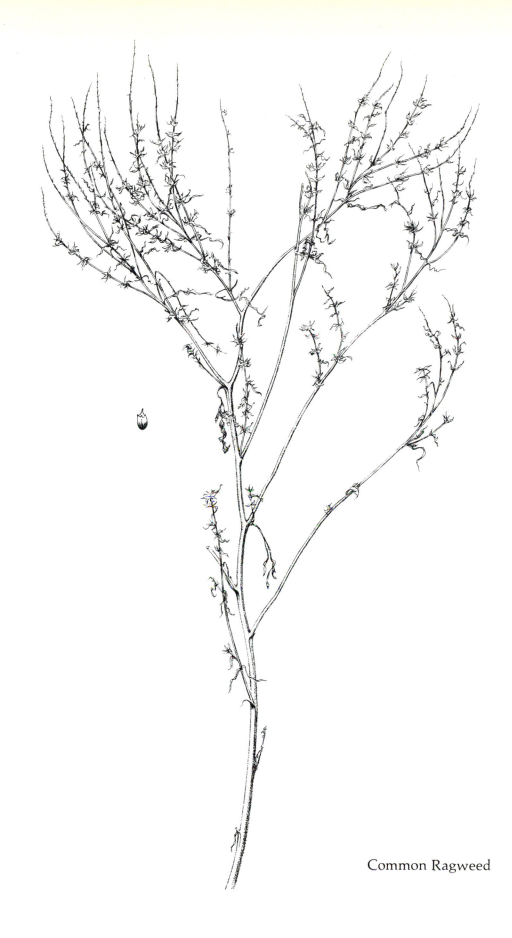

Common Ragweed

Compositae: Composite or Daisy Family

BLACK-EYED SUSAN ✺

Rudbeckia hirta Linnaeus (for O. Rudbeck) (rough)

When the white drifts of ✺Ox-eye Daisy have faded from the summer fields, the yellow and brown flowers of Black-eyed Susan appear, seeming to have absorbed the summer sun. This wildflower of late summer is a biennial, or a perennial of only a few years. The heads are 2 to 3½ inches (5 to 9 cm) across. Ray flowers are sterile and deciduous, the dark purple-brown disk florets ripen into a rounded conical head of chaff and tiny four-angled achenes, arranged in rhythmic spirals.

Long, rough hairs cover the stem, leaves and involucral bracts and persist on the winter plant. Two rows of bracts, whose tips tend to break off in winter, surround the receptacle. Leaves are alternate, slightly toothed or entire. The stem is ridged, adding to its strength; scissors are required to cut a stalk in order not to pull up the root. The cultivated Gloriosa Daisy was developed from a species of *Rudbeckia*.

Rudbeckia hirta grows from 1 to 3 feet (30 to 91 cm) tall in dry fields, prairies, open woods, or roadsides. Its hairs retard evaporation and enable it to tolerate the hot, dry conditions of the Midwest, where it originated. It is thought that perhaps the seeds were shipped east in bales of hay, or with clover seed; it has now spread to the coast and ranges throughout most of our area.

In naming this plant, Linnaeus honored his former teacher and predecessor at Uppsala University, Olaf Rudbeck (1630-1702), and his son Olaf (1660-1740).

FIELDS AND PRAIRIES NATIVE

Compositae: Composite or Daisy Family

BEGGAR-TICKS, STICKTIGHT

Bidens frondosa Linnaeus (two-toothed) (leafy)

There are approximately 19 species of *Bidens* in the Northeast. *Bidens frondosa* is a familiar annual one, not known for its flowers, but for its fruit. This species grows in wet or dry fields and waste places; its stem is 2 to 3 feet (61 to 91 cm) tall, nearly smooth, much-branched, and leafy. In late summer and fall, the plant has inconspicuous heads of tiny orange disk flowers among green chaff, surrounded by two rows of long green bracts.

The achenes that follow pollination of the flowers are about 1/4 to 1/2 inch (6 to 13 mm) long, sepia in color, flattened laterally and armed at the top with two nearly parallel barbed prongs, or awns, that are among the now buff chaff. Many achenes are seated in a head, with their awns pointed outward, and are dispersed by riding away on the fur of mammals or on our clothing.

The leaves of *Bidens frondosa* are compound, having three to five lance-shaped, toothed and stalked leaflets. This species is among several plants that are host to the Silver-spotted Skipper Butterfly.

FIELDS NATIVE

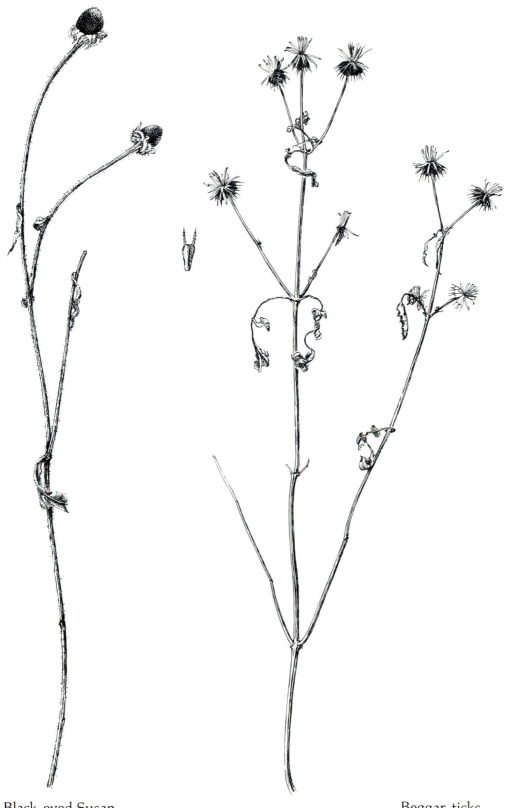

Black-eyed Susan Beggar-ticks

Compositae: Composite or Daisy Family

COMMON YARROW, MILFOIL

Achillea millefolium Linnaeus (for Achilles) (thousand-leaved)

Yarrow is a familiar perennial of old fields, waste ground, and roadsides everywhere. It was once thought to be an alien species, but is now considered by some authors to be native. Flowering all summer and into autumn, its tight flat flower cluster is composed of small heads 1/4 inch (6 mm) across, each with tiny yellow disk florets that soon turn putty gray, and four to six short white ray florets; a pink-rayed form also occurs. These massed flowers attract pollinating insects, primarily bees and small butterflies; thus many flowers are pollinated and many achenes produced. The plant also spreads by underground runners.

Common Yarrow grows 1 to 3 feet (30 to 91 cm) tall or taller in rich soil. It has a tough, somewhat hairy stem and stiff ascending branches. The aromatic fernlike leaves are sessile and finely dissected, those on the stem shorter than the basal leaves. Achenes that germinate in autumn produce overwintering basal rosettes, which may be the "squirrel tails" of the Indians' name for this plant.

Achillea millefolium has been mentioned in the mythology, literature, medicine and folk lore of peoples around the world since the ancient Greeks. It is believed that the Greek hero Achilles discovered the genus's healing powers and used it for his soldiers' wounds. In the days when the only medicines were those obtained from plants, Yarrow was also considered valuable for treating hemorrhages and for breaking fevers. In addition the plant has been used as a substitute for hops in beer, and in Yarrow tea, said by some to induce sweating—by others to dispel melancholy. However, Yarrow, and most other wild plants, could be harmful to humans if taken without thorough knowledge of methods and dosages.

In winter the flat-topped fruit cluster of *Achillea millefolium* is leafless, dark brown or gray. At first bristly with chaff, it later shows bare conical receptacles. The chaffy stage is painted green and used as trees in architectural and electric train models.

FIELDS AND WASTE GROUND NATIVE

COMMON TANSY, GOLDEN-BUTTONS, BITTER-BUTTONS, *Tanacetum vulgare* Linnaeus.

A very old house in Maine was found to have Tansy leaves under the rugs, placed there to repel ants, moths, and other insects. Bunches of this aromatic herb are still hung in some country cupboards for the same purpose. An Old World species, Tansy was raised in European kitchen gardens for Tansy tea, said to be extremely bitter, which was taken as a spring tonic and for various maladies. A wine was made from Tansy, and cakes or puddings, called "Tansies," were flavored with this bitter herb. The word is said to be derived from the Medieval Latin for "medicine to prolong life," yet full-grown leaves and stems contain tanacetum, a toxic oil potent enough to be poisonous. In ancient times the oil was used to cause abortions, sometimes killing the mother as well as the fetus.

Common Tansy escaped from gardens and has become naturalized. It is a handsome perennial wildflower, grown in flower gardens today for its flat-topped heads of golden yellow, buttonlike flowers composed of perfect disk flowers and inconspicuous ray florets. Leaves are glossy, stiff, and deeply cut. When young, they yield a yellow-green dye. The stem is erect and smooth, branching only for the flower cluster, and becoming as much as 5 feet (1.5 m) tall; I have shown the fruiting top of the plant and an overwintering leaf.

Seeds are soon blown away by winter winds, leaving the receptacle bare and its overlapping calyx bracts curved up around like a bowl. A basal rosette of leaves appears in autumn and remains green until spring, when it continues to grow and produces several flower stalks by late summer.

Tanacetum vulgare settles where it will, and in those places multiplies readily, both from seeds and from creeping rootstocks. Where the plant is established it supplies bouquet material of both summer flowers and winter dry stalks. Fields, roadsides, and railway beds are the plant's preferred habitat; it ranges from Nova Scotia to British Columbia southward.

FIELDS ALIEN

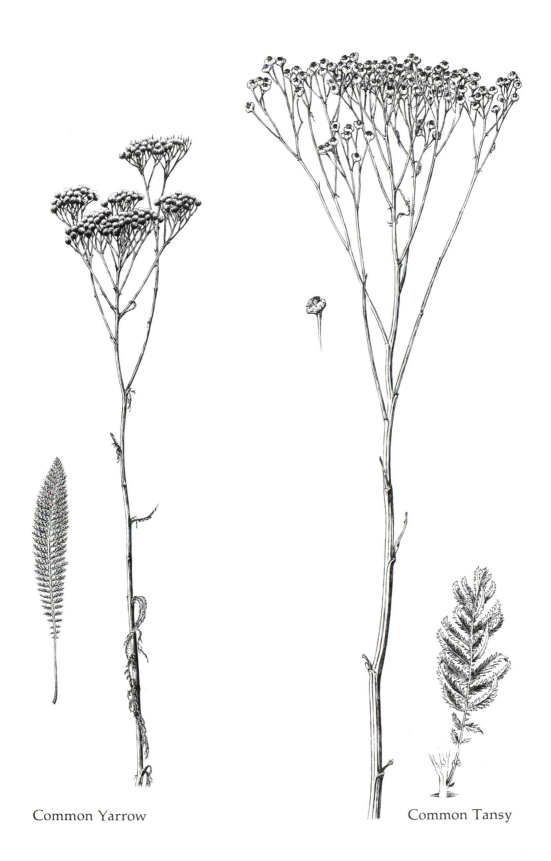

Common Yarrow Common Tansy

Compositae: Composite or Daisy Family

COCKLEBUR, CLOTBUR

Xanthium strumarium Linnaeus (yellow) (tumors)

This unusual composite is an attractive plant in winter with its glossy, rich brown, ovoid burs, each bur tipped with two sharp beaks. The burs are clustered in the leaf and branch axils along the faceted stem. Cocklebur is a narrowly branched annual that may reach 6 feet (1.8 m) in height; I have shown one branch in the illustration. In late summer and fall, the heads are yellow-green and completely enclose the pistillate flowers. Small staminate flowers are borne in short spikes or racemes separate from and above the female flowers that develop into mature ovaries after pollination, each holding two flat seeds. The burs correspond to the involucral bracts surrounding more usual composites, such as daisies.

Leaves are coarsely toothed and lobed, and contain toxins to help protect the plant from browsing animals. The burs disperse their seeds by clinging but they are not as hooked as those of Burdock and some branches can be gathered for dried bouquets if handled carefully.

Xanthium strumarium is widespread throughout the Northeast. *Xanthium* is from the Greek word *anthos,* "yellow," the name of a plant once used to dye hair—no one seems to know which species was so used. The specific name records that the plant was thought to cure strumae, or scrofulous tumors.

WASTE GROUND ALIEN

Compositae: Composite or Daisy Family

COMMON BURDOCK

Arctium minus (Hill) Bernhardi (a bear) (smaller)

Arctium minus is known to almost everyone for its tenacious burs that are borne singly or in groups at the tips of the many wide-spreading branches; I have shown one branch in the illustration. From July to October a cluster of pink, purple, or white tubular florets surmounts a green globe of bracts in thistle-like fashion on short stalks. The plant's stem is stout, 3 to 5 feet (91 to 152 cm) high, with ovate upper leaves and large heart-shaped lower leaves whose petioles are hollow. These leaves may become a foot (30 cm) in length.

By autumn the flower cluster with its bristly bracts has matured into a spherical, brown, barbed bur 1/2 to 3/4 inch (1.3 to 1.9 cm) across with hooks that are effective in catching onto anything or anyone passing by, so that the bur and the two to several dark brown achenes inside may be transported to a new location.

Artium minus is an annual or sometimes a biennial herb that grows near old farm buildings, in dumps, and along old fencerows and roadsides, occurring almost everywhere in our area. It can be a troublesome weed where we do not want it, its luxurious leaves taking up much moisture. The plant contains protective toxins against browsing but the flowers are sought by insects and butterflies for nectar and pollen, and the seeds by birds. Children stick the burs together to build toys; the leaves and fruit yield a yellow dye; and the roots of a cultivated variety are cooked by the Japanese, to whom it is known as Gobo. American Indians historically used the plant to cure coughs, calling it Bitterleaf.

Burdock also inspired a useful invention: in 1948 George de Mestral, a Swiss engineer, noted how effectively the hooks of Burdock caught on his clothing, and after eight years of work he patented Velcro, a fastening device made of hooks and loops. He fashioned the name from two French words, *velours,* "velvet" and *crochet,* "hook."

The name *Arctium* refers to the brown burs; *minus* tells us that the burs of this species are smaller than those of the other species in the Northeast. Great Burdock, *Arctium lappa,* has burs 1 to 1½ inches (2.5 to 4 cm) across on long stalks that are deeply grooved.

WASTE GROUND ALIEN

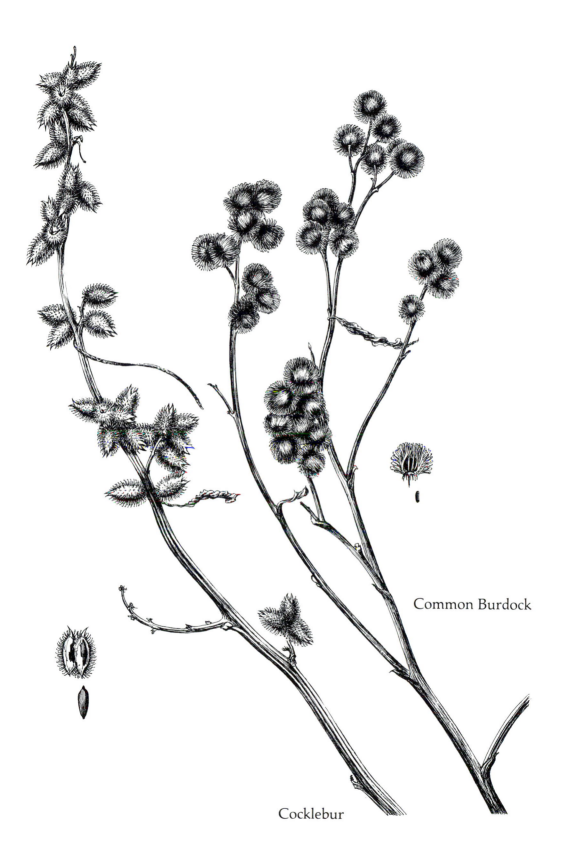

Common Burdock

Cocklebur

Compositae: Composite or Daisy Family

FIELD THISTLE

Cirsium discolor (Muhlenberg) Sprengel (swollen vein) (two-colored)

Cirsium is a large genus of wild thistles, of which seventeen species are recognized in the Northeast. All have prickles, many have showy flowers in summer that provide bees and butterflies with quantities of nectar and pollen in return for cross-pollinating, and offer us beauty and interest on summer countrysides. *Cirsium discolor* is a biennial with a stem 3 to 5 feet (91 to 152 cm) tall that is strongly furrowed but not winged, as is Bull Thistle, *Cirsium vulgare.* Each branch of the inflorescence terminates in a solitary head, 1½ to 2 inches (4 to 5 cm) long, composed of purple tubular flowers. These are subtended by many overlapping rows of closely appressed bracts, the outer ones each tipped with a weak prickle bent outward, the inner ones with a weak appendage.

Numerous alternate leaves decrease in size toward the top of the stem, and small sessile leaves embrace the head. Stem leaves are petioled, deeply cut into simple or forking lobes, and have needle-sharp prickles on their margins. Their upper surface is medium green and may be smooth or hairy, and the underside is white and velvety with soft hairs; the specific name refers to the two sides of the leaf. An overwintering rosette of leaves that develops early in autumn may be 18 inches (46 cm) long by winter, lying limply among the surrounding grasses.

The achenes of Field Thistle are oblong, crowned with a pappus of white, feathery soft hairs—wonderful for nest linings. The hard-coated achenes are a favorite food of Goldfinches, who scatter some as they yank them from the head, giving the wind a hand in spreading the species. The Painted Lady Butterfly prefers thistles as host plants. In the past humans used decoctions of thistle roots for sores, stings, bites, boils and for a "swollen (varicose) vein," according to the generic name. Indians used the roots for winter food.

Field Thistle grows in fields, open woods, and prairies, and is common from southwest Maine to Missouri southward to Georgia and Tennessee, although it is now listed as rare in Vermont.

TALL THISTLE, *Cirsium altissimum* (Linnaeus) Sprengel, is similar to Field Thistle but may grow to 10 feet (3 m). These leaves are also white-woolly beneath, are lanceolate, and are edged with weak marginal bristles. Tall Thistle is found in thickets and rich soil, from southern New York to Minnesota southward.

FIELD AND THICKETS NATIVES

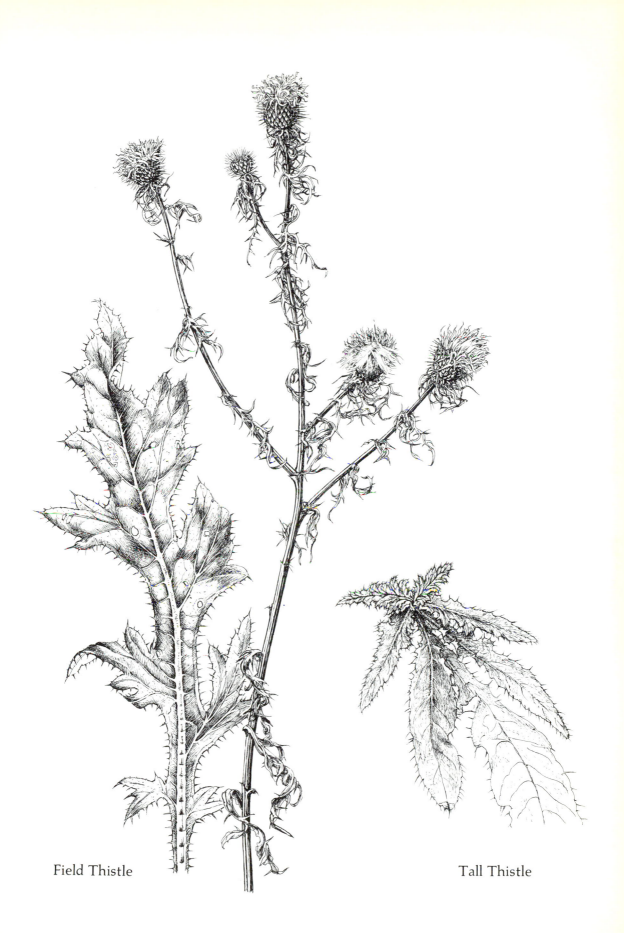

Field Thistle Tall Thistle

Compositae: Composite or Daisy Family

BLACK KNAPWEED, STAR-THISTLE

Centaurea nigra Linnaeus (Centaurie) (black)

Species of *Centaurea* are known as Star-thistles because the flower heads resemble those of thistles, genus *Cirsium,* and the corollas could be seen as starbursts of purple, pink, or white—too lovely to be called a weed. All of the species have ovoid or spherical heads with overlapping bracts beneath tubular flowers; many also have showy ray or raylike flowers. The involucral bracts are variously and distinctively margined or appendaged, one means of separating the species even in winter.

Centaurea nigra, flowering in summer, has a rose-purple tubular corolla, and sometimes outer florets with enlarged lobes simulating ray flowers. The ovoid involucre has narrow bracts, the outer ones with fringed upper margins that are black or dark brown and two or three times as long as the bract is wide. Slender peduncles thicken toward the head. The leaves are sessile, narrow and pointed, often with a few teeth or lobes. Leaves of the basal rosette are oval with wavy or toothed margins.

Black Knapweed is a perennial, growing in moist soil to a height of 1 to 3 feet (30 to 91 cm) in fields and waste places, and along roadsides, ranging from Newfoundland to Ontario south to Maryland, Ohio, and Michigan. Now naturalized here, this species was introduced from Europe. Our only native Star-thistle is *Centaurea americana.* Centurie was an ancient plant name; *nigra* refers to the black fringe on the bracts.

FIELDS ALIEN

Compositae: Composite or Daisy Family

COMMON CHICORY, BLUE SAILORS ❊

Cichorium intybus Linnaeus (Arabic name) (old generic name)

Chicory is so common that it is not noticed except on summer mornings, when its sky blue flowers color roadsides, fields, and waste places. It occurs almost everywhere in the country except in the deep South. Clusters of one to four flowers are scattered along the stalk and at branch tips; the head of blue rays with square, saw-toothed ends spreads 1 to 1½ inches (2.5 to 4 cm) wide. Occasionally a white or pink form is seen. Each flower opens at dawn to close about noon. A double set of involucral bracts surround the receptacle, the five outer bracts about half as long as the eight to ten inner ones; these wear away over winter. At maturity the achenes are 1/8 inch (3 mm) long and more or less four- or five-angled, with a pappus of minute bristly scales. These are enclosed in the bracts.

The rough-hairy stem and its stiff, spreading branches grow from a deep perennial tap-root. Stem leaves are sessile, small, narrow and widely toothed, their lobes sometimes clasping the stem. Basal leaves and lower stem leaves resemble those of dandelion and are said to be equally nutritious if gathered very early in spring and prepared in the same manner. The Cecropia Moth feeds on Chicory leaves and the cocoon overwinters.

A European native now naturalized here, Chicory grows 1 to 5 feet (30 to 152 cm) high, and prefers neutral or limy soils. Livestock are said to relish a bit of Chicory, but the plant does not survive in cultivated land. It proliferates in places we have left waste, where Goldfinches and other birds feed on the seeds. Roasted Chicory root sold commercially is from a species cultivated for this purpose in Europe and imported in great quantities. The cultivated salad greens Endive are the leaves of *Cichorium endivia.*

WASTE PLACES ALIEN

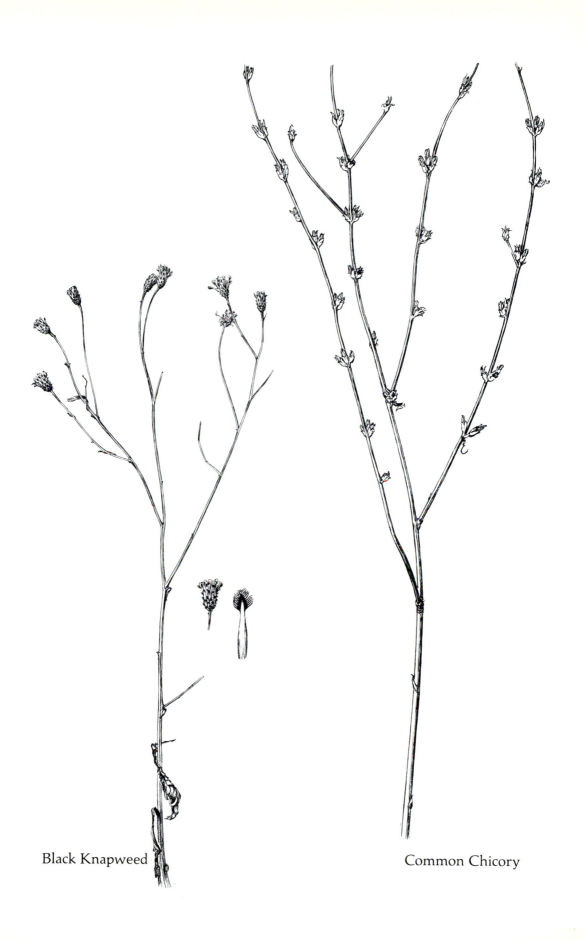

Black Knapweed

Common Chicory

Ericaceae: Heath Family

MOUNTAIN LAUREL
Kalmia latifolia Linnaeus (for Pehr Kalm) (broad-leaved)

The broad, leathery, evergreen leaves of this attractive shrub may be 2 to 5 inches (5 to 13 cm) long and are usually alternate but sometimes opposite or in whorls of three. In spring or early summer large dome-shaped flower clusters terminate the branch tips, each white to pale pink flower having the same form as that of Sheep Laurel but larger, 3/4 to 1 inch (1.9 to 2.5 cm) across. The arrangement and method of pollination are also similar to those of *K. angustifolia.*

Capsules are globose, slightly flattened, five-celled and glandular; they are dull red, becoming dark brown or black as they open gradually during late autumn and winter to release their oblong seeds.

Kalmia latifolia grows in woods or clearings, preferring partially shaded rocky slopes with acid or sterile soil. A plant of this species can live many years, usually attaining a height of 6 feet (1.8 m), although an old stand may reach 15 feet (4.6 m) in the North and 25 feet (7.6 m) in the South. The plant occurs from New England to Indiana southward, chiefly in the Appalachian Mountains. Mountain Laurel is the state flower of Connecticut and of Pennsylvania. It is reported to be steadily decreasing in numbers in Maine, of special concern in New Hampshire, on the watch list in Vermont, likely to become threatened in New York, and rare in Indiana.

Pehr Kalm, an eighteenth-century botanist who had been a pupil of Linnaeus, introduced Mountain Laurel to Europe after traveling and collecting in America.

ROCKY SLOPES NATIVE

SHEEP LAUREL, LAMBKILL, WICKY, *Kalmia angustifolia* Linnaeus. Heaths are
mostly woody shrubs or trees that grow in acid bogs or on mountains. *Kalmia angustifolia* is a small shrub that reaches 1 to 3 feet (30 to 91 cm) in height, colonizing in dry or wet sterile soil, old pastures, swamps, and barrens, in either sun or shade. The tough, slender stems have nearly erect branches. Slender leaves are 1 to 1½ inches (2.5 to 4 cm) long, opposite or in threes, dark olive green above, pale green beneath. Old leaves, those we see in winter, droop. New leaves sprout from the apical bud in spring, and in summer pairs of deep rose-pink flower clusters seem to encircle the stem below the leaves.

Flower buds are conical and pleated; an open flower is 1/4 to 1 inch (0.6 to 2.5 cm) across, its five petals joined to form a cupped corolla. Ten pits in the cup of the open flower hold the anthers, causing the filaments to arch from the center of the flower. A pollinating insect, working its way to the nectar, springs the stamens and the released anthers shower the insect with pollen to be carried to the receptive stigma of another flower. These plants serve the Northern Blue Butterfly as host.

Sheep Laurel's globose capsules ripen in September or October. They are small, glandular-hairy and orange-brown, aging to gray. A calyx of five fused sepals persists, and the long style remains on many capsules. Last year's dry fruits are still on the branch, below the current ones, but only the most recent summer's leaves are present.

Kalmia angustifolia ranges from Newfoundland to Michigan south to the mountains of Georgia, although this species is now recorded as very rare in Virginia and vulnerable in New York. The plant is said to be poisonous and probably earned its colloquial names from sheep farmers; all species of *Kalmia* contain a toxic substance. Leaves of new shoots could be mistaken for those of Checkerberry (page 286)—be sure of your identification before chewing *any* leaves.

ROCKY SITES AND PASTURES NATIVE

LABRADOR-TEA
Ledum groenlandicum Oeder
See text on page 24.

PLANTS OF STERILE GROUND
Rocky Sites • Sandy and Gravelly Soil • Mountains

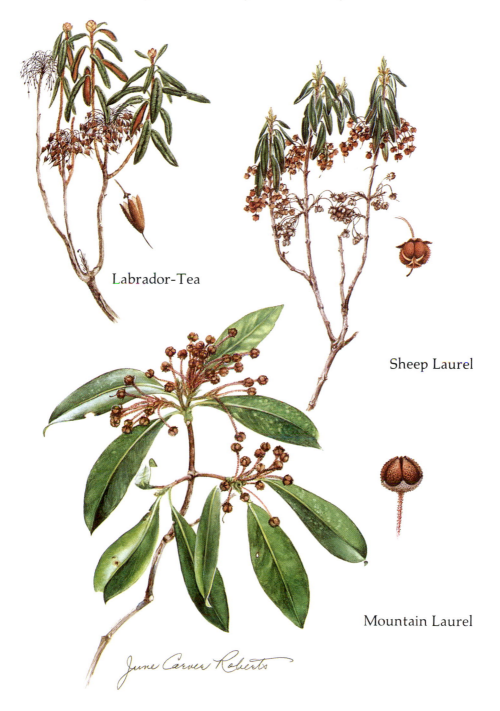

Labrador-Tea

Sheep Laurel

Mountain Laurel

June Carver Roberts

SMOOTH ROCK TRIPE

Umbilicaria mammulata. (Acharius) Tuckerman (resembling a naval) (with nipples)

Any boulders or rocky ledges in eastern North America might be encrusted with this large lichen. The thallus is broad, thin and leaflike, termed foliose. A lichen is not differentiated into true roots, stems, and leaves, but is able to take in water-dissolved substances over its entire surface. The leathery thallus of *Umbilicaria mammulata* is smooth, matte, gray-green above and flexible when moist; it is taupe-brown, hard and crisp when dry. The underside is jet black with a granular-appearing nap. This species may be 10 inches (25 cm) or more across, but usually is attached to the rock surface by only a cord, or umbilicus, from a point near the center. The uneven or ragged edges drape in graceful folds, revealing the black undersurface.

Reproduction in lichens is mostly vegetative, meaning that fragments of plants are torn, blown or rainwashed away, or carried on the feet of animals. New plants may develop from these pieces. But some species produce spores (see British Soldiers, page 272), and in others microscopic algal cells wrapped in fungal filaments form a fertile powder on the lichen's surface. The upper surface of Smooth Rock Tripe has this fertile powder in summer; it holds all of the components of *Umbilicaria mammulata,* and can develop into new lichens when dispersed onto a rock surface. Small, disk-shaped spore-bearing fruits occasionally form on the upper surface but are seldom seen.

Species of *Umbilicaria* have long been valued by weavers for the red and purple dyes they yield. Rock Tripes are said to be edible as a survival food after they have been roasted then boiled for an hour or more. In Japan, species of Rock Tripe are eaten in salads or fried in deep fat. I have read of only one lichen that is poisonous, although lichen acids may be irritating to the system in some cases. Unfortunately, because lichens assimilate materials present in the atmosphere, today they are likely to contain heavy metals.

ROCKS NATIVE

Smooth Rock Tripe

Parmeliaceae: a Lichen Family

BOULDER LICHEN

Parmelia conspersa Acharius (small round shield) (besprinkled)

Boulder Lichen beautifies bare rocks, cliffs, stone walls, old tombstones, and sometimes tree roots and stumps with its rosettes of grays and gray-greens. *Parmelia* is the largest genus of the foliose lichens; there are at least 87 species with *Parmelia conspersa* the most common. Paper thin and lying very flat, a single rosette is a few inches (cm) in diameter; several overlapping rosettes may measure over a foot (30 cm) across. Boulder lichen is attached to the substrate over most of its thallus by holdfasts called rhizines; only the lobes around the perimeter are free. The upper surface is bumpy, or "besprinkled" with tiny lumps; the underside of the thallus is jet black and woolly, not visible unless a piece loosens or falls off.

Unlike those of some lichens, the fruits of Boulder Lichen are easily seen. They form in the central portion of the plant and are shaped like tiny cups that bear chestnut to dark brown spores on their inner surface. Scientific analysis of their chemical, crystal, and color composition most accurately distinguishes lichen species, but common species usually can be identified by their visual characteristics. *Parmelia conspersa* may be found throughout our region and beyond.

This and several other species of *Parmelia* are important sources of brown and purple dyes. For other uses and temperature tolerances of lichens see British Soldiers, page 272, and Reindeer Lichen.

ROCKS AND TREES NATIVE

Cladoniaceae: a Lichen Family

REINDEER LICHEN, REINDEER MOSS

Cladonia rangiferina (Linnaeus) Wiggers (branch) (reindeer)

Reindeer in the far North depend upon species of *Cladonia* for food in winter. Caribou, Musk-ox, and other herbivores also feed upon these lichens. *Cladonia rangiferina* forms colonies of delicate pale green or gray tufts, 2 to 4 inches (5 to 10 cm) high, like miniature cumulus clouds. The tufts grow on soil, humus, or exposed rocks, in the open or in shade. They may cover an area of a few inches or of many miles. This species occurs from the Arctic southward into the northern United States.

The hollow stalks and branches interweave so that each tuft resembles a small sponge, and it performs in a spongelike way, absorbing and retaining large amounts of water. At such times the tufts are soft and resilient, whereas in spells of dry weather the plants become stiff and crumbly.

Lichens are slow-growing plants; when this species is harvested by man, as it is in Lapland, Finland, and other regions, ten years or more are required for the plant to regenerate. Plants grazed by animals are merely trimmed and return to full growth more quickly. Some of the uses of *Cladonia rangiferina* are in usnic acid medicinal preparations, in model landscapes, in perfumes and cosmetics, and as pollution monitors.

After the atomic bomb tests of the 1960s it was discovered that arctic lichens had accumulated radioactivity from the atmosphere, which was soon built up in reindeer and other herbivores that fed upon them. Subsequently, the radioactivity was passed on to the Eskimos and Laplanders who fed upon the animals. Those bomb tests have been halted, but the consequences are still being felt through the food chain. Lichen species are sensitive in varying degrees to other pollutants as well, especially sulphur dioxide, herbicides and pesticides. Lichens are now being used to monitor the levels of these toxins in the same way that canaries were once taken into the mines to warn miners of toxic levels of gases. There is a troubling difference—lichens that sicken from pollutants are reflecting past, not present, conditions.

SOIL AND ROCKS NATIVE

Boulder Lichen

Reindeer Lichen

BRITISH SOLDIERS, SCARLET-CRESTED CLADONIA

Cladonia cristatella Tuckerman (branch) (crested)

The bright red of the head of this familiar lichen is the color of the jackets worn by British soldiers. These red heads at the tips of the stalks are the globular fruiting bodies. No more than an inch or two (2.5 or 5 cm) tall, the upright, frosty-green stalks, called podetia, rise from basal scales that grow on decayed wood, bare rock, or soil, colonizing where many more complex plants cannot live. This is true of all lichens, which are often pioneer plants of barren places, from tidal zones to mountain summits.

Lichens are able to survive in such places by being composite plants, an alga and a fungus living together in symbiotic association. The alga is most often embedded in a meshwork layer below the surface—visible only through a microscope. Green and able to photosynthesize, the alga manufactures food for both partners. For its part, the non-green fungus collects water and minerals necessary for photosynthesis, and protects the alga from dehydration.

Reproduction in lichens is by fragmentation (see Reindeer Lichen, page 270), by fertile surface powder (see Smooth Rock Tripe, page 268), and by spores borne in special structures. The red heads on British Soldiers are exposed spore-bearing bodies whose surface is a uniform layer of spore sacs, or asci, each ascus containing one to eight spores. Lichen spores grow only from and germinate into the fungal partner and must match up with suitable algae in order to produce new plants.

Slow-growing and long-lived, lichen colonies centuries old are known; lichens are now used in dating ancient sites. The study of lichens is relatively recent and the nomenclature still unsettled; the names I have used might differ in some guides. Lichens are described as scabby, scaly, leafy, shrubby, etc. *Cladonia cristatella* is a shrubby lichen, referred to by botanists as fruticose.

Pyxie Cup, *C. pyxidata,* (on right in the illustration) is another fruticose lichen, often found with British Soldiers. Pyxie Cup bears its tiny brown fruiting disks on the lip of the miniature mineral green cup in summer or on branches that develop from the cup's lip.

OPEN ROCKS AND SOIL NATIVE

British Soldiers

Pinaceae: Pine Family

COMMON JUNIPER, DWARF JUNIPER

Juniperus communis Linnaeus () (in clumps)

Common or Dwarf Juniper is a low, aromatic evergreen shrub in North America—a tree in Eurasia—whose branches spread horizontally and radially from the root. The plants colonize and are capable of forming extensive mats on open rocks or sandy soil. This is a northern shrub, ranging from Greenland to Alaska south to New York and Minnesota and in mountains to North Carolina. Currently it is considered threatened in Vermont.

Branches and the three-sided twigs are covered with stiff, three-sided needles in whorls of three. The needles are 3/8 to 1/2 inch (9 to 13 mm) long, awl-shaped, and end in a sharp skin-pricking point. They grow from the stems horizontally and are jointed at the base to turn upward close to the twig or to spread, according to their need to absorb or conserve moisture. The side of the needle facing the twig, or often the ground, has a whitened groove, most apparent when viewing the underside of a branch.

The flowers of *Juniperus communis* are inconspicuous, but the berries are 1/4 to 3/8 inch (6 to 9 mm) long, ovoid to globose, hard, aromatic, and light green maturing in two or three years to dark blue with a pale bloom. Bobwhites, grouse, pheasants, deer, moose, songbirds, and other wildlife feed on Juniper berries. They are the flavoring in gin and will also produce yellow and brown dyes. In Asia, Juniper oil is used in perfume and in incense.

ROCKS AND POOR SOIL NATIVE

Myricaceae: Wax-myrtle Family

BAYBERRY

Myrica pensylvanica Loiseleur-Deslongchamps () (of Pennsylvania)

In summer the leaves are the showy part of this native shrub, the flowers being very small in dry scaly spikes. Green female flower clusters resemble short twigs on the branches below the leaves; green male flower clusters are larger and more oval; both grow from axillary buds formed the previous autumn and are therefore on last year's wood. New leaves and branch sections sprout from terminal buds in the spring and the shrub fills out with leaves that have a delicious aroma, similar to bay leaves. They are 2 to 4 inches (5 to 10 cm) long, elliptical and alternate, thin, with fine hairs above and along the ribs beneath. The undersurface is paler, often downy with scattered resinous dots.

Twigs and bark are also aromatic, as are the mature berrylike drupes, about 3/16 inch (0.5 cm) in diameter and with pale gray wax coatings, once rendered into bayberry candles. Today, most commercially sold bayberry candles are made from species of other countries, with less satisfactory results, yet with the current demand, our native plant would soon be extirpated. These fruits are an important food source for migrating birds, especially for Myrtle Warblers and Tree Swallows, as well as for Ruffed Grouse, Bobwhites, and pheasants.

The gray leafless branches of winter, studded with clusters of these waxy spheres, are as attractive in their own way as are the leafy boughs of summer; I have shown one branch in the illustration. Bayberry grows 2 to 8 feet (61 to 244 cm) high, in dry or moist sterile soil, which it helps to improve by fixing nitrogen. This species is found mostly along the coast from Newfoundland to North Carolina, where it receives mineral nourishment from the sea in the form of spray, fog, and rain. Inland, it grows locally along the shores of Lake Erie, although it is now reported to be potentially threatened in New York.

Myricaceae is a small family, containing this genus, which also includes the Wax-myrtles and Sweet Gale, and the genus *Comptonia*. *Myrica* was an ancient Greek name for a fragrant shrub.

STERILE GROUND NATIVE

Common Juniper Bayberry

Myricaceae: Wax-myrtle Family

SWEET-FERN

Comptonia peregrina (Linnaeus) Coulter (for H. Compton) (foreign)

Sweet-fern is a low woody shrub, not a fern, although its alternate leaves are long and slender, and are pinnatifid in a fernlike manner. Spreading by underground shoots, the plants grow in dry open rocky or sandy soils on upland slopes, where they may be sharing the sun with Low Blueberry, *Vaccinium angustifolium,* Black Huckleberry, *Gaylussacia baccata,* and Bayberry (page 274). In damp hollows Sweet-fern may attain 5 feet (152 cm), but is usually 2 or 3 feet (61 or 91 cm) tall; I have shown one branch.

Flowers appear before the leaves in spring, the sexes on separate plants. Staminate flowers are brown cylindrical catkins that are flexible and expand to about 1 inch (2.5 cm) long at maturity. Pistillate catkins are smaller, green-brown, and globose or ovate. Wind does the pollinating, and the fruit is a smooth 3/16-inch (5-mm) nut, said to be edible, enclosed in a light green, burry covering.

Comptonia peregrina has a sweet fragrance redolent of happy childhood summers for those who live within its range. Leaves are dark green above, paler beneath, their margins slightly inrolled. Pairs of pointed stipules have flaring bases that hug the twig. New twigs have soft hairs; branches may be smooth or hairy. At the ends of the twigs are next summer's male catkins; they are short, light brown, and tightly closed.

A mild, fragrant tea can be made by steeping dried leaves, providing the plants are numerous enough to afford the loss. A strong tea wash has been recommended for Poison Ivy rash (I have not tried it) and other skin irritations. Sweet-fern roots, in association with soil bacteria, are able to convert nitrogen from the air into a form that improves soil.

This northern shrub occurs from eastern Canada to Minnesota south through New England and the Appalachian Mountains to North Carolina.

ROCKS AND SAND NATIVE

Corylaceae: Hazel Family

MOUNTAIN ALDER, AMERICAN GREEN ALDER

Alnus crispa (Aiton) Pursh () (crisped)

Alders are tall shrubs or small trees with green, woody, ovoid fruits that turn dark brown at maturity and superficially resemble small pine cones; they are called cones, and sometimes placed in the Birch family, Betulaceae. All species have alternate branches and leaves, and bear their pistillate and staminate flowers separately but on the same plant.

Mountain Alder is distinguished from other species of *Alnus* in winter by having more compact cones, winged seeds, and a lack of visible pistillate catkins because they are wrapped in buds during winter. Green, tightly closed immature staminate catkins form at branch tips in autumn and overwinter. In spring their numerous flowers elongate and become pendulous, maturing to coincide with the opening of the tiny female flowers, whose hairlike pistils project into the pollen-laden air. Leaves, emerging later, are 1¼ to 3¼ inches (3 to 8 cm) long, broadly oval, and finely toothed or double-toothed; the specific name refers to these "crisped" leaf margins.

A cluster of two to ten of the conelike fruits, each 1/2 to 3/4 inch (1.3 to 1.9 cm) long, develops from the pollinated flowers. Cones mature in late summer or autumn and remain on the shrub throughout winter, dispersing seeds. Each seed has two thin lateral wings to help it glide away.

The bark is smooth and gray; winter buds are pointed and sessile or on a very short stalk. *Alnus crispa* may grow to 12 feet (3.6 m) high, dividing at the base into many strong branches that root where any touch the ground. They also send out underground roots from which new shoots sprout; and new plants start from seed. In this way Alders colonize cold, boggy ground of rocky shores and mountains where other woody plants cannot live, holding and improving the soil. Alder thickets offer excellent cover for wildlife, and this

Mountain Alder

Sweet-fern

species is a host for the Faunus Anglewing Butterfly. Alder leaves and bark yield a brown dye.

Alnus crispa occurs from Labrador to Alaska south to northern New England, New York, Ontario, Michigan, and Minnesota. See also American Hazelnut, page 152, in this family.

WET ROCKY SITES NATIVE

Caryophyllaceae: Pink Family

SANDWORT

Arenaria sp. Linnaeus (of sand)

Arenaria is a genus of small dainty plants in the Pink family that are less than 10 inches (25 cm) tall, with wiry stems, tiny sessile opposite leaves, and white five-petaled flowers at the branch tips. The flowers somewhat resemble those of ❀Chickweed, *Stellaria,* but although sometimes notched, the petals of Sandwort are not divided, and the sepals are short. Flowering stalks rise from tufts of basal leaves in many of the species, of which there are about 200 in this nearly worldwide genus. Capsules are short, splitting into the number, or twice the number, of styles, usually three.

Species of Sandwort often inhabit rocky or sandy places, hence the generic name from *arena,* "sand." The plants persist into winter, as dainty as ever. See also genera *Lychnis,* page 210 and *Dianthus,* page 208, for more on this family.

ROCKY AND SANDY SOIL NATIVE

Rosaceae: Rose Family

THREE-TOOTHED CINQUEFOIL, WINE-LEAVED CINQUEFOIL

Potentilla tridentata Aiton (little potent one) (three-toothed)

These little gray stalks are but a memory of the summer flowers that spangled bare mountaintops and other open sandy or rocky sites. The white five-petaled flowers, 1/2 inch (1.3 cm) across, develop into hairy achenes enclosed by upright calyxes with five teeth. Leathery leaves are low on the stem, with three leaflets instead of the usual five of most cinquefoils; each leaflet is tipped with three rounded teeth. Spreading by subterranean stems and woody branches on the surface, upright branches grow 2 to 10 inches (5 to 25 cm) tall in areas where little else can survive except perhaps lichens and a few tough grasses. In September the leaves dress the rocks in scarlet as chlorophyll breaks down.

Potentilla tridentata once occurred across Canada and the northern United States southward to Georgia. Its current status is designated as rare in Connecticut and Virginia, critically imperiled in New Jersey, endangered in Pennsylvania, presumed extirpated in Rhode Island, and imperiled in West Virginia.

See also Rough-fruited Cinquefoil, page 218, in this genus.

OPEN ROCKS NATIVE

Sandwort Three-toothed Cinquefoil

Ranunculaceae: Buttercup or Crowfoot Family

WILD COLUMBINE✽

Aquilegia canadensis Linnaeus (eagle, or to collect water) (of Canada)

Wild Columbine is one of the loveliest of our spring wildflowers, gracing rocky wooded ledges, cliffs, and valleys with its crimson and yellow flowers, pendant on delicate pedicels from the tips of the branches. Five crimson, yellow-edged petals are long-spurred and alternate with petal-like sepals. Yellow stamens protrude downward from the center like a golden tassel, providing the flower's flying pollinators a place to cling. Only the long-tongued moths and butterflies, and the red-loving Ruby-throated Hummingbird can reach the nectaries in swellings at the ends of the spurs. This slender plant stands 1 to 2½ feet (30 to 76 cm) high. Leaves are blue-green, divided and subdivided into threes, each leaf segment rounded and notched. Leaves are basal and low on the stem except small ones where the flower stalks branch. Mature caterpillars of the Columbine Duskywing Butterfly feed on the leaves of Columbines exclusively, and overwinter to pupate in spring.

When the flowers are fully developed the pedicels straighten to support the fruiting head in an erect position. The five slender, long-beaked follicles of the head open by splitting along the inner side, their lobes flaring outward. Close veining creates a herringbone pattern on the outside of the follicle. This is another fruit for a dry bouquet. *Aquilegia canadensis* occurs across Canada southward beyond our region. The generic name is thought either to refer to the curved nectaries that somewhat resemble the talons of an eagle, or to derive from Latin *aqua* "water" and *legere* "to collect," alluding to the ample nectar.

This native American wildflower was sent to John Tradescant, gardener to Charles I, for the gardens at Hampton Court, by a kinsman living in Virginia. Garden, or European, Columbine, *Aquilegia vulgaris,* an escape from cultivation, is a stouter plant with blue, pink, purple, or white flowers, shorter and thicker spurs, and stamens that do not protrude.

See also Thimbleweed, page 156, for more on this family.

ROCKY WOODS NATIVE

Leguminosae: Legume or Pea Family

ROUND-HEADED BUSH-CLOVER

Lespedeza capitata Michaux (for V. M. de Céspedes) (in heads)

Bush-clovers, Sweet Clovers, Tick-trefoils, Hop Clovers, Alfalfa, Medicks, and Clovers are similar species of the Legume family with bilaterally symmetrical flowers, often clustered in heads, and alternate trifoliate leaves. Eighteen species of Bush-clover occur in the Northeast. A few are trailing plants, the remaining are erect. *Lespedeza capitata* is a variable species that hybridizes with other species of *Lespedeza,* but generally has the largest flower and fruit heads of the Bush-clovers in our area. It has an erect, stout, somewhat woody stem that is simple or branched and covered with silky hairs. Leaves are crowded on the stem; the leaflets are entire, elliptical, and silvery underneath; the middle leaflet is stalked.

In late summer creamy-white, globose flower heads on short stalks are in the upper leaf axils. These dense, bristly heads are composed of many small five-lobed florets whose calyxes may be 1/2 inch (1.3 cm) long, and have slender lobes. Cleistogamous flowers, which are self-fertilizing and do not open, are sometimes present, hidden among the others. The fruit is a reticulated, one-seeded pod that is greatly exceeded by the calyx lobes. In winter the dry, brown heads often become silvery gray on their weather side.

Round-headed Bush-clover grows in dry sandy places, improving the soil with its nitrogen-fixing roots. Legumes are high in protein and this species is an important food source for Bobwhite Quail. It is also one of the host plants to the Eastern Tailed Blue and the Hoary Edge Butterflies. *Lespedeza capitata* occurs from New England and Ontario to Minnesota southward beyond our region. *Lespedeza* is a misspelling of V. M. de Céspedes, who was a Spanish governor of East Florida where Michaux explored in the late eighteenth century.

DRY SANDY SOIL NATIVE

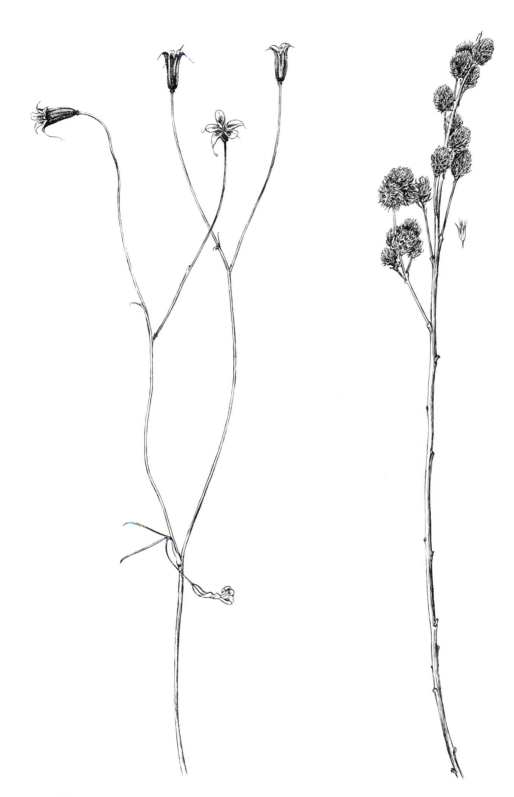

Wild Columbine Round-headed Bush-clover

Hypericaceae: St. Johnswort Family

PINEWEED, ORANGE GRASS

Hypericum gentianoides (Linnaeus) Britton, Sterns & Poggenberg
() (resembling gentian)

Hypericum is a large, widely distributed genus, principally of the Northern Hemisphere, the various species ranging in size from a few inches (centimeters) to about 7 feet (2.1 m). This annual is one of the smallest, growing 4 to 20 inches (10 to 51 cm) tall, in gravelly or sandy sunbaked soil. In July and August, colonies of new stems emerge; they are yellow-green, slender, stiff, and straight, like pine needles coming out of the ground. Later, they have ascending opposite branches with scalelike leaves and small, golden yellow, four-petaled flowers. The 1/4-inch (6-mm) conical capsules that follow are brick red and lance-shaped, much longer than the calyx. In the illustration, the capsules are spent and only the calyxes remain on the gray stalk.

Pineweed ranges from Maine to Indiana southward, although it is currently listed as rare in Vermont and vulnerable in New York. *Hypericum* is from the ancient Greek name for this genus that Linnaeus continued to use. Perhaps he chose "gentian-like" for the specific name because the fruit reminded him of the shape of the flowers of Closed Gentians. I think the common name "Orange Grass" must have come from the optical blending of the yellow flowers and the red fruits, causing one to see orange from a distance, as in pointillist painting.

See also Common St. Johnswort on page 228 and Dwarf St. Johnswort on page 46.

SAND AND GRAVEL NATIVE

Cistaceae: Rockrose Family

PINWEED

Lechea sp. Linnaeus (for Johan Leche)

Pinweeds are often inconspicuous plants in summer, even though they grow in groups. They have terminal panicles of numerous minute green or red flowers whose three petals rarely open. The calyx has two outer sepals and three broad inner ones that overlap the bud and, after maturation, conform to and enclose the nearly spherical capsule. The loose cylindrical to pyramidal flower clusters of the various species branch from different heights on the stem. Leaves are small and linear to elliptical.

The capsules are as small as pinheads. Beginning sometime between August and November the capsules' three valves open at the apex to allow minute brown seeds to disperse. These delicate plants stand all winter, their branches dotted with the little brown fruits whose tiny seeds offer winter food for small birds.

About eight species occur in our area, varying in size and range. All develop leafy basal shoots in autumn whose variations are an aid in separating the species. These are perennial herbs and are frequently woody at the base. The generic name honors Johan Leche, a Swedish botanist who lived from 1704 to 1764.

DRY STERILE GROUND NATIVE

Pineweed

Pinweed

Ericaceae: Heath Family

LARGE CRANBERRY
See text on page 24.

MOUNTAIN CRANBERRY
Vaccinium vitis-idaea Linnaeus (of cows) (grape of Mt. Ida)

Mountain Cranberry is a trailing evergreen heath of cold rocky or dry peatlands. The flowers of early summer are borne on short pedicels at the tips of branches. The pink, four-lobed corolla is bell-shaped, not recurved, so that it does not resemble a crane's head.

Leaves are 1/2 to 2/3 inch (13 to 17 mm) long, leathery, wider toward the tip, dark green and lustrous above, their margins slightly rolled under. The underside is paler with very small, dark, bristly points. Heaths, like orchids, are in symbiotic association with root fungi in order to receive adequate nutrients from poor soil so they can live through the year.

The dark red, tart berries in clusters are rounder and smaller than those of Large Cranberry, about 1/4 to 1/2 inch (6 to 13 cm) in diameter. Ripening in August or September they cling to the branches all winter. Birds and black bears in Canada and polar bears on arctic shores feed on Mountain Cranberry. In Nova Scotia, New Brunswick, and parts of Quebec, where these plants are more plentiful than in the States and where the fruit is larger, Mountain Cranberries are good eating in late winter, cooked with honey or sugar.

Vaccinium vitis-idaea once ranged as far south as from New York to Minnesota, but at present it is listed as rare in Vermont, endangered in Massachusetts, possibly extirpated from Connecticut, extirpated from Michigan, and endangered in Wisconsin. This species is also native to Greenland and eastern Asia.

ROCKS AND DRY PEATLANDS NATIVE

BEARBERRY, KINNIKINICK, *Arctostaphylos uva-ursi* (Linnaeus) Sprengel. *Arctostaphylos uva-ursi* is a ground-hugging shrub with long prostrate branches that can spread into dense mats a few inches (centimeters) high on exposed sandy or rocky soil. The bark is rough and reddish-brown; the crowded, leathery evergreen leaves are about 1 inch (2.5 cm) long, lustrous and blunt at the tips. These leaves have been used as a remedy for headaches and urinary troubles, one of the many wild plants modern science has imitated to produce synthetic medicines. American Indians not only used Bearberry in medicine, but also smoked it as a substitute for tobacco; the Indian word *Kinnikinick* was applied to any plant they used in this way.

Terminal clusters of small, white or pink, ovoid flowers adorn the plants from May to early July, followed by attractive, currant-sized red berries that persist into the next flowering period. Although dry and insipid to human taste, they are much favored by wildlife, such as grouse, songbirds, and mammals. Few fruits were left in the clusters when I painted this plant late in the season. Butterflies, especially the Brown and the Hoary Elfin Butterflies, feed on various parts of the plants.

Today *Arctostaphylos uva-ursi* is planted as a ground cover in some parts of the Northeast, and in Iceland the plant is combined with "black mud" from bogs to yield a deep and permanent black dye for wool cloth. Its range extends from the Arctic to New Jersey west to California on this continent, and across the northern parts of other continents. This northern range is reflected in its names: *Arcticos* means "the country of the Great Bear in the northern sky," and *ursinus* refers to the Great Bear; both Bears are the constellation *Ursa Major*, known in the United States as The Big Dipper. The "grapes" are the fruit clusters.

This species is now listed as being extremely rare in Virginia, extirpated from Pennsylvania and Ohio, rare in Indiana, and endangered in Illinois.

ROCKS AND SAND NATIVE

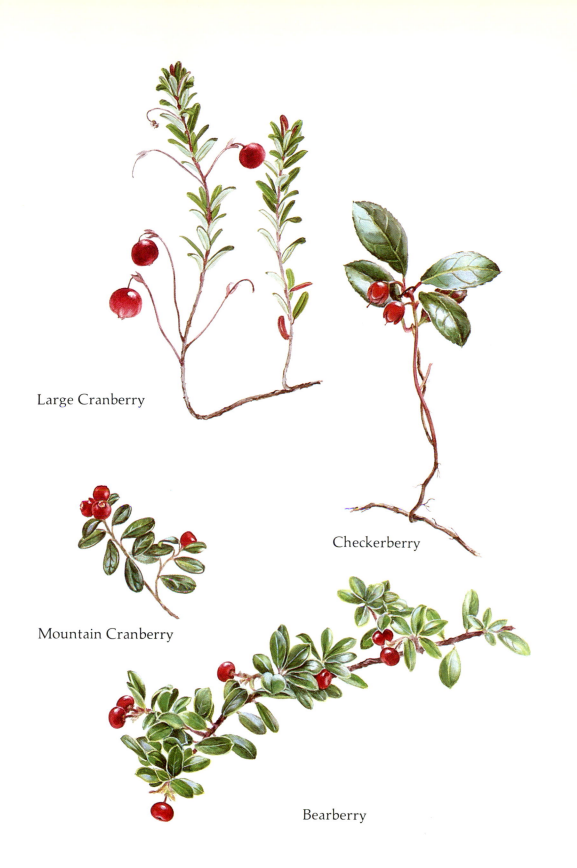

Large Cranberry

Checkerberry

Mountain Cranberry

Bearberry

CHECKERBERRY, WINTERGREEN, TEABERRY, *Gaultheria procumbens* Linnaeus. The stem of *Gaultheria procumbens* lies flat on or beneath the surface of the ground, from which rise erect, ruddy branches 2 to 6 inches (5 to 15 cm) high. A few leathery evergreen leaves with toothed margins are alternate at the top of the branches; old leaves are often tinged with or are entirely red. In July and August two or three white, ovoid flowers hang beneath the leaves. As they mature their calyxes become fleshy and swell into spicy red fruits that enclose the many-seeded capsules. Grouse, partridges, wild turkeys, several songbirds, and mammals feed on these fruits and help to spread the species when they pass the seeds in a more remote place.

In winter the leaves are quite tough, but still have a pleasant flavor when chewed. (NOTE: The poisonous leaves of Laurels, *Kalmia,* page 266, are similar—be sure of your Checkerberries). The leaves contain oil of wintergreen, which at one time was extracted from this species and from Sweet Birch, *Betula lenta,* as a flavoring for medicines, chewing gums, and candies. Today wintergreen flavoring is made synthetically, helping to conserve this native wildflower. Indians and early colonists made a tea of the aromatic leaves to treat coughs and sore throats.

The presence of wintergreen oil may be a reason to call the plant Wintergreen, but since it is not in the Wintergreen family, and since Partridgeberry, *Mitchella repens,* is also sometimes known as Wintergreen, Checkerberry seems a better choice for this member of the Heath family.

Gaultheria procumbens grows in upland woods and clearings, under conifers, especially on south-facing rocky sites. It occurs from Newfoundland southward and westward beyond our region, although it is now designated as endangered in Illinois. Only two species of *Gaultheria* occur in North America, this one and *Gaultheria hispidula,* Creeping Snowberry, a plant with small leaves along the stem and a white berry that also tastes of wintergreen.

Jean-François Gaultier was a naturalist and physician at the royal French court at Quebec in the early eighteenth century.

UPLANDS NATIVE

Labiatae: Mint Family

BLUECURLS

Trichostema dichotomum Linnaeus (hair/stamen) (forking in pairs)

Bluecurls is a mint with a different look: the flowers are not in axillary clusters nor in panicles but are usually solitary at the tips of branches. Blossoming in summer and early fall, the flowers are light blue or violet, each 1/2 to 3/4 inch (1.3 to 1.9 cm) long, with protruding, curved stamens the same color; these are the curls of the common name and the hairlike stamens of the generic name. *Dichotomum* describes the manner in which the square stem branches, by forking in pairs at regular intervals. Leaves are narrowly oblong or lance-shaped with smooth margins, 3/4 to 2½ inches (1.9 to 6 cm) long. The fresh plant is sticky, but by January all stickiness is gone.

The calyx has three long upper teeth and two short lower ones, but as the fruit dries the pedicel performs an extraordinary maneuver: it twists so that the fruit is inverted, with the shorter teeth above and the longer ones below. The ripe nutlets within become visible, held loosely by the little handlike calyx that will scatter its nutlets as chance agents dislodge them.

Trichostema dichotomum is an annual herb, growing 6 to 24 inches (15 to 61 cm) high, preferring dry open sandy or gravelly soil, as along railroad tracks and in bulldozed spaces. This species occurs from southern Maine to Missouri southward to Florida and Texas, but is now reported to be threatened in Michigan and rare in Indiana.

STERILE SOIL NATIVE

Bluecurls

Scrophulariaceae: Snapdragon or Figwort Family

OLD-FIELD TOADFLAX, BLUE TOADFLAX

Linaria canadensis (Linnaeus) Dumont (flax) (Canadian)

In giving this small lovely wildflower its common name the intention was to make a derogatory comment. "Toad" was applied to plants considered spurious, in this case resulting from disappointment in a plant that resembled flax, but was not. Common Flax, *Linum usitatissimum,* meaning "most useful," is the species that was and is cultivated. Occasionally it grows wild in waste places.

Old-field Toadflax is a biennial or annual, whose smooth slender stem may be simple or branched. In late spring and summer the stem terminates in a loose raceme of blue-violet flowers 1/4 to 1/2 inch (6 to 13 mm) long. Each corolla has the same form as that of Butter-and-Eggs (page 248), two-lipped with a humped palate and a narrow spur at the base of the lower lip.

The sessile leaves are linear, have smooth margins, and are alternate on the flowering stem; on sterile shoots they may be alternate or opposite. The tiny globose capsule opens by two apical valves to release many angled seeds over winter.

Linaria canadensis grows 6 to 24 inches (15 to 61 cm) tall, in dry, sandy or sterile acid soils, occurring throughout our range, although it is now considered rare in West Virginia and threatened in Ohio.

STERILE SOIL NATIVE

Compositae: Composite or Daisy Family

EARLY GOLDENROD

Solidago juncea Aiton (make whole) (stiff, like a rush)

Early Goldenrod is a common species of dry soils, rocky banks, roadsides, and open woods, one of the first to start the season of goldenrod flowering that lasts into autumn. Growing to 4 feet (1.2 m) tall, *Solidago juncea* has a smooth, stiff stem and recurving branches, referred to as elm-shaped. Numerous small flower heads are along the upper sides of the branches that may be one-sided or spreading. Lower stem leaves are broad, sharp-toothed and tapering to the winged petioles; upper leaves are more slender and lack teeth; often smaller leaves grow in the leaf axils. Lush basal and stoloniferous leaves appear early in spring, to build a strong root that will produce the tall flowering stalk in summer.

Goldenrod pollen is heavy and sticky, primarily carried by insects, not wind; yet it has been blamed as causing hay fever. Most often it is Ragweed (page 254), whose inconspicuous flowers mature at the same time and whose pollen *is* windblown, that causes hay fever. Goldenrods are the most bountiful wildflowers of summer, and usually great golden bouquets can be picked without endangering their survival. The flower heads can also be used in dyeing.

A goldenrod stalk may have a spherical or elliptical swelling—a Goldenrod Ball Gall or an Elliptical Gall; the first is caused by a small fly and the second by the larva of a moth. Inside the Ball Gall the fly larva awaits spring to pupate; some say that this gall is found only on *Solidago canadensis,* but I have seen it on *S. juncea* and *S. rugosa* in Maine. Bunch Gall also may be found on goldenrods, formed by a midge in a leaf bud and resulting in a bunch of small leaves, usually at the stalk's summit. Ball and Elliptical Galls are woody, and not only house their builders, but when empty, provide shelter and nest sites for non-gall-making insects. Woodpeckers feed on the gall larvae, and I am told that fishermen use them as bait.

Solidago juncea occurs across Canada, throughout our region and in the mountains of Georgia. See other Goldenrods for more on this genus.

DRY, ROCKY GROUND NATIVE

Old-field Toadflax Early Goldenrod

Compositae: Composite or Daisy Family

DOWNY GOLDENROD

Solidago puberula Nuttall (make whole) (minutely pubescent)

From August to October near the coast, the stiffly erect wands of Downy Goldenrod seem to glow along dry roadsides and on rocky outcroppings. The red-purple stem is 8 to 40 inches (20 to 101 cm) tall and downy, although it may require a hand lens to see these minute hairs, but there are other identifying features. The panicle is simple, or if branched, the branches are short, merely making the wand fatter; only occasionally are the lower branches of the crowded inflorescence long enough to result in a pyramidal shape. Individual flowers are larger than those of many other species, evident in winter from the large dried calyxes.

Stem leaves are lanceolate or oblong with pointed tips and toothed margins; they are 2 to 4 inches (5 to 10 cm) long, decreasing in size toward the top, an arrangement that prevents upper leaves from shading lower ones. In autumn, the leaves of this species turn dark purple as photosynthesis ceases.

Solidago puberula occurs from Nova Scotia to southern Ontario south to Georgia and Arkansas, but is now reported to be declining in Maryland and threatened in Kentucky. See other goldenrods in Sections I, III, IV, and V.

STERILE GROUND NATIVE

Compositae: Composite or Daisy Family

PEARLY EVERLASTING

Anaphalis margaritacea (Linnaeus) C. B. Clark () (pearly)

In winter the dry stalk of this perennial wildflower may be gray, hanging its head and leaves in a shrivelled state, but it is instantly recognizable. The fresh plant of summer, growing in open rocky places, perhaps near Sweet-fern (page 276), stands out against any background with its clean whiteness. The slightly fragrant, pearly white flowers are in a cluster at the top of the stem that stands 1 to 3 feet (30 to 91 cm) tall. Each small flower is composed of several overlapping ranks of dry petal-like bracts with tubular florets in the center—there are no ray flowers.

In bud, all of the heads are white and tightly closed, male and female flowers on separate plants. Open staminate flowers show a tuft of yellow stamens in the center; pistillate flowers produce seeds with short pappus bristles. At maturity the bracts spread and remain white until winter weathering grays them. The erect stem and the sessile leaves are covered with long white cottony hairs. The American Painted Lady Butterfly feeds on the leaves of species of *Anaphalis* and *Gnaphalium,* and makes a nest of silk and leaves.

Pearly Everlasting occurs across Canada and northern United States south to the mountains of Virginia, west to West Virginia and Ohio, and north to the Dakotas. However, the picking of these plants has diminished or depleted the population in some areas.

The generic name is said to be an anagram of *Gnaphalium* (page 196).

ROCKY SITES NATIVE

Downy Goldenrod Pearly Everlasting

GLOSSARY

Achene: A small one-seeded fruit that does not open to disperse the seed. Buttercup and dandelion fruits are achenes.

Alga: *(pl.* algae) A diverse group of predominately aquatic plants, usually with unicellular sex organs.

Alternate: An arrangement in which leaves and branches are borne one above the next and on the other side of a stem or trunk.

Ament: A catkin; a dry scaly spike, usually unisexual, as the inflorescences of willow and hazelnut.

Angiosperm: A class of vascular plants bearing seeds within enclosed ovaries.

Annual: A plant that flowers, produces seeds, and dies in one year. Compare biennial and perennial.

Anther: The pollen-bearing tip of a stamen.

Apical: Of the apex, or tip.

Aril: A fleshy or hairy outgrowth of a seed, as in Wahoo and Yew.

Ascus: *(pl.* asci) In fungi of the class Ascomycetes, a specialized cell in which spores develop.

Awn: A bristle-shaped apendage.

Axil: The angle formed between two organs, as between leaf and stem.

Axis: The longitudinal support on which parts are arranged; as stem, stalk, and rachis.

Basal: At the base, as basal leaves, those at the base of a stem.

Basidium: *(pl.* basidia) A spore-bearing structure in the class Basidiomycetes of fungi.

Beak: A firm, prolonged slender tip.

Beard: Long stiff hairs, as on the lower petals of flag irises.

Berry: A pulpy fruit with immersed seeds, as in grape and cranberry.

Biennial: A plant that usually takes two years to flower and produce seeds, then dies. Compare annual and perennial.

Biotic: Biological; relating to life.

Blade: The broad flat part of a leaf or frond.

Bloom: A white or blue powdery or waxy coating on a surface.

Bog: Wet spongy ground, usually acidic, inhabited by sedges, heaths, and sphagnum.

Bract: A modified leaf in the inflorescence or on the stem, differing from the other leaves of a plant.

Calyx: The outer circle of floral parts; the sepals, separate or joined, which enclose the other parts of the flower in bud, often persisting to enclose or surround the fruit.

Capsule: A dry multiple-seeded fruit that splits open at maturity into two or more sections, or valves. Also a structure containing spores in mosses.

Carpel: The female organ of a flower; a simple pistil or one section of a compound pistil.

Catkin: A dry scaly spike of usually unisexual flowers, as in willow and hazelnut; an ament.

Chaff: A small thin dry scale or bract.

Cleistogamous: Of a flower, self-fertilizing in an unopen, budlike state.

Composites: Members of the Compositae, the Composite or Daisy family, the largest family of flowering plants, in which the inflorescences are composed of many small flowers in heads or clusters.

Compound: Composed of two or more similar parts united into one whole, as compound leaf, a leaf divided into smaller leaflets.

Cordate: Of a leaf, heart-shaped with the point apical.

Corm: The enlarged fleshy base of a stem, bulblike in shape, but solid.

Corolla: The inner circle of separate or joined floral parts, the petals—usually the alluring part of the flower.

Corymb: A flat-topped or convex open flower cluster whose branches are alternate and whose margin flowers open first.

Crosier: A young fern frond tightly curled like the staff of an ecclesiastic.

Crown: An appendage to a petal, corolla, or seed.

Cyme: A somewhat flat inflorescence whose terminal, or central, flowers open first.

Deflexed: Turned abruptly downward.

Dicotyledon: A plant of one of the two major divisions of flowering plants, the Angiosperms. Dicots are characterized by a pair of embryonic seed leaves at germination whose veins are usually branched. Compare Monocotyledon.

Dimorphous: Having two distinct forms.

Dioecious: Of a species having male and female flowers on different plants.

Discharge: To forcefully eject.

Disk, disk flowers: In Compositae, the tubular flowers in the central portion of the head, differentiated from the straplike marginal ray flowers.

Doctrine of Signatures: The medieval belief that God had shaped plants to signify the parts of the body they would cure.

Drupe: A fleshy fruit with a single stony seed, as in cherry and Partridgeberry.

Entire: Of a leaf margin, one that is continuous, not toothed or lobed.

Epiphyte: An air plant, one growing attached to but not parasitic on another plant.

Extirpated: Eradicated from a given region.

Fen: An area covered or partially covered with water that is primarily from the ground; usually neutral or slightly alkaline.

Fertile: Capable of producing fruit.

Filament: In flowers, the stalk of a stamen that supports an anther.

Flora: A systematic treatise on, or a list of plants.

Floret: A small flower, usually one of a cluster.

Follicle: A dry fruit consisting of a single carpel that opens along one side to release its seeds, as in milkweed.

Frond: The expanded leaflike portion of a fern.

Fruit: A mature carpel or carpels, bearing the seed(s). It may be dry or fleshy, edible or inedible.

Fungus: (*pl.* fungi) A saprophytic, symbiotic, or parasitic plant. It differs from green plants in not possessing chlorophyll, therefore is not able to photosynthesize its own food, but obtains food from organic matter already produced by other organisms.

Gametophyte: Here referring to the sexual stage of the life cycle of mosses and ferns that arises from spores produced by the sporophyte stage.

Genus: (*pl.* genera, *adj.* generic) A category of classification designating a division of a family.

Glabrous: Smooth and without hairs.

Glaucus: Covered or whitened with a coating, or bloom.

Gleba: The mass of spore-producing tissue in the fruiting bodies of such fungi as puffballs and earthstars, enclosed by a peridium.

Gray, Asa: (1810-1888). Leading American botanist and taxonomist; original author of *Gray's Manual of Botany* (1848) rewritten and expanded in an 8th Edition by Merritt Lyndon Fernald in 1950, with a corrected printing in 1970.

Gymnosperm: A class of chiefly woody plants bearing naked seeds not enclosed in ovaries.

Head: A dense cluster of sessile or nearly sessile flowers or fruits on a short axis or receptacle.

Herb: (*adj.* herbaceous) A plant with no persistent woody stem above ground.

Hymenium: A spore-bearing layer in fungi or in their fruiting bodies consisting of asci or basidia.

Hypha: (*pl.* hyphae) One of the threads that make up the mycelium of a fungus.

Indusium: The covering of the sorus, or fruit-dot, in ferns.

Inflorescence: A group or cluster of flowers on a plant, having one of several arrangements; see raceme, panicle, umbel, spike.

Involucre: A circle or collection of bracts surrounding a flower, a head, or a cluster of flowers.

Lanceolate: Lance-shaped, broader toward one end and tapering toward the other.

Leaflet: A single division of a compound leaf.

Linnaeus, Carolus: (1707-1778). Born Carl Von Linné, Swedish botanist and taxonomist, considered the founder of the binomial system of nomenclature and the modern scientific classification of plants and animals.

Lip: A division of a bilateral corolla or calyx.

Lobe: A segment projecting between indentations, as on a corolla tube, leaf blade, or calyx.

Locule: The cavity of an ovary or anther of a flower.

Loment: A legume composed of one-seeded jointed sections, as in tick-trefoil.

Marsh: Soft, wet land inhabited by grasses, cattails, and other monocotyledons.

Monocotyledon: A plant of one of the two major divisions of flowering plants, the Angiosperms. Monocots are characterized by a single embryonic seed leaf at germination that usually has a single nerve or parallel veins, stems with no pith, and flower parts that are never in fives. Compare Dicotyledon.

Mycelium: (*pl.* mycelia) A mass of loosely woven filaments, hyphae, that makes up the vegetative body of most true fungi.

Mycorrhizal Fungi: Those having a symbiotic relationship with the roots of a plant, as with orchids and heaths.

Nerve: A leaf vein or rib that is unbranched, as in the leaves of most monocotyledons.

Node: The place on the stem that normally bears a leaf or a whorl of leaves, or a knoblike enlargement.

Nutlet: A diminutive of a hard one-seeded fruit, a nut.

Opposite: Of leaves or flowers, growing in pairs on either side of the stem.

Ovary: The part of the pistil that contains the ovules, the bodies that become the seeds after fertilization.

Ovate: Of leaves, egg-shaped, longer than wide with the broadest part toward the base.

Ovoid: An egg-shaped solid.

Palmate: Radially lobed or divided.

Panicle: A compound raceme in which the secondary flower branches are usually racemes as well.

Pappus: (*pl.* pappi) A modified calyx comprising a ring of fine hairs, scales, or teeth on a fruit, which persists after pollination and aids in wind dispersal, often by forming a parachute-like structure. Seen in members of the Compositae.

Parasitic: Growing on and deriving nourishment from another plant.

Pedicel: A small stalk bearing an individual flower in an inflorescence.

Peduncle: A primary flower stalk, holding either a solitary flower or a flower cluster.

Perennial: A plant with an indefinite life span of more than two years duration.

Perfect: Of a flower, having both stamens and pistils.

Perianth: The floral envelope surrounding the stamens and pistil(s), composed of the calyx and, when present, the corolla.

Peridium: The usually two-layered wall enclosing the spore mass of certain fungal fruiting bodies.

Persist: To endure, as a calyx or leaves through the winter.

Petal: An individual part of the corolla when it is divided. Petals surround the stamens and the pistil(s) and usually are the showy part of the flower.

Petiole: The stalk supporting a leaf blade.

Pilose: Covered with soft hairs.

Pinna: *(pl. pinnae)* One of the primary divisions of a compound frond or leaf.

Pinnate: Compound with the blade or frond cut into leaflets or pinnules arranged on each side of a common axis.

Pinnule: A secondary pinna where the pinnae are themselves divided.

Pistil: The seed-bearing organ of a flower that receives the fertilizing pollen and consists of the ovary, the style and the stigma.

Pistillate: Of flowers with pistils but no stamens; female flowers.

Placenta: The part of the interior of the ovary that bears the ovules.

Pod: A fruit, usually a legume, that develops from a single carpel and opens into two equal valves, as in beggar-ticks.

Poditium: *(pl. poditia)* A specialized spore-bearing structure in the bodies of *Cladonia* lichens.

Pollen: The powderlike microspores of seed plants, borne in the anthers.

Pollination: The fertilizing of a flower by the transfer of pollen from an anther to a mature stigma.

Prothallus: *(pl. prothalli)* The gametophyte stage of a moss or fern; typically a small, flat, green thallus attached to the soil that results from the germination of an asexual spore. Sexual organs develop from it that may produce a new plant.

Pubescent: Covered with short, soft, downy hairs.

Raceme: A simple inflorescence of pediceled flowers on a common elongated axis.

Rachis: The elongated axis of an inflorescence, a compound leaf or a frond.

Rays, Ray flowers: In members of the Compositae, the straplike marginal flowers, differentiated from the central disk flowers.

Receptacle: The more or less expanded tip of the flower stalk that bears the organs of a flower or the collected flowers of a head.

Rhizine: A holdfast that anchors the undersurface of a lichen to the substrate.

Rhizome: A horizontal underground stem, often short and thick, usually rooting at the nodes.

Rosette: A cluster of leaves, etc., in a circular form.

Saprophyte: A plant that obtains nourishment from the products of organic breakdown.

Scale: A thin, dry membranous body.

Scape: A leafless flowering stem rising from the ground.

Sepal: An individual part of the calyx when it is divided. The sepals may be green or another color.

Septum: A partition.

Serrated: Having sharp forward-pointing teeth.

Sessile: Having no stalk.

Sheath: The tubular base of a leaf surrounding the stem.

Silicle: A short silique.

Silique: A specialized capsule in which seeds are attached to a framelike placenta from which the valves fall away; as in the Cruciferae, the Mustard family.

Simple: Not compound.

Sorus: *(pl. sori)* A cluster of sporangia on fertile fern fronds.

Spadix: A flower spike with a fleshy axis, as in Skunk Cabbage.

Spathe: A bract enclosing an inflorescence, as in Skunk Caggage and Blue-eyed Grass.

Spatulate: Of a leaf, oblong with the basal end tapering, like a druggist's spatula.

Species: *(adj. specific)* A catagory of classification designating a division of a genus.

Spike: A simple inflorescence with the flowers sessile or nearly so on a common axis.

Sporangium: *(pl. sporangia)* A structure in which spores are formed, a sporecase.

Spore: A simple asexual unicellular reproductive unit in non-flowering plants such as fungi and ferns, whose function corresponds to a seed but has no embryo.

Sporophyll: A spore-bearing leaf.

Sporophyte: Here referring to the asexual stage of the life cycle of mosses and ferns that bears specialized bodies for producing spores from which arise the gametophyte stage.

Spur: A hollow tubular or saclike extension of some part of a flower, usually producing nectar.

Stamen: One of the several to many male, pollen-bearing organs of a flower, composed of a filament terminated by a variously-shaped, variously-colored anther.

Staminate: Of flowers with stamens but no pistil(s); male flowers.

Stigma: The part of the pistil, usually surmounting the style, which receives pollen for effective fertilization. It is rough, sticky, grooved, or otherwise modified to catch and hold the pollen grains.

Stipe: The stalk of a fern frond or fungus cap.

Stipule: A small leaflike appendage at the base of a petiole or leaf, often in pairs.

Stolon: A runner, or any basal branch that extends horizontally over or under the ground, rooting at the tip.

Strobilus: *(pl.* strobili) A group of closely packed sporophylls around a central axis, as in clubmosses and horsetails; a cone.

Style: The slender stalk of a pistil that bears the stigma, occasionally wanting.

Substrate: The substance or base on which an organism grows.

Swamp: Poorly drained land between grassy marshland and wet forest; contains shrubs and trees.

Terminal: At the apex.

Thallus: A plant body that is not differentiated into true roots, stems and leaves, as the fruiting bodies of fungi and lichens.

Tuber: A thickened underground branch bearing buds.

Umbel: An inflorescence whose peduncles or pedicels radiate from the same point like the ribs of an umbrella.

Valve: One of the sections into which a capsule splits at maturity.

Veins: Vascular bundles that form the branching framework and support of a leaf or other organ, as in most dicotyledons.

Weed: A plant growing where it is not wanted by humans.

Whorl: An arrangement of three or more leaves, fruit etc., in a circle around a stem or branch.

Winter annual: A plant from autumn-germinating seed that flowers the following spring.

BIBLIOGRAPHY

Bailey, L. H. *How Plants Get Their Names.* 1933; reprint ed. New York: Dover Publications, Inc., 1963.

Baskin, Carol C., and Jerry M. *Germination Ecophysiology of Herbaceous Plant Species in a Temperate Region.* Special paper. Lexington, Kentucky, June 1987.

Blackmore, Steven, and Tootill, Elizabeth. *The Penguin Dictionary of Botany.* 1984; reprint ed. Aylesbury: MarketHouse Books Ltd., 1986.

Blamey, Marjory. *Flowers of the Countryside.* New York: William Morrow & Co., Inc., 1980.

Blanchan, Neltje. *Nature's Garden, An Aid to Knowledge of Our Flowers and Their Insect Visitors.* New York: Doubleday, Page & Co., 1900.

Bland, John H. *Forests of Lilliput: The Realm of Mosses and Lichens.* Englewood Cliffs, New Jersey: Prentice-Hall, 1971.

Borland, Hal. *Hal Borland's Twelve Moons of the Year.* New York: Alfred A. Knopf, 1983.

Borrer, Donald J. *Dictionary of Word Roots.* Mountain View, California: Mayfield Publishing Co., 1971.

Braun, E. Lucy. *The Monocotyledoneae.* Columbus, Ohio: Ohio State University Press, 1967.

Britton, Nathaniel Lord, and Brown, Hon. Addison. *An Illustrated Flora of the Northern United States and Canada.* 1913; reprint ed., 2d ed. revised. 3 vols. New York: Dover Publications, Inc., 1970.

Brooklyn Botanic Garden Plants and Gardens. *Handbook of Dye Plants & Dying.* Vol. 20, no. 3. New York, 1969.

Brooklyn Botanic Garden Plants and Gardens. *Handbook of Ferns.* Vol. 25, no. 1. New York, 1977.

Brown, Laura. *Weeds in Winter.* New York: W. W. Norton & Co., Inc., 1976.

Brown, Tom, Jr. *Tom Brown's Guide to Wild Edible and Medicinal Plants.* New York: Berkley Books, 1985.

Cobb, Boughton. *A Field Guide to the Ferns.* 8th printing. Boston: Houghton Mifflin Co., 1963.

Coker, William Chambers, and Couch, John Nathan. *The Gasteromycetes of the United States and Canada.* 1928; reprint ed. New York: Dover Publications, Inc., 1974.

Conrad, Henry S. *How to Know the Mosses and Liverworts.* Dubuque, Iowa: William C. Brown Co., 1956.

Core, Earl L. *Plant Taxonomy.* Englewood Cliffs, New Jersey: Prentice-Hall Co., 1955.

Cox, Donald D. *Common Flowering Plants of the Northeast.* Albany, New York: State University of New York, 1985.

Crum, Howard A., and Anderson, Lewis E. *Mosses of Eastern North America.* 2 vols. New York: Columbia University Press, 1981.

Cusick, Allison W., and Silberhorn, Gene M. *The Vascular Plants of Unglaciated Ohio.* Bulletin of the Ohio Biological Survey, New Series. Vol 5, no.4. Columbus, Ohio: Ohio State University, 1977.

Dana, Mrs. William Starr. *How to Know the Wildflowers.* 1893; reprint ed. of revised ed. of 1900. New York: Dover Publications, Inc., 1963.

d'Estaing, Valerie Anne Giscard. *World Almanac Book of Inventions.* New York: World Almanac Publishers, 1985.

Densmore, Frances. *How Indians Use Wild Plants for Food, Medicine and Crafts.* 1928; reprint ed. New York: Dover Publications, Inc., 1974.

Duncan, Ursula. *A Guide to the Study of Lichens.* Grace Station 28, New York: Scholar's Library, 1959.

Dwelley, Marilyn J. *Summer and Fall Wildflowers of New England.* Camden, Maine: Down East Books, 1977.

———. *Trees and Shrubs of New England.* Camden Maine: Down East Books, 1980.

Felt, Ephraim Porter. *Plant Galls and Gall Makers.* New York & London: Hafner Publishing Co., 1965.

300

Fernald, Merritt Lyndon. *Gray's Manual of Botany*. 8th ed. rewritten and expanded. New York: D. Nostrand Co., 1970.

Gibbons, Euell. *Stalking the Wild Asparagus*. New York: David McKay Co., Inc., 1962.

_____. *Stalking the Healthful Herbs*. New York: David McKay Co., Inc., 1966.

Gleason, Henry A. *The New Britton & Brown Illustrated Flora of the Northern United States and Adjacent Canada*. Lancaster, Pennsylvania: Lancaster Press, 1952.

Gleason, Henry A., and Cronquist, Arthur. *Manual of Vascular Plants of Northeastern United States and Adjacent Canada*. New York: Van Nostrand Co., 1963.

Hale, Mason E., Jr. *How to Know the Lichens*. Dubuque, Iowa: William C. Brown Co., 1969.

_____. *The Lichen Handbook*. Washington, D.C.: Smithsonian Institute, 1961.

_____. *The Biology of Lichens*. London: Edward Arnold Ltd., 1967.

Hamilton, Edith. *Mythology*. 6th printing. New York: The New American Library of World Literature, Inc., 1956.

Harlow, William M. *Fruit Key and Twig Key to Trees and Shrubs*. 1946; reprint ed. New York: Dover Publications, Inc., 1954.

Harris, William H., and Levey, Judith S. *The New Columbia Encyclopedia*. New York: Columbia University Press, 1975.

Hawksworth, David L. *Lichens as Pollution Monitors*. London: Edward Arnold Ltd., 1976.

House, Homer D. *Wildflowers of New York*. 2 vols. Albany, New York: The University of the State of New York, 1918.

Johnson, Charles W. *Bogs of the Northeast*. Hanover, New Hampshire & London: University Press of New England, 1985.

Kamm, Minnie Watson. *Old Time Herbs for Northern Gardens*. 1938; reprint ed., New York: Dover Publications, Inc., 1971.

Kappel-Smith, Diana. *Wintering*. 5th printing. Boston and Toronto: Little, Brown & Co., 1984.

Korling, Torkel, and Petty, Robert O. *Wild Plants in Flower*. Evanstown, Illinois: Torkel Korling, 1977.

Kreiger, Louis C.C. *The Mushroom Handbook*. 1936; reprint ed. New York: Dover Publications, Inc., 1967.

Lincoff, Gary H. *The Audubon Society Field Guide to Northern American Mushrooms*. New York: Alfred A. Knopf, 1981.

Little, Elbert L. *The Audubon Society Field Guide to North American Trees*. New York: Alfred A. Knopf, 1980.

Mabey, Richard. *The Frampton Flora*. New York: Prentice-Hall, 1985.

MacKenzie, Katherine. *Wild Flowers of the North Country*. Plattsburg, New York: Tundra Books of Northern New York, 1973.

Marchand, Peter J. *Life in the Cold*. Hanover, New Hampshire and London: Press of New England, 1987.

Marsh, Janet. *Janet Marsh's Nature Diary*. New York: W. H. Smith Publications, Inc., 1984.

Martin, Alexander C.; Zim, Herbert S.; and Nelson, Arnold L. *American Wildlife and Plants*. 1951; reprint ed. New York: Dover Publications, Inc., 1961.

Mathews, F. Schuyler. *Field Book of American Wildflowers*. New York and London: G. P. Putnam's Sons, 1927.

McIlvaine, Charles, and Macadam, Robert K. *One Thousand American Fungi*. 1900; reprint ed. New York: Dover Publications, Inc., 1973.

Medsger, Oliver Perry. *Edible Wild Plants*. 2d printing. New York and London: Collier Macmillan Publishers, 1974.

Mickel, John T. *How to Know the Ferns and Fern Allies*. Dubuque, Iowa: William C. Brown Co., 1979.

Miller, Orson K. Jr. *Mushrooms of North America*. 3d printing. New York: E.P. Dutton & Co., 1979.

Miller, Orson K., Jr., and Miller, Hope H. *Mushrooms in Color*. New York: E. P. Dutton Publisher; [n.d.]

Muenscher, Walter Conrad. *Poisonous Plants of the United States*. New York: The Macmillan Co., 1951.

Newcomb, Laurence. *Newcomb's Wildflower Guide*. Boston and Toronto: Little, Brown & Co., 1977.

Niering, William A. and Olmstead, Nancy C. *Audubon Society Field Guide to North American Wildflowers*. 2d printing. New York: Alfred Knopf, 1979.

Parsons, Frances Theodora. *How to Know the Ferns*. 1899; reprint ed. New York: Dover Publications, Inc., 1961.

Peterson, Roger Tory, and McKenny, Margaret. *A Field Guide to Wildflowers of Northeastern and North Central United States*. Boston: Houghton Mifflin Co., 1968.

Petrides, George A. *A Field Guide to Trees and Shrubs*. 2d ed. Boston: Houghton Mifflin Co., 1986.

Pyle, Robert Michael. *The Audubon Society Field Guide to North American Butterflies*. 2d ed. New York: Alfred A. Knopf, 1985.

Richardson, Joan. *Wild Edible Plants of New England*. Chester, Connecticut: The Globe Pequot Press, 1981.

Rickett, Harold William. *The Field Guide of American Wildflowers*. New York: G. P. Putnam's Sons, 1963.

_____. *Wildflowers of the United States*. Vol. 1 of 4 vols. New York: McGraw-Hill Book Co., 1965.

Roberts, June Carver. *Born in the Spring; A Collection of Spring Wildflowers*. Athens, Ohio: Ohio University Press, 1976.

Rohde, Eleanor Sinclair. *A Garden of Herbs*. 1963; reprint ed. New York: Dover Publications, Inc., 1969.

Shuttleworth, Floyd S., and Zim, Herbert S. *Non-flowering Plants*. Racine, Wisconsin: Western Publishing Co., 1967.

Smith, A. W. *A Gardener's Book of Plant Names*. New York: Harper & Row Publishers, 1963.

Stokes, Donald W. *A Guide to Nature in Winter*. Boston and Toronto: Little, Brown & Co., 1976.

_____. *The Natural History of Wild Shrubs and Vines*. New York: Harper & Row Publishers, 1981.

Stokes, Donald W., and Stokes, Lillian. *A Guide to Enjoying Wildflowers*. Boston & Toronto: Little, Brown & Co., 1985.

Stokoe, W. J. *The Observer's Book of Wildflowers*. Reprint ed. London and New York: Frederick Warne & Co. Ltd., 1961.

Symonds, George W. D. *The Shrub Identification Book*. New York: William Morrow & Co., 1963.

Teale, Edwin Way. *A Walk Through the Year*. New York: Dodd, Mead & Co., 1978.

_____. *Wandering Through Winter*. 1965. Paperback ed. New York: Dodd Mead & Co., 1981.

Trelease, William. *Winter Botany*. 1931: reprint ed. New York: Dover Publications, Inc., 1967.

Weishaupt, Clara G. *Vascular Plants of Ohio*. 3d ed. Dubuque, Iowa: Kendall/Hunt Publishing Co., 1971.

Wharton, Mary E., and Barbour, Roger W. *A Guide to the Wildflowers and Ferns of Kentucky*. Lexington: University of Kentucky, 1971.

Young, Andrew. *A Prospect of Flowers*. New York: Viking Penguin Publishers, 1985.

STATE LISTINGS OF RARE AND ENDANGERED PLANTS

Connecticut's Species of Special Concern Plant List. Connecticut Geological and Natural History Survey; October 1985.

Checklist of Endangered & Threatened Animals & Plants of Illinois. Illinois Endangered Species Protection Board; March 1989.

Current List of Plants in Indiana. Indiana Department of Natural Resources, Division of Nature Preserves; January 1989.

Endangered, Threatened and Rare Plants and Animals of Kentucky. Kentucky Academy of Science; November 1986.

Official List of Maine's Plants That Are Endangered or Threatened. State Planning Office and The Critical Areas Advisory Board; March 1989.

Rare, Threatened and Endangered Plants of Maryland. Maryland Natural Heritage Program; 1987.

Massachusetts Rare Plants. Massachusetts Natural Heritage Program; August 1987.

Michigan's Special Plants. Michigan Natural Features Inventory; March 1989.

Plant Listings. New Hampshire Natural Heritage Inventory; [n.d.]

Special Plants of New Jersey. New Jersey Natural Heritage Program; July 1989.

Protected Native Plants. New York State Department of Environmental Conservation; [n.d.]

Rare Species of Native Ohio Wild Plants. Ohio Department of Natural Resources, Division of Natural Areas and Preserves; 1986-87.

Conservation of Pennsylvania Native Wild Plants. Pennsylvania Bureau of Forestry; July 1988.

Plant Species of Special Concern. Rhode Island Natural Heritage Program; May 1989.

Vermont's Rare, Threatened and Endangered Plant Species. Vermont Natural Heritage Program; July 1989.

Rare Plants of Virginia. Virginia Natural Heritage Program; August 1989.

State Element Lists—Plants. West Virginia Natural Heritage Program; December 1988.

Wisconsin Endangered and Threatened Species List. Wisconsin Department of Natural Resources; September 1989.

INDEX